D1201222

FV

WITHDRAWN

St. Louis Community
College

Library

5801 Wilson Avenue
St. Louis, Missouri 63110

ARTS
AND THE
SCHOOLS

ARTS
AND THE
SCHOOLS

JEROME J. HAUSMAN, editor
assisted by JOYCE WRIGHT

JOHN I. GOODLAD

JACK MORRISON

DENNIE WOLF

HOWARD GARDNER

NANCY R. SMITH

BENNETT REIMER

JUNIUS EDDY

LILLIAN K. DRAG

MC GRAW-HILL BOOK COMPANY
New York St. Louis San Francisco
Auckland Bogotá Düsseldorf
Johannesburg London Madrid Mexico
Montreal New Delhi Panama Paris
São Paulo Singapore Sydney Tokyo
Toronto

Copyright © 1980 by the Institute for the Development of Educational Activities, Inc. All rights reserved. Printed in the United States of America. No part of this publication may be reproduced, stored in a retrieval system, or transmitted, in any form or by any means, electronic, mechanical, photocopying, recording, or otherwise, without the prior written permission of the publisher.

Thomas Quinn and Michael Hennelly were the editors of this book. Elaine Gongora was the designer. Thomas Kowalczyk supervised the production. It was set in Century Schoolbook by University Graphics, Inc. and was printed and bound by Book Press.

Library of Congress Cataloging in Publication Data
Main entry under title:

Arts and the schools.

 (A Study of schooling in the United States)
 Bibliography: p.
 Includes index.
 1. Arts—Study and teaching—Secondary—United States. 2. Arts and society—United States.
I. Hausman, Jerome J. II. Goodlad, John I.
III. Series: Study of schooling in the United States.
NX304.A1A77 375'.7 80-10208
ISBN 0-07-027225-5

123456789 BPBP 806543210

Acknowledgment is made to the following publishers for use of material under copyright. Lydia A. Gerhardt, *Moving and Knowing,* © 1973, p. 63. Reprinted by permission of Prentice-Hall, Inc., Englewood Cliffs, N.J. Leonard B. Meyer, *Music, The Arts and Ideas,* University of Chicago Press, 1967.

The following persons assisted in the early planning for this volume and contributed valuable insights and directions. We wish to thank them for their time and effort. The resulting book, however, is the responsibility of the authors and A Study of Schooling and may not reflect the opinions of those listed below.

Frank Barron
University of California,
 Santa Cruz

Kathryn Bloom
JDR³ʳᵈ Fund

Carl Dolce
North Carolina State University

Junius Eddy
Consultant

John Goodlad
|I|D|E|A| and
University of California,
 Los Angeles

Jerome J. Hausman
Minneapolis College of Art
 and Design

Hilda Lewis
San Francisco State University

Jack Morrison
American Theatre Association

Bennett Reimer
Northwestern University

Joyce Wright
|I|D|E|A|

This book is one of the volumes commissioned as background information for A Study of Schooling. The Study is an in-depth examination of representative elementary, junior high, and senior high schools located in several regions of the United States. The Study focuses on the school as a whole and includes the curriculum, the student and adult experiences in the school, and relationships with the community. Results of the research are presented in subsequent reports and a summary volume.

John I. Goodlad
Principal Investigator

SUPPORTED BY
The Danforth Foundation
International Paper Company Foundation
The JDR³rd Fund
Martha Holden Jennings Foundation
Charles F. Kettering Foundation
Charles Stewart Mott Foundation
National Institute of Education
The Needmor Fund
Pedamorphosis, Inc.
The Rockefeller Foundation
The Spencer Foundation
United States Office of Education

Substudy on the teaching of the arts in schools supported
by an additional grant from the JDR³rd Fund and the
Rockefeller Foundation

Conducted under the auspices of |I|D|E|A|, a division of the
Charles F. Kettering Foundation.

CONTENTS

PREFACE

It is a truism to assert that "man does not live by bread alone." Beyond our basic needs for survival there are needs that relate to the qualitative aspects of human experience. There is a human need to decorate or embellish; there are tendencies to seek out the unusual and extraordinary; there are inclinations toward becoming involved with things that are poetic and metaphorical—in short, there is a qualitative dimension to life.

Underneath the hustle and bustle of contemporary living we have a yearning for beauty and quality in our lives. Alongside human desires in the so-called practical realm are desires that are best satisfied through involvement with the arts. Indeed, there is evidence of intense human activity in the arts long before the advent of present-day science and technology.

Arts activity has been a vehicle for exploring a wide range of perceptions and values. The resultant forms have become the means for embodying or encompassing a virtually infinite range of human possibilities. Art forms exist in differing scale and proportion (for example, a crafted metallic piece of jewelry or a large cathedral). Art forms exist in differing space and time relationships (for example, a poem or film or a dance or musical performance). Art forms have been created with differing purposes and intentions (for example, a religious ritual or sidewalk graffiti). Taken together, works of art reveal and reflect the myriad of human experiences, values, and ideas.

To understand the arts fully requires focusing attention upon matters of quality—the quality of ideas, the disciplined control of media, and the imaginative grasp of possibilities. Such understanding enables a particular understanding of the accomplishments of others and the possibilities for oneself. Hence, education in the arts opens possibilities for focusing upon intrinsic qualities in objects and events. The emphasis is placed upon the immediate apprehension of quality. Objects, past and present, have but one meeting point in the actual experience of a human being.

The idea of "progress" may be applied appropriately to many areas

of study in our schools. We have progressed in our understanding and accomplishments in technology. Mechanical controls have grown in sophistication. As a result, it is possible to refer to the latest developments or improvements in science. It is possible to trace ideas from early, less sophisticated, or informal beginnings to the present with a sense of forward movement and accomplishment. "Newer," in this context, is "better."

This idea of "progress" does not hold in the same way for the arts. A contemporary poem cannot be seen as having "progressed" from Milton; a newly written play is not likely to be more advanced than Hamlet; a jazz or rock concert is no more complicated than a performance of Baroque music; a painting by Pollock is different from (but no more sophisticated than) a painting by Giotto. The arts address themselves to matters of form and quality. As such, they invite study of the different means available to us for the expression and realization of ideas. Study of the arts addresses itself to matters of quality, not matters of "progress."

Artistic activity needs to be understood as a basic human activity. The creation of art forms should be seen and understood in the context of the human need to express and realize ideas and feelings. Just as the arts have addressed themselves to the full range of human experience, arts education can become a means for the expression and realization of differing ideas and feelings. Just as the arts have grown from diverse purposes and media, arts education can address the use of many means in the creation or appreciation of aesthetic ideas.

What, then, do we mean by arts education? First, it is that area of education that deals with the means or media for artistic expression—music, dance, literature, drama, and the visual arts—and that deals with the many ways by which people can realize (or have realized) ideas and feelings: sound, words, movement, dramatic situations, and visual forms. Secondly, it is that area of education that addresses itself to the needs or purposes for individual or group expression—ritual, celebration, role playing, exploring personal feelings, or inventing new structures and concepts. Arts education stems from a human desire to create, to build, to project oneself symbolically into an aesthetic form or event.

From the outset, it should be clear that the concept of arts education presented in this book starts with an assumption that the experience of expressing and responding to artistic ideas and events can be made available to all students. The content for instruction can be conceived in qualitative and process-oriented terms. There is not a fixed, sequentially organized, necessary body of activities or knowledge that can be identified as being the absolutely necessary infor-

mational content of the arts. Indeed, there are differing avenues possible for achieving the goal of an informed, sensitive, and perceptive grasp of music or drama or dance or any other art. The concept of arts education accepts the fact of multiple means for artistic expression and the idea of art as meeting a basic human need. The concept of arts education assumes that it is possible to create situations in which artistic learning is maximized.

Three general characteristics need to be present in an effective arts program: 1) opportunities for personal identification and involvement with arts forms; 2) help in developing understanding and/or control of artistic media; and 3) knowledge of a broader context of artistic efforts by others (past and present).

Personal identification involves processes of empathy, projection, and engagement with ideas and feelings. A child's imaginative play, an adolescent's involvement with movement and sound, an adult's enjoyment of tragedy or comedy—each becomes the proper domain for arts education. Creating or responding to works of art offers opportunities for internalizing and then expressing one's innermost feelings. The forms being apprehended or created serve as the embodiment of an aesthetic concept.

The quality and depth of identification possible is related to the individual's knowledge and/or control of the medium being utilized. Perception and judgment of an object or event are intimately related to one's understanding and/or control of the medium. Clearly, it is possible to approach any art form naively, without any prior conceptions or knowledge of techniques employed. However, any sustained and cumulative impact in experiencing the arts mandates a growing awareness and/or control of the medium being used.

Lastly, what is important to grasp is the larger context or tradition within which any artistic expression exists. Whatever the medium, or the time of creation, or the circumstances, there is always the continuing link with other people through the arts. Within a single classroom or a school building, there are many opportunities for individuals to share their efforts with others. This sense of exchanging or sharing via the arts becomes greatly expanded when one can grasp the wealth of the arts via their historic traditions.

Learning about the arts, like learning about language, is a function of individual need and inclination; it is also a function of social and cultural dynamics. We can no more learn about the arts in a vacuum than we can learn language in isolation. Different times and different circumstances have given rise to different forms. What is important to understand is that the arts represent a continuing quest for quality in changing circumstances. A young child brings particu-

lar knowledge, sensibility, and control to the need to create. An adolescent, having grown up on a farm or in rural surroundings, brings a particular awareness of nature. A young man or woman in an urban context has a different frame of reference for ideas and feelings.

It is exciting to contemplate the availability of art forms, past and present, for study of the arts. Any art—music or drama or painting or poetry or dance—can offer forms for study. Each invites creative involvement and interpretation in the present. Each of the arts provides examples of objects, forms, or events developed out of the creative insights of another individual or group. As importantly, art works can then involve other human beings in the idea of the work and hopefully would serve to kindle a spark of creative imagination and appreciation.

Why have the arts in the schools? If the schools are to address themselves to the needs of people and if all people have the need and potential for focusing upon the more imaginative and aesthetic aspects of their experience, then the importance of the arts in the schools should be obvious.

When and where in school programs do the arts belong? Broadly conceived, the content of the arts belongs in the education of students at all levels of our elementary and secondary schools. What is important to understand is the essential challenge of approaching instruction with a clear sense for the multiple means available through differing art forms for heightening and intensifying knowledge and experience. Creating and experiencing the individual arts (music, dance, poetry, painting, etc.) invites a direct encounter with personal modes of perception and expression. Studying about the arts becomes a means for understanding the ideas and feelings of others. Hence, study of the arts can be inextricably linked to study in the humanities and social sciences.

How do we design effective programs in the arts? First, it is important that those designing the program have a clear understanding of the arts. Effective programs start from a grasp of what the arts are about and a strong commitment to them. Perhaps this accounts for the persuasiveness and effectiveness of artist-teachers. The excitement in dealing with ideas and feelings, the willingness to venture forth into the realm of the imaginative and innovative, and the discipline that comes of controlling the means and media of the arts— these are factors that contribute to teaching effectiveness. It should also be noted that a strong commitment to the arts and grasp of what they are about can also be associated with scholarly and critical inquiry. Creative engagement with the arts can come about via one's involvement as an onlooker. Reading a poem or listening to a string

quartet or looking at a piece of sculpture can become the basis for the joy of recreating and realizing ideas and feelings.

Second, it is important that those designing the program have a clear understanding of the growth and developmental character of learning in the arts. Learning in the arts, as is the case with learning in other areas, proceeds from a point of existing "readiness" on the part of the student. The concept of "readiness" is a function of differing factors: physical capabilities, past experiences with the medium, and social and psychological motivation. Effective teaching starts with a sense for what is known and valued. It then moves students to reach higher and more sophisticated levels of knowledge and understanding.

Third, it is important that those designing the program have a clear understanding of contextual and environmental factors. To whatever extent possible, the program should draw upon existing strengths—other artistic interests and capabilities within the school and community; available cultural resources such as museums, theaters, libraries, and galleries. Every community or cultural group has certain ties with the arts. Effective programs in the arts can reach out to engage other areas of school and community activity.

The gnawing question remains: "what does a good program in arts education look like?" Having accepted the generalizations about the value of the arts and the importance of educating the senses, there remains the question of "how do we accomplish these lofty goals?" Indeed, this was one of the important starting points for this publication.

Have we, in fact, succeeded in setting forth clear, concise, and unambiguous models of excellence for arts programs in our schools? I think not! What this publication does do is lay out the broad framework within which excellence can be achieved. It describes and suggests alternative strategies for greater effectiveness. The publication points to essential considerations in operationalizing an effective educational program in the arts. In so doing, it invites the creative engagement of others in working with students. If, as has been pointed out, the very nature of the arts is that they invite a continuing dialogue and reappraisal, then it should come as no surprise that those who engage in effective teaching are themselves continually challenged by these same conditions.

A great deal has happened since the early meetings of the publication's planning committee: Frank Barron, Kathryn Bloom, Carl Dolce, Junius Eddy, John Goodlad, Hilda Lewis, Jack Morrison, Bennett Reimer, Joyce Wright, and myself. Many people working in the field were invited to prepare and submit position papers that ad-

dressed critical issues at an operational level. Each position paper author was encouraged to present a descriptive essay about his or her program responding to such questions as: What is to be taught? By whom? How might time and space be organized? What staffing patterns are possible? How might teaching materials be used? What about in-service trainging, inter-disciplinary connections, communications, staff decision making, and evaluation? In short, we sought to elicit a working resource of program narratives. These materials served as background for the chapters that follow. Excerpts from these position papers are included in Appendix A and Appendix B lists the contributors.

This publication is the result of the work of many people. For the most part, participation in the project is recognized and acknowledged in our listing of authors and our Advisory Panel. However, special recognition and appreciation need to be expressed to two people: Dr. Hilda Lewis of San Francisco State University for her contribution in the planning, conceptualization, and logistics of getting the book started, and Judith S. Golub of the staff of A Study of Schooling for her perceptive and informed editing of the publication.

Preparation of this volume was supported by grants from the JDR³ʳᵈ Fund and the Rockefeller Foundation. Both have a longstanding interest in the arts and arts education. The JDR³ʳᵈ Fund supports the Ad Hoc Coalition of States for the Arts in Education and the League of Cities for the Arts in Education. Nine state departments of education are members of the former and six cities belong to the latter. The purpose of both networks is to plan and carry out strategies for making all the arts an integral part of the education of all children. The Rockefeller Foundation was a major sponsor of the Panel on the Arts, Education and Americans which produced *Coming to Our Senses* and its recommendations for the future of arts education. The Foundation continues to fund follow-up activities to implement the recommendations.

One of the most important factors to be taken into account in seeking to create comprehensive, exemplary school arts programs is the condition of school programs now. How wide is the gap between present realities and perceived alternatives? What are likely to be productive entry points for general improvement? What resources are likely to be required and which strategies are likely to be most successful?

At the time this book is going to press, a comprehensive inquiry into the daily life and programs of a sample of schools is nearing completion. Entitled A Study of Schooling and directed by John I. Goodlad, the project has been supported by a consortium of private phil-

anthropic foundations, the National Institute of Education, and the United States Office of Education, and conducted under the auspices of /I/D/E/A/, a division of the Charles F. Kettering Foundation. A substudy of this larger inquiry, not yet published, has examined arts programs in precollegiate education. When the results become available, they will provide useful insights into a wide range of present realities regarding school-based arts program for children and youth. Comparing this research report with the present volume, which is designed in part to suggest promising directions for the future, should prove a useful, interesting activity. It may be possible to set forth a reasonably specific agenda for translating growing concern for the arts in education into practice.

Jerome J. Hausman
Minneapolis, March 1980

ARTS
AND THE
SCHOOLS

THE ARTS AND EDUCATION

JOHN I. GOODLAD
*University of California, Los Angeles, and
/I/D/E/A/*

JACK MORRISON
American Theatre Association

A three-pronged argument for the support of affirmative policies and comprehensive programs in arts education can be offered. First, the arts are recognized and established in the existing sociopolitical goals of education and schooling in the United States. Second, we have sufficient insight into human beings to know that the arts have a central, not a peripheral, role to play in their full development. Third, the arts as a domain of human experience and activity have so much to offer that their neglect in general education is a form of societal and individual deprivation.

The often contradictory wishes of the people, the nature of human beings, and the subject matter of their learning are the sources from which educational policies and programs in general are derived. Although we attempt to treat each of these somewhat discretely here, the close relationship among all three is such that they become organizing themes which appear and reappear, particularly in discussing the nature of human beings and their arts. It is our hope that the resulting repetition adds to rather than detracts from the whole.

THE SOCIOPOLITICAL GOALS OF SCHOOLING

There is a strong thread of pessimism among arts educators regarding present and potential support for arts education in schools. As a nation, we have some distance to go before the arts become an integral part of our daily lives. Both inside and out of schools, developing artists and providing experiences in the arts are given far less attention than developing athletes and promoting athletics. But a defeatist attitude among educators is itself detrimental to progress and is, in part, a self-fulfilling prophecy.

Responsible groups of educators have long recognized the importance of the arts and supported their inclusion in public education. As long ago as 1927, the Department of Superintendents of the American Association of School Administrators (AASA) resolved that ". . . we are rightly coming to regard music and art and other similar subjects as fundamental in the education of American children." In 1959, the AASA further resolved, "We believe in a well-balanced school curriculum in which music . . . and the like are included with other important subjects such as mathematics, history, and science. It is important that pupils, as part of general education, learn to appreciate, to understand, to create, and to criticize with discrimination those products of the mind, the voice, the hand, and the body which give dignity to the person and exalt the spirit of man."[1] Three years later the Educational Policies Commis-

sion of the National Education Association stated, "We think it is important that all individuals have a wide exposure to the arts. This should be a part of the school program at all ages and in as many artistic areas as can be provided. Particularly, we think that each student should have rich experiences not only in appreciating the artistic works of others but also in creating artistic experiences for himself."[2]

What about the American population at large? In January 1973, Lou Harris Associates polled a scientifically drawn, representative cross-section of 3,005 Americans from the various regions of the country and major demographic groups. Interviews lasted an average of an hour and thirty-four minutes. The sample can be reasonably projected to the nation's population as a whole. The study found that Americans strongly support development in the arts and express willingness to put money behind such development.[3] Of those polled 64 percent stated that they would be willing to pay an additional $5 per year in taxes if the money went to arts and cultural facilities. More than 80 percent thought that all the arts and crafts should be offered in schools. Harris commented, "Clearly the arts must emerge from their cloistered chambers of elitism; they must be brought to the people and the people must be asked to help pay the freight for them. The real news from this study is that the people are ready to respond."[4] Further, in discussion of the data, he says, " . . . the public feels strongly that cultural opportunities are important for children. Moreover the public endorses the presentation of the arts and creative activities in the core curriculum, alongside the basics of the educational system—mathematics, English, and science. The public also recognizes the importance of an interplay between what happens in the schools and what is available in the community at large, and favors more exposure across the board to cultural events for children."[5]

Other evidence attests to the phenomenal growth of community arts activities for whole families, but particularly adults, in recent years. One survey revealed that the public chose museums over stadiums as important to the quality of community life.[6] There has been a dramatic shift, too, from observation to participation. University extension classes emphasizing involvement in creative writing, drawing, painting, film, and drama usually are quickly oversubscribed. Most colleges and universities have long waiting lists of students wishing to major in the arts.

One could argue, with supporting evidence, that most of this activity is a middle- and upper-middle-class phenomenon of rela-

tively affluent persons seeking enrichment as secondary to their vocational pursuits. But one could argue, also, that it is evidence of the natural drive of humans to express themselves, a drive that seeks outlets just as soon as a little time from childraising and breadwinning is available. Further inquiry would reveal that more and more people feel a need to balance income-earning work with good human work of another kind, each enriching the other. At long last, we are getting over the puritanical notion, not without difficulty and guilt, that work must be somewhat distasteful if it is to be good for the soul. We are beginning to recognize the importance of and relationship between love and work in the sense that Freud used these concepts.

Somewhat less readily, adults are coming to realize that learning and school need not and should not be painful either, although the relaxation from their upbringing in which parents indulge often is not applied to their children or schools. Attention to the individual and his self-development is a relatively recent concern in goals for schooling. In this country, seventeenth-century goals were spare and stark, stressing " . . . ability to read and understand the principles of religion and the capital laws of the country."[7] During the next hundred years, the importance of preparing for jobs was added, but, with the nation's founding, moral instruction and inculcation of love of country were reaffirmed as prime business for the schools. And for still another hundred years, little was added to the central theme of responsibility—"a degree of education to enable one to perform all social, domestic, civic, and moral duties."[8]

Humanistic stirrings in education during the concluding decades of the nineteenth century were applied more to organizational and pedagogical practices than to goals and content. Just a little probing into manuals for teachers, textbooks, and classes reveals heavy concentration on previous goals; God and country loomed large. We entered the twentieth century with the expectation that schools would teach the fundamentals of writing, reading, and arithmetic; would provide the preparation required for entry into the workplace (usually translated into eight years of elementary education); and would prepare for an array of responsibilities accompanying adult citizenship.

Except in some forward-looking writing of the time, most of it addressed to educating the very young (as in the kindergarten), words such as self-realization, individual autonomy, creative expression, dramatic play, and aesthetic development seldom appeared in the lexicon of schooling. It took more than fifty years of

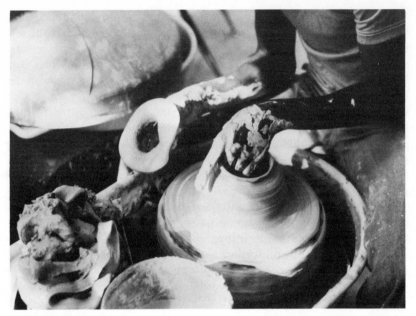
Arts Magnet School, Dallas, Texas

the present century for such words to make their appearance some-
what routinely in the sociopolitical goal statements and accompa-
nying rhetoric of state and local school systems.

Thus, we must remember that although references to the arts now
appear in these statements, often obliquely under labels such as aes-
thetic education, acceptance of the arts in formal statements of goals
for schooling is a relatively recent development. And, usually, the
reference appears as the last in a list of ten or eleven goals. Only a
handful of states have come out—all recently—with accompanying
guidebooks or manuals suggesting how the implied commitment
might be fulfilled.

Nonetheless, the commitment is there. It provides justification for
the allocation of resources and the cornerstone for program devel-
opment. Indeed, the goal statements of state and local school dis-
tricts constitute a kind of mandate for educational administrators.
Failure of concerned citizens to find K–12 arts programs in the
schools to which they send their children probably constitutes more
justifiable grounds for complaint than does inadequate progress of
their offspring in reading or mathematics. At least the latter sub-
jects invariably are offered in school; part of the responsibility for
inadequate progress lies with students. But to provide no programs

in the arts is to deny young people opportunities presumably promised in the district's goals for its schools. Although we have reservations about certain intrusions of the courts into schools, a suit charging failure to deliver in the arts is one we could appreciate.

The 1970s brought a reaction to the expansive mood of the 1960s in almost all aspects of human life. Edmund G. (Jerry) Brown, Jr., swept into office and captured attention in California and other parts of the nation on a platform of individual responsibility and restraint, particularly on the part of public officials. Jimmy Carter stressed old-time morality, work, and both individual and governmental restraint. More and more people saw conservation as not just an ideal but an idea whose time had come as a practical necessity. The sixties, one of the most tumultuous decades in American history, were "out"; jazz, country music, memorabilia of the 1930s and earlier, and an assumed better life of the past were "in."

In schooling, was not back-to-the-basics "in" and progressive, innovative education "out"? And wouldn't this mean that recently established goals and anything "artsy" and, therefore, not fundamental also was "out"? There is no doubt that arts programs suffered from budgetary cuts resulting in part from declining enrollments and in part from not being recognized as being equally important with other program components. But for school leaders to conclude that today's citizens want a lean curriculum stressing only the three R's and that they reject the arts as a goal for schooling is a serious miscalculation. Indeed, many superintendents and others in responsible positions may already have overreacted to a degree they may come to regret. Some have locked themselves into decisions that fail to reflect sound educational policy and practice. The back-to-basics movement, like other temporary swings of the pendulum, is as much fueled by educators with eyes fixed on their jobs as by segments of public opinion.

Based on the Harris poll cited earlier, one must question whether there was much of a change in overall parental expectations for schooling even at the height of the reappearance of the back-to-basics theme during the 1970s. As further evidence, McIntyre's study is revealing.[9] He created a "school game" by means of which parents might construct conceptually the kind of school they would like for their children and make decisions about goals, curriculum, pedagogical methods, and so on. Embedded in each item of choice was a value position, ranging in conventional terms from traditional through middle-of-the-road to progressive. For example, parents could choose from goal items stressing the three R's or the development of children's self-expression. Fathers and mothers were asked

to place in one pile all the cards describing goals or procedures they liked or wanted and in another all they disliked or did not want. In the school district studied, a large number of parents participated and almost all placed *all* goal statements in the "want" or "like" pile! In other words, they wanted the full array of goals, including those referring to self-development and self-realization to which most states and local districts make a commitment.

Over the past two decades or more, subtle but ultimately pronounced changes could be observed taking place in many school board members and interested citizens who became involved with schooling to promote or urge a return to so-called basic education. They usually begin with clichés denigrating "progressive education" and with generalities about cutting off the fat and getting down to basics. Pushed to be more specific, they frequently become evasive and uncomfortable. Asked a question such as, "Since you are for the 3 R's, would you cut out social studies?," they frequently reply, "Oh no, it is important for young people nowadays to know a great deal about the world in which they live." "Then, surely you would not want the arts?" And the reply comes back, "My child enjoys music; I want the schools to encourage her talent." Soon the critic sounds very much like those "progressive educators" he or she formerly denounced.

During the seventies, pressure increased for states to support a larger share of school costs as a means of easing the inequities in local ability to pay. This was fueled by a taxpayers' revolt, coming to a head first in California and then in other states, over rapidly inflating property taxes and perceived insensitivity on the part of their elected "representatives." Legislators became more sensitive than they had been previously to what state funds were to support. Several state legislatures engaged seriously in trying to define basic education, but the task proved far more demanding than they had anticipated. Committees found themselves unable to agree. Some resolved the matter by being eclectic, endorsing most of what most schools say they do; others side-stepped the issues by declaring that state funds would support mathematics and reading or English, leaving the local district to decide what to support with the rest of its resources.

Whatever one's own bias or preference as an individual, each of us must keep in mind that most people, when given the opportunity to think seriously about the problem, expect much more of schools than teaching the fundamental skills of reading, writing, and mathematics. We are uncomfortable when forced to choose among these fundamental skills, vocational preparation, socialization, and the

development of the self, including special talents. We want all of these properly educative things and much more—probably too much more: custodial babysitting care, the conferring of status and credentials, development of patriotism, training in good manners, and on and on. "These views suggest that if intellectual development were the only outcome of schooling, parents would not expect their children to spend at least twelve years in school, and the public would not spend an average of over \$15,000 per child on schooling."*[10]

Educators would be well advised to pay more attention to the long-term, relative stability of the public's expectations for schools and less to temporary fluctuations frequently blown out of proportion, first by the media and then by nervous colleagues. Even at the height of the back-to-basics movement of the seventies, 57 percent of those members of the public polled by Gallup had never heard of it.[11] For the past quarter century, public expectations as expressed in the sociopolitical goals of most state and local school districts have included the arts.

THE NATURE OF HUMANS AND THEIR ARTS

Important as public directives are in determining the ends and means of schooling, they provide insufficient guidance for the conduct of education. Education is more than what educational institutions are expected to do. Further, the education of young people is too important to be left entirely to the limited wisdom of their parents and relatives. There is a side of education which transcends institutions and other people and which determines the personal meanings derived from all experience. The person seeks much more than socialization and it is this seeking that requires of formal educational processes much more than preparation for and introduction into " . . . all social, domestic, civic, and moral duties." John Dewey's definition of education as the reconstruction or reorganization of experience (*Democracy and Education,* 1916) departed dramatically from 250 years of emphasis on responsibility to matters lying beyond oneself. Cremin paraphrases Dewey's definition as ". . . a way of saying that the aim of education is not merely to make citizens, or workers, or fathers, or mothers, but ultimately to make human beings who will live life to the fullest."[12]

*In 1977, the National Center for Education Statistics estimated \$21,000 per student, a figure covering both elementary and secondary education.

While the arts have contributions to make to the learning of fundamental skills, vocational preparation, and social responsibility, it is in the interpretation of life experiences and continuous reconstruction of the self that they come into their own. This idea means that utilizing several hours each week for activities designated as music or drama or dance or visual art is not necessarily evidence of adequate commitment to the arts. Artistic experience and expression and, in turn, the development of creative, sensitive human beings means much more than that. We no longer are speaking of schedules and subjects but of orientation and process. We shall have more to say on this subject later, but the point to be made here is that the major role of education is development of the individual, and it is virtually impossible for individuals to develop in whole and healthy fashion without the arts and aesthetics playing a part.

We can think of the subjects of the curriculum in some ascending or descending order of importance and relegate the arts to the nonbasic. (Those 41 percent of respondents to the 1977 Gallup poll on public schools who had heard of the back-to-the-basics movement reportedly thought of reading, writing, and arithmetic as basic.) But this cannot and does not neatly compartmentalize the human being, assuring that he or she will bring only mathematical and linguistic interest and abilities to the learning process. Further, there is no evidence to suggest that concentration on these abilities to the attempted exclusion of all else is the best way to develop mathematical and linguistic facility or talent. Indeed, quite the reverse probably is true.

At least six arguments based on the nature of human beings, their learning processes, and the arts lend support to policies and programs for and in arts education. First, as pointed out in preceding paragraphs, for a person to grow up insensitive to both beauty and art form in its many variations, and humankind's artistic methods and interpretations, is to grow up deprived. In the same way that individuals are deprived, society is the poorer when it fails to develop both sensitive, attuned human beings and talented persons to enrich the lives of us all. Since people are the wealth of nations, nations would be well advised to seek the maximum development of their human resources. Educational experiences in the arts do not assure artistic and aesthetic fulfillment, but they help.[13] People do not learn what they have no opportunity to learn; they learn best what they spend time learning. We do not yet have a society that assures the full development of human character, with all its richness and complexity, simply by growing up in it. Deliberate educational processes are required.

Second, " . . . man has a biologically-rooted need to engage in complex activities. . . ."[14] The arts offer access to virtually infinite environmental complexity. In the same way that Dewey chose industrial arts, particularly woodworking, to provide a new context for problem solving, insightful modern educators suggest incorporating the arts in general education to challenge that part of the brain not actively engaged by many other kinds of stimuli.[15] The pedagogical beauty of the arts, properly conceived and taught, is that they offer unlimited self-involvement on the part of the learner. The teacher need not establish and reestablish specific objectives and activities; experiences leading to new ones and the evolving interpretation of these experiences provide ends and means simultaneously. Not that goals matter when the doing is motivation enough: " . . . for our highest activity, we do not argue that the end justifies the means; the means justify themselves. We need to extend this lesson to the whole of our experience; namely that our happiness—in a real sense, the quality of our lives—lies in the doing and not in the done; in the doing is where our real goals lie. And these goals need no rationalized ends to justify them."[16]

Third, the vicissitudes of life, the dull and boring, the necessary but disagreeable tasks, are more easily borne when one is securing deep satisfaction from at least part of what one does. In school, for example, there are young people who simply are turned off by much of what they are called upon to do—because of dull teaching, repetition, lack of fit between level of attainment and curricular demand, and so on—but who come alive to the arts. Opportunities in music or drama or dance sustain them as they cross what otherwise would be a desert. For example, a survey of thirty city school districts found that participation in the arts is one of the successful strategies used to "arouse zest for learning in students from diverse backgrounds, including those whose histories have been marked by failure, loss of hope and/or anti-social behavior."[17]

Even students who enjoy and do well in English, mathematics, and science grow bored and restless during a school day made up only of these subjects. There is no need for five or six hours of schooling each day if classrooms adhere closely to basics defined as reading, writing, and arithmetic. A morning or afternoon session would be sufficient, a development which would put severe demands on the community and deprive parents of relatively inexpensive babysitting services.

As an aside, we might add that "back-to-the-basics" alternative schools almost invariably attempt both a restricted curriculum and a restrained learning environment emphasizing external controls.

In a full-length school day, the two sets of characteristics probably go together, for how else would young people be kept quiet and orderly? Either the teachers must cheat a little by including some unscheduled spice in the fare or they must resort to the strictest controls emphasizing reward and punishment. It is difficult to confine and restrain the human spirit, as demagogues throughout history ultimately have discovered.

Closely related to the above is a fourth, more speculative argument for supportive policies and strong programs in arts education. During the sixties, much of the curriculum reform movement was based, at least rhetorically, on "the structure of the disciplines," an idea popularized by Bruner, in particular.[18] The learner achieves a certain power, a freedom to explore and create, when those concepts or skills basic to the structure on the subject matter are mastered. For example, the visual arts can be conceptualized and understood in terms of concepts such as space, form, color, light, and texture, properties not unique to but uniquely expressed in this field. The arts, then, may provide an alternative route to acquiring not only disciplined control but also appreciation of what advanced learning in any field demands.

But there is another related, perhaps more important, sense in which the idea of mastery or control enters the learning process. Elsewhere, one of us has argued for schools organized in phases, each of three to four years in length.[19] Each phase would assure, among other things, that each girl or boy would develop at least one area of endeavor—mathematics, an art form, a sport—to a level of considerable competence. A criterion of competence would be peer-group recognition and ability to demonstrate for or teach others. The more fundamental criterion would be self-recognition, an awareness of being able to do at least one thing very well. Clearly, the accompanying feelings of accomplishment and self-worth would carry one a long way through the vicissitudes referred to earlier.

Athletics and the arts lend themselves unusually well to this concept, not just because of their inherent nature but also because of their neglect in the formal curriculum of schooling, their failure to come under the scrutiny of orderly, rational curriculum planners. We are not at all convinced that fields of study tightly organized around their assumed discipline structure lead naturally to superior performance. The "basics" are so well ordered in the formal curriculum that there is little room to leap ahead or to come upon and explore intriguing bypaths. Those "Suggestions for Further Study" in most textbooks sound so dull! Observations during the 1960s of even the pilot classes of curriculum reform projects revealed that

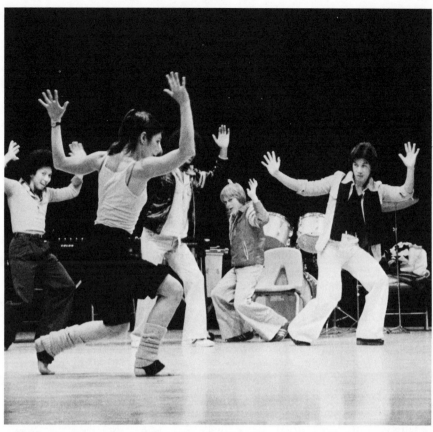

Shirley Jenkins, visiting artist at Lincoln High School, Seattle, Washington. *(Photograph by Bob Dong. Courtesy of Ann Reich)*

the more able students using "self-instructional, programmed" workbooks sat waiting for teachers' directions after finishing segments of work.[20] Studies conducted decades ago revealed that able students frequently are handicapped rather than helped by carefully ordered, step-by-step instructions. More recent studies of brain functioning suggest that one solves new intellectual puzzles better when in command of a few relevant principles than when armed with ample previous practice in solving related but different puzzles. The arts, by both their nature and benign curricular neglect, offer points of entry for the most divergent array of abilities as well as compelling paths for the more venturesome.

It is our contention (and evidence in support of it can be mounted) that this proposed development of a talent has transfer value. The

sense of self-worth and accomplishment not only carries one through but also provides some zest in tackling other, perhaps less enjoyable, pursuits. Indeed, we are intrigued by the thesis that failure to have experienced success in some form, to have practiced over and over for long hours in the achievement of satisfaction, is another variety of human deprivation. The cultivation of one or several talents through successive phases of schooling could help to minimize such misfortune.

There are those who argue, with considerable supporting testimony from teachers and some supporting research evidence, that the transfer is more direct, that properly conceived and conducted programs in the arts actually enhance reading and other skills. Benefits from compensatory instructional intervention appear most likely to occur when attention to children's affective and psychomotor development is orchestrated along with direct cognitive stimulation.[21] Although a good case probably can be made for direct transfer benefits, to justify the arts on the basis of what they contribute to student achievement in "basic" subjects is to gain only temporary sociopolitical benefits in policy formation. Many studies in the declining years of the Progressive Education Movement sought to justify exciting educational ventures on the basis of their contribution to established subjects. In failing to do this to the satisfaction of skeptics, the eager researchers obfuscated the inherent values of these new ventures. In the long run, the case for the arts is best argued on its own merits.

Implied in the above is a fifth argument in support of affirmative policies and programs in arts education. It has to do with the second supporting leg on which the curriculum reform movement of the sixties was to be based but which received much less attention than the structure of the disciplines. This was the somewhat existential notion of intuitive learning, an idea not readily incorporated into the relatively planned and serially ordered processes of schooling.[22] It was much easier for teachers to incorporate new content in instructional materials than it was to shift over to a new pedagogy requiring greater involvement and self-direction on the part of students. Intuitive learning, which is, according to Bruner's definition, a kind of bold, free-flowing inquiry, defies such packaging. It became the forgotten part of the "new" math and science, a nonevent.[23]

There has been a healthy unwillingness among many artists and arts educators to neglect the intuitive, "discovery-oriented" aspects of their field in favor of its structure or discipline. Perhaps this is because so many of them are performers or past performers who have come to respect both dimensions through their own experience.

While all fields offer ample room for improvisation, they are too often presented to the learner in rather precisely defined serial order. The arts and arts teachers suffer less from prescription; education in the arts therefore offers unique opportunities for developing those creative, critical abilities so often referred to in the sociopolitical goals of education but so little attended to in the schools.

We close this section in support of policies for and programs in arts education with an argument rising directly out of the role the arts have played in civilization. Since the invention of the printing press and until very recent times, we have relied almost exclusively on the printed word in seeking to study and express the human drama and its lessons. The varied themes and contexts to be learned frequently come into the schools in watered-down, secondhand prose, with much of the human style and vigor gone. But if one views the arts as Hausman does in Chapter 2, it becomes apparent that the story of civilization can best be understood through studying the literature, drama, music, dance, and visual arts of previous eras and by reinterpreting the human condition through contemporary participation in the arts.

If the arts are perceived in this way, it is ironic that they so often are relegated to a peripheral status in educational policy and school programs. There is very little worth teaching that cannot be told through the arts or that can be adequately conveyed without the arts. The arts can be the prime vehicle for general education or can be integrated with other fields so as to be pervasive. It is difficult to identify among our several arbitrary categories of knowledge a better medium for general liberal education at all levels than the arts.

IMPLICATIONS: A SUMMING UP

The consistency with which reference to the arts and the aesthetic appears in state and local district goals for schooling constitutes a mandate for policy makers from state legislators to school principals. The gap between this rhetoric of intent and educational practice is, of course, formidable. The point to be made here is that the importance of the arts is recognized within the ongoing sociopolitical structure, not only by commissions made up of prestigious citizens and educators.

Some school board members and superintendents will argue that their communities do not want or will not pay for school arts programs. Frequently, however, they cite only a handful of vocal critics. Relatively simple procedures for assessing parental views are available, such as McIntyre's school game referred to earlier, or the

more complex survey techniques developed by a Study of Schooling in the United States (see Foreword). The burden of proof regarding lack of interest in arts education today rests with those who make such a claim, given the general level of commitment expressed in state and local goals for schools.

But even when communities reveal themselves to be, at best, only mildly interested in arts education, one must raise the issue of leadership responsibilities. The arguments for the role of the arts in human development and the history of civilization are so substantial that leaders who fail to employ them in policy discussions might well be judged delinquent or incompetent. Education of the person is incomplete when it fails to include the arts. This is the conclusion one reaches almost inevitably after serious study of either the nature of the arts or the nature of man. Therefore, a school curriculum including little or no time for the arts is inadequate, whatever the level of student achievement in reading, mathematics, or science.

Because such curricula are the rule rather than the exception, American schooling is deficient and young people are denied what our rhetoric promises. This is the sober but inescapable conclusion one draws from examining programs of general studies, provisions for the handicapped, or opportunities for the gifted and talented. Unfortunately, except for the affluent, the chances for making up such deficiencies in the larger education community are sharply limited. Matching our rhetoric for the arts with comprehensive school programs in arts education provides, then, not only the obvious challenge for educational planning and engineering but also another agenda item for the drive toward equal education opportunity.

There is a basic commonsense question which may strike directly to the hearts as well as the heads of those who operate schools, those who send their children to schools, and those concerned citizens in society at large. "How do you want your children to grow up?" If you want your children to grow up as children did in Sparta, spending more time with the short-sword than with arithmetic and excluding all of the arts, you will have that kind of schooling. If society wants the child to grow up using all of his or her resources as a fully functioning human being at home with the arts as well as the intellectual and academic disciplines, then it will happen. The evidence that children are better off growing up without experiencing expressive behavior in the arts is not to be found without going back to the Calvinists and Cotton Mather's question to the overseers of Harvard University in 1723: "Whether the scholars have not their studies

filled with books which may truly be called *Satan's Library*. Whether the books mostly read among them are not plays, novels, empty and vicious pieces of poetry."[24] A more contemporary view is expressed by Feldman, who comments:

> The one really hopeful speck on the horizon is what appears to be a rediscovery of the arts. . . . After decades of not-at-all benign neglect, we may be beginning an unprecedented commitment to the arts—not because they will provide strategic superiority, but because security may not be worth protecting if grim competition with predators is our prime preoccupation! It is too early to tell whether interest in the arts will be sustained, but there is at least the potential for a renaissance in accepting and appreciating artistic achievement. It seems beyond question that such a commitment to the arts would enrich the lives of our citizens and help provide vision and perspective for our culture.[25]

The domain of the arts is vast. Study of the arts not only includes all of man's expressive modes other than words and numbers but involves the themes, myths, images, and ideals of every human culture. They provide a powerful way of holding a culture together. The arts widely used in the schools offer a means of creating and sharing commonly held experiences. If the opportunity to develop artistic competence is not available before adolescence, our children are unlikely to acquire basic literacy in using these tools to capture their ideas and feelings in artistic ways and appreciating the ways others capture their experiences in art forms. If this task is not taken up by the schools, it will not be taken up at all.[26]

Herein rests the challenge facing educators concerned with the arts in education. The changing relationships among the arts themselves have brought us to a point of new promise for their role in education. Evidence from professionals and lay people alike converge on concern for the inclusion of both cognitive and affective learning for effective education. Legitimate weighting of one or the other is appropriate to the various disciplines, but neither can be slighted in a balanced curriculum.

Given reasonable agreement with the arguments we have presented, the conclusion one comes to is that the arts are not to be considered merely optional in school programs. Returning to where this chapter began, this book develops three arguments for why the arts are fundamental and basic. First, this chapter has argued that they are part of the articulated goal commitment of most states. This means that schools should be able to demonstrate that the arts

Student batik. Buena Vista Annex Elementary School, San Francisco, California. *(Courtesy of Joyce Wright)*

are available to all students. An accounting of how students spend their time in any given year should reveal time spent on the arts to be commensurate with this goal commitment.

The second argument grows out of the role the arts have played in human history and in all our daily lives. Our minds should be opened by the concepts and illustrations presented in Chapter 2. We will see that it is more than artistic ability that school arts programs cultivate. They also provide links to understanding civilization without which insight and appreciation are necessarily limited. The demonstrations of commitment schools must provide are courses in appreciating the arts; or integrated curricula in which concepts from the arts are interwoven with concepts from other fields; or courses in fields such as history that include attention to the place of the arts; or all of these. To neglect the arts in the study of civilization is, in effect, to present a distorted picture of human progress and enrichment. To omit the arts from school curricula is to half-educate those who will determine our future civilization.

Third, the artistic and expressive are part of the normal developmental processes of human beings. Whereas our first argument rests on semilegal grounds, this one rests on knowledge about human beings, especially the biochemical functioning of the brain.

This is the argument developed and documented in Chapter 3, an argument that presents stunning challenges to educators. Again, the conclusion one draws is that failure of schools to cultivate these natural processes from the earliest years through the secondary school is to half-educate the individual. Schools making a serious effort to fulfill their educational responsibilities will be characterized by arts programs geared to the stage-by-stage development of the students enrolled.

School arts programs are based, then, on an understanding of human beings, the arts, and the role arts play and have played in society. Chapters 4, 5, and 6 are designed to illustrate what such programs might look like. Chapter 4 describes classroom practices designed to reflect the developmental view of artistry presented in Chapter 3. Chapter 5 looks at school programs, drawing extensively from existing practices which reflect what we consider to be the roots of exemplary curricula and teaching. Chapter 6, in recognizing many of the same concepts, uses specific examples of practice to illustrate how school efforts can be enriched and buttressed not only through use of resources in the community but also by community-based arts programs.

Foregoing paragraphs have presented an aggressive view of the role of schools in arts education, implying that schools are delinquent in their responsibility to society and their students if they are unable to provide evidence of comprehensive arts programs. They should be held accountable for so doing. In recent years, however, we have been prone to expect a great deal from our schools while too often withholding the financial and moral support they must have. Chapter 7 takes on the task of defining the processes of improvement required of schools and the supporting infrastructure that must be created if exemplary arts programs are to be widespread in any early future.

At the time these words are being written, there are clear signs—some of them enunciated in Chapter 7—that we are coming out of a period of disaffection with schools. More parents are recognizing both their own responsibilities in the realm of education and the fact that schools need support. There is a shift in the negative view so often presented by the media to recognition of need for a more constructive role. More and more people are recognizing that, although the schools may have taken on too much, this does not mean that a diminution in their educational role is needed. Rather, there is need for clearing our heads regarding what education is— and that, in turn, leads to a firm place for the arts in the curriculum of America's schools.

NOTES

1. Joint statement issued by the American Association of School Administrators and the Music Educators National Conference, 1965, Joint Committee AASA/MENC, MENC, 1201 16th Street, N.W., Washington, D.C.

2. Ibid.

3. *Americans and the Arts,* available from Advocates for the Arts, % American Council for the Arts, 1564 Broadway, New York.

4. *Americans in the Arts: Highlights from a Study of Public Opinion,* American Council for the Arts, 1974, p. 31.

5. Ibid.

6. Educational Facilities Laboratories, *The Place of the Arts in New Towns,* EFL, Inc., New York, 1973.

7. George L. Jackson, *The Development of School Support in Colonial Massachusetts,* Teachers College, Columbia University, New York, 1909, p. 8.

8. John I. Goodlad, *Facing the Future: Issues in Education and Schooling,* McGraw-Hill, New York, 1976, p. 25.

9. Ronald G. McIntyre, "The Development of a Conceptual Model for Selection of Optional Educational Programs in an Elementary School," unpublished doctoral dissertation, University of California, Los Angeles, 1976.

10. Committee on Fundamental Research Relevant to Education, *Fundamental Research and the Process of Education,* National Research Council, Washington, D.C., 1977, p. 3.

11. George Gallup, *Ninth Annual Survey of the Public's Attitudes Toward the Public Schools,* Public Opinion Surveys, Inc., Princeton, N.J., 1977.

12. Lawrence A. Cremin, *The Transformation of the School,* Alfred A. Knopf, New York, 1961, pp. 122–123.

13. Recent reports of a National Assessment of Educational Progress survey on the arts indicate that art skills (in this case the visual arts) can be learned and show a steady increase from age nine to age thirteen to age seventeen. Whether this increase can be attributed to school programs is another question, though items in the survey were based on content and objectives considered important for school programs by art educators. See, "Can Art Skills Be Learned? Survey Suggests 'Yes,' " *National Assessment of Educational Progress Newsletter,* June 1977, pp. 4–5.

14. Robert Rosen, "Do We Really Need Ends to Justify the Means?," *Center Report,* February 1976, p. 29.

15. For a useful summary of recent research on the brain and its implications for education, see *UCLA Educator,* vol. 17, no. 2, Spring 1975, M.

C. Wittrock, guest editor, and *Education and the Brain,* 77th Yearbook of the National Society for the Study of Education, Part II, University of Chicago Press, 1978.

16. Rosen, op. cit., p. 30.

17. Urban Education Studies, 1977–78 Report, sponsored by the Council of the Great City Schools in collaboration with the University Council for Educational Administration under a grant from the Spencer Foundation, 1978.

18. Jerome S. Bruner, *The Process of Education,* Harvard University Press, Cambridge, Mass., 1960.

19. John I. Goodlad, "The Child and His School in Transition," *National Elementary Principal,* LII, no. 4, January 1973, pp. 28–34.

20. See the findings of John I. Goodlad, M. Frances Klein, and Associates, *Behind the Classroom Door* (revised and retitled, *Looking Behind the Classroom Door,* 1974), Charles A. Jones, Worthington, Ohio, 1970.

21. A. Harry Passow, "Compensatory Instructional Intervention," in Fred N. Kerlinger and John B. Carroll (eds.), *Review of Research in Education,* Peacock Publishers, Itasca, Ill., 1974, p. 154.

22. For an interesting analysis of the difficulty of existentially oriented reforms in traditionally organized schools, see B. J. Benham, "Thoughts on the Failure of Curriculum Reform," *Educational Leadership,* December 1977, pp. 205–208.

23. John I. Goodlad, with Renata von Stoephasius and M. Frances Klein, *The Changing School Curriculum,* Fund for the Advancement of Education, New York, 1966.

24. Quoted in Jack Morrison, *The Rise of the Arts on the American Campus,* McGraw-Hill, New York, 1973.

25. David Feldman, review of *The Intellectually Gifted: An Overview, Harvard Education Review,* vol. 47, no. 4, November 1977, p. 581.

26. Howard Gardner, *The Arts and Human Development,* Wiley Press, New York, 1973.

THE DOMAIN OF THE ARTS

JEROME J. HAUSMAN
Minneapolis College of Art and Design

It is all well and good to talk or write about the value of the arts. It is another order of business to figure out what is to be done in schools. It is one thing to assert certain general propositions about the arts in relation to human experience; it is still another to develop clear "translations" as to what is to be done in the lives of people.

Currently there are many institutions and groups that seek to make the arts more available to people—museums, symphonies, drama groups, community arts centers, art schools, dance organizations. Each organization justifies its existence by virtue of the importance of the arts and the services it renders. Each has its program directed at one or more particular constituencies.

The current picture is one of growing consciousness and awareness of the arts and the proliferation of groups and organizations responsive to those circumstances. The dynamics are those of felt human needs and groups or organizations responsive to those needs. Yet, as these forces interact there is still another major force to be contended with—the nature of the arts themselves. Herein lies a major concern for those who engage in arts education—the concern that teaching draw upon the essential qualities and disciplines that characterize the arts. Conversely, we need to be wary of the proliferation of activities and institutions organized with intentions of "doing good" on behalf of the arts but in the process losing sight of what the arts are all about.

CONTEMPORARY ART AND THE TEACHING OF ART

It would seem a truism that those teaching about any discipline need to consider what practitioners in that discipline do. Within the arts, there is the long tradition of the artist-apprentice relationship as a primary means for educating young people in the values, attitudes, and practices of painting, sculpture, musical performance, theater, and dance. Just think of the countless artists in Medieval, Renaissance, and Modern times whose training was the result of their own sustained contact with other artists. Teaching and learning came about through direct encounters with the process of creation. Standards and values were implicit in what was done as much as in what was written or spoken.

In today's context there is an increasing mandate to reappraise more traditional ideas about education in the arts. First, the challenge of educating our youth is now presented within a democratic ethos, and educators are accountable to a mass population. There is a larger and more diverse constituency that we seek to educate. Second, our means for the storage and dissemination of information

about the arts (as well as the availability of art forms themselves) have been enlarged. There is an ever-expanding accumulation of art objects and events that competes for our interest and attention in the present. Third, there are great changes in our world context. Political, social, economic, and psychological shifts have altered human perceptions and values. Inevitably, these shifts have influenced everything else in our experience—including attitudes and values held about the arts. And fourth, there have been radical changes in the arts themselves—new media, new concepts, and new forms. Taken together, these factors have given rise to a more complicated situation with regard to arts education. Overall, the situation can be said to be one of challenge and change. The complications we face are related to the factors of more people interested in the arts, more information about the arts, and changes in the arts themselves.

Many forms constitute the arts. There is not a necessary and sufficient structure and sequence that places one art form above another. Different times, places, and circumstances have influenced the production of different forms. Human beings throughout history have found differing means to explore and express a wide range of ideas and feelings. The "arts" usually refers to music, theater, literature, dance, and the visual arts. Within each of these general categories there is great variety. For example, the field of music includes the many means possible for the aesthetic control of sound. The medium for music can be the human voice or many different instruments or combinations of voice and instrument. The resultant works can be heard as a ballad, or concerto, or fugue, or song, or symphony, or mass. Frequently, art forms are combined in a single event as is the case in opera or musical comedy or architecture. To use another example, the visual arts include such media as paint, clay, wood, stone, metal, fiber, film, photography, and video. The resultant art works could range from a highly personalized drawing or sketch to a cooperatively produced mural or film.

In the reality of schools, instruction in the arts is usually organized under the rubrics of the visual arts, music, dance, theater, and literature. In varying degrees, specialists are available to work with students and teachers in the use of a particular medium or technique. Thus, a teacher of dance might be available to work with a class in creative movement or ballet or folk dance. A theater specialist might offer instruction in improvisation, pantomime, or monologue. It is important to emphasize, however, the multiple connection points between the arts and the totality of the learning experience. The range of forms that constitute the arts makes pos-

Student ceramics. Jefferson County High School, Colorado. *(Courtesy of Larry T. Schultz)*

sible many connections to enliven and enrich the quality and depth of learning in the schools.

If one is teaching about the arts—whether in a professional school or an elementary school classroom—there are the continuing problems and issues that surround the bases for making value judgments about artistic forms. Such judgments are partly a matter of one's knowledge and understanding of traditions, techniques, and the context of the art form being created or judged, but they are also a matter of personal, subjective values and response to the object or event being perceived. In part, we come to the experience of artistic objects or events already armed with our criteria for judgment; in part, the emergence of new art forms (the uniqueness of new perceptions) forces us to reappraise and, perhaps, alter these criteria. The "present" constitutes the critical meeting ground upon which all forms of art are experienced and evaluated.

Just as the "present" provides the meeting ground for experiencing works of art, it is also the context in which contemporary forms are created. For those who teach the arts, there is a special responsibility for confronting the arts and artists of our own time, if for no other reason than that they are of our own time! Of course there are the problems of distortions that can result from factors of immediacy and closer identification with artistic personalities. We are all painfully aware of artists celebrated or praised in their own time (or conversely unrecognized or ridiculed) only to have the more imme-

diate responses altered in later years. Our immediate judgments may not be the responses that will be validated by history. Nevertheless, these same factors of immediacy and identification can also lend strength and aesthetic relevance to our perceptions. At their best, the contemporary arts deal with contemporary issues. Oftentimes there is the challenge of confronting ideas that are new and unfamiliar and, hence, uncomfortable. There are also the potential rewards of new realizations and understandings.

Basic to understanding the current state of affairs regarding the arts is a conscious awareness of change itself. The twentieth century is a period in which the means for organizing, communicating, and storing information have had profound effects upon our way of life. New means for the communication and storage of information have provided for an extension of human consciousness. There has been an ever-increasing tempo of action and reaction as new art forms become more readily available for comparison with other forms past and present. Knowing the works of his precursors forces an artist to new and different approaches of dealing with the more personalized and unique experiences at hand. Thus, artists in the twentieth century have drawn upon the traditions of their discipline. They have also sought to go beyond that tradition.

Looking to the present and future, one is drawn to a hypothesis set forth by Leonard Meyer that envisages:

> . . . the persistence over a considerable period of time of a fluctuating stasis—a steady-state in which an indefinite number of styles and idioms, techniques and movements will co-exist in each of the arts. There will be no central, common practice in the arts, no stylistic "victory." In music, for instance, tonal and non-tonal styles, aleatoric and serialized techniques, electronic and improvised means will all continue to be employed. Similarly in the visual arts, current styles and movements—abstract expressionism and surrealism, representational and Op-Art, kinetic sculpture and magic realism, Pop and non-objective art—will all find partisans and supporters. Though schools and techniques are less clearly defined in literature, present attitudes and tendencies—the "objective" novel, the theater of the absurd, as well as more traditional manners and means—will, I suspect, persist.[1]

Substantial implications for designing and teaching arts programs can be drawn from Meyer's statement. The fundamental change resulting from the fact that "there will be no central, common practice in the arts, no stylistic victory" is that there can no

longer be a single style or artistic mode that serves as *the* exemplar for music or dance or drama or the visual arts. Teaching in the arts cannot point to a single, idealized version. Rather, the basis for designing and teaching arts programs requires a more open and flexible adaptation of the values of the past in relation to the emerging circumstances of the present.

ARTISTS IN THE MODERN PERIOD

What of the arts and artists of our own time? We live in a time of dramatic events occurring in what Marshal McLuhan refers to as a "global village." The speed-up in communications made possible by mass media and electronic technology has narrowed the time and space gap between events and their consequences; it has altered our ways of thinking and possibilities for action. Past and present, events near and far, enter our consciousness. All of this has had profound effects upon our conceptions of art and suggests directions for the teaching of art.

To grasp the nature of the continuing state of change within which we now find ourselves, it is useful to retrace some of the pathways leading to the present. By the time the nineteenth century approached its end, the momentum for change in all of the arts had accelerated. Indeed, the turn of the century can now be seen as a period of significant shifts in the Western world. Napoleon III had been deposed and France's Third Republic proclaimed. The Industrial Revolution was well underway. The first volume of Marx's *Das Kapital* had been published. Maxwell's theory of the electromagnetic field was published, as was Darwin's *Origin of Species* and Mendel's *Laws of Heredity*. In literature, Dostoyevsky and Tolstoy had already written their major works. Writing as different as Zola's naturalistic works and Verne's science fiction had been published. In music, Wagner's popular acceptance was well established. French music was characterized by the rise of Fauré, Debussy, and Ravel. Roger Shattuck referred to this period (from 1855 through World War I) as the "banquet years." "To a greater extent than at any time since the Renaissance, painters, writers, and musicians lived and worked together and tried their hands at each other's arts in an atmosphere of perpetual collaboration."[2] This was best exemplified in Montmartre and the Latin Quarter in Paris. More than cabarets and cafés, these were communities of artists exchanging ideas leading to a new, modern aesthetic.

By the end of the nineteenth century, ideas were set in motion that liberated artists from the conventional and prescribed roles of

the seventeenth and eighteenth century. Increased communication and exchanges among artists gave rise to more rapid shifts in the forms they created. Most importantly, artists regarded themselves as champions of revolution and change. Fired by ideals of the Enlightenment and political revolution, they tended to see the arts as vehicles for new expression and realization. Gone were the more conventionalized and formalized approaches to what art or artists were "supposed to do." Patronage shifted from the Church and State towards the more fluid and perhaps more capricious bases of private patrons and commercial galleries. Geraldine Pelles, writing of these individuals, observed:

> Youths did not visualize themselves as painters, composers, or writers merely in terms of the work they did standing before an easel or meditating at a desk. Their very association with this type of work seemed to be a declaration of independence against the ordinary life of the times and an affirmation of the mythical free individual who had become an ideal in the intellectual and political developments of the past hundred years. For a feminist like George Sand, this sort of attraction was particularly strong. She recalled in her autobiography, "To be an artist! Yes, I wanted to be one, not only to escape from the material jail where property, large or small, imprisons us in a circle of odious little preoccupations but to isolate myself from the control of opinion . . . to live away from the prejudices of the world."[3]

In the long run, the consequences of this shift have led to more personalized and expressive emphases for artists. No longer in the service of Church or State, artists were freer to explore new forms and indulge their own more personalized visions. This image of an artist as "expressing" highly personalized ideas and feelings encourages the view of the artist as the "free spirit" and imaginer that Wolf and Gardner discuss in the next chapter.

Following 1900, developments in modern communications, transportation, and industrialization were well underway in the Western world. Railway trains, driven by steam or electricity, were making their way over land. Max Planck had set forth the foundations of quantum theory and Sigmund Freud had published some of his early work in psychoanalytic theory. Within the next five years the experiments of Pierre and Marie Curie were to provide key insights into atomic disintegration and Albert Einstein was to publish his theory of relativity.

In the arts, we were already aware of the writings of Gide and

Shaw. There were the psychological dramas of Strindberg and Ibsen as well as the literary impressionism and mysticism of Rilke. This was also a great period for opera. Verdi and Puccini were active. Oscar Wilde's *Salome* was set to music by Strauss. Ballet, evolving from the elegance and artificiality of seventeenth and early eighteenth-century France, expanded to include more interpretive modern forms such as the works of Michel Fokine and especially Isadora Duncan, who turned more to natural and spontaneous movement. Her dance drew upon lyrical and heroic classical themes. She extended the possibility of movement to encompass more individual taste and expression. Clearly, she shattered the prevalent notions about theatrical dance as an academy of prescribed steps. Duncan marks a turning point in Western dance. She rejected ballet and thereby became a pivotal figure leading to a new pathway that now includes Wigman, Joos, Holm, and in contemporary dance, Nikolais.[4]

As a simple and obvious example of the effect of industrialization and technology on the arts, consider the growth of railroads by the beginning of the twentieth century and the consequences for travelling theatrical companies. Going "on the road" became more feasible. This created a new openness and receptivity for the theatrical arts.

Paralleling the dramatic changes in the other art forms, one can observe fresh traditions and new harmonic relations being created in music—for example, the compositions of Debussy, Ravel, and Stravinsky. Early in the twentieth century Arnold Schoenberg expounded a theory of twelve-tone composition. Quite independently, there were the musical compositions of Charles Ives. Both Schoenberg and Ives composed music that stretched traditional concepts to accommodate new possibilities. Both reveled in the sensuousness of sound. In literature there was a revolution in structure and technique. For example, in poetry there was the "liberation of verse" and what Mallarmé characterized as "the advent of pure poetry to recapture the best in music." In the visual arts, artists like Cézanne, Seurat, Gauguin, and Van Gogh had already created the images that revolutionized our very concepts about painting: Cézanne expanded our understanding of visual structure and its integration into compositional form; Seurat analyzed color into its component parts and painted these color points so as to invite "mixing" in the perception of the viewer; and Gauguin and Van Gogh used color and gesture in painting, opening possibilities for more expressive compositional forms.

Paul Cézanne is generally regarded as a pivotal artist whose

Paul Cezanne, "The Card Players," 1885–90, oil. *(Courtesy of Metropolitan Museum of Art, New York City)*

paintings provide us with a greater awareness of structural reality. In his work, he sought to liberate art from its dependence upon imitating nature. The reality he strove for was an art that existed in its own right, shaped by the plastic requirements of the work itself. It is this structural awareness that suggested the "next steps" of Cubism. Artists like Picasso and Braque explored the imagery of objects seen from different vantage points. Their works incorporated the idea of the simultaneous occurrence of events. Referring to "the Cubist artist," Moholy-Nagy commented:

> He rendered the object in its true nature in its totality. With this, he unbound himself from the dictates of naturalistic renderings; from the pressure of conventional, repetitive, and imitative demands to a growing consciousness of the autonomous interpreting power of the artistic.[5]

Conscious awareness of movement and change were very much a part of the times. In February 1909, F. T. Marinetti, a poet and edi-

tor, published the initial "Manifesto of Futurism" on the front page of the Paris newspaper, *Le Figaro*. This was the first in a series of manifestos that urged the negation of past values in favor of a new dynamism born of a machine age:

1. We intend to glorify the love of danger, the custom of energy, the strength of daring. 2. The essential elements of our poetry shall be courage, audacity, and revolt. 3. Literature has hitherto glorified thoughtful immobility, ecstasy and slumber; we wish to exalt the aggressive movement, feverish insomnia, running the perilous leap, the cuff and the blow. 4. We declare that the world's splendour has been enriched by a new beauty; the beauty of speed. A racing motor-car, its frame adorned with great pipes, like snakes with explosive breath . . . a roaring motor-car, which looks as though running on shrapnel, is more beautiful than the Victory of Samothrace.[6]

The aggressive self-consciousness of the Futurists was soon adopted by another group. In Zurich's Cabaret Voltaire, in 1916, the poet Tristan Tzara, two writers, Hugo Ball and Richard Hülsenbeck, and the artist Hans Arp joined to form the Dada Movement. The name, *Dada,* was chosen at random out of a dictionary as if to flaunt the importance and prestige attached to names or titles. These were artists seeking a forceful and dramatic rejoinder to the wanton pain and destruction of World War I. For them, bourgeois rationality had brought mankind to destruction and despair. "Tradition" and "cultural values" were seen as masking an underlying self-interest of the few and powerful. "Dada is forever the enemy of that comfortable Sunday Art which is supposed to uplift man, by reminding him of agreeable moments. Dada hurts. Dada does not jest, for the reason it was experienced by revolutionary men and not by philistines who demand that art be a decoration for the mendacity of their own emotions. . . ."[7]

Interestingly, an art form begun as "protest" aimed at revolution was to lead toward significant constructive change in poetry, literature, drama, and the visual arts. The "nonsense" of the forms produced soon gave rise to a "new sense." In poetry, for example, there was a freeing of words from conventional grammatical syntax. The perceptual effects of words—their emotional weight, their rhythm and cadence, and their associative meanings—became the means for expressing ideas of deep emotional significance.

Inextricably linked to the Futurist-Dada Movement is the work of the Surrealists. The word "surrealism" is thought to have been used first by the poet and critic Apollinaire in 1917. In this connection, it

is interesting to note the importance of Freud's psychoanalytical studies and their influence upon André Breton, who was formerly a psychiatrist. It was Breton's interest in the phenomenon of the subconscious that led to aesthetic experimentation with automatism, accident, and dreams as sources for art. His definition, published in the Surrealist Manifesto (1924), was:

> Pure psychic automatism, by which one intends to express verbally, in writing or by any other method, the real functioning of the mind. Dictation by thought, in the absence of any control exercised by reason, and beyond any aesthetic or moral preoccupation.
> Surrealism is based on the belief in the superior reality of certain forms of association heretofore neglected, in the omnipotence of dreams, in the undirected play of thought. . . .[8]

Works of Breton, Tzara, Apollinaire, and others were to exert substantial influence upon modern literature, especially on writers like Gertrude Stein, T. S. Eliot, and James Joyce. Seen from a larger perspective, literary developments were analogous to developments in other arts. Overall, there was a freeing of artists to engage in the exploration of new means and meaning. This is the basis upon which Jill Johnson observed:

> The music of Satie, the poetry of Apollinaire, the plays of Jarry, Cubism and Surrealism in painting, the various Dada manifestations, all expressed the radical shift in emphasis from the rational, securely focused, unitary concept of composition to the fragmentation and juxtaposition of elements with no essential beginning or ending, no transitional continuity, no focal climaxes and no dramatic resolutions.[9]

Marcel Duchamp exemplifies the strength and enigmatic qualities of Dada and Surrealism. His *Nude Descending a Staircase* became the target of conservative critics at the now famous New York Armory Show in 1913. It was he who submitted a porcelain urinal turned upside down and entitled *Fountain* to an exhibition of the Society of Independent Artists. And, it was he who retouched a reproduction of *The Mona Lisa* with a mustache and goatee. These seemingly radical moves with regard to established and widely held definitions of what art was "supposed to be" were balanced by an intense interest in philosophical and aesthetic concerns. Duchamp was drawn to the strict logic and structure of ideas. Indeed, looking to the unfolding of contemporary art, one can find a recurring bal-

ance between artists whose works have courted ambiguity, doubt, mystery, and chance and other artists who have sought different ends—rationality, precision, structural unity, and aesthetic control. It was as if Duchamp anticipated the aesthetic issues of the 1960s and 1970s. His "readymades" have been grudgingly incorporated into the "history of art"; they have forced us to reconsider and extend our very definitions of art. Objects drawn from "everyday life" (bicycle wheels, bottle dryers, windows) were now acceptable in a gallery setting. Such radical juxtapositions brought into question the whole concept of the "artisan" striving for craftsmanship and the uniqueness or perfection of aesthetic form.

As if to balance the conscious and deliberate extensions of the possibilities in concept and form, there were parallel extensions that sought more classical and idealized forms in the arts. For example, in 1915, Theo van Doesburg, a Dutch painter and writer, joined with the painter Piet Mondrian in leading the DeStyll Group devoted to the exploration of what they referred to as a "new plastic reality." They observed that there was an underlying structure to natural phenomena. An analysis of plastic art reveals a dynamic equilibrium (through a rhythm of lines, colors, and forms) in a way that can evoke aesthetic emotion. Theirs was an argument for a pure, abstract image in which form and content would be unified. As was projected by Mondrian:

> This consequence brings us, in a future perhaps remote, towards the end of art as a thing separated from our surrounding environment, which is the actual plastic reality. But this end is at the same time a new beginning. Art will not only continue but will realize itself more and more. By the unification of architecture, sculpture, and painting, a new plastic reality will be created. Painting and sculpture will not manifest themselves as separate objects, nor as "mural art" which destroys architecture itself, nor as "applied" art, but being purely constructive will aid the creation of a surrounding not merely utilitarian or rational but also pure and complete in its beauty.[10]

In retrospect, the early decades of the twentieth century give evidence of the reaffirmation of an artist's mythically free role as a creator of truth and beauty. It is a period in which there was an expansion of form and syntax in the possibilities for art and a reuniting of artists with wider personal and social aims. Modern art came to be valued as a liberating agent and as a means for raising the aesthetic quality of the total environment. The process of change

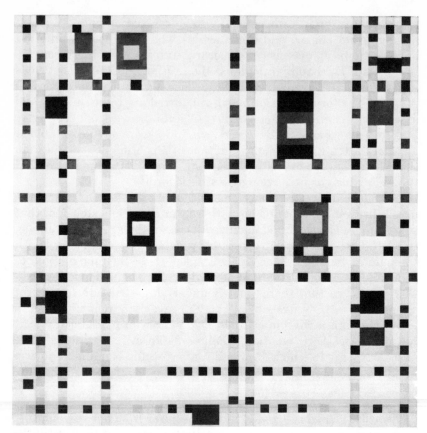

Piet Mondrian, "Broadway Boogie Woogie," 1942–43, oil on canvas, 50 × 50″ *(Collection, The Museum of Modern Art, New York)*

in the arts was facilitated by new mechanisms for the communication and storage of information which served to alter the possibilities for thought and action. Artists in the Western world became more consciously aware of the dynamics within which they existed and worked. Discussion of contemporary art must take into account the pluralistic nature of the differing artistic tendencies. For better or worse, the phenomenon of the "global village" has made available information pertaining to other artists and other art forms. Indeed, diverse (or even contradictory) tendencies now exist side by side.

PATHWAYS IN THE PRESENT

And what of the present? One can come to a better understanding of our current artistic diversity by following the patterns begun at the

turn of the century. Our media for artistic expression have increased arithmetically; the form possibilities have multiplied geometrically. Early photography required extended periods of film exposure and posed severe restrictions. As film chemistry improved, our knowledge and control of the medium increased, enabling the manipulation of visual elements and the creation of aesthetic forms. Experiments with still and motion picture photography gave rise to different and more popular art forms. The storefront nickelodeon soon grew to an ornate "dream palace" for movie entertainment and, then, from large theaters to smaller, more adaptable means to experience films. Multiple and wide screens also extend possibilities for the filmmaker. The history of cinema is a chronicle of invention, hope, and expectation as evidenced in the works of such greats as D. W. Griffith and Cecil B. DeMille. As characterized by Erwin Panofsky, film:

> . . . is the nearest modern equivalent of a medieval cathedral; the role of the producer corresponding more or less to that of the bishop or archbishop; that of the scenario writers to that of the scholastic advisors establishing the iconographical programs; and that of the actors, cameramen, cutters, soundmen, make-up men, and the diverse technicians to that of those whose work provided the physical entity of the finished product, from the sculptors, glass painters, bronze casters, carpenters, and skilled masons down to the quarry men and woodsmen.[11]

The growth of television as another means for artistic expression in the twentieth century has been phenomenal. In 1948, approximately fifteen commercial television stations were in operation; there were about 200,000 American homes with sets. By 1970, there were thousands of stations and approximately 100 million sets (including about 14 million color sets). "'Television can't be used as an art medium,' claims Les Levine, 'because it already is art. CBS, NBC, and ABC are among the greatest art producers in the world.' The art of which he speaks is the art of communication."[12]

Technology is also having a profound influence on music. Most of the music now heard comes via sound recordings. The long-playing record and the tape recorder have had an impact comparable to the printing press in relation to literature. Technology helps to make us conscious of the universe of aural sensations as source material from which new forms can be created and understood. The result is that one can experience such diverse forms of music as the New York Pro Musica, Duke Ellington, Rosemary Clooney, Joan Baez, Beethoven,

Bach, the Beatles, and Ravi Shankar. We now have electronic music in which composers work with the idiomatic qualities of high fidelity sound. In such instances, there is a change from traditional composer-performer-audience relationships in that the composer and performer become one, under conditions of virtually unlimited means for generating and controlling sound.

Overall, it can be said that new media and technologies have provided for extensions of human powers. It is not only a matter of new media becoming available to artists. There are also differing ways in which contemporary artists or performers now conceive of what they do in relation to more traditional media. In painting, for example, there was a radical shift from expectations that a work of art was to be placed in a frame that afforded a "window into space." By the 1950s, substantial groundwork had been laid for altering such expectations—the Cubists, Surrealists, and Dadaists. Then, as Harold Rosenberg described it, "At a certain moment the canvas began to appear to one American painter after another as an arena in which to act—rather than as a space in which to reproduce, redesign, analyze, or 'express' an object, actual or imagined. What was to go on the canvas was not a picture but an event."[13]

It was not a far step for the "event on canvas" (Abstract Expressionist Painting) to extend into three-dimensional space and from there to deal with the dimension of time. More than simple elaborations of form, the work of such artists as Kaprow, George Brecht, and Robert Rauschenberg represents a return of art to its ritualistic beginnings. As was articulated by Kaprow:

> Among the things I have felt to be important in the conception of my work is the idea that it could be called art, or ordinary nature. I devote great effort to balancing what I do as precariously as possible on this tightrope of identities. I find here a certain drama. And then, more crucially, life and art begin flowing together in an easy give and take.[14]

Just as the Cubists, Dadaists, and Surrealists provided background for developments in the visual arts, ideas and individuals have profoundly influenced contemporary music. The works of Schoenberg, Ives, Ruggles, Cowell, and Varese shaped our contemporary forms. Early examples referred to as "totally organized music" were composed by Milton Babbitt in 1948; a few years later John Cage created his *Music for 12 Radios*.

Many have characterized Cage as one of our leading "avant-garde" artists. His background has brought him in contact with dif-

fering ideas and media—as a student of harmony and composition, as an accompanist and composer for a modern dance group, as a teacher of experimental music at the Institute of Design (Illinois Institute of Technology) and Black Mountain College, as a Musical Director for Merce Cunningham, and as a student of Eastern philosophies. His work raises essential issues about the means and media for creating images and sounds. He brings to the fore questions about the relationship between the composer, performer, and audience. Cage has a great many thoughts on art and life, and the steady erosion of all traditional barriers between the two. Contemporary art, he tells us, turns spectators into artists; the doors to participation have been opened by artists who no longer place themselves on pedestals, and the goal of the new art is simply "to introduce us to the very life we are living."[15]

The transitions toward modern dance can be traced from the Diaghilev period in Europe through Isadora Duncan, Ruth St. Denis, and Ted Shawn to the emergence of Martha Graham, Doris Humphrey, and Charles Weidman in this country. The essential thrust was toward an iconoclastic form, one that eliminated decorative and imitative impulses and turned toward the essentials of movement. Their productions were "uncompromising." As characterized by Selma J. Cohen, "No pretty costumes, just plain dresses of unadorned black jersey; no pink slippers, just bare feet; no elaborate scenery, just a functionally lighted cyclorama. . . . The movements that derived from the primitive sources were as unornamented and unornamental as the costumes of the dancers."[16]

Merce Cunningham, earlier with the Graham Company, is one of our most important contemporary dancers. Cunningham's works introduced a different relationship between dance and its musical accompaniment. He experimented with chance theory and design and created sequences that would vary from performance to performance. Experiencing a dance performance from this orientation can be likened to experiencing movement in everyday life. The central focus is selected by the viewer; there are no simple beginnings and endings with a linear sequence. To the untrained eye, the events seem without plan. Yet to the trained observer, the individual components are the result of long preparation and great discipline. There is the delight that comes of combining seemingly random and gemlike events within a particular space and time frame.

The work of Alwin Nikolais represents still another kind of dance emphasis. Nikolais designs his lighting and choreography with conscious attention to a total environment. His choreography stresses the idea of man in relation to the cosmos. There is a willingness on

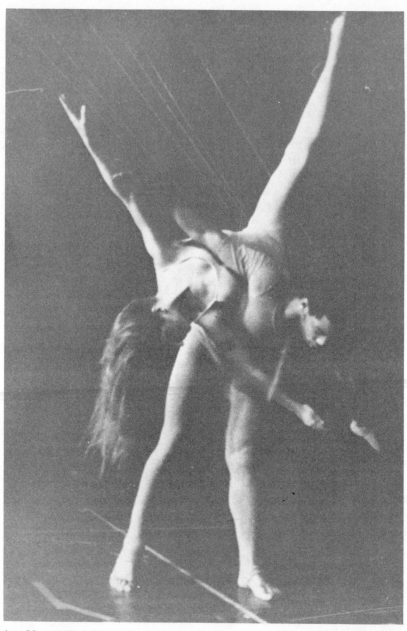

Arts Magnet High School, Dance Cluster, Dallas, Texas. *(Courtesy of Paul Baker)*

his part to manipulate light and plastic materials, along with electronic sound, as an integral part of the dance performance. The resulting form tends to be an intermedia event. Throughout his work there is a sense of individual performers as part of a larger concept. As was observed by Nikolais, "We are now in a new period of modern dance, and it is a period of new freedom. All the arts, we find, are now becoming vitally concerned with the direct and poignant translation of those abstract elements that characterize and underlie an art subject. . . . Freedom from the domination of the concrete is a logical manifestation of our times."[17]

As far as contemporary theater is concerned, there have been a number of major influences: (1) the postwar emergence of such Europeans as Beckett, Ionesco, and Genet; (2) the growth of "off-Broadway" and "University" Theater; and (3) the growing interest in sexual psychodrama themes (for example, Tennessee Williams) and social-realist themes (for example, Arthur Miller). The same general tendencies toward altering the basic form and concept are found in theater as in other art forms. John Cage commented:

> I try to make definitions that won't exclude. I would simply say that theater is something which engages both the eye and the ear. The two public senses are seeing and hearing; the senses of taste, touch, and odor are more proper to intimate, non-public situations. The reason I want to make my definition of theater that simple is so one could view everyday life itself as theater.[18]

The implications of this point of view influence the very space in which dramatic events are performed. Conscious manipulation of space and the relationship between performers and spectators are very much a part of happenings, just as chance events and audience participation are part of Street Theater. In many contemporary theatrical events, members of the audience are placed in informal seating arrangements; in some instances they are free to move about, and at other times viewers are led through spatially separated performance segments much as medieval worshipers were moved from one station of the cross to another. These are the tendencies that reflect a radical shift away from an "object" or "performance-oriented" attitude toward an attitude which sees theater as a participating, planning, or ritualistic event.

What does all this mean for arts activities in schools? First, the subject matter for the arts can range from everyday occurrences or

events to highly imaginative or metaphoric themes. The subject matter for the arts can grow out of very personal or social sources; subject matter might also grow out of themes from nature or the manufactured environment. And, of course, the subject matter for the arts might grow out of the arts themselves.

Similarly, the media for expression have expanded dramatically. Tape recordings of sounds in a city, filmed versions of machines or events, the use of electronic images, or objects drawn from family celebrations have all become possible means for artistic expression. The lesson being taught us by the artists of our own day is that the very "ground rules" for what constitutes "art" have undergone change. There must be a similar opening-up of possibilities for students who learn about and experience the arts in school. It must be remembered that children who have been exposed to "Sesame Street" and the "Electric Company" have a sense for animated imagery and the connections between sound and movement. Children who have seen film and video images have a rich store of ideas from which to develop their own expressive forms. Planning for classroom activities must draw upon these experiences.

CONTINUING RESPONSIBILITIES OF CHOICE

Where does all this leave us? Theater as "life process"? Theater of the Absurd? Repertory companies doing Shakespeare or Ibsen? Musical Theater? Theater in television or film? . . . Or, in music, how do we reconcile Mozart, Haydn, Beethoven, Brahms with Bartok, Stravinsky, and Stockhausen? And what about jazz or rock or country musical forms?

The pathways to the present bring us to a point of confronting the multiple and simultaneous developments in each of the arts. Aestheticians have long debated the definitions of art. Now, more than ever, we are faced with differing forms and aesthetic positions that constitute "the arts," and all of us—especially those who have the responsibility of helping children learn—must join in the debate. Overall, our circumstances mandate a more open and flexible attitude in dealing with music, the visual arts, theater, dance, and multi-art forms.

Yet, "openness" and greater "participation" of themselves still leave us with continuing critical concerns and the necessity for personal choice and evaluation. The willingness to entertain diversity should not lead to a renunciation of standards; nor should it imply that newer, more radical forms are necessarily superior to more traditionally oriented efforts. There are plenty of limited or inferior or

pretentious works in the "avant-garde," as Susan Sontag observed, but new standards of beauty and taste prevail, standards that are pluralistic and both highly serious and whimsical. The new cannot be rejected out of hand; neither can it be accepted uncritically.[19]

What can this mean for our schools? It requires those who teach about the arts to deal with the accumulated knowledge and wisdom of the past as well as the necessity for action in the present. Above all, it requires the active pursuit of ideas and ideals. Developing a contemporary sensibility cannot and should not be at the cost of rejecting humanist or liberal traditions. Conversely, attention to the past should not override the willingness to engage in experiencing contemporary forms.

The changing implications for education in the arts are no less dramatic than the changes that have taken place in the arts themselves. There is a much wider range for choice as to what is to be taught and the circumstances for teaching. For example, examine the range of media now available for instruction in the visual arts: paint, chalks, clay, wood, plastics, metals, film. Consider the availability of instructional resources provided through museums, galleries, and the mass media. There can be greater awareness of human activities in the arts past and present. There can be greater consciousness of the future.

All of this has resulted in a very different "look" in some schools today. Whereas the turn of the century classroom could be characterized by rows of students attending to a teacher in the front of the room, modern classrooms are more flexible in their structure and mode of organization. In some elementary school classrooms, a few students are working with wire and clay, while others are at a listening center, and still others are working with mathematical games. There are junior high school art rooms in which students are working in photography and printmaking and sculpture. In high school literature courses we can sometimes see students dealing with haiku poetry and television dramas as well as classical novels.

If the arts can be understood as having expanded and altered their bounds, then education in the arts can be conceived and carried out in a larger and more flexible setting. Staffing and scheduling patterns within schools are more open and responsive to what is being taught. It is not unusual to have practicing artists (musicians, dancers, painters, architects, and poets) as visitors to classrooms. Moreover, students are able to visit workshops, theaters, and galleries as part of the school's program. Most important, there are differing aspirations and expectations for the purposes of education. Expanded aspirations and expectations along with enriched

resources offer new educational possibilities. Just as the arts now encompass new media, form possibilities, and ideas, educational programs in the arts can be responsive to new teaching opportunities. The following chapters will offer some alternatives for conceiving and fulfilling these opportunities.

NOTES

1. Leonard B. Meyer, *Music, the Arts, and Ideas,* University of Chicago Press, Chicago, 1967, p. 172.

2. Roger Shattuck, *The Banquet Years,* Anchor Books, New York, 1961, p. 29.

3. Geraldine Pelles, *Arts, Artists, and Society,* Prentice-Hall, Inc., Englewood Cliffs, N.J., 1963, p. 18.

4. Thanks are due to Bella Lewitzky for her review and suggestions about the development of dance.

5. L. Moholy-Nagy, *Vision in Motion,* Paul Theobald, Chicago, 1947, p. 116.

6. F. T. Marinetti, "The Foundation and Manifesto of Futurism," in Herschel B. Chipp (ed.), *Theories of Modern Art,* University of California Press, Berkeley, Ca., 1968, p. 286.

7. Richard Hülsenbeck, as quoted in Moholy-Nagy, op. cit., p. 311.

8. André Breton, "The Surrealist Manifesto," as quoted in William S. Rubin, *Dada, Surrealism, and their Heritage,* The Museum of Modern Art, New York, 1968, p. 64.

9. Jill Johnson, "Modern Dance," in Richard Kostelanetz (ed.), *The New American Arts,* Collier Books, New York, 1965, p. 166.

10. Piet Mondrian, *Plastic Art and Pure Plastic Art,* Wittenborn, Schultz, Inc., New York, 1947, pp. 62–63.

11. Erwin Panofsky, "Style and Medium in the Motion Pictures," reprinted in James B. Hall and Barry Ulanov (eds.), *Modern Culture and the Arts,* McGraw-Hill Book Co., New York, 1967, pp. 370–371.

12. As quoted in Gene Youngblood, *Expanded Cinema,* E. P. Dutton and Co., 1970, p. 337.

13. Harold Rosenberg, *The Tradition of the New,* Grove Press, Inc., New York, 1961, p. 25.

14. Allan Kaprow as quoted in the exhibition catalogue for *Environments, Situations, Spaces,* Martha Jackson Gallery, June 1961.

15. Quoted by Calvin Tomkins, "Review of *A Year from Monday* by John Cage," *The New York Times Book Review,* January 21, 1968, p. 6.

16. Selma J. Cohen (ed.), *The Modern Dance,* Wesleyan University Press, Middletown, Conn., 1965, p. 8.

17. Alwin Nikolais, "No Man from Mars," in ibid., p. 63.

18. Michael Kirby and Richard Schechner, "An Interview With John Cage," *Tulane Drama Review*, vol. 10, no. 2, Winter 1965, p. 50.

19. Susan Sontag, *Against Interpretation,* Farrar, Straus and Giroux, New York, 1961, p. 304.

3

BEYOND PLAYING OR POLISHING: A DEVELOPMENTAL VIEW OF ARTISTRY

DENNIE WOLF AND HOWARD GARDNER
Harvard Project Zero and Boston Veteran's Administration Hospital

*"Better go down upon
your marrow-bones
And scrub a kitchen
pavement, or break
stones
Like an old pauper, in
all kinds of weather;
For to articulate sweet
sounds together
Is to work harder than
all these . . ."*
-W. B. Yeats in "Adam's Curse"

(Photograph by Mark Harris)

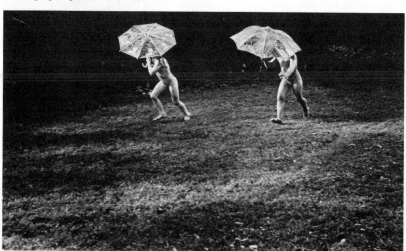

(Photograph by Nancy Scanlon)

*"For all good poetry is
the spontaneous
overflow of
powerful feeling . . ."*
-William Wordsworth in
"Preface to the Lyrical Ballads"

Even among those who write, paint, or dance, the artist is often seen wearing different faces. On the one hand, the artist is the "master," a skilled craftsman-critic, paring and honing, judging and refining. On the other hand, the artist is the "free spirit," the child-like original who gives expression to experience with a rare spontaneity and directness most adults have shed or forgotten. These two portraits of the artist stare at one another in sharp contradiction. The first highlights conscious, deliberate, intellectual skills as the skeleton for composition. In the second, a freedom from traditional methods and an overstepping of established categories allows the sharp, even brash perspective essential to artistic perception. Not surprisingly, these contradictory figures are everywhere. They exist in classrooms where education in the arts occurs, alternatively making them into ateliers or playgrounds, and they influence those whose business is to inquire into artistic skills—psychologically trained scientists.

In 1908 Sigmund Freud wrote, "every child at play behaves like the creative writer, in that he creates a world of his own, or rather, rearranges the things of his world in a way that pleases him."[1] In so doing, Freud gave explicit form to a profile of the artist as dreamer and child whose feelings and fantasies escape into his work. The silhouette of the artist-dreamer had been articulated earlier in the works of Romantic poets like Coleridge and Keats. They saw creation as self-expression, the effective venting of personal emotion or vision in an intense and individual way. Also implied in this portrait is a view of art as similar to play—an arena for both self-expression and experiment. The creative process is envisioned as free-ranging, unfettered by notions of what is merely appropriate, giving ample space to impressions, intuition, and fancy. Within this framework, education for the arts has as its first obligation preservation of the capacities to perceive, experience, and express oneself directly. Those charged with education must seek to protect and even promote experimentation, a zest for the undiscovered, and a corresponding contempt for the cliché. The role of institutions and teachers is to provide materials and opportunities, then to "stand back," inflicting neither methods, images, nor labels. At a deeper level, this vision of the creative process implies a notion of development as the unfolding of potential, the leafing-out of innate abilities that are easily stunted by an abrasive or unstimulating environment.

NOTE: Some of the research reported in this paper was supported by the Spencer Foundation and the National Institute of Education (G003 0169).

Somewhat skeptical of the preceding formulation, the psychologist of art Rudolf Arnheim has written, "what we call creativity is a kind of reasoning . . . either intellectual or perceptual."[2] According to this portrait of the artist, emphasis falls not on the direct expression but rather on the transformation that the artist works on experience, her conscious efforts at selecting. "The task of processing the raw material of experience is reserved to the highest functions of the mind. It is the task of finding order in the disorder, of sifting the essential from the accidental, the significant from the private."[3] The artist is portrayed as consciously weaving into the complex fabric of a composition her knowledge of her craft, her acquaintance with myth, history, and cultural tradition, and her awareness of what is significant in human experience. The effort is directed more at communication than self-expression, its ends achieved more through deliberate structure than self-expression or accident. This portrait of the artist makes much of her tools and methods, insisting that the metamorphoses wrought on raw experience are structured and heightened by choices of materials (bronze over marble), forms (sestina, sonnet, or free verse), images (war as chess game, murder or heroic combat), allusion (woman as Eve or Athene), and effects (assonance or dissonance, geometric order, or frenzy of impressions).

In this portrait, the artist is not only craftsman, he is also critic. It is the artist who judges what elements are harmonious, what is effective, what is "finished." *The Mona Lisa* underwent years of changes and refinements, never, in Leonardo's eyes, reaching completion. The final version of Picasso's *Guernica* is built on a scaffolding of nearly 200 preparatory sketches and studies. Flaubert is said to have arisen every morning at 6, writing and rewriting steadily until noon in his adamant search for *le mot juste*.

Intrinsic to this picture of the artist is a view of art as occurring at the confluence of various forms of knowledge—mastery of technique, control of cultural heritage, the cognitive abilities to organize and plan, a critical sense of what is pleasing and effective. Clearly, education designed to produce an artist in this sense would be rigorous, directed, intent on both practice and problem solving. At a more fundamental level, this view of the artist and education for the arts rests on a notion of disciplined development with active intervention by the appropriate individuals and institutions.

These two views of the artist, as sketched, are perhaps nearer to caricature than portrait. Yet they are tenacious, recurring ever since analyses of creative processes began. Further, the profiles serve as background for two broad but distinctive ways of thinking about artists, about their works and audiences, and about education

for the arts. Unravelled, they reveal sharply different views of the nature of the individual and of the developmental process through which he or she passes.

All too often, these portraits face each other in a grim standoff. It becomes a matter of exposure or predilection which profile to accept as fact and which to reject as fiction. But the two can be combined. Ravel commented that "inspiration is the reward for daily work," and Ben Shahn has suggested the artist at work is not one but two people, "the imaginer and producer" and "the critic of inexorable standards."[4] Perhaps these are not faces but only equally prominent phases of artistic activity. The challenge, then, is to construct a larger context in which both assume their place. The remainder of this chapter offers a view derived from the discipline of developmental psychology in which one sees both imaginer and critic emerging. From an understanding of artistic growth we can perhaps derive a more comprehensive portrait of the emergence and dynamics of creative abilities and the processes likely to nurture them.

DEVELOPMENTAL PSYCHOLOGY AS A SOURCE OF INSIGHTS

It is somewhat brave to propose that developmental psychology, a discipline at some remove from the arts as usually practiced or studied, provides the tools and materials for merging the two contrasting pictures of artistry. But psychologists have long claimed that "the child is father to the man," and, paradoxical as it may seem, embedded in the evolution of the scribbler to the painter, the storyteller to the novelist, are suggestive insights into mature creative processes.

Conceived broadly, developmental psychology is the study of age-related changes in humans. But if it is to possess any conceptual power, a developmental approach to change must feature more than a chronological catalogue of differences tied to age. To say that a child first holds a pen at ten months, first scribbles with interest at a year and a half, and draws representationally by four only mimics a developmental perspective. Only when one begins to focus on such issues as the rate at which this growth occurs, the steps by which the various landmarks are achieved, the organization of motor, cognitive, and social skills into a coordinated system for both creating forms and infusing them with meaning, only then has one "thought developmentally." It is the burden of developmental psychology to discern qualitatively different stages in physical, intellectual, and affective growth, the fundamental units and operations entailed in

each stage, the factors contributing to the growth and differentiation of each, and the interrelations and organization among them. It seeks to be not so much an index but an explanation of change. It asks not only when but also how and why a child learns.

Such questions as "how" can hardly be posed, much less answered, without some informing notion of the endstate toward which such changes tend. But implied in the selection of a goal to growth is the selection of a focus, the highlighting of some forms of change above others. And, indeed, schools of developmental psychology can be distinguished from one another on the basis of the way in which they address the question, "Toward what?" It may therefore help convey this developmental approach if we consider the way in which the several schools of developmental analysis explicate a particular childhood event of special significance to artistic growth—the acquisition of symbolic skills.

Between the ages of two and five, the average child becomes capable of using symbols—words, gestures, drawings, musical phrases—to represent her experience to herself and others. There is striking consensus among developmental theorists about the centrality of these experiences of symbolic realization. They catapult the child from an animal-like to a human-like existence, rendering her mobile in time and space in a way radically different from the less symbolically inclined infant. But the instant that one begins to interpret the significance of this "quantum leap," the emergence of symbol use acquires strikingly different contours.

If, for example, one views physical maturation as the significant endpoint to human growth, symbol use emerges as the realization of biologically blueprinted potentials of the brain and nervous system. If, like Pavlov and other stimulus-response psychologists, development is seen to eventuate in efficient response patterns, then symbol use makes the acquisition of a "second signal system," a higher-order set of stimulus-response pairs whose meanings result from a sort of socially mediated conditioning process.

Placed in a psychoanalytic sequence of development, where the goal of growth is the evolution of a normal or "healthy" personality, symbol use acquires a different significance. There, symbol formation expedites the transition from the pleasure-centered id orientation to less selfish, more thoughtful ego functions. Insofar as symbol use makes it possible to substitute an image for an actual object, it enables the child to delay gratification, replacing immediate sensual pleasures with longer range, more abstract goals. Simultaneously, symbol use carves out a permanent but adaptive place for primal wishes and desires by donating the forms in which fantasy and feelings can find organized, socialized expression.

In the work of cognitive psychologists like Jean Piaget the emphasis falls much more exclusively on the development of intelligence and genesis of logical thought. Seen in regard to this endpoint, symbol use loses much of its affective and expressive significance. Instead, the occurrence of words, numbers, and representational drawings signals the formation of tools useful in constructing categories of knowledge about the physical and social world. Further, symbolization is viewed as a means whereby communication of knowledge between individuals can proceed.

Symbol formation can, therefore, be conceptualized as either biological or cultural realization, the control gate between wish fulfillment and adapted thought, or a crucial step in the organization of conceptual knowledge. Given this diversity of views, it is striking that nowhere, to our knowledge, has the achievement of artistic competence, whether as creator, performer, audience member, or critic, been considered as a serious endstate for development. This is all the more remarkable because the case could be made—as is suggested in Chapter 1—that participation in the arts is an extremely fruitful endstate to the entire developmental process.[5] It combines much that is central to our concept of what it means to be human: self-expression, communication, participation in a rich and actual culture.

How likely is it that artistry can stand "shoulder-to-shoulder" with physiological maturation, healthy personality, or logical thought as a valid way to view development? In the next pages we would like to preview this possibility and to point out the new contours that human development might assume were artistic sensitivity envisioned as a primary goal for growth.

In recent years two comprehensive views describing growth from birth to maturity have come forward. Characterized in the broadest of terms, they are the *cognitive approach* (typified by the work of the Swiss psychologist, Jean Piaget) and the *affective view* (best characterized by Erik Erikson's efforts to extend the work of Sigmund Freud). Though these views contrast in emphasis and vary widely in content, they do exhibit considerable consensus as far as the major stages of growth are concerned, encouraging the belief that such stages of growth may inhere in the human organism rather than merely in theoretical discussion. If the cognitive and affective views of development were to be carefully sifted for their points of agreement, these congruences might be translated into a new model for growth focused on the emergence of artistry.

This is precisely the task attempted here. Searching through cognitive and affective descriptions of growth for fundamental agreements about significant alterations in the child's capacities and

interests, we will try to carve out their intersection. Bearing in mind the basic components of artistic participation—self-expression, communication skills, symbol use, the apt use of tools and materials, the emergence of critical faculties—we can attempt to detail the steps which culminate in effective artistry. At the same time we will be sketching a novel ladder of growth, one that ascends toward active participation in the arts.

THE STAGES OF ARTISTIC GROWTH

Broadly considered, we propose four major stages of artistic growth. During the first year and a half of growth, the child, like a stranger in a new place, evolves the most elemental forms of communication. Through her own continuous activity, she arrives at "practical knowledge" of the world and moves from a point where "all is one" to a point where she distinguishes between herself, others, and objects. As these distinctions emerge, pauses in the stream of pragmatic behavior occur—pauses to examine an object intently, to study the results of action, to play games which focus attention sharply on interpersonal relations. In the context of early and still intensely physical communicative efforts, these pauses anticipate aesthetic efforts of beholding, judging, and performing.

In the subsequent period (from two to five) the child emerges as a playful symbol user. Her physical exploration with materials and tools generates gestural, graphic, linguistic, and musical media; her mental play and fantasy spin out new and intriguing thoughts which at once test and enlarge her mastery of media, eventuating in the creation of numerous symbol systems. Simultaneously, the child becomes an avid "reader" of others' symbols—listening to stories, interpreting illustrations, moving to music. Practice both in producing and perceiving awaken in her the expectation that forms can "mean" and "reveal."

From five to eleven the child becomes the craftsman and sender of messages. He meets head-on the issue of effective design for his messages, struggling with problems of execution, clarity, and adherence to culturally determined canons of expression. As he becomes capable of internalized thought, the dramatic play and spoken narratives of the earlier player "go underground," his efforts becoming more intensely personal and therefore less accessible to his former audiences.

With adolescence, the child emerges (hopefully) ready to deal with the full range of artistic activity. The ability to reflect on his own activity and to generate numerous approaches or solutions to a prob-

lem grant the adolescent the capacity for critical thinking, conscious decisions about style, and deliberate use of the potentials of materials. Typically at this time early childhood capacities for direct self-expression combine with later developing sensitivities to technique and tradition into a willingness to externalize and share once again. Artistic development, when fruitfully negotiated, harnesses spontaneity and craft, honed and informed by critical abilities—a point of view much in accord with Ben Shahn's notion of the artist as "imaginer" and "inexorable critic."

But just as intellectual potential may fail to be realized or the capacity for a healthy personality impaired, artistic development is not always, or even often, fully realized. The phases of growth described above do not follow one from another with any assurance. Artistic development is continuously sensitive to undernourishment and to abuse, particularly at points of transition. With each movement across stages a potential tear or break develops in the process of growth; at each transition the question occurs: will growth proceed monotonically or will it accept a new and fuller modulation? And it is at these junctures that education most clearly promotes or impedes growth.

As the child moves from the direct physical communications of infancy to symbol use, the issue arises: will she meet with an environment supportive of her struggle with the emergent complexity of rules and forms? As the child travels from the immediate self-expressions of the preschool years toward more socialized and competent forms of offering meanings, the question becomes: will she accept culturally dictated forms and meanings all too heartily, her work becoming predictable and clichéd? Finally, in adolescence, where the child may attempt the step to full-blown participation in the arts, the problem becomes whether, in the face of her own new critical skills, she will risk the arduous recombination of intense expression with the technique painstakingly developed in the preceding period. Where the fear of failure immobilizes her, she persists as the methodical craftsman. Where the possibilities of artistry entice rather than threaten, she may realize the potential of development artistically defined.

It becomes clear, then, both intuitively and on the basis of developmental psychology, that the artist is not simply the spontaneous imaginer nor the craftsman-critic. Although early phases of aesthetic development may exhibit an ascendency of one face over the other, the final stage is ideally represented by their reemergence in combination. Correspondingly, education for the arts becomes inept whenever it is simply nurturance or technical instruction alone.

TABLE I MILESTONES IN ARTISTIC DEVELOPMENT

PHASE	AGE*	MAJOR FEATURES	CHALLENGE FOR EDUCATION IN THE ARTS
Child as Direct Communicator	0—18-24 months	Fundamental forms of direct communication; acquisition of a trusting relation with others Awareness of a stable object world to communicate about	Transition from direct bodily expression to more "distant" and rigorous symbolic expressions (i.e., from crying to asking, from grabbing to pointing)—with the confidence that the audience of "others" will watch, listen, and respond.
Child as Symbol User	18-24 months—5-7 years	Understanding the fundamentals of symbol use: creating and "reading"	Transition from spontaneous and idiosyncratic to socioculturally dictated forms of representation (i.e., from subjective portrayals to realism) still preserving spontaneity, originality, individuality
Youth as Craftsman	5-7-11-13 years	Socialization of self-expression; emergence of conscience Urge for competence; influence of peers Emergence of basic categories of adult thought; decline in egocentrism	Transition from strict competence to a recombination of craft with self-expression; the acquisition of critical tools as well as articulated personal tastes and standards without paralyzing feelings of inadequacy.
Youth as Critic and Full Participant in the Artistic Process	11-13 years on	The internalization of thought Reflectivity Capacity to think hypothetically and to confront choices	

*Ages are indicated as having broadly defined points of origin and termination. Wide variability of onset and progression seems characteristic of stages in aesthetic development.

Table I outlines the major phases, acquisitions, and challenges of aesthetic development as they are discussed in this chapter.

STAGE 1. GAINING PRACTICAL KNOWLEDGE OF THE WORLD

During infancy, life is organized around the self. Originally there is no "world" for the infant; this is because there is no environment except as the infant collides with it. There are no "others" except as people meet or thwart the infant's desires. In fact, the major accomplishment of the first eighteen months of life is the relaxation of a remarkably self-centered existence, so that the infant gradually comes to acknowledge and embrace both the larger human world and the compelling world of objects. This achievement is double. On the one hand it is shaped by a slow separation of self from other, possible only where the fear of isolation is moderated by the possibility of communication. On the other, the contours of this most fundamental differentiation depend on the gradual but steady construction of an independent reality. Though, in most senses, the child at the end of this period is still remote from the artistic process, the events of infancy constitute the essential prerequisites for effective artistic communication.

From the point of view of affective development, the first eighteen months of life center on the creation and elaboration of fundamental forms of interchange between an infant and his surrounding social world. As repeated and coherent contact with the social world etches a consistent pattern of experience, and inner image of "who one is" emerges, complemented by an incipient notion of "who they are" and "what is likely to happen between us." And, as this primitive sense of identity coheres, a corresponding concept of distance from others occurs. Not every message sent is heard; sometimes there is misunderstanding, sometimes there is conflict. This is the context of early wordless exchanges, in which the child judges for the first time the qualities of a "message" sent by others, intuiting the genuineness (or falsity), the depth (or superficiality) of care he receives. Simultaneously, the infant returns the simplest and most original forms of response, first communications coming in the form of a returned eye glance, smile, vocalization, or tentative efforts at imitation. So, within the first year of life, as the boundaries between self and other appear, forms capable of spanning the emerging distances also evolve.

In the months that follow, a child exchanges the role of an "audience member" who reacts to parental displays for that of performer

The earliest audience, the first messages. *(Photograph by Nancy Scanlon)*

and creator of his own messages. Physical development yields both an efficient manual grasp and an effective means of locomotion, both tremendous amplifiers of the range of experience. Simultaneously, reliable vocalization patterns, control of posture and facial expression, and articulated limb movements appear. Such bodily autonomy contributes to two further developments. First of all, to avoid lonely distances between child and caretaker, more vigorous forms of mutual exchange must evolve. In the process the child's identity acquires a new dimension—he experiences himself as a mover, doer, or maker. He struggles to shape his responses to experience through the conscious design of interactions. He pulls the adult toward a dead bird, grimaces, and shakes his head slowly. He openly expresses his delight in fall foliage, throwing his head back, dancing along the sidewalk, uttering long, pleasureful "oooohhhhs." Second, with practical behavior—grasping, standing, walking—well in hand, it becomes possible to exploit motions and forms of exchange for themselves. Rather than running to get something, a child can race across the room for the pure pleasure of doing so. The child

engages in peek-a-boo and primitive hide-and-seek games which explore disappearance and reappearance as forms rather than facts. Such explorations and games may constitute the first aesthetic behaviors. They are the earliest indexes of a willingness to "behold" or "perform" rather than merely to "do."

But the directness of these early communications, while powerful, is also limiting. The meanings conveyed can be only as precise as variations in the rhythm, intensity, and direction of action. Further, they are offered and understood fully only in the context of the shared history and reciprocal trust relations that bind child to care-taker. And finally, they remain essentially reactive—they are immediate responses to the dynamic properties of current events. The possibility of deliberately constructing a message which refers rather than reacts, communicates rather than expresses, that subordinates action to the demands of a symbolic product—all these wait upon later development.

Thus, our view of affective development can be characterized as the construction in infancy of a theater of communication, defining the roles of performer and audience as well as the urge to engage in the drama of exchange. In a complementary manner, a view of cognitive development in infancy describes this first year and a half as the construction of a compelling and reliable object world about which one can later communicate.

An infant playing with his own hand waves, shakes, and drops it. He views it from the side, from above, from below. He attends variously to its visual contours, textures, and physical properties. Ultimately, he employs it in a range of instrumental sequences, using it as circumstances demand as rake, bat, or toy. By virtue of the hand's persistence and constancy through these displacements, the infant ultimately arrives at the concept of an object which is independent of its spatial position, temporal occurrence, currently perceptible qualities, or uses.

This achievement is of major significance. As the object world becomes fixed, the child is sprung from being locked in present experience. The attainment of "object permanence" signals the advent of an outer world so well remembered it becomes possible to borrow details, feelings, and characteristics from objects encountered in the past and attach them to new objects. Both accurate substitution and imaginative transformation are possible. A block's squareness and solidity may make it an effective house or, in the context of fantasy play, it will serve as plate, car, even a person. Indeed, the reliability of the present physical world makes possible tentative journeys into the past and the future, the hypothetical and the imaginary. Since,

The beginnings of a world of objects. *(Photograph by Nancy Scanlon)*

to be considered, objects need only be "in mind" and not "in hand," it becomes possible to wonder, to plan, and to fantasize.

Hence the cognitive growth intrinsic to this earliest period breaks ground for artistry. It gives rise to the notion that an object's significance may exceed the boundaries implied by its physical contours. Moreover, by breaking the bounds of moment-to-moment experience, it permits the integration of past and present, the comparison of this object and that, the relating of one person's experience to that of another, thereby laying a significant foundation for later forms like narration, metaphor, and drama.

Both views of infancy (the affective and cognitive) suggest that certain fundamental prerequisites for artistry are built during the first two years of life. The encounter with a reliable social world produces games and patterns of mutual interchange suggestive of the roles of performer and audience. These exchanges anticipate subsequent communicative interactions, whether in the form of daily conversation, folk dancing, or murals in the public buildings. By the same token, the conscious encounter with a stable physical world offers a realm of experience vivid and lasting enough to be imbued with meaning. Missing, however, are *forms* capable of effec-

tively mediating between the direct experience of the child-artist and the audience of the larger world. Either the infant communicates effectively with his bodily gestures, or he fails to communicate altogether. The construction or adoption of such forms—conventional gesture, language, representational drawing—belongs to the ensuing period of growth. But between these periods lies a "crisis of transition."

The child's entry into the company of fluent users of symbols hinges on his confidence and competence in handling the syntax, conventions, and control characteristic of the forms that he is reaching out to adopt. The child, fully accustomed to expressing his anger with foot stomping, cries, or scowls, may have to struggle to channel his fury into the subject-verb-object framework of language, the lines and colors of drawing, or the regulated patterns of gesture. He must accept the task of translating personal anger (or equally personal delight) into the public or conventional forms that may seem arbitrary, barren, and sparse beside his own familiar patterns of yelling and banging (or laughing and chasing). Further, the child must grapple with the "distance" and control inherent in the effective use of symbolic forms. After all, in direct bodily expression of fury or fancy, there is no editing or conscious shaping; and yet the deliberate effort to represent the cause, experience, or result of anger or joy demands just that.

Hence, there arises at the close of infancy the first of a series of major challenges for education in the arts: how to introduce a child into the world of symbol use, encouraging him to move from sheer manipulation of materials toward infusion of meaning into his expressive products, all the while shielding him from the fear and frustration entailed in confronting the sometimes rigorous demands of syntax, convention, and control. We can merely offer two hints at what might be indicated for practice. The first is a gradual movement from direct bodily expression to work with increasingly demanding materials commonly associated with representation: routing the translation of body motion to easel painting through a "middle way" of finger painting, permitting sound play as a preface to poetry, encouraging the direct expression of feeling states prior to dancing in the strictest sense. In addition a gentle transition, a generosity on the part of the audience, seems required: a willingness to assume the child's perspective in order to understand his meanings, rather than a hastening on in the name of achievement, or an abrupt negative critique of the child's still awkward communicative attempts.

STAGE II. FROM TWO TO FIVE: COMING TO KNOW SYMBOLS THROUGH PLAY

The infant's world is circumscribed by what can be touched, thrown, or seen. But the three-year-old squatting on the living room rug is "actually" a witch in her castle or a monster prowling his lair. Between the ages of two and five, the boundaries of the physically given world are expanded as the child emerges as "imaginer," a role made possible by the transition from reaction to representation. During this period, the child both stumbles upon and actively seeks forms which can "freeze" her experience and fantasy for appraisal, elaboration, and sharing with others.

From the first moments of infancy there exists the capacity to react in different ways—some objects provoking a violent startle, others eliciting only interested gazes, still others slipping by unnoticed. Soon a capacity to mirror a model's actions emerges as well: the infant blinks her eyes rhythmically in response to the opening and closing of another's hand. Such early imitations display a striking structural equivalence to the models, a capacity to capture its characteristic dimensions or qualities. But only when the child is able to represent the model "in her head," an ability which presupposes a developed object concept, can she enact sequences which do not merely echo contemporaneous events. At this point, toward the end of the second year of life, she can take up a stick and make it a gun by holding it outright and stiffly jabbing the air. Simultaneously she "molds" her voice into short brief staccato blasts, echoing the charging weapon. Whereas action had been the first form of communication, it now becomes the first medium of depiction; the child's own body movements, postures, vocalizations, and facial expressions constitute the raw materials for early "re-presentations" of experience.

Just as mastery of her own body yields the child a highly articulate gestural vocabulary, it also renders the child more independent and capable in the eyes of observing adults. As a result the child is permitted to play more freely. Outside she encounters sticks, dirt, mud, water, and sand. Indoors she is presented with blocks, clay, crayons, and paint. Everywhere she hears the sounds of speech. Quite unlike the medium of action where, once performed, all is gone, these "plastic" materials take up and "hold" the imprint of the child's manipulations, becoming a "product." If clay were squeezed to form a handle and trigger, a once formless mass would become a gun. The child would have fashioned, not just imagined, her props into existence. While squeezing the clay as if it were a trigger involves little else than the transfer of meaning from particular

The imprint of play action on materials. *(Photograph by Mark Harris)*

action patterns to their by-products, it does represent the initial step from that most personal of idioms, bodily response, toward the shared forms of symbol systems.

As the mother-child bonds of physical intimacy are dissolved, the distance between audience and actor threatens to widen unless newer, more powerful means of communication are built. And so the child struggles from the direct but limited forms of body language toward more "readable" forms. She must translate what she experiences subjectively—tempos, active forces, feelings of fullness or emptiness—into qualities that will persist for others—contour, spatial relations, patterns of sight and sound. Simultaneously, the child is also struggling to reconstruct on a symbolic level the primeval trust relationship; now the quality of her relations can be expressed by the exchange of words, gestures, and visual symbols rather than through directly experienced embraces.

In the cognitive view of this process, highly individual symbols give way to socially validated signifiers. Early symbols are highly personal; as imitations, they "picture" the qualities of objects to which they refer. Further, they arise in the context of individual

Contact with conventions and categories. *(Photograph by Nancy Scanlon)*

lives. One child's symbol for "bicycle" derives from her father's old wobbly two-wheeler, another's builds upon her brother's sleek racing bike. Yet, while such personal forms provide fertile grounds for initial symbolization, they are insufficient for persistent social use. A child may initially refer to all older children as "Peter" after an older brother, but such idiosyncratic language breaks down as the child is corrected, acquires new terms, becomes aware of being misunderstood, and struggles for greater precision. According to a cognitive orientation, she reaches out for words expressing logical categories—terms like "boy," "man," and "brother"—forms powerful not only because they are readily understood but because they organize and interrelate the universe. The child acquires a representational set as she names, recognizes, and begins to note what properties are focused upon by those around her.

These two views of early symbol use seem to reflect distinctive emphases in the genesis of connotation and denotation. The affective view emphasizes an enduring degree of experiential color even in sophisticated communications, and the cognitive viewpoint stresses the shedding of idiosyncratic meaning in favor of socially donated forms and concepts. Here lies a second major challenge to education in the arts. How can the freshness, directness, power, and deeply felt significance of personal response be maintained in the wake of the effort to construct interpersonally valid forms of communication? The question remains crucial in subsequent periods as the child adopts with increasing exactitude the standards, norms, and formulae required of her by the social world. Eagerly reaching out to accept culturally dictated skills of reading, writing, and making numbers, the child may accept them with such focus and emphasis that drawing, dance, music, and other artistically valid forms will be downgraded or neglected. Letters seem to convey meaning with more certainty than lines; metaphors may miscarry; a viewer can read so many things into a dance sequence. Clearly one challenge for education in the arts is to maintain a place for exploration of ideas through drawing as well as diagramming, through connotation and denotation, and with expressive skills as well as analytic capacities.

STAGE III. FROM FIVE TO ELEVEN: THE APPEARANCE OF THE CRAFTSMAN

Closely examined, the message of a four-year-old is more fiction than fact. He fills in, stretches, and elaborates at will. On the one hand, he "hallucinates" ego mastery, using fantasy to bolster a self-concept which is often threatened by adult demands and standards. On the other, his ideas are too subjective, global, and unanalyzed to submit to reason. The four-year-old remains incapable of assuming the role of an audience to his own "performances," of judging whether his meaning "comes through," is misconstrued, or altogether missed. Moreover, he lacks the technical facility to organize his performance in a consistent and "readable" fashion.

A more advanced relation to symbolic objects arises in the early school years from three sources: the development of conscience or the internalization of cultural standards; membership in the peer group and the community; and finally a gradual shift from the role of "pure" child to that of youthful adult.

The five-year-old's urge to live unharnessed and unmanaged repeatedly encounters controls: "Not 'goed,' it's 'went'"; "color only on the paper"; "don't touch that, it is your father's." An internal

observer, a superego or conscience, gradually emerges in response to these external insistences. Viewed broadly, conscience is more than a sense of right and wrong: it is an embodiment of cultural heritage, a definite selection of standards and attitudes of an amazing variety, bequeathed to children less automatically but as surely as physique. Conscience furnishes the child with tastes, themes, and stereotypes drawn from his parents and from the cultural and social experiences of his community. Once adopted, such sensitivities serve to make the child's thought continuous with that of his surrounding milieu. In the early elementary school years the child learns how a hero behaves, whether poetry is foolish or powerful, if atonal compositions are "noise" or music.

Even as the development and internalization of conscience bind the child to his own family, his increased mobility and independence simultaneously permit him to transcend the family circle, entering into the company of peers and a crowd of strangers. Amidst his contemporaries, the child learns to "think as one should," that is, in ways appropriate to age, sex, class, or clique. He arrives at ever firmer definitions of what is valuable, handsome, worthwhile, or moving. In addition to the voices of conscience and peers, another strain is heard—the hubbub of the "world at large." Magazine illustrations, billboards, television, motion pictures, and museums all hawk their notions of what is to be treasured, what is to be shunned.

At the same time, the child's self-expression is being pressured into efficient communication. In a world of strangers and in the jostle and teasing of the peer group, what matters is *effectiveness* within the context of group values, not *expressivity* within one's own personal system. The fantasy that was tolerated or encouraged in the indulgent, comprehending atmosphere of the home may be out of place on the street or in the school bus. In its place, concreteness, literalism, and realism come to the fore. Required to "face up to things," give directions, make change, figure out what's wrong with a bike, the child increasingly uses symbols in a functional and pragmatic manner.

Freer movement through the environment narrows the gulf that once separated the child's infantile self from the adult world. He discovers that, after all, he is not so unlike the adults he encounters. With new and more observant eyes he scans the workaday world with the emerging realization that its tasks, techniques, and troubles will one day be his. And, where the arts are concerned, the child evolves from the individual imaginer to the worker in a tradition. A drawing, poem, or sculpture is no longer a spontaneous by-product of experience—instead it becomes a task to be confronted and mas-

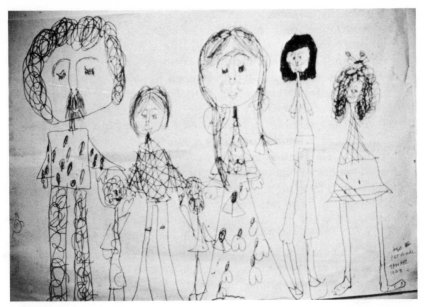

An emerging sense of what is right, valued, or appropriate. *(Photograph by Deborah Steiner)*

tered. Tools and raw materials must be used appropriately. The product must be in accord with conscience and peer group values. It must "speak for itself" even to strangers. It must struggle to capture not the individual child's response but something of the basic structure of object or event, the concrete, palpable characteristics of experience that any and all can see. The most plausible and inviting route is to learn the "tricks of the trade," the conventions and techniques that assure competent, comprehensible messages. Consequently it is during this period that the child first wrestles with perspective drawing, "proper" rhyme schemes, accurate musical scales, sculpting a figure that is plausible from any aspect, slowly seeking to acquire the technical facility that assures messages will be received. In most cases, children actively seek to achieve competence and mastery and display an ease in learning and a tenacity in drill.

Cognitive development mirrors these affective and social contours during the elementary school years. Social pressures to drop fantasy are complemented by the emergence of the capacity to internalize thought. Fantasy no longer needs to be acted out and goes underground; dramatic play becomes daydream. Moreover, the child strives to coordinate his intellectual views with those of others. For

the first time he exhibits the ability to shed his own perspective and assume that of another individual: he can offer an explanation or retell a story in a way that is increasingly intelligible. Similarly, his maps and diagrams include genuinely salient information rather than those features which happen to strike him as interesting. This sensitivity means that the very quality of language changes; it becomes somewhat less egocentric and appears in response to the questions and interests of others rather than spilling over, unchecked, from his own impressions.

During the elementary school years children also exchange their subjective explanations of natural phenomena ("the moon shines so that I can see") for a more objective "scientific" view. Attention refocuses, forsaking how natural events "feel" in favor of how they "appear" and what causes their action. In the artistic realm, the child becomes interested in how to achieve effects; recognizes that "progress" depends on the enhancement of his own skills; and can adopt the view of others in assessing his products, revising, altering, and otherwise transforming them in the service of increased comprehensibility.

The switch from experiencer to observer is paralleled by a transition from a "spontaneous" producer toward becoming a deliberate technician. During these years, the child gains a complement of skills that help to engineer more effective thought and communication. He acquires the logical and linguistic machinery for constructing sequences and causal relations. To this, he adds the ability to carry out prolonged comparisons and the capacity to break up experience into consistent categories such as shape, color, and size. The subjective and often fantastic organization spun by the younger child in an effort to integrate the diversity of his world is replaced by a kind of logical and literal "grid system" for segmenting and mapping experience. The power of such a grid lies in its being a reliable system for the construction of a reality that is both self-consistent and capable of being shared with others. Paradoxically, its utter reliability limits this sense because of the consequent strict attention to what is concrete and observable. And herein lurks yet another challenge for education in the arts.

At the brink of adolescence, the young artist is alert to the realistic texture of experience—its sizes, shapes, weights, and volumes. Further, he is equipped with the tools and techniques for clearly encoding important facets of what he perceives. He is also ripe for a crisis that centers on discovering the limits of realism and mere faithful rendering and the emptiness of sheer exercise of skill.

Let us consider briefly the form that this crisis may assume in the

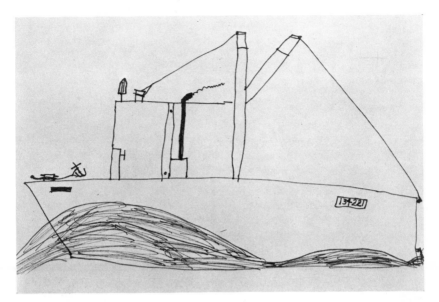

The appearance of technical skill and realism.

various art forms. In the case of the visual arts, the ten-year-old struggles to get the rungs of a chair "right," erasing in hopes of a closer and closer approximation of the chair. But drawing is neither a map nor photography, and its success depends not so much on perfect copying as on capturing the sense, spirit, and structure of chair, whether it is a rigid ladder-back or corpulent upholstered armchair. The compulsive drive for replication may yield physically faithful sketches but it leads to diagrams rather than drawings. Similarly, the fledgling pianist may repeat his scales until they have achieved virtuoso proportions while failing to realize that, when so embedded in a composition, such passages will sound mechanical and lifeless. A young poet completely masters the rhyme scheme and meter of the sonnet, but fails to appreciate the artful "deviations from the book" which can lend special power to his efforts; and the young ballerina learns each of the basic steps and positions to perfection, but overlooks the subtle variations and interactions which spell the difference between a merely competent and an affective performance.

The challenge during preadolescence for education in the arts is, therefore, to lead the child beyond proficiency to the point where his craftsmanship becomes a vehicle rather than an end in itself. Arts education should offer the child a bridge from mindless technical virtuosity to significant artistic accomplishment.

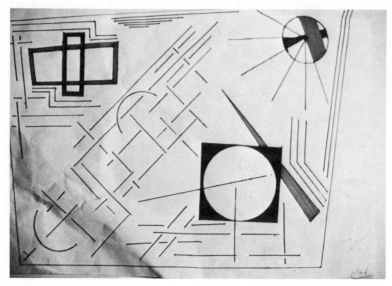

Beyond mere skill to insight and artistry. *(Photograph by Deborah Steiner)*

STAGE IV. ADOLESCENCE: A CONFRONTATION WITH ONE'S LIFE AND ONE'S WORK

The preadolescent has already attained considerable understanding of the rules and practices governing the social, intellectual, and aesthetic world. Indeed, in speaking to her or observing her engaged in activities, one may well fail to appreciate the extent to which she yet differs from the adult. The difference lies in her concreteness—her interest in activities themselves rather than in discussions or analyses of them—and in her parochialism—her unquestioning assumption that the standards of her group are those of the world beyond. She already understands pragmatically a substantial portion of the major symbol systems of her culture, but she has not yet obtained distance from them. In general, she does not appreciate that these symbol systems are human constructions, that they can be put to many purposes, revised considerably, or even replaced by others of her own invention.

The appreciation of the "realm of the possible," the multiple roles which can be assumed by an individual, the range of religious, social, and aesthetic choices and experiences, the nature of scientific investigation and explanation—these theoretical, philosophical, and metaphysical realizations constitute the cognitive achievements of the adolescent years. The youth not only can produce in the arts but now can reflect upon the artistic process and enter fully

into the realm of critical inquiry. Accompanying these understandings is both a tremendous feeling of power and liberation and, in many cases, considerable unease. Once fully aware of possibilities and choices, one must confront the necessity for choice and the recurrent possibility that one may choose wrongly or unwisely. The individual must face her own future—selection of career, life style, mate or mates, tastes, and allegiances—and, no matter how intelligent or "adjusted" the child may have been, this "ultimate responsibility" cannot have been fully anticipated.

The final period of artistic growth, initiated in adolescence, centers on crises of choice. Both social mobility and the power of logical thought engender a vast array of possibilities, and the adolescent must learn to make personally satisfying as well as culturally appropriate choices among alternatives. To that extent the next phase of aesthetic development may be seen as an effort to integrate the subjectively satisfying universe of the imaginer-player with the objective, technical, and culturally appropriate universe of the craftsman.

The adolescent's search for her own identity often carries her beyond the limits of the peer group and immediate community toward a knowledge of other ethnic groups, radically different cultures, and the life-styles and mores of other periods. In the process, her consistent and conflict-free universe seems to blow apart. The adolescent discovers that the themes, attitudes, and values once held uncritically are simply instances and certainly not fixed truths. Earlier, familial and group pressures helped to maintain communication between child and peers, between actor and audience. But in the face of newer diversity, the adolescent asks if "real communication" can ever occur, and what sort of exchange there can be amidst a relativistic flux? The subjectivity of her own experience conflicts with her impulse to employ recently acquired technical skills in order to carve out a much needed sense of her own capacities and potentials.

Sensitized to the subjectivity of experience, the adolescent participant in the artistic process confronts three issues. The first concerns a search for standards in a welter of diversity. On the one hand the adolescent may despair of being able to communicate anything at all. On the other hand, she can hope that artistic activity, occurring at the intersection of feeling and form-giving, can provide some special integration of personal worlds. But the mere enunciation of that hope turns the adolescent back to the question of her own aims and capacities. "Is that a hope that I could realize?," she wonders, and so confronts the formation of artistic identity.

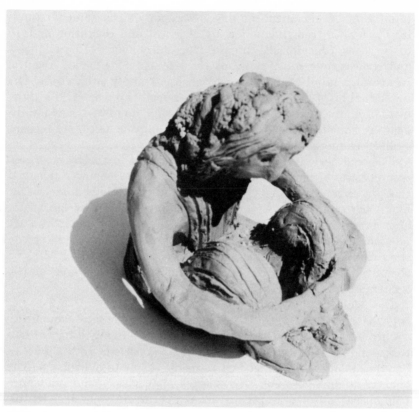

The adolescent struggle to integrate identity and skill. *(Photograph by Judy Burton)*

The complementary question, "But how?," gives play to the intellectual achievements of the period. With adolescence comes both the capacity and the curse of hypothetical thought—the ability to generate all the logical alternative solutions to a problem. Aesthetically construed, a universe of possible formats, techniques, and styles faces the adolescent, the very diversity raising for the first time the conscious relation of content to form. It is in this sense that aesthetic development nears culmination in adolescence, for it is then that the achievements of earlier stages are woven into a unified effort. The adolescent artist struggles toward an integration, trying to coordinate the vigorous individuality of early emotional response with the shared perspectives donated by conscience and the socialization of thought. Similarly, she strives to weld the directness characteristic of early gestural depiction to the later drive for technical

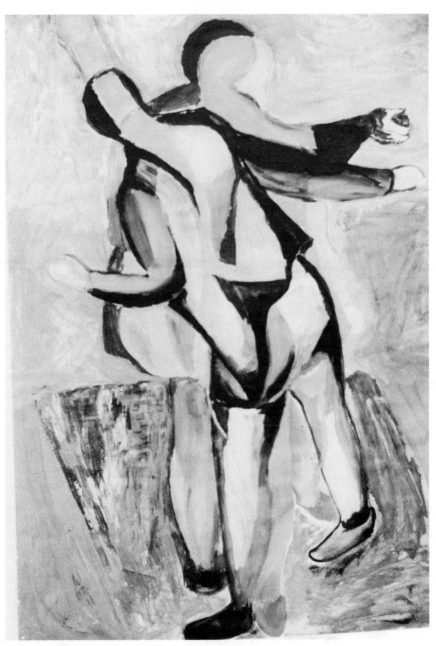

The important merger of ability and idiom. *(Photograph by Judy Burton)*

proficiency, in the process arriving at a style which is at once a personal idiom and a compelling form of communication. Finally, she attains distance from her involvement in the arts and can, perhaps for the first time, adopt a genuinely critical stance toward her own efforts as well as those of others. One glimpses this combined achievement in the painting on page 73 entitled *Throwing a ball— it's like I'm whirling all the time.* Self-expression, strong execution, and a sense of having achieved a compelling image intertwine.

The third issue, perhaps most crucial for artistic education, centers on the question: "Can I meet my own standards?" Gaining personal pleasure or achieving a rough likeness may have satisfied the younger child; but aware of the possibilities of achievement, including those realized by the greatest artists of the past and the most gifted of contemporaries, the adolescent artist must emulate much more formidable models. And if she judges that her own products and skills fall too far short of these standards, she is likely to despair, to reject her own works, and, ultimately, to avoid future participation in the artistic process. Perhaps the gifted aesthetic educator can aid the adolescent to confront, and to master, this *Angst;* perhaps the youth can be helped to accept her own abilities and limitations and to forge ahead. One must also consider the possibility that potent educational interventions may no longer be effective during adolescence. Preparation in anticipation of the crisis of adolescence—by equipping the youth with considerable technical skills and by familiarizing her with the processes of criticism when she is not yet so excessively sensitive—may prove the best guarantee that the crisis of adolescence can be successfully negotiated.

CONCLUSION

The foregoing sketch has described four major stages, as well as their intervening pivotal crises, which characterize the child as he develops toward participation in the arts. We have viewed the cognitive steps, the affective forces, the specific problems and promises characteristic of the periods of infancy, toddler years, middle childhood, and adolescence. In the course of this review, some sense of the developmental process and some critical highpoints of normal human development have been conveyed. Nonetheless, two outstanding issues need to be confronted before our discussion is complete.

First of all, we must consider certain limitations of the picture presented above. It is a picture which rings true within contempo-

rary American and perhaps Western society, but one whose relevance to other cultures and other eras remains to be established. Moreover, it is a picture that has been drawn with excessive sharpness. The stages we have described do not commence or conclude with suddenness but instead blend gradually into one another, and the ages that we have suggested are approximate at best. Finally, certain distinctions we have introduced presuppose a separation which does not actually exist. Thus, we have discussed cognition and affect as if they were two separable and separate realms; whereas in truth cognitive and affective aspects are so intertwined that any attempt to tease them apart can only be defended on pedagogical grounds. All of these reservations should be kept in mind in any evaluation of our portrait of artistic development.

Our description of artistic development not only has its limitations, it has left unanswered the crucial question posed at the head of this chapter. We have yet to reach a conclusion about whether the child is better envisaged as a spontaneous imaginer, with whom no educator ought to interfere, or as a potential craftsman in need of intelligent training at the hands of a master artist. As we return for a final time to the contours of children's artistic development, we may discern at least a tentative answer to this guiding question.

The ability to give aesthetic form to strong meanings arises gradually. In infancy the fundamental roles of performer-creator and audience are elaborated, and the basic drama of communicative exchange is played out for the first time. But only during the second through fifth years of life does the child-as-creator first begin to work with the materials out of which the arts are constructed—the various symbols and symbol systems which can capture and convey information of varied sorts to others in the culture.

The toddler of three or four no longer deals with objects completely on a practical level. She begins to investigate the surface textures of various media as well as their syntactic and semantic potentials. Exploring the materials that come her way, she discovers the sounds and rhythms of language, the colors and shapes of drawing, the directions and postures characteristic of make-believe and dance. Joyfully and with little concern for their impact on others, she creates products on her own, miniature works which may bear a certain resemblance to those molded by others but which, in the deepest sense, are personal expressions. At this time, to be sure, the child is already aware of the behaviors and examples of others, and as a result she may incorporate what she beholds or overhears into her symbols. Yet these years seem to be a period during which the child draws on her own dynamic; accordingly, the role of the

educator is primarily one of fostering the child's own spontaneous expression, rather than explicitly training specific artistic skills.

As the child enters school, her involvement with symbols becomes much more controlled and objectified. As a consequence of the development of a sense of conscience, increasing involvement with peers, and a gradual participation in the adult world, the child becomes able to adopt other points of view. At the same time she learns to classify and categorize systematically and to produce and appreciate symbols with reference to a reliable set of standards. She becomes interested in attaining skills, intent upon achieving mastery of form, uniquely equipped to practice and perfect. As the molding of products which speak to others becomes increasingly important, the child is prompted to master tools and techniques and to learn the fine points of giving shape to content. Eager to seek aid, the child seems to benefit considerably from direction by a skilled and sympathetic tutor, and this emerges as the optimal moment for educational intervention.

The years of adolescence are marked by a coming together of the themes of earlier life. In the arts, the playfulness and direct expressivity of early childhood and the careful craftsmanship of the elementary school years confront one another. Persistence of artistic efforts requires the achievement of an artistic identity, a personal idiom at once "true" to subjective experience and goals and capable of speaking to others, and a continued openness to exploration and play, paralleled by a sense of direction and aim. Whether explicit training can temper the despair which may beset the adolescent artist is problematic; yet a sensitivity to the adolescent's dilemma and a sympathetic understanding of the sometimes conflicting desires for individual expression and communal acceptance are essential during this turbulent period of life.

In sum, then, the two- to five-year-old recalls the romantic view of the artist as player and dreamer. During her middle years, the child resembles the craftsman who urges her work carefully toward completion—scrubbing, picking, honing, always polishing. The adolescent is both visionary and technician. Mature artistic activity is a dramatic mixture in which personal statements are modulated by a keen sensitivity to structure, shaped appearance, and method.

If educational principles in the arts are to dovetail with insights about child development, it seems, at first glance, that there is a season for nurturance and a time for training. As suggested, the early years of life constitute a time of natural development of artistic competence. And so, during this period the approach of unfolding, of giving free rein to natural tendencies, seems indicated. In

middle childhood, however, a more active type of instruction or intervention may be desirable; not rigid exercises but rather situations which give the child tools and techniques, the opportunity to work intensively in a studio, to talk about this work, and to hear others appraise it. Ultimately, during adolescence, education for the arts must address the themes of diversity of expression and emergence of personal identity. Intensive exposure to the idioms of individual artists and periods coupled with a deliberate exploration of the various routes to effective expression are needed.

We offer two concluding thoughts. The first is that a nurturant atmosphere is always appropriate. Even the skilled adolescent needs refuge from the harshness of her own sharpening critical awareness, and the small child explores her clay longer and more productively when her manipulations are spurred by eye-opening questions or by new tools. The second is that a judicious blend of the two approaches of "unfolding" and "training" seems consonant not only with the findings of developmental psychology but also with our knowledge of the creative process. Based on the testimony of writers and other artists, there seems to be a necessity for both free play and careful shaping, inspiration and criticism. An encounter with any new material, concept, or subject matter will involve a movement from exploration to expertise and an emerging eagerness for tuition. Wordsworth's "the spontaneous overflow of powerful feeling" and Yeats's "scrubbing" and "breaking" are two faces of artistic activity. Despite their contrasting natures they become intertwined, whether in the brief compass of a single effort or the prolonged process of aesthetic development.

NOTES

1. Sigmund Freud, "The Relation of the Poet to Day-dreaming," in *On Creativity and the Unconscious,* Harper and Row, New York, 1958, p. 45.

2. Rudolf Arnheim, "On Inspiration," in *Toward a Psychology of Art,* University of California Press, Berkeley, Ca., 1972, p. 287.

3. Ibid., p. 290.

4. Ben Shahn, "Biography of a Painting," in Vincent Tomas (ed.), *Creativity in the Arts,* Prentice-Hall, Englewood Cliffs, N.J., 1964, p. 20.

5. See Howard Gardner, *The Arts and Human Development,* John Wiley and Sons, New York, 1973.

CLASSROOM PRACTICE: CREATIVE MEANING IN THE ARTS

NANCY R. SMITH
Boston University

> *The purpose of poetry is to help*
> *people live their lives.*
> —*Wallace Stevens*

The arts, as Wallace Stevens says, belong in the middle of the fabric of life, giving insight and shape to experience, helping to inform our responses and actions. The degree to which they play a fundamental and central role in human existence is further evidenced by the course of development of artistic behaviors in children. Artistic activity begins, as Wolf and Gardner have recounted, not separated from, but rather integrated within the child's everyday thought and life. Young children begin to create expressive and symbolic forms motivated by their own independent discoveries and continue to refine them in self-taught sequences. Artistic expression arises as part of the growth process, and it is clear that its psychological function is to *extend the range and capture the quality of experience, that is, to formulate and substantiate meaning.*

To organize and substantiate thoughts and feelings is a fundamental human need. It is done through a variety of practical, scientific, and artistic means, but as Eisner writes:

> Art is one of man's major avenues for the formulation and expression of his ideas, his images, and his feelings. It is through the process of working with materials that these ideas, images, and feelings are not only formulated, but clarified and shared. This process affords the individual and those receptive to his products an opportunity to understand and undergo experiences that cannot be acquired through other modes of thought.[1]

One factor that distinguishes the arts from other modes of representing experience is the deliberate consideration given in them to aesthetic and formal characteristics. Another factor is the conscious consideration they give to emotional content. Finally, a third factor relates the first two: in a work of art, emotional qualities are embodied and presented in the formal organization of the artistic materials.[2] Because of this inherent relation between aesthetic form and emotional content, the arts are particularly suited to portray subtleties of feeling and complexities in experience.

However, as Wolf and Gardner have pointed out, it is important to remember that the arts involve as well objective thought and skill. There is, in fact, a unique interplay between emotional and intellectual factors in the arts; on the one hand there is the inherent embodiment of emotional qualities in form, and on the other, the intellectual order and coherence created by form. Because of this interplay between emotion and intellect, it is possible, through the arts, to substantiate the blend of thought and feeling in real expe-

rience. In the arts the uneasy relation between the inner and outer worlds of human experience, between subjective and objective realities, is given recognition and aesthetic, if temporary, resolution. The basic function of the arts is to capture and embody meaning, but their special psychological function is to bridge thought and feeling in so doing.

This analysis makes plain the deeply serious role the arts play in the organization of human thought and, at the same time, argues for a clear focus on this role in educational planning. It is particularly important for educators to realize that the primary purpose of the arts in a general school program is not to train artists, but to train the growing child's ability to create meaning. To do this educators must keep in mind both the basic and unique functions of the arts. The overall goal of arts education should be *to help children fully develop their ability to create and understand meaning in forms that bridge thought and feeling.* Education directed toward this goal makes possible the development of a child's capacity for living in the fullest sense that Goodlad and Morrison discussed so persuasively in the first chapter.

In order to plan curricula focused on this goal and based on the nature of children's development in the arts, a distinction between the function of fine art and child art must be made. The fine arts and child art are similar in that they are both directed toward the creation of meaning, but they are different in that they do so for different reasons and in critically different contexts. The young child's art is the result of a process of understanding and organizing experience that occurs with a minimal knowledge of history and conventional art forms. The child has yet to confront the art of the past; his enthusiasm for art is, in part, the consequence of his innocence unfettered by too much knowledge. His need is to organize his immediate world, to construct meanings for himself out of the present everyday reality.

By contrast, the fine artist functions within the context of the cultural past and her task is to create images of the future, new understandings of a changing reality for society. The function of fine arts is the formulation of new realities for the society. Child art does not attempt to speak to and for society. The function of child art is to help the child understand herself and her world better. The goal of developing the child's capacity for the creation of meaning should be implemented with this frame of reference in mind.

In the sections to follow, examples of curricula, lessons, and children's work will be offered to illustrate particular objectives and strategies which help children develop their capacity to create and

respond to meaning. Examples were chosen for their importance in relation to the overall goal of the creation of meaning and for their proven effectiveness with children. They were selected to illustrate the important learnings they make possible, not because they produce polished artistic products. Furthermore, examples were selected from as wide a range of the arts as possible. A description of a comprehensive program in any one art or in all the arts was not intended.

GENERAL PEDAGOGICAL OBJECTIVES AND STRATEGIES

This section outlines general objectives for any arts program at any age level and strategies for achieving them. Individual examples are necessarily limited to one age group, but the principles themselves may be applied to all ages. A later section will discuss age-specific objectives and strategies. Five general objectives can be listed:

1. Children's work should involve personally meaningful experiences.

2. Children should have the opportunity to explore the physical and visual properties of various media.

3. Children should be helped to explore the expressive properties of materials and experiences.

4. Children should be helped to generalize from sensory experiences to their theoretical and conceptual bases.

5. Teachers should respond appropriately to children's work.

Discussion of these objectives and strategies to implement them follows.

EXPLORING PERSONALLY MEANINGFUL EXPERIENCES

It is important to ensure that children's work involves personally meaningful experiences. Introducing direct experiences into the curriculum is one strategy for accomplishing this objective. Such activities must be appropriate to the children's developmental needs and interests, and the teacher must structure lessons properly to be certain that the meaning of the experience is kept in focus.

Direct experiences such as those made possible by an enriched environment of equipment and materials, visiting artists, and trips to museums and performances can easily be superficial. Such activities should be carefully integrated with the concepts and experiences of the rest of the curriculum. They should be introduced so

that their significance in relation to the curriculum is made explicit and followed up by activities which engage children's direct participation. Group discussions should be used to explore and clarify each child's understanding of the experience.

Equally meaningful experiences can be brought into the curriculum by asking the children to recall events of importance to them from outside the classroom; these can become the sources for stories, poems, plays, and visual work. To ensure that the children draw on significant memories, the teacher must understand their feelings, as for example in responding to the evocation of mood and event in this poem (written by a boy in an ungraded class in an urban elementary school):

> I'm sorry I busted your window
> I took a big rock
> and aimed at your window.
> It broke the glass
> and I'm sorry.[3]

In addition, it is important to be responsive to the children's feelings because their expressive clarity and aesthetic organization very often derive from their feelings about an event, as in this tiny poem:

> How do you feel
> when you have
> the whole road?[4]

It is also helpful to highlight mundane but meaningful events of classroom life. In explaining a movement arts lesson for young children, Miriam Stecher writes:

> Too few teachers pay enough attention to body sensations. They take little note of fatigue, pain or pleasure. . . . When a good workout leaves everybody tired and hot, would it not be of interest and benefit to ask all to *lie down on your back, arms and legs loose, eyes closed, and be with your tiredness for a few minutes.*
>
> Quietly given suggestions for inner listening might be: *With eyes still closed, begin to listen to your body. . . . Take a few deeper breaths. . . . Where are your arms?. . . . Does your back feel the floor?. . . . Notice if the floor feels cool or warm to you. . . . Notice what else you are feeling.*[5]

Here the teacher focuses awareness on the present sensations of the child rather than on a new theme. These sensations follow nat-

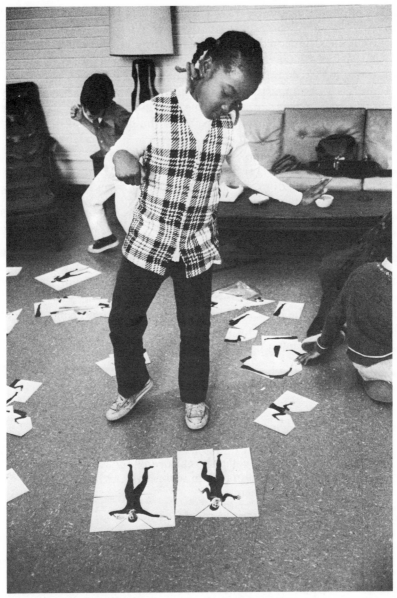

St. Louis County Schools, Missouri. *(Courtesy of CEMREL, Inc.)*

urally from earlier activities and should be brought into focus and incorporated in the content of the lesson. Thus, immediate experiential significance is added to the learning.

In order to consider both the cognitive and affective aspects of an experience, the teacher must be sure to ask the children to identify

all the elements of the experience important to them. The children's observations may correspond to the teacher's and they may not. Often the children add dimensions of experience that never occurred to the teacher. Sharing them makes it possible for the children and teacher to have a common frame of reference from which to proceed.

Finally, it is important to crystallize experiences in developmentally appropriate symbolic forms. The clarification of experience is most successful when put into forms the child understands and has helped to shape himself.

EXPLORING PROPERTIES OF THE MATERIAL

In order to use a medium for the expression of thoughts and feelings it is necessary to have some experience with it and some concept of its characteristics. Therefore, as a general rule, opportunity should be provided for exploration of all new materials and processes when they are first introduced. For example, the teacher should provide time for elementary school children to experiment with cutting and printing in linoleum before a finished print is planned. However, such "exploration-of-the-material" lessons need to be structured to focus clearly on the most significant properties of materials while at the same time encouraging wide-ranging experimentation. Burton and Smith offer such a lesson for kindergarten and first grade:

PAPIER MACHÉ: COMBINING FLAT AND TEXTURED SHAPES

Purpose of Lesson:

The purpose of this lesson is to help children focus on basic aspects of the material, its plasticity and textural properties. It is also designed to develop the children's sense of competence with materials by enabling them to discover a variety of transformations of the material.

Materials and Mechanics:

For each child, a small pile of newsprint (pages from a telephone directory are excellent); a flat piece of cardboard, approximately 12″ × 12″; a small bowl of wheat paste of creamy consistency; one large stiff paste brush.

Possibilities for Discussion between Children and Teacher:

- You have some newspaper and a piece of cardboard.
- How are they the same? How are they different?
- Yes, you can fold your newspaper much more easily than the cardboard. What else can you do with the newspaper?

- What sort of shapes can you make that way? (crumpled, little, big, rolled, small balls, envelopes, etc.)
- If you cover all your paper with paste before you make your shape, will that make it stay just the way you want it?
- What else can you do with the paste? (join shapes)
- How can you make the cardboard look different?
- If you paste your paper shapes onto the cardboard, will you put them all on one part of the cardboard?
- Will some of them be near together? Will some be far apart?
- Will you leave some of the flat parts of your cardboard as part of your design?
- Will you make some shapes stand up high?
- Will you put some on top of others?
- Where will you begin?

What the Children Will Make:

1. Cardboards covered with crumpled paper, pasted and spread out, or placed one piece on top of another for several layers.

2. Boards with crumpled balls, and other small shapes arranged as a design.

3. Carefully organized shapes, folded, rolled, crumpled, placed next to each other or on top of each other making a design or a story.[6]

While the products of this lesson vary greatly, the discussion is tightly focused on specific and characteristic properties of papier maché. It is designed to give young children the support they need to explore a new medium with concentration and to help them attend to their sensory experiences while so doing. Future lessons may carry these learnings into both designs and sculptural imagery.

EXPLORING EXPRESSIVE PROPERTIES OF MATERIALS AND EXPERIENCES

Human perception finds expressive qualities in almost any object or event. These qualities are conveyed by properties such as movement, weight, or balance, and changes in dynamics such as level, pitch, or rhythm, and they almost always convey emotion. In the arts expressive properties are also the foundation of compositional organization as one element is balanced against another to achieve unity. Young children are naturally responsive to expressive properties, but the capacity for response is sometimes buried as children

grow. Because of their important role in the creation of formal unity and meaningful content, expressive properties should be emphasized in curricula throughout elementary and secondary arts education.

A number of pedagogical strategies may be used to cultivate children's awareness of expressive properties. Two types of lessons will be discussed here: (1) those focusing creative activities on expressive properties, and (2) those focusing critical activities on expressive properties.

Often an introductory creative lesson on "exploration-of-the-material" touches on several types of properties. The movement lesson discussed earlier begins with the teacher saying:

> *Let's try rocking. There are so many different ways to rock. Maybe we can find some of them.* She does *not* say, *Who thinks he has an idea how to do it?* before the children have even had a chance to experience the exploration. The intellectual "knowing" grows out of the "doing." All the children work at once toward discovering their personal solution. The teacher at some point might report in a general way: *Some people are rocking on their knees and some lying down on their backs or tummies. Some people are rocking side to side and some are moving back and forth.* She might add, *Let's try some of these together as a change-off from your own. Then do your own again . . . see if you can move smoothly from your own way to another way to rock. That's really hard to do.*
> Contrast can be introduced through the use of dramatic imagery, such as *Rock as if a soft little breeze is swaying you (as a boat or cradle).* Or, *Rock as if a stormy wind is tossing you.*[7]

This lesson begins as the children experiment with physical properties and continues as the teacher suggests other emotionally significant experiences of rocking. Thus, opportunity is provided for direct exploration of the physical sensation of rocking and then for recall of expressive associations to it. Each strategy increases the significance of the activity for the child.

Consider now an example of a creative lesson on expressive properties with a child of middle school-age. Angiola Churchill describes a sequence of lessons with a boy, Robin, who consistently painted nonobjectively. He usually began a studio session independently; when finished, he sometimes wanted to discuss his work.

> Certain questions dominated the discussion. What is happening in this new one? What is its relation to previous

designs? ... Robin likes the mixed colors he had used in this one, and he felt that the repetition of triangular shapes was interesting. There was some motion in the wavy lines, fast in the diagonals and slow in the large circular form. But what he found new and exciting was the figure outlined in white, and next to that the purple outlining the yellow, because they merged and gave a sense of space.

Both he and the teacher hit upon the idea that in his next painting he should perhaps try to create parts or sections with more contrasting values, and since he liked the wavy sensation, to emphasize it.[8]

Their discussion analyzes the formal and expressive properties of composition and of movement in the painting. The teacher helps Robin isolate these properties and become aware of what creates them.

The older child has greater objectivity and greater capacity for conceptualization, so he can plan ahead on the basis of analysis. Thus, the teacher helps Robin identify what he has done, determine the particular qualities he prefers in the painting and plan for the next one. She uncovers his feelings and ideas about his work and then reinforces them. She selects from her knowledge that which makes a good but challenging fit with his.

The information and observations the teacher offers at such a time must fit closely with the child's thought and yet stretch it. In order to do so the teacher must have a deep sense of the individual child's intentions. The teacher's personal interests and tastes must be put aside in an effort to see those the child is bringing to the task. In this instance both the teacher and Robin are interested in developing his capacity to use expressive properties.

The observation of expressive properties is an equally valuable exercise to practice in critical activities. Mary Townley offers a subtle example of such a lesson for elementary school children. The children are shown two sea pictures, *Yacht Approaching the Coast* by J. M. W. Turner and *Moonlight Marine* by Albert P. Ryder. The teacher asks a question first about the subject matter to provide a basis upon which to continue. She asks what things both paintings have in common, expecting the answers, "sky, water, boats." The questions continue:

- These paintings show how the sky looks to two different artists who have not only looked at the sky, but have thought about it, and have put into their paintings their feelings about the sky, water, and boats.

- What kind of feeling does picture 1 give you? What kind of feeling does picture 2 give you?

- The paintings have the same things in them, but do they give you the same feeling?[9]

Thus, the point is made that feeling can derive from something other than subject matter. The teacher continues the lesson by playing about two minutes of the beginning of Richard Wagner's "Ride of the Valkyries" and Claude Debussy's *Nuages* or *La Mer,* asking the children to decide which painting goes best with which musical composition. The questions then continue:

- What is there about the music and the painting that makes them go together?
- Which music sounds *loud* and which sounds *soft?*
- Which painting has a loud quality and which has a soft quality?
- Look at the edges of the water in the paintings. Which painting has blurred edges? Which seems sharp or clear?[10]

The questions continue with the contrasting pairs: big shapes/small shapes, swooping/rippling, bold/gentle, and light/dark. The purpose of the questions is to establish that each medium has expressive properties that prompt similar feelings.

RELATING THEORY AND SENSORY EXPERIENCE

If a lesson is grounded in sensory experience, it is more likely to be meaningful. However, the teacher must also make clear the general theoretical basis of that experience. The child will then be able to transfer the experience, to expand, develop, and relate it to other experiences.

For example, teaching the recognition of shapes (circle, square, rectangle, and triangle) is a common practice in preschool and kindergarten. Understanding that shape differences may be logically organized is generally useful. Often, however, it is taught as a reading readiness skill and becomes a rote activity in which no general principle is apparent. By contrast, note in Gerhardt's example how the teacher leads the children to deduce the general principles of shape discrimination.

Discussion: Sitting Along the Sides of a Six-foot Square

Teacher: What is different about juice today? (The children usually sit in a circle.)

Jenny:	Today it's a square. Before we had a circle.
Teacher:	What are the differences?
Matthew:	A square has sides and a circle doesn't have any sides.
Peter:	A square has straight sides and a circle has bendy sides.
Erica:	Circles don't have any points but squares do have points.
Hal:	It has points just like the cots do.
Steven:	A square has lines but a circle doesn't have lines.
Erica:	A square has straight lines but a circle has lines that are all bended.
Teacher:	(to Matthew) Would you agree to that?
Matthew:	No! A circle has bended lines.
Teacher:	Supposing we made a triangle on the floor to have juice on. Would there be any differences then?
Geoffrey:	It would have just three corners.
Peter:	It has a point at the top.
Erica:	If you had lots of different triangles you would have a lot of private places for everyone.
Matthew:	A triangle has three sides.
Teacher:	Is that different from a square?
Matthew:	Yes, because a square has four sides.
Hal:	A triangle doesn't have a side on top.
Geoffrey:	A square is like this *(draws a square with his finger)* and a triangle is like this *(draws a triangle with his finger)*.
Teacher:	Everyone do what Geoffrey did. A square is like this *(children make motions)* and a triangle is like this *(more motions)*. . . .
Steven:	A triangle has three points and a square has only four.
Teacher:	There are lots of differences aren't there? So maybe we should make a triangle some day and sit on it.[11]

Juice time, a familiar occurrence, takes place in a slightly discrepant form. Thus, direct experience prompts the discussion. The

children make associations from concepts to real experiences; both squares and cots have "points." The principle is taught by centering the discussion on the relation of sides and angles in the different shapes. The teacher uses the easier concepts of circle and square to launch into exploration of triangles. Her final remark, "Maybe we should make a triangle some day and sit on it," helps to make the children aware of their sensory-motor experience of the shapes.

In the comparisons of sides and angles, the general principle is explored. Thus, the logical basis of the learning is presented together with its sensory-motor foundation. Learning concepts both directly and theoretically allows children to feel and to master them. It allows children to use them freely according to their own purposes and in many contexts. The pedagogical strategy of teaching from a basic sensory property to a general theoretical principle is very broadly applicable.

RESPONDING

Formulating appropriate responses as the children work is an important pedagogical strategy. Some responses are designed to help the child identify his thoughts and feelings and thus to gain a greater sense of the meaning in his work. Others help him to recognize his accomplishment and thus to gain a greater sense of his own mastery. The following responses were included in the papier maché lesson presented above:

- You have made lots of shapes. Let's choose some and feel the tops of them. Are they all different? Do they look the way they feel?

- You began with some flat pieces of paper. What different ways did you find to make them into shapes?

- You crumpled shapes one on top of the other. What happened to the ones underneath? How did you make these stand up?

- You pasted all your long shapes at the top of your board, all the little flat ones at the bottom. How are you going to arrange the rest of your shapes?

- Now that it has dried, is your papier maché strong? What was it like when it was wet?

- It was heavy when it was wet. Now that it is dry, is it still heavy? Does the big shape still seem heavy? And the little one?[12]

These questions call attention to physical and formal properties of the sculptures the children have made, thus helping them to

become more aware of their sensations and ideas about the material.

Pamela Sharp draws a parallel between responses in art lessons and extensions in language development. "Extension" is a term used by Roger Broan, Courtney Cazden, and others who study language development for the type of adult response to a child's statement which builds on and amplifies some aspect of meaning in the child's statement. Such extensions are pedagogically valuable because they stimulate more language. Also, they are apt to increase learning because, following directly on the child's statement, they are paired with meanings the child understands. Consequently, Sharp proposes to use this concept of linguistic extensions in the aesthetic realm.

> A concept of aesthetic extension naturally follows. Suppose that teachers of young children responded to children's art, not with statements of praise for having worked hard, or directions for naming or storage, but with aesthetic extensions, statements of feeling generated by the work at hand. Suppose the extensions were offered just as the child finished his work while attention lingered. And, following good practice in language, suppose the extensions were clear, tied to concrete phenomena, appropriate to developmental levels, and presented smoothly, in a natural, flowing manner. It's reasonable to assume that such statements could offer children 1) models of adult talk about the feeling found in art, 2) verbal stimulation, vocabulary, and forms of response, and 3) expanded concepts of what may be seen and felt in works of art.[13]

Appropriate responses have these effects on both elementary and secondary school students. More generally, responses designed to stimulate children's awareness of their own working processes help them to expand their abilities in the arts and thus to become more proficient in the process of creating meaning.

A number of pedagogical practices have been discussed: (1) focusing lessons on meaningful experiences; (2) structuring lessons on the properties of media; (3) focusing lessons on the expressive qualities in both medium and subject; (4) relating sensory experiences to fundamental principles; and (5) validating and extending children's thoughts and feelings through skillful responses to their work. These strategies help children learn to search for the properties of a medium that may be used to convey and embody meaning. They are asked to consider what experiences are significant to them and how and why. They are taught to look for expressive characteristics and

to use them to create meaningful work. They are taught to generalize from immediate sensory experiences to a fundamental principle so that they can see one meaning in relation to another. And, the expressions of meaning the children create are validated and extended, thus supporting their personal creativity and thought. These practices teach children to search for conceptual and emotional significance and to develop their abilities to express and portray them.

With appropriate developmental modification, each of these objectives and strategies may be used across the full range of school grades from kindergarten through high school. Such modifications should take affective as well as cognitive development into account since the psychosocial significance of experience and skills and abilities change with development.

The pedagogical practices to be discussed in the next section are more specifically related to stages of development. To consider them it is convenient to begin with children at about two years of age, in Wolf and Gardner's second stage. This is not to dismiss the importance of a supportive and responsive environment for the infant as the foundations of understanding and communication are prepared, but rather to begin the account when artistic activities become possible.

STAGE II: ACQUIRING AWARENESS OF SYMBOLS: PERSONAL AND SOCIAL FORMS

The young child needs several years of development to learn to make organized forms in a given medium, and to make symbols he must organize forms. First the child must discover the basic properties of the medium, then concepts of organizing those properties, and finally means of using them for representation. Children need sufficient time during the preschool-kindergarten years to carry out the natural course of this development. For example, the process of mastering the basic properties of two-dimensional visual media begins at about one and one-half and shows steady development into the fifth year, by which time the child has begun to symbolize.

In the beginning the child simply wishes to move with the material and uses reflexlike rhythmic motions. The material responds accordingly. In the case of a crayon, a very limited set of zigzag, circular loops, or dots are produced, all the result of repeated motions of the arm. However, these markings present certain properties to the child's eye and mind, and over time she strives to iso-

late the properties she has made by accident, for example straight and curved lines. She then practices and masters them. The capacity to make straight and curved lines leads to making configurations such as parallel-vertical lines and circles within circles. And so one learning leads to the next, in self-motivated exploration, until symbolization is possible.[14]

This course of developing concepts of the material follows a general pattern observed by Piaget. The pattern begins with discovery; is followed by deliberate repetition in an attempt to master the new discovery; and finally results in coordination of new graphic concepts with others resulting in more elaborate configurations. The latter is exemplified in children's art by the coordination of concepts of line and space in the highly organized, complex designs of the five-year-old.

It is important that the teacher provide appropriate opportunities for such self-directed learning to take place. In the visual arts this means supplying materials whose physical characteristics make them easy for young children to manipulate and whose sensory properties are strongly distinguishable. They should be used frequently by the children to allow for development of skill and extension of concepts. They should be provided in such a way as to make experimentation and concentration possible.

Appropriate times, spaces, materials, and activities provoke the young child to explore, put her in a position to concentrate, and help her to reflect on what she has done. A jumble of materials is confusing, not provocative. Dirty paints lose their visual stimulation and do not allow the child to arrive at correct conclusions about color mixing. An art area too far away is overlooked; one too much in the mainstream becomes a roadblock, not a workshop. The same principles hold for facilitating drama in the house corner or among the blocks, for involvement in movement arts, music, and reading aloud.[15]

Responses to the child's work as he is working or finishing are particularly effective in the early years since didactic teaching is much less possible with young children. Responses should call attention to the properties of the material (big lines and little lines) and to their organization (big lines above and little ones below).

With the development of symbolization, it is particularly important to try to understand the child's thought. In visual media the transition to symbolization begins as the children offer names for their nonrepresentational configurations. They have no intention to represent. They draw and then associate a meaning to the finished drawing.[16] In time they come to reverse this process, drawing a con-

figuration to fit an intended subject. However, the relation between drawing and subject is still very personal and arbitrary, making it difficult for adults to understand and respond. The teacher should try to elicit some verbal clues from the child to determine what representation is intended.

As the child's thought becomes more complex and more socialized, his drawings are easier for adults to understand. His drawings will retain his personal thoughts and feelings to a greater or lesser degree, depending on the encouragement and acceptance he has received for his earlier inventions. Thus, for the child's work to make the transition into more recognizable forms but still preserve "spontaneity, originality, (and) individuality," as Wolf and Gardner suggest, it is important for adults to try to understand and accept the early idiosyncratic formulations of the child.

Of course, the constraints on the child's own invented forms are greater in a mode of representation that has socially defined limits, for example when the child learns the conventions of reading and writing. The teacher should try to help the child retain his expressive use of language while at the same time teaching him skills. One means of accomplishing this is by making gradual transitions, as illustrated below.

SOCIALIZED FORMS OF SYMBOLIZATION

The act of forming symbols is very complex and has a number of components, particularly in a complex symbol system like reading and writing. The child often comes to particular components separately and masters them individually. To the degree that this separation enables her ultimately to express her own inner thoughts and feelings in socialized forms, it is beneficial. As the child is overcoming hurdles in the acquisition of a complex symbol system the teacher can often allow developmentally natural transitions to take place. Thus the child's own strengths can be cultivated and her idiosyncratic forms respected while at the same time socially approved forms are being introduced.

One such experiment was conducted by Kathleen Gerritz, a first-grade teacher in a suburban school. For one year she carried out a writing program in which children were expected to write as much as possible on their own. She describes it as follows:

When the child asked an adult for the spelling of a word, he was instructed to try it for himself; if he continued to ask, he

would in turn be asked, "How do you think it starts?" Once this question was answered by the child, for himself, he would go on and finish the word as he thought it should be spelled. When the children asked if they had spelled a word correctly, adults in the classroom would answer honestly, but not volunteer a correct spelling. The children were satisfied with this arrangement, and pleased to say, "I wrote this myself." Part of a typical language arts class might include a group writing lesson, incorporating handwriting, some punctuation and creative writing. The teacher would provide the beginning for a story, either on the blackboard for the children to copy or on a dittoed handout. After a short discussion of the formation of letters or the necessity for capital letters, the children would finish the story. During the first months of the year, some children would dictate their stories to a teacher or student teacher.[17]

The end of the day included a time for writing in their journals, one of the classroom requirements.

Readers familiar with the "language experience"[18] approach to teaching reading will recognize many features of that program in this description. The basic theory behind the language experience approach to reading is to make the transition as natural as possible from the child's own spoken language to encoding it in written form, and to base the child's concept of reading on his already developed language ability.

In the case of Gerritz's students, this approach produced very active and involved writers and readers. The children learned conventional spelling with no discernable disadvantage in the second and third grades. In the first grade, writing extensively and personally without having to master the illogic of English spelling enabled them to invest their new mode of symbolization with the meaning inherent in their speech. As a result, several significant features may be noted in the children's writing.

The first of these features is the sense they have of being in communication with their teacher. These children have not lost their sense of language as communication in the effort to write. The second feature is the degree to which they write about matters of importance to them. They are not writing rehashes of storylike phrases picked out from readers, but rather use language to examine real life: writing about work roles, the forces of nature, social difficulties, and the struggle to differentiate fantasy and reality.

The following children's stories, reproduced here in their original orthography paralleled by a "translation," are offered as examples.

I LIK CHOKLET CAK THE
BAST BCAZ I LOVE THE
FAVER DO YOU? I NOW I
DONDT LIK IT WEN ITS
TIM TO GO HOME

DO YOU LIK IT WEN ITS
TIM TO GOW? I DONT I
HOPE I CAN HAVE A
SIEPOVER POTE DO YOU?

I like chocolate cake the best
because I love the flavor do
you? I know I don't like it
when it's time to go home

do you like it when it's time
to go? I don't I hope I can
have a sleep-over party do
you?

Michael[19]

TENOLJRS THA GO TO
SKOL A HOWSOIF SHE
ORKS IN THE HOWS A
MOTL SHE MOTLS KLOS
TV STARS THA ORK ON
TV A TLAFON OPRATR
SHE KNEKS PEPLE OITH
ETHER PEPL

teenagers they go to school a
housewife she works in the
house a model she models
clothes TV stars they work
on TV a telephone operator
she connects people with
other people

Jack[20]

TO DEY I DID NOT HAV
SACH A GOOD DEY I THIK
I SHOOD NOT TO TO MIS
GOD SDYN RUM NEKST
WEEK KUZ I AM SHAEE

Today I did not have such a
good day I think I should not
go to Miss Goldstein's room
next week cause I am shy

Emily[21]

HOW I HYR THE SUN THE
SUN IS SO BRIT THAT I
SWET I ASK MY MOTHER
HOW I CAN HYR THE SUN

How I hear the sun The sun
is so bright that I sweat I ask
my mother how I can hear
the sun

I LISIN TO HER TOKE SHE
SES WEL JAN THIS IS
HOW IT IS WELL WEN
YOU LYN AGENST THE
WIND THE SUN IS SO HO
YOU CAN YVIN AMAJIN
IT TOLK THE END

I listen to her talk She says
Well Jan this is how it is
Well when you lean against
the wind the sun is so hot you
can even imagine it talks The
End

Diana[22]

STAGE III. ACQUIRING AWARENESS OF TECHNIQUES AND PROCESSES: SKILLS AS TOOLS FOR EXPRESSION

The child is developmentally ready to learn techniques and pro-
cesses consciously during the elementary school years (ages six to
twelve). His range of experience and understanding expands dra-
matically. He begins this period tied closely to home and family and

ends it identified with his age-mates, almost ready to set out on his own. He amasses a vast store of knowledge about the world, which he thinks about in a more and more logical fashion. He develops the capacity for self-awareness and in the arts he wants to know "how" as well as "what." As Wolf and Gardner have stated, one of the most important challenges for teachers of the arts in the elementary school is to provide technical information appropriate to the child's developmental needs without an accompanying loss of creativity and expressiveness.

SEQUENCING LESSONS AS A STRATEGY
In order that techniques and processes do not become an end in themselves, and thus cause loss of significance in the child's work, it is important to teach their use as tools for expression. To achieve this end they should be taught in sequences that lead to and necessitate their use for expressive purposes. Thus, meaning can be retained as the focus and mere facility avoided.

One such sequence has been designed in the project, *Books From My Head,* carried out at the Neighborhood Art Center, Boston Center for Arts, directed by Sidney Brien. In the project fourth-grade students in an inner-city school and in a suburban school are paired for the school year. The children are bused to the Center for a half-day a week and, for another half-day, the staff from the Center works with the children in their own schools. Activities include theater, movement, language exercises, games, performances, storytelling, writing, drawing, collage, printing, and calligraphy. By the end of the program, each child produces an original handmade book he has written, illustrated, and bound by himself.

Brien states the first goal of the program is to provide "an attitude, atmosphere and activities to strengthen the individual ego."[23] Some of the means used to accomplish this are:

1. The content of the program is based on personal experience.

2. Personal choice-making is structured into every step of the process.

3. A variety of representational modes is offered at every step of the process from which children may choose to give emphasis.[24]

This interdisciplinary strategy is implemented by a specific schedule for the flow and sequence of activities. Work on story writing begins with the dramatization of a story read aloud. The story elements "beginning, getting excited, most excited, and end" are iden-

tified as the story is read. An experience of group story-building in drama using these four elements follows a bit later. Finally, a comic strip comprised of four squares, one square for each element in the story line, is made. One session is spent in "making the exciting part exciting." Exercises in writing include sentence expansion to create richer and more communicative language. Then there are stories about the self. One such story reads:

> I'm in the middle of my family. Sort of, I feel lonely because I'm in the middle between two girls. I always get bugged by them. I always have fights with them. It's hard being in the middle. I get a funny feeling when I am surrounded by girls.[25]

Graphic skills are the focus of other lessons: calligraphy, illustration, and the technical aspects of bookmaking. Finally, all the learnings are woven together in a carefully planned and executed book. The sequence itself teaches children that skills are part of an overall artistic process.

The transfer of meaning from one medium to the next, according to the immediate task at hand and to the personal preferences of the children, is beneficial as well. Direct evidence of the benefits of this approach is offered by the children's experience of success. One of the instructors writes:

> The unique way the program unfolds and uses the three arts enables children to experience success at their own level and success in one area of expression carries over motivating effort and success in other areas. For example: R, a learning disabilities child, was the star in a theatre performance and became very enthusiastic and confident about her abilities in that area. Simultaneously her interest in putting a good effort into writing increased and soon she was writing at home, bringing in her stories and poems. Such examples which occur many times throughout the program clearly document the direct reinforcement of the affective learning objectives.[26]

Some of the children's books are strongly visual with lovely illustrations carrying much of the significance, such as one girl's story about a seagull.

In other stories illustrations are secondary to plot line. In this story the writer expresses his desire for power, speed, and control, within the context of a race. Fantasy is tempered by limitations of time, space, and auto mechanics.

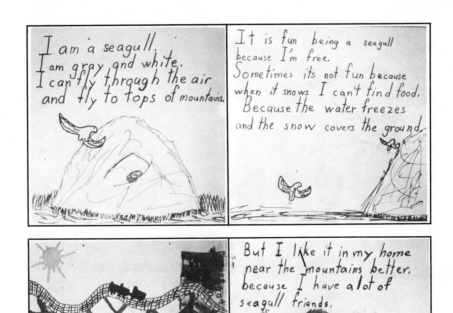

"The Seagull"
Neighborhood Arts Center, Boston-Center for the Arts, Massachusetts. *(Courtesy of Nancy R. Smith)*

THE DAY I WON'T FORGET
Young Racer Breaks World Record

YOUNG RACER BREAKS WORLD RECORD—that was the headline last month when I won the Junior Race. You see it all started when I always wanted to get a racing car.

This year there was a once in a lifetime Junior Race five days after my birthday. My birthday came, and I got a racing car.

The first thing I did was set it up and test it. It worked well. I painted it red flashy with silver lightning marks and the rest blue. I got a blue helmet. I greased and oiled it every day.

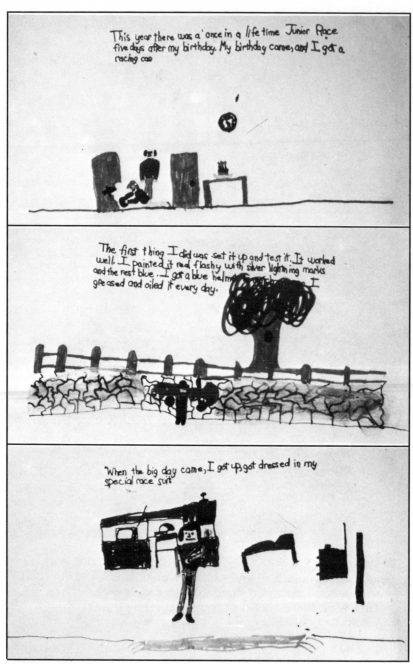

"The Day I Won't Forget"
Neighborhood Arts Center, Boston-Center for the Arts, Massachusetts. *(Courtesy of Nancy R. Smith)*

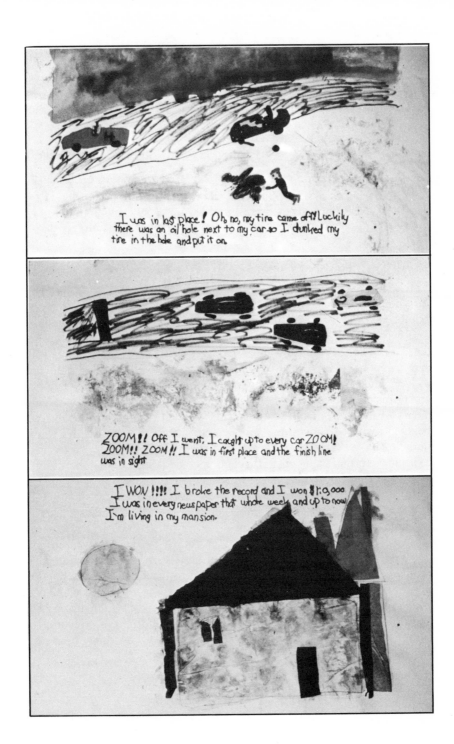

When the big day came, I got up, got dressed in my special race suit.

Then when I got to the race track, I realized a tire was loose. I got a tire and tools, but it was too late. The man put the flag down so I threw my tools and tire in my silver and blue car and jumped in. The race was on!

I was in the last place! Oh no, my tire came off! Luckily there was an oil hole next to my car so I dunked my tire in the hole and put it on.

ZOOM!! Off I went. I caught up to every car ZOOM! ZOOM!! ZOOM!! I was in first place and the finish line was in sight.

I WON!!!! I broke the record and I won $7,900. I was in every newspaper that whole week and up to now I'm living in my mansion.[27]

PERSONAL DISCOVERY OF FORMAL ELEMENTS AS A STRATEGY

Another strategy particularly suitable during the elementary school years is that of guiding children to make their own individual discoveries of formal compositional elements in the arts. Elements discovered in this way are more likely to have personal significance, and so to become part of the child's active working repertoire for making and responding to meaning in form. The child's discoveries are primarily based on his subjective and intuitive responses to elements of form. Personal identification of such elements helps him to become aware of, distance, and objectify them without at the same time losing a subjective "feel" for their inherent expressiveness. Learning formal elements through personal discovery makes it more possible for the child to bridge subjective and objective in the creation of and response to forms. A curriculum in music written and implemented by Jean Bamberger and Dan Watt offers a subtle example of this strategy in action. The curriculum consists of eleven lessons for a small group of third or fourth graders. A pattern of listening, composing, performing, and assessing is carried out. The sequence begins as the children are asked to listen for the "changes" in a seventeenth century composition. The formal elements (changes) they hear and identify for themselves are then discussed and noted down in pictures and words. The children are encouraged to find their own means of describing and recording their discoveries. Bamberger and Watt write:

At this early point in the children's learning . . . it is most important for the children to realize that there are many ways to describe changes which occur even in this simple example.

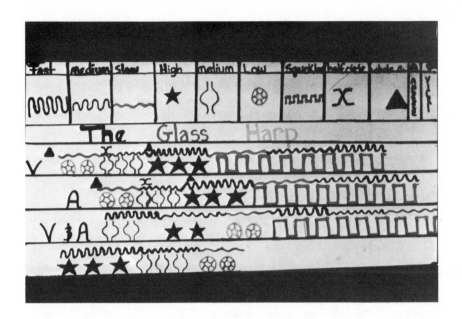

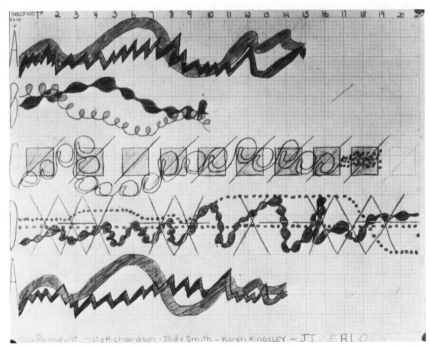

Student-created scores for their own musical compositions. Bedford Jr. High, West-port, Connecticut. (*Courtesy of Joyce Bogusky-Reimer*)

They should be encouraged to use whatever means they have for "pointing" to what they can find in the music, itself. Our group of children spontaneously found words and pictures which captured quite a wealth of possible features to account for their experience and each of them might lead to further explorations. But for the moment, an *accurate* description is not the point. The focus should be on just what *could* be a description. How can we get out on the table, so-to-speak, some expression of what we are *doing* and how and what it is that we immediately "know" when we hear and respond to change. Airing possibilities is quite sufficient to the immediate purpose for it leaves no doubt that the piece has "parts" and we can all eventually agree to what they are.[28]

The children then derive a structure for a composition of their own from the elements they discovered in the seventeenth century model. Some features of the model may be unnoticed or ignored and other features may be added as the group works out a composition with rhythm instruments. In one group an ending was added; though quite different from earlier portions of the piece, it arose quite naturally from the children's working process:

What this ending should *be* was not immediately clear to the children, and in fact, the actual ending was not invented until a later class, although the idea of a different ending was included in the original plan. Finally, the modifications that occurred in the process of actually working out the details, reflects the kind of process that composers often experience. The particular musical materials (motifs, rhythms, sounds) create particular demands as a result of their immediate context—just what comes before and after any moment in the flow of the piece. Thus, the ending the children made up was necessitated by the cumulating progression; there needed to be still more.[29]

The children were helped to take what they wanted from the model piece, use it in their own way, and add what seemed important to them. Personal discovery of formal elements in this way ensures the children's understanding of their significance and their successful use in bridging thought and feeling.

AWARENESS OF A PERSONAL WORKING PROCESS
Awareness of one's own preferences and procedures, as distinct from those of others, also helps the child to retain his sense of personal identification with his work. Working in the arts involves making

choices, determining goals, and planning how to achieve them. Using the child's new found capacity for self-awareness the teacher can help him to become aware of each step in the process and to make conscious choices at each step. Such awareness will make it easier for him to have confidence in his personal preferences. It will also enable him to evaluate and use new techniques and ideas in relation to them. The more children become aware of how they think and work the greater personal control they will have over their activities and decisions. As Vygotsky has pointed out, "control of a function is the counterpart of one's consciousness of it."[30] Such self-awareness helps the child to establish a sense of his own forms and their validity; at the same time it gives him more flexibility and control with all forms.

The teacher responses discussed earlier are a very effective method for helping children develop self-awareness. However, more structured activities may be used with older children. In a curriculum designed to improve the reading and writing of a group of sixth-graders, the teaching group centered their curriculum on a science core of *Structure and Function in Animals*.[31] Language, art, and drama were integrated around this core with math, social studies, and science. Direct experiences included trips, animals in the classroom and scientific experimentation. There were two major synthesizing projects: each child constructed a three-dimensional animal and wrote a book. The animals were constructed of boxes and other scrap materials, with the stipulation that each part of the animal had to have a specific function, either realistic or imaginary. The books included accounts of trips, factual information, and imaginative stories. In each book one chapter documented the child's working process while making the animal. One boy's interest and involvement in making his animal comes through as vividly as his writing difficulties.

How I Made My Creacher

Well I was going to make an incect at first, but the didnt work out so I decided to make a bird. First I picked up a tiny tube and put it into four pieces four the four legs then some stirofoam cut into feet then a fatter tube for the stomache. A cork for the head and a nother tube for the neck. Then I fastened them together with tape and when I paper mached it it became stiffer and stronger. When I painted my creacture I decided to make it black and white to camoflash it with the stars at night.[32]

One can hear his awareness of the limitations of materials, and of his own decision-making processes. His remark, "I decided to make

it black and white to camoflash it with the stars at night," is particularly revealing of his thought process. One benefit of helping the children to become aware of their own working processes was indicated by the greatly increased motivation and productivity of the children in this program.

STAGE IV. STYLE: CONVENTIONS AS EXPRESSIVE CHOICES

The preceding section discussed helping children aged six to twelve to coordinate developing skills with personal expressiveness by: (1) teaching skills in sequences that lead to personal creative use; (2) helping children discover and use formal elements; and (3) helping children to develop an awareness of their own personal working process. With the advent of adolescence these strategies must be applied to a new range of thoughts and feelings.

Adolescence brings with it radical emotional and intellectual changes. Among these is the ability to consider concepts in relation to each other, as Wolf and Gardner point out in the previous chapter. The child is also experiencing social and emotional changes which prompt greater differentiation of emotions. He can now conceptualize and evaluate feelings and, reciprocally, he can consider the emotional implications of social values. He can understand and debate the meaning of concepts such as *loyalty* and *justice* or of artistic concepts such as *expression* or *style*. In the adolescent's considerations of style, the conflict between craft and expressivity, first encountered during the elementary school years, reaches full intensity.

The word *style* is used here to refer to any recognizable set of compositional conventions. Some styles are historical (the Baroque), some national (French impressionism), and some are based on a particular technique (classical ballet). There are also, of course, personal and individual styles in the arts. A particular style is usually defined by specifying its limited set of characteristic elements, techniques, subjects, compositional devices, and meanings. In a personal style these may simply be a matter of individual preference. In other styles, however, the conventions are shared by a large group of people and are deeply tied to the values of the culture in which they evolved. Such styles express important values and significant concepts of that culture.

Each adult artist must develop her own personal style in relation to the style of the period in which she exists as well as in relation to the styles of the past. Just as the adolescent must establish her

adult individuality in relation to the society in which she lives, so too must she develop her personal artistic style in relation to contemporary and past art styles. In this she is at a disadvantage because her capacity for understanding the meaning of styles is newfound and often remains untrained.

True, the elementary school child is a natural observer of the obvious conventions of popular culture. In his desire to learn how the world works and to master adult modes of behavior he acquires the forms of simple conventions such as popular music, dancing, and comic strips at will. What he chooses to absorb seems to depend chiefly on the ease with which the conventions can be learned and whether the content is emotionally satisfying. However, the elementary school child has a limited ability to understand and use a style with conscious awareness of its meaning.

The adolescent, on the other hand, is developing the capacity for such awareness and should be taught the forms and variations of stylistic conventions in order that she may make personal, expressive use of them. Theoretically there is no limit to the conventions she may be taught except that, once again, they must be taught as a means of expression. This proviso requires that the subject matter be of importance to the student and that sufficient time be allowed to enable her to develop the expressive use of new skills. Since both considerations create practical limitations on what it is possible to teach, it seems reasonable that only conventions of fundamental importance and capable of a high degree of meaning and significance be included.

The techniques used for teaching skills in the elementary school may also be used for teaching an understanding of style at the high school level: (1) teaching conventions in sequences that lead to personal creative use; (2) helping students to make personal discoveries of stylistic differences and conventions; and (3) helping the student to become aware of her own style in relation to those of others. These strategies help to keep the bridge between subjective and objective in art forms in the forefront of the curriculum, avoiding meaningless use of stylistic conventions and virtuosity for its own sake.

SEQUENCES LEADING TO CREATIVE USE OF STYLISTIC CONVENTIONS

In Western graphic art, the forms of objects are often modeled through the use of lighter and darker shades of the drawing material to give the illusion of light falling over three-dimensional objects in space. This convention is frequently used in representational and illusionistic styles; it is a very fundamental convention

and one adolescents often wish to master; and it thus provides a convenient example.

Adolescents often have difficulty making convincing representational drawings because they do not understand the concepts involved in modeling forms. The artist must understand objects as solids in space and be able to see their forms accordingly, as well as master the application of lighter and darker marks on the paper. The student is inclined to focus on the application of marks, not on seeing the solidity of forms in space. The teacher needs to take this factor into account when designing the curriculum.

A lovely book written directly to adolescents by Moy Keightly contains exercises for children and many fine examples of their work. In a sequence devoted to form, Keightly suggests drawing familiar objects, first attending to the play of lights and darks over them while looking for their most basic shapes. Then she offers lessons designed to give the student fresh perspectives on seeing forms in space. One of the lessons reads:

> Use a piece of typewriting paper and crush it gently in your hand. Make some pen and ink drawings. Imagine the up and down journey that a tiny insect would make in walking over the surfaces.[33]

The shift to crumpled paper is a means of seeing planes in space uninfluenced by associations to an object; the imaginary insect focuses the student's attention on the direction and movement of the planes. Through its charm the lesson helps the student to assume a more personal and yet more objective relationship with the convention of modeling forms in space.

PERSONAL DISCOVERY OF STYLISTIC SIMILARITIES AND DIFFERENCES

The teacher should teach the comparative characteristics of various styles to adolescents. Such knowledge will both broaden the artistic understanding of the students and help them identify their own personal tastes. Once again, the strategy of ensuring that the characteristics of styles be discovered personally ensures that they will have significance and importance to the students.

Jean McCawley, teaching music history in a suburban high school, begins this process with an ingenious game.[34] Similar short movements from a Classical and Romantic composition, such as Haydn's G Major Trio and the *Trout* Quintet by Schubert, are selected in advance by the teacher. They are chosen for their easily

discernable similarities and differences, particularly instrumentation, tempo, and harmony. At the beginning of the class several students are chosen to leave the room. One of the "mystery" compositions is played while the remaining students suggest identifying characteristics to be listed on the blackboard. No help is offered by the teacher as specifics of tempo, mood, texture, instrumentation, and so forth are mentioned. The students often make associations to real experiences, such as "a walk in the woods." Those absent are then invited to return and asked to guess from the list of words which of the two compositions was originally played. Ultimately, the whole group is asked to consider which words were most helpful and which least.

The first attempt at such an exercise is generally rather awkward as the students struggle to sharpen their perception of basic musical characteristics. When carried out over four or five different comparisons, they become quite skillful and ready for new types of comparison. Ultimately, the students identify the fundamental and unique characteristics of each style. As in the elementary school examples, they begin with identification of elements; but in the end the adolescents come to understand the elements as a particular set in relation to each other, comprising a style with particular formal and expressive qualities.

BECOMING AWARE OF PERSONAL STYLE IN RELATION TO THOSE OF OTHERS

Just as a sense of his own working process helped the elementary school child to achieve control and confidence, so too will a sense of his own emerging personal style help the adolescent. Developmentally he has begun to establish a sense of his own identity and relation to society as a whole; in that context, his sense of his own artistic style must be clarified in relation to the styles of others. Students are thus helped to develop critical skills and to articulate "personal tastes and standards without (experiencing) paralyzing feelings of inadequacy," as Wolf and Gardner suggested.

A number of the objectives and strategies discussed in this chapter have been implemented in an arts enriched program in an urban Boston high school. The importance of the creation of meaning and of helping students become autonomous are recognized and stated in the goals of this program:

a. Carefully designed motivational challenges should assist students in structuring their thoughts, feelings, and ideas in such a way as to give their experiences personal, social, and cultural validity.

b. Such experiences should be instrumental in leading students towards a positive sense of control over their own action patterns, competence in the formulation of their ideas, and the knowledge that they can effect purposeful change.

c. Central to the organization of course content should be the recognition that students need to break down ideas and problems into manageable basic components. This should lead to an increased capacity to analyze, think through, and formulate ever more complex ideas.[35]

The program has been very successful in implementing these goals through a broad variety of arts activities offered by a dedicated staff.

One lesson for juniors and seniors from this program is a fine example of an exercise designed to help students identify their own style of seeing and relate it to that of others. It is helpful for students to recognize that they have different ways of looking at and seeing the world around them. How they see and their personal point of view influence their personal style in art.

In this lesson the teacher first asks what physical qualities might be used to describe objects and events, expecting the students to suggest size, color, texture, movement, weight, shape, and so forth. She then asks whether these qualities are useful in comparing two quite different objects and suggests that there may be other means of comparison as well. The lesson continues with questions as the teacher displays a group of photographs:

> Here are a number of photographs of different objects and events. What different things can we put together by finding out what is alike about them. Which pictures would you put together as a pair? Work alone for fifteen or twenty minutes to see what kinds of pictures can be put together; make a note of why they are alike. Then we'll share our ideas.
> The students were immediately interested and very involved. When the class began to share ideas it was amazing both to the students and myself the variety of ways the pictures could be looked at.[36]

The teacher poses a complex problem for the group through the activity of pairing the photographs: what different qualities of an experience do people focus upon? In the ensuing discussion, each student is obliged to make her own point of view clear and to recognize those of others. Some of the modes of comparison are shared by many students, others are unique. As the discussion continues, the students become intrigued with and more accepting of unusual pair-

ings. Through the activity they expand their threshold of acceptable points of comparison at the same time as they identify their own preferred mode. A follow-up lesson asks each student to use a preferred mode in creative work. Thus the sequence helps the student to recognize her own mode of seeing, her personal style, and those of others.

In this section three pedagogical techniques designed to help adolescents use stylistic conventions as a means of personal expression have been suggested. These were: (1) teaching stylistic conventions in sequences that lead to their creative use, (2) enabling adolescents to make their own personal discoveries of styles, and (3) helping adolescents to become aware of their own styles of seeing. Such techniques help the adolescent retain her ability to create and respond to meaning while at the same time developing her critical understanding of the adult world of art.

A FINAL NOTE

Reflecting back over the lessons and the children's work presented here, one is struck by the natural ease with which children respond to this kind of teaching. The approach is complex to organize and teach, but the learning process is natural since it is based on fundamentals of human psychology. However, older children, who may have become used to other approaches, need a thoughtfully planned period of introduction and transition to become comfortable with the demands made on them to become self-reliant and to use their own inner resources.

Of course, arts programs are more successful if consistent with the program of the whole school. Many of the objectives and strategies discussed in this approach can fruitfully be applied to other disciplines within a total school program. Techniques such as exploring the meaningful properties of experience, relating theory and sensory experience, responses that support and extend learning, sequences that lead to personal mastery and use of formal elements, and becoming aware of personal working processes are equally effective in other areas of learning. The overall goal of the creation of meaning is relevant in all disciplines. It is particularly in the emphasis on bridging cognitive and affective aspects of experience that the arts differ from the other disciplines. Thus they fit coherently into a total school program and yet make their own unique contribution.

In conclusion, it is important to observe that no program or curriculum can succeed without an atmosphere of trust and purposeful-

ness in the classroom and in the school. There are many ways to bring about such an atmosphere. The program sketched here has been characterized by the degree to which the creation of meaning is at the core of that trust and purposefulness.

NOTES

1. Elliot W. Eisner (ed.), *The Arts, Human Development, and Education,* McCutchan Publishing Corp., Berkeley, Ca., 1976.

2. Probably the best known exponent of this view of the purpose of art is Suzanne K. Langer; see *Feeling and Form,* Charles Scribner's Sons, New York, 1953.

3. Ricardo Alonzo (ed.), *I am Sorry I Busted Your Window: Poems by Quincy School,* Tri-Arts Project, Massachusetts Council on the Arts and Humanities, Boston, 1978, p. 1.

4. Ibid., p. 56.

5. Miriam B. Stecher, "Expressing Feelings, Facts and Fancies Through the Movement Arts," *Childhood Education,* January 1975, p. 125.

6. In Judy Burton and Nancy R. Smith, *Materials and the Structuring of Experience: A Developmental Interaction Curriculum in Art,* Department of Visual and Related Arts, Newton, Mass. Public Schools, 1975. (Mimeographed.)

7. Stecher, op. cit., p. 124.

8. Angiola R. Churchill, *Art For Preadolescents,* McGraw-Hill, New York, 1970, p. 180.

9. Mary Ross Townley, *Another Look,* Addison-Wesley, Menlo Park, Ca., 1978, p. C-69.

10. Ibid., p. C-69.

11. Lydia A. Gerhardt, *Moving and Knowing,* Prentice-Hall, Englewood Cliffs, N.J., 1973, p. 63.

12. Burton and Smith, op. cit.

13. Pamela Sharp, "Aesthetic Responses in Early Education," *Art Education,* September 1976, pp. 26–27.

14. Nancy R. Smith, *Developmental Origins of Graphic Symbolization in the Paintings of Children Three to Five,* unpublished doctoral dissertation, Harvard University, Cambridge, Mass., 1972.

15. Nancy R. Smith and Lois Lord, *Experience and Painting,* Bank Street College of Education Follow Through, New York, 1975, p. 7. (Mimeographed.)

16. For a discussion of the influence of different materials on the child's choice of referent see Nancy R. Smith, "Developmental Origins of Structure and Variation in Symbol Form," in Nancy R. Smith and Margery B.

Franklin (eds.), *Symbolic Functioning in Childhood,* Erlbaum Associates, Hillsdale, N.J., 1979.

17. Kathleen Gerritz, *First Graders' Spelling of Vowels: An Exploratory Study,* unpublished doctoral dissertation, Harvard University, Cambridge, Mass., 1974, pp. 18–19.

18. See, for example, Russell G. Stauffer, *The Language Experience Approach to the Teaching of Reading,* Harper & Row, New York, 1970.

19. Gerritz, op. cit., p. 112.

20. Ibid., p. 117.

21. Ibid., p. 141.

22. Ibid., p. 101.

23. Sidney Brien, *Books From My Head: A Developmental-Interactionist Program for Pre-Adolescents in a Cultural Institution,* unpublished master's thesis, Leslie College, Cambridge, Mass., 1978, p. 19.

24. Ibid., p. 20.

25. Louise Andrews and Susan Dinga, *Books From My Head: A Program of Integration through Interdisciplinary Language Arts,* proposal submitted by The Neighborhood Art Center at The Boston Center for the Arts to the Bureau of Equal Educational Opportunity of the State of Massachusetts, 1978, p. 24.

26. Brien, op. cit., p. 34.

27. Ibid., n.p.

28. Jean Bamberger and Dan Watt, *Making Music Count,* Education Development Center, Newton, Mass., 1978, p. 17.

29. Ibid., pp. 26–27.

30. L. S. Vygotsky, *Thought and Speech,* Wiley and Sons, New York, 1962.

31. *A 6th Grade Interdisciplinary Project: Interactions—Man, Nature, Objects,* curriculum carried out at the Davis School, Newton, Mass., by Judy Burton, Peggy Clark, Virginia Kropas, Shirley Mishara, Lincoln Yates, 1976–79.

32. Ibid., n.p.

33. Moy Keightly, *Investigating Art,* Paul Elek, London, 1976, p. 64.

34. Jean McCawley, personal communication, July 1978.

35. Judy Burton, *Proposal Developed by Massachusetts College of Art and Boston English High School for the Development of the Present Magnet Art Program, Boston English High School, Implementation,* 1976–77, pp. 4–5. (Available from Judy Burton, School of Visual Arts, Boston University.)

36. Mary Astell, "Analogies between Different Visual Images: A Project with High School Students at English High Boston," personal communication, May 1978.

5

DESIGNING EFFECTIVE ARTS PROGRAMS

BENNETT REIMER
Northwestern University

Previous chapters have discussed a rationale for introducing and maintaining arts programs in schools, explored the nature of the arts, presented theories of artistic development, and examined arts activities that implement developmental theory. We now shift our focus to the problem of designing school arts programs. We do not attempt to be prescriptive; rather, we raise issues which ought to be considered by those involved in building arts programs and suggest approaches to their resolution.

At every level of schooling—elementary, middle, junior high, and high school—three basic factors should be kept in balance when formulating arts curricula. First, as discussed in Chapters 3 and 4, programs must take into account the particular developmental level of the students. Second, programs at each level should articulate with the other levels, contributing toward the total, accumulating impact of the student's years in school. Finally a rich, life-enhancing environment for immediate satisfaction must be provided. Any imbalance among these fundamental obligations will seriously impair the positive impact of the program.

This chapter will explore several essential factors bearing on establishing good curricula in the arts. It balances a certain amount of confidence required to undertake such a task with a large measure of diffidence in the face of its complexity.

THE PROBLEM OF OBJECTIVES

What is an arts program supposed to accomplish? Many regard this question as premature: "Let's just get a program going in the first place and worry about objectives later." Others regard it as unnecessary: "We all know the arts are good for people." Many newly emerging arts programs are based on precisely these two nonanswers to the question of objectives: (1) "These are the activities our program consists of" and (2) "Most people seem to like it."

There are some good intuitive bases for the superficiality of objectives of many arts programs. It is true that efforts to formulate highly detailed objectives at the start of a new program can stifle creativity and paralyze imaginative new thrusts. And it is also true that the fresh, immediate pleasure of just being directly involved with the arts is a value to be cherished. Further, no topic in the field of professional education in recent years has been so massively debated, so ponderously articulated, so boringly and endlessly harped upon as that of "educational objectives." So one can surely understand the impulse to say, "Look, let's do what we can do to get things moving and to get kids excited. Isn't that enough?"

Probably not. Quick action and immediate excitement are often expedient—perhaps even necessary. But sooner or later the glow dies down and everyone begins to wonder just what is being accomplished by all the activity. The responsibility to articulate objectives cannot be ignored for very long.

Objectives exist on a continuum from very general to very specific. At the general end are overarching statements of philosophy. These provide the direction for a program; they explain what the fundamental values are and give some guidance as to how to realize such values.[1] The lack of an underlying philosophy—of a sense of what matters most—ensures that a program will be aimless. Unfortunately, many new arts programs are of that sort. They are grounded entirely on good intentions. When the surface of these intentions is scratched little appears underneath. Inevitably, after the first flush of excitement, the programs turn out to be disappointing to all concerned. Their perpetuation often hinges on the continued dedication of a few people who continue to plead for the program, often in the face of declining interest and their own doubts.

At the other end of the objectives continuum are those of a highly specific sort—the day-by-day expectations that add up to a tangible record of what has been accomplished throughout the school year. Strict behaviorists argue that such objectives number in the millions and that each must be stated according to a formula. A counterargument asserts that this ensures triviality. This chapter is not the place to tackle that long-standing debate nor to list objectives for daily learning. It must be said, however, that just as the lack of underlying principles ensures ineffectiveness, lack of attention to important short-range outcomes is equally debilitating. Many arts programs suffer as much from weaknesses at this end of the continuum as at the other. It simply will not do to continue to proclaim that "the kids are turned on," and to expect everyone to be satisfied. Such a claim, as the sole basis for program evaluation, would be outrageous in other areas of the curriculum. If arts programs are to exist as more than rest and recreation centers, they will have to demonstrate that some learning is taking place. The fact that learning ruins enjoyment is a dead weight on the back of aesthetic education, as is the avoidance of reasonable specificity of objectives.

Arts programs need a long-range philosophical vision clearly articulated and generally shared, balanced by short-range objectives sufficiently detailed to give both students and teachers a sense of tangible progress. Between those two ends of the objectives continuum are some basic behaviors which every arts program should take into account if it is to be both aesthetically pertinent and edu-

cationally sound. These behaviors are the all-embracing, synthesizing modes through which people and art interact. Though various thinkers have stated them in somewhat different forms, the following explanation seems to be fairly inclusive.[2]

PERCEPTION

An arts program must directly influence each child's ability to discern aesthetic qualities more keenly. If this happened automatically, as the result of any kind of arts involvement whatsoever, aesthetic education would be a simple matter and hardly worthy of professional concern. Such is not the case. Development of perception in the aesthetic realm, as in any other complex field of human endeavor, requires careful, intelligent curriculum planning. Without it an arts program will only be fun and games. To the degree that a program promotes deeper artistic discernment it ensures both immediate satisfaction and long-term growth.

For example, while elementary school music lessons may focus on single qualities of sound—tempo, meter, direction, dynamics, register, or phrases—middle school lessons can become more consciously integrative since at this school level children are capable of more sophisticated aesthetic perceptions. Several qualities of rhythm, for example, can be perceived as working together to cause a particular illusion of movement. At the senior high level, the aim is toward even more synthetic perceptual challenges: discernment of the music-forming process as an unfolding set of rhythm-melody-harmony-tone color dynamics relationships; attainment of a broad view of music styles (baroque, jazz, impressionism) as being characteristic uses of the musical elements; discrimination of the special expressive qualities in music of various cultures, and so forth.

For each art the qualities corresponding to those mentioned for music become merged into larger wholes as the curriculum both reflects the students' present powers of perception and challenges those powers to keep developing. Similar opportunities should be increasingly given for more holistic perceptions of the relationships among the arts. For younger students, interdisciplinary arts lessons can explore similarities and, more important, differences among the arts in their use of single qualities—accent, pattern, direction, repetition, line, and so on. Then perception can focus on broader observations: for example, how the arts create tension; why the illusion of movement is present in all art yet manifested differently in each; the qualities that allow us to recognize an art work as "modern"; or art as a means of exploring new ways to feel.

Aesthetic perception is a (many would say "the") foundational

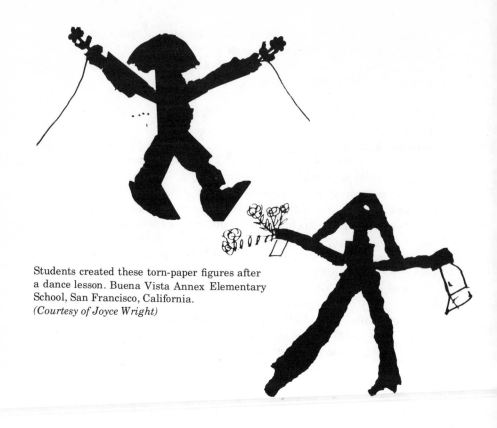

Students created these torn-paper figures after
a dance lesson. Buena Vista Annex Elementary
School, San Francisco, California.
(Courtesy of Joyce Wright)

behavior for aesthetic education. Curriculum planning for each
school level must be in tune with the dramatically increasing per-
ceptual capabilities of children.

REACTION

The ability to perceive or discern a work of art is not sufficient; stu-
dents should experience some kind of emotive reaction. In an
authentic aesthetic experience mind and feelings work interdepen-
dently in discerning expressive qualities and experiencing their
affective power. The value of an arts program is the vividness and
depth it adds to people's subjective experience. The primary obliga-
tions of an arts program are to offer immediate opportunities for
such experience and to help the quality of such experience deepen.
To keep aesthetic perception developing through a balance with

direct, involved, affective aesthetic reaction is the end toward which all aesthetic education strives.

Just as perceptual capabilities deepen as children develop so does the potential for deeper emotional reactions. Proper challenges to perception will provide for possibilities of deeper affective response, since more subtle noticing allows more subtle feeling. In addition, the choice of works to be studied should reflect the students' level of emotional maturity, their capacity to concentrate and handle complexity, their openness to divergent and unusual ideas, and their ability to make discriminations when comparing different styles, media, aesthetic intentions, cultures, and different societal uses of the arts.

As students mature both perceptually and emotionally, they grow toward more mature interactions with expressive forms. The curric-

Students learn techniques for making their own animated films. "Super Sleuth" (opposite) is the work of a 14-year-old boy. Newton Creative Arts Center, Newton South High School, Newton, Massachusetts. Instructor, Yvonne Andersen. *(Courtesy of Al Hurwitz)*

ulum, in content and in approach, must encourage this dual development.

PRODUCTION

Every child needs to encounter the arts as creator (composer, painter, poet) and recreator (player, singer, dancer, actor). In many traditional programs, producing art is regarded as an end in itself, self-sufficient and self-justifying. One may go so far as to say that producing art has often been regarded as synonymous with arts education.

A major realization among arts education professionals in recent years is that production does not necessarily pay off in deeper aesthetic sensitivity (that is, better ability to perceive and react aesthetically). Production must be used educatively; this requires balancing the doing of art with sufficient use of each of the other behaviors discussed here so that children become more sensitive to art *through their production of it.*

For example, there is a vast difference in educational content between rehearsal time used for preparation for a concert or contest and rehearsal time seen as an opportunity for first-hand musical exploration. In the former case the director has a single goal to which all else must become subservient—to make the group sound as good as it can in the time available. Therefore, he tells rather than explains. He imparts necessary information rather than shar-

ing illuminating insights. He gives directions rather than guidance. He is a rehearser rather than a teacher.

Similar imbalances in favor of mindless exercise over educative involvement occur frequently in other performance activities—play productions, dance productions, combined performances. Even in nonperforming arts the tendency to emphasize technique over understanding exists. Many students who produce paintings, ceramics, or weavings in arts classes end up with little or no increment in their sensitivity to the visual arts and the visual environment because their experience has been so narrowly focused on the completion of an impressive product. They have not expanded, through their doing, their understanding of visual art as a whole and their own role within it.

In a project which combined production with other behaviors, all fourth, fifth, and sixth grade students in Buena Vista Annex Elementary School in San Francisco participated in a film program. Each week they saw one silent black-and-white film featuring Charlie Chaplin, Laurel and Hardy, Buster Keaton, and other classic comedians. The 300 students enjoyed seeing the films, evidenced by their willingness to walk the ten blocks to and from another school's auditorium in order to view them. Then they participated in follow-up activities exploring concepts such as pantomime, plot, character development, as well as aspects of filmmaking like camera angle, sequence and transitions, composition, and movement. The next step was to use that knowledge as a medium for giving form to their own perceptions and feelings. Accordingly, a group of students wrote, filmed, acted in, and edited their own film based upon their exposure to the old silent comedies. In *The Peeky Boo Bunch* they explored their own feelings about school by showing what a few students might do in the city if they played hooky for a day. Assisted by a filmmaker consultant, the students created a film which demonstrated both technical skill and expressive power. It won the first prize for preteen-age filmmakers in a national competition and a CINE Golden Eagle Award.

How does technical "making" become transformed into meaningful creativity? By keeping the doing of art balanced with perception, reaction, conceptualization, analysis, and evaluation, all the behaviors a complete aesthetic education entails.

The school arts instructor who becomes fixated on students' technical skills without attention to the other behaviors may well stunt the very aesthetic growth that he is supposed to foster.

The vast majority of people will not continue producing art after the school years but all can continue to enjoy the arts as a significant force in their lives. If school arts production contributes to this end it is entirely justified as part of general education. If it does not it can only be regarded as special education for the talented, with concomitant unfortunate results for the majority of children and for the arts education profession. One of the most pressing tasks facing arts education is to provide opportunities for all students to experience the power of producing art while ensuring that this experience pays off in a desire to continue an involvement with art if production activity dwindles. This task takes on added importance with the spreading realization that, no matter what the level of an individual's production skill, one's ability to enjoy the arts goes far beyond what one can produce. A school arts program limited to simply *doing* is technical education in the narrowest sense. At the same

time, no good arts program can exist without meaningful, involved production.

CONCEPTUALIZATION

Ideas about art are powerful educative tools. An effective school arts program will raise many issues pertinent to the arts and to the conceptual abilities of the students. What good is art? How do people go about dealing with art as creators, recreators, teachers, critics, scholars, technicians, therapists, collectors? How do different cultures interact with art? What has art been like in the past? What is its future? What qualities does art use to be expressive? Are the arts alike? Are they different? Questions such as these add the dimension of understanding, without which a program is vacuous for students ready for such understanding.

They also provide an effective means of curriculum organization. There is a strong tendency for arts programs to wander aimlessly, under the vaguely paranoid notion that organization of any sort is hostile to art. Of course a sterile, rigid organization will sap the lifeblood of an arts program as it would any other program. When kept in balance with all the other behaviors, conceptualization adds the necessary dimensions of depth, enlightenment, and coherence to study of the arts.

ANALYSIS

Aesthetic growth requires aesthetic probing. If students are to become sensitive to their own and others' creations they must explore the inner workings of aesthetic objects. Analysis is an essential component of all activities in an arts program. Effective creation requires that the student be intensely aware of unfolding interrelations. Effective re-creation requires the same heightened awareness. And if the experience of art is to be more than casual it requires more than casual discrimination. Analysis is the means for getting deeper into aesthetic qualities and processes. It accompanies all other activities, often tacitly but on many occasions as a matter of more conscious, focused behavior.

EVALUATION

Development in the aesthetic realm requires the growth of critical acumen. Wolf and Gardner pointed out in Chapter 3 the importance of fostering such critical abilities before adolescence as well as in later years of schooling. Even at the elementary school level children make aesthetic judgments and the arts teacher must encourage them. The perspicacity of such judgments can be further devel-

oped in the secondary years. A good school arts program will provide many opportunities for aesthetic appraisals to be made, not necessarily to make critics of all the students, although some argue that this is indeed the major result of good aesthetic education, but to provide the student a self-critical perspective of his own creations and a means for encouraging intelligent estimation of the work of others.

Judgment making should be an ongoing, active ingredient of sensitive decision making as every phase of learning proceeds. For example, rehearsals can become rich with aesthetic significance when the performers are involved in making many of the artistic judgments about what they are doing, rather than, as is typical, always following the orders of the director. This applies as well to student productions in visual arts classes, music classes, literature classes, and others. When appraisal is seen as a necessary means for constructive growth, its use fertilizes budding minds and sensibilities. A major obligation of the arts program as students progress through it is to channel their raised consciousness and higher level of technical ability into a more enlightened facility for making aesthetic judgments.

VALUING

Underlying all the specifics of an arts program is the hope that young people will find satisfaction in the arts now and in the future. Few would argue with the assertion that a major objective of aesthetic education is to foster discerning appreciation or sensitive enjoyment or "enlightened cherishing" of the arts. But in their zeal to make students "love art" teachers often rely more on hoping their own passion for art will rub off than on helping students get closer to art and trusting that art will be valued for its own power. A teacher's love for art should shine through all that is done. But it should not impose itself on students, making them think they are obligated to admire what someone else admires. An effective program will indeed promote a love for the arts, partially through human example but primarily through deepening each student's ability to share the affective impact of art.

Teachers must be sensitive to the dangers of forcing students to value this or that art work or style of art. Because of the intensity of social, psychological, and emotional developments among school-age individuals, tastes in art become a mixture of the aesthetic and nonaesthetic, as Wolf and Gardner pointed out. Peer-group enthusiasms, the need to diverge from adult-imposed values, the need to identify with hero figures, the exploration of various self-concepts,

and many more complex personal factors enter into a student's value system, strongly influencing preferences in the arts. It is counterproductive to ignore the strength of all these factors, as if tastes in art, or anything else, exist in a vacuum.

The school arts program can incorporate child and teenage enthusiasms without being limited to them. It can honor the students' preferences while exploring the wider domain of art. It is vitally important to balance an acceptance of what children are in the present with the obligation to open up possibilities of what they might become in the future.

The seven behaviors discussed here should permeate education in the arts at every level. Also common to every level is the fundamental objective of improving all the behaviors for each student. What changes is their depth and balance based on the developmental level of the child. Wolf and Gardner's discussion in Chapter 3 and Smith's in Chapter 4 should provide guidance. It may be impossible to achieve complete success in balancing these behaviors correctly for each child, but to strive toward doing so is to assure continuous improvement.

PROGRAMMING THE ARTS

How can an arts program be organized to fulfill its objectives? Three major modes of programming have evolved in response to this question: (1) single, autonomous arts study; (2) interdisciplinary arts study; and (3) arts study integrated within the general curriculum. Each of these modes has devoted advocates. In the discussion below some comments will be offered about the advantages and disadvantages of each. Our not very surprising suggestion is that an arts program that uses all three in balance is likely to be the most successful in the long run.

SINGLE, AUTONOMOUS ART STUDY
This is the traditional way of programming art in American education. For almost a century and a half music has been a recognized curriculum subject in public schooling and visual art education is almost as old. Until recent years these have been the only art fields with regular curriculum status (excepting literature as part of language study), and, again until recent years, they have gone their own separate ways, seldom communicating let alone cooperating. Each has its long-honored traditions, its national and state organizations, its journals and official publications, its research committees, its conventions and conferences, and all the other trappings of

an operative professional field. Each prepares teachers for the schools and, in graduate programs, trains scholars, researchers, and teachers of teachers. All of this is done so independently that occasional convergences can be regarded as remarkable. The same may be said of the experiences offered to students in schools; music education does its job, art education does its job, and when the twain meet it is usually regarded as a special occasion.

In addition, in most cases, the arts remain a thing apart from the real educational business of American schools, especially at the secondary level. In Gene Wenner's words:

> ... the isolation of the arts programs from the rest of the school curriculum is a natural result of the departmentalization of most *secondary* schools. In many schools the isolation is so complete that the art and music staff never meet together, let alone jointly plan their course offerings. Since most of the activities are performance *or product* oriented, their relationship to the other areas of the curriculum, which tend to be just as specialized, is limited or non-existent. Their major concern is with the talented children and they rarely concern themselves with the arts for all students.[3]

The noticeable lowering of barriers between music and art education and the more active participation of the other art fields in cooperative arts endeavors are among the most important breaks with tradition occurring in American schooling in our times. If there is to be a revolution in arts education, or at least an accelerated evolution, as it is devoutly hoped there will be, it will no doubt consist largely of fundamental changes in the old provincialism among the arts fields as demonstrated by cooperative programs of teaching and learning.

This is not to say, however, that single art study does not have essential functions in a total arts program. Chief among these is in production or performance. A good arts program should offer all students rich opportunities to sing, to play instruments, to paint, sculpt, dance, act, create films and poetry and musical compositions, to become involved in many varieties of aesthetic creation and recreation. In the vast majority of cases these are single-art experiences by their very nature. An important obligation of arts education is to foster the artistic talent of those who are gifted in this way. But, as Goodlad and Morrison pointed out in Chapter 1, equally important is the obligation to provide creative experiences for students of moderate and even limited talent, for the sheer enjoyment of it and the payoff in deeper understanding of the inner workings of the arts and of the self.

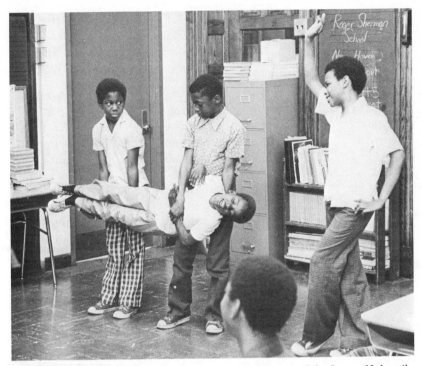

Roger Sherman School, New Haven, Connecticut. *(Photograph by Jerome Nalewajk. Courtesy of American Shakespeare Theatre)*

The visual arts program for students in kindergarten through grade 6 in the Palo Alto City Unified School District in California is an example of a program which is not comprehensive but which focuses on one art area. While it has grown and developed over the years, all the program's components are still related to the visual arts. Students are provided with several different types of experiences designed to accomplish the following goals:

1. Use a wide variety of art materials

2. Enjoy beauty in the environment

3. Appreciate art created by people of other times and places

4. Make informed judgments about works of art and the artifacts of daily life

Under the direction of an art consultant, the program maintains art studios at about half the district's seventeen elementary schools. The studios are open during the noon recess and are staffed by teams of parents. Other parents (approximately thirty) go into the

regular classrooms in all schools to show works of art and to discuss art and artists. Pupils also are given opportunities to see local artists and their work, both in the classroom and in the artists' studios. A series of curriculum units including general study and production activities for students have been developed, including "Meet the Masters," "Ten Modern Masters," and "American Art and Artists." The lessons within each unit center around individual artists and are based on prints of the artists' works that are readily available to the district's elementary school teachers. Students engage in both group discussion activities, concentrating on unique attributes of the art works such as stylistic qualities and historical or social importance, and production activities which encourage students to emulate stylistic features of the artists' works. In addition, "Ten Modern Masters" and "American Art and Artists" include biographical sketches (at a fourth-grade reading level) and independent follow-up student activities.

The Evanston Township High School in Illinois is an example of a secondary school in which several arts are offered but only through single art programming. It maintains three major arts departments—Art, Music, and the Speech Arts (which includes oral interpretation, radio-television, speech communications, and theater arts). Each department is staffed by arts specialists in that particular field who teach the wide range of courses offered in each department. Although all courses fall within the elective category, Evanston High has long required that each freshman elect one course within any of the arts departments. Moreover, at advanced levels students can choose from among an unusually comprehensive list of courses—including performance and production work—if their interest in an art leads them to pursue learning in depth.

The point about these two programs is that they have retained the strengths of traditional single-focus experiences, yet they offer students a choice of creative involvements. An even wider choice is available when the range of arts covered is more comprehensive and includes such subjects as dance, film, architecture and environment, and theater.

In addition to production activities in single, autonomous arts are programs devoted to the general study of music and the visual arts. In the elementary schools such study has been provided mostly by the classroom teachers, with some 20 percent offered by music specialists and a somewhat lower percentage by visual art specialists. In most secondary schools general music and visual art classes are taught by specialists and are conceived as providing broad, multiactivity involvement with each of these arts. Recent developments in general music and art have been toward a much greater stress on

perception, conceptualization, analysis, and evaluation, with less use of the classes for strictly production activities. Some opportunities to apply insights gained to other arts are also included. For example, traditional middle school and junior high general music classes, which represent the most widespread attempt in American education to teach a fine art to all students through specialist teachers, are becoming less and less "singing classes" (each class being treated as a sort of nonselected chorus) and more of a serious exploration of how the art of music works and how it manifests itself in a diversity of styles. And it is no longer unusual for occasional lessons to be included that examine how music is in some ways similar to and in some ways different from the other arts.

Parallel developments are beginning to appear in classroom instruction in visual art at this level. The old isolation of music and art teachers—each unaware of the other arts and each engaged primarily in production activity to the exclusion of a broad-based study of the nature of each art—is breaking down. One may hope that such classes will continue to become more effective in fostering general aesthetic sensitivity to their own art and to all the arts. One may also hope that additional classroom study of this sort will become available for the other arts. If this were to happen, two essential obligations will have been met in regard to the single arts aspect of the total program: first, every child will have choices among all the arts in which to become engaged as a creator, and second, every child will be involved in classroom study of various arts to become an enlightened appreciator of each art's uniqueness and to gain a better sense of their common nature.

INTERDISCIPLINARY ARTS STUDY

While study of single art forms is beginning to include some tentative steps toward interdisciplinary concerns, some attempts are being made to inaugurate more extensive interdisciplinary programs. Few modes of curriculum organization have turned out to be as difficult to create and maintain. Yet the opportunities are exciting and the need for imaginative cross-fertilization among subjects is perhaps greater now than ever before. If education is to help students synthesize, unify, and begin to understand the underlying structures of knowledge, it must encourage the broad view as well as a grasp of details. Synthesis among subjects does not occur automatically, however ready the children are becoming for it. It must be planned for and taught for. Interdisciplinary approaches offer unique opportunities to probe beneath the surface for more fundamental insights.

They also present some of the toughest problems in all of educa-

tion, for when more than one subject is being dealt with, conceptual and pedagogical issues multiply. In the arts these issues are raised very strongly but somewhat differently in the two basic ways to organize interdisciplinary experiences: (1) classroom study of the arts and (2) production activities.

Two approaches to organizing *classroom study of the arts* will be discussed here. One is usually called *humanities,* the other *related arts, allied arts, common elements,* or simply *arts.* Both tended to originate at the college level, especially the humanities approach. They eventually began to be offered in high schools and are now trickling down into the middle schools and elementary schools. While there is some common ground between the two, they each have distinctive goals. The problem is to balance the two fruitfully.

Humanities approaches usually emphasize cognitive learning, with works of art providing illustrative material for the issue or theme being studied. Typical themes are Man and Nature, Man as a Social Being, Man's Search for Beauty, the Need for Freedom, and so on. For example, in Massachusetts, the art specialist in the Newton Schools has developed a course entitled "Man and His Symbols," (Carl Jung's book is the text), in which art is studied from a social-anthropological vantage point. During the course students create their own slide-films on anthropological themes and work on environmental light-sound projects using different media combinations.

Another common humanities approach is chronological. Periods of history are studied in several of their dimensions, the arts being more or less emphasized. The advantages of both approaches are that students are introduced to the major issues confronting human beings and to a sense of the continuity of history. This can be exciting and liberating, adding depth to their view of themselves and their world. It is especially important in light of the adolescent crisis discussed by Wolf and Gardner.

Several important risks are involved, however. Most problematic is an inevitable tendency toward academicism; such courses often become so bogged down in historical and factual information that they lose the immediacy of the experience of art and the need for students to encounter their world through active involvement with it. The ideas dealt with in humanities courses are extremely complex, leading often to more and more abstraction from immediate experience. Overemphasis on intellectualization can result in teachers force feeding bored students, and the tendency is very strong toward intellectualism given the biases of the humanities approach.

Further, there is a grave risk of misrepresenting the arts when study is organized by theme or historical period. On the one hand, abstract art, nonprogrammatic music and dance, and non-theme-

oriented works are usually ignored since they do not contribute to the theme under discussion. This gives the impression that such works are not important in themselves or representative of their art. The works that are studied are often probed only for their non-artistic "message," as if works of art exist primarily to make social and philosophical statements. For many if not most art works this is a serious distortion of their function.

In addition, historical study tends to be far removed from the experience of children. It tends to pigeonhole art into this or that neat category, ignoring the fact so clearly pointed out by Hausman in Chapter 2 that much art does not simply reflect the period in which it was created and that in every period different arts tend to be at different stages of stylistic stasis and change. It is no simple matter to grasp the history of the arts; attempts to involve children in such study can result in oversimplification or confusion.

Yet, having said all this, one must recognize that humanities approaches can be designed properly for all levels of schooling. Some attempts have indeed been successful, keeping involvement at high levels while adding depth at every opportunity.[4]

The involvement aspect usually comes from effective use of the *related arts* or *allied arts* approach. This is a much more art-centered mode of interdisciplinary study, with comparisons and contrasts among the arts as the major organizational factor. As children mature they can handle fairly large notions about the process of creating art. Exploring, for example, *action* as an aesthetic quality present in all forms of art, the students can compare music, which gives an illusion of action that takes place *through time,* with the illusion of action in a painting in which all elements causing action are present *at the same time.* Why is the illusion of action in dance similar to that in music? In what ways is dance very different from music? Why is the illusion of action in architecture like that in painting? In what way is architecture very different from painting? How does a poem create a sense of action? Is it anything like sonorous action or kinetic action or visual action? What special quality does a poem have?

The lesser concern at the elementary and middle school levels with "courses" as such allows for a much more open, experimental approach to interdisciplinary arts study, which can avoid the doctrinaire rigidities so often associated with the high school level. Out of the ferment of trial and error in these earlier grades we can hope for an emergence of options that accomplish the major goal of interdisciplinary arts study, giving students an understanding of the special character of each art and of their common nature as a family.

The second way that interdisciplinary arts can be offered is

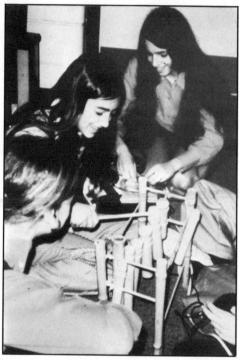

through *production activities*. As has been discussed, a long tradition of single-art production activities exists in the schools, but experience with multi-art production has been more limited. And while much debate has taken place about proper ways to organize multi-art study in classrooms, the issues raised by multi-art production are often not even recognized, let alone discussed.

Most aesthetic production involves one art only—composing a string quartet, performing it, painting on canvas, writing a poem.

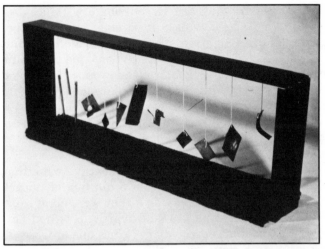

Student-created musical instruments. Bedford Jr. High, Westport, Connecticut. *(Courtesy of Joyce Bogusky-Reimer)*

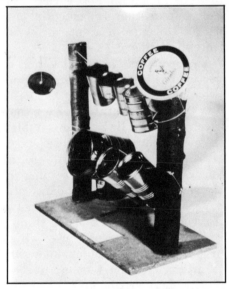

Often, however, a second art contributes. In music a poem may be used in a song. This is an interdisciplinary endeavor only in the broadest and weakest sense. What actually occurs is that the poem is subsumed within the music. Words become another element in the musical totality, along with melody, rhythm, harmony, tone color, and form. The result is music—not poetry and music in co-equal partnership, but a form which is purely and completely music.

The same process occurs in other instances in which an art form

uses a second art or several other arts as contributory. Dance does not require music. When music is used it becomes another dance element along with costume, lighting, staging, and so on. The result is dance. Theater does not require sculpture. When a piece of sculpture is used it becomes one more theater element along with plot, lighting, staging, movement. Film does not require music or dance or poetry or painting. When they are used they contribute to the film as film—not as equals in an interdisciplinary partnership among autonomous art forms. They become film elements and the result is the art of film.

Arts teachers are often unaware that the presence of more than one art must be handled delicately to avoid a dilution of impact. When each art is given equal emphasis, as if they were all of equal importance in the whole, the result is a kind of artistic vacuousness so often observed in school arts productions. What one observes in these cases is a kind of "variety show," diffuse, weak, one thing at odds with another, the potential power for participants and observers lost because of a superficial notion about what is and is not "interdisciplinary."

The reverse occurs—and is immediately apparent—when the production has been in the hands of someone who knows his or her art (whether or not he or she happens to know aesthetic theory) and how to treat it truthfully. Here the impact of art touches all those involved, overriding the inevitable technical limitations, creating the aura of authenticity, the excitement of focused, unified aesthetic creation. A school opera or operetta production can be a high level music event, in which everything enhances the musical integrity of the performance. A school dance production can be exciting as pure dance, when all efforts are pointed toward the impact of movement. A school play production can shine with theatrical validity when a sensitive director has focused all elements of the performance on drama as drama. Students know when they've experienced authentic artistic creation; they are likely never to forget it. But it takes a director-teacher who knows how to harness all the forces and move them in a unified direction. The word "interdisciplinary" may well be a hindrance in such endeavors.

In addition to all the production opportunities in the traditional arts are new forms which are truly innovative, experimental departures in that they actually are "interdisciplinary." In these new forms several arts are treated as separate but equal. Whether called "multimedia," "happenings," or any other such term, the aesthetic principle underlying these works is to retain the autonomy of each participating art while creating a whole larger than the sum of its

parts. This entails a far different process from the traditional theater, opera, or dance forms discussed above and raises so many problems stemming precisely from its interdisciplinary nature that many critics insist it is impossible to realize it successfully. Advocates point to the special opportunities for aesthetic challenge in such forms. Experience has shown that, when used intelligently, multimedia productions in the schools can be among the most exciting experiences in which youngsters can be involved. They can also be disasters, as when the variety show syndrome sets in. In this area, as in any other in arts education, a little know-how can mean a great deal, while the assumption that "as long as you're doing something active you're bound to be all right" fairly well ensures superficiality. A genuine attempt to produce a multimedia event, including such elements as student-created slides, electronic music, student-created musical instruments, creative movement, poetry with and without action, planned and unplanned dramatic events, lighting effects (some productions have even experimented with smells and tastes), each medium enhancing the total effect yet each retaining its own character, can be an unforgettable experience for youngsters (not to mention their audience!). Not the least of the benefits is a deeper understanding of the differences between single art and genuine multimedia productions. [5]

ARTS STUDY INTEGRATED WITHIN THE GENERAL CURRICULUM

Most school programs for education in the arts, past and present, are located in the two modes of programming discussed above—single art study and interdisciplinary study. An additional mode is to include the study of the arts and aesthetic components of non-art within the total school curriculum. Consider the following assertion, presented under the title "The Place of the Arts in the Curriculum":

> The goal is the utilization of the arts process as an integral part of basic education. . . .
> Properly conceived, the arts constitute a great integrating force in the school curriculum. To achieve such an end they must be viewed as a component of every discipline, for their subject matter is as broad as life itself. . . .
> Such an approach permits the arts to be viewed as alternative means of understanding subject matter or processes that at the same time complement and are integral to the total basic education program. . . .
> The idea of the arts in basic education means that the arts will be infused with other major areas of the curriculum in

such a way that they mutually nourish one another to the benefit of all students. In other words, the arts ought to *permeate* the subject matter in the schools.

Infusion is not correlation. It implies far more than a world cultures course that uses the arts of a people as illustrative material only, or a physical education program that gives cursory attention to dance through square or social dancing, or an elementary program which occasionally allows the students to "act out" a story or illustrate student-written haiku for the class poetry book. It means more than an occasional excursion to a museum, theater, or concert.

Infusion signifies that the arts should be thought of and incorporated as interdisciplinary studies that are the responsibility of *all* teachers. Such a program—designed to bring all the arts to all students through all the subject matter in the school—must be the primary focus of arts education. . . .[6]

A problem with this approach may be that it pushes a good idea to an untenable extreme. Try substituting the word *sciences* for *arts*. The argument holds up just as well (with the necessary allowances). Then try changing *arts* to *social studies* and *physical education* and *vocational education*. We are left with a monolithic, amorphous school curriculum, everything merging and blending into a colorless wash of mutual infusion. Is there, perhaps, room in education for the exploration of science as a field with its own identifiable characteristics, its invaluable structure of knowledge? For the social studies? For the arts? Perhaps we can balance the opportunities for connection among subjects with the need to recognize— even to protect and to celebrate—their individuality. It would seem that total interinfusion is recognized to be insupportable even by those who appear to advocate it. The excerpt quoted above goes on to the following sentence: "This philosophy would also encompass specialized arts courses that treat the subject matter of the arts as discrete disciplines."

The impulse to include the arts within study of other subjects is healthy. It encourages an ongoing, constant interaction with the arts and illuminates the pervasiveness of art within human culture. It can clarify the special nature of art by comparing and contrasting it with other subjects and, at the same time, show how aesthetic components operate within non-art subjects. It can involve elementary classroom teachers and non-art specialists in ways beneficial to themselves as individuals and teachers and to their students, who can share with them the excitement of new explorations. There may even be some transfer from the creativity of good arts study to study of everything else and to general attitudes.

An example of an arts program trying to integrate the arts with each other and with other curricular areas is Project SEARCH. Several elementary schools in Utica, New York, are involved in this statewide program begun in 1970. Project SEARCH is based on the premise that the integration of the arts and the humanities with the rest of the curriculum results in a richer educational experience for students. Integrated arts experiences are offered to further the goals of developing students' and teachers' reasoning and valuing skills, affective sensitivities, and active involvement in school experiences. Teachers and students are exposed to a variety of arts activities which they participate in and subsequently analyze so as to be able to extend the processes to learning in other areas. For example, students use scenes in paintings as an impetus for improvisational dialogue, and use photography to explore, record, and analyze aspects of their community to determine its uniqueness, organization, and influence on school curricula.

A series of workshops are provided for teachers during which they participate in a variety of arts activities and are helped to develop curricular sequences which extend the activities into other subject areas. Arts specialists are included in the program in the hope that the complexities and integrity of each art will be maintained.

Another approach to integrating the arts with other subjects in the elementary school curriculum is exemplified by the City Building Educational Program, which is used in several Los Angeles area elementary schools. Architecture, city planning, and environmental design[7] serve as the core around which other subjects—math, reading, and language arts—revolve. Upper elementary teachers work with architect/planners to design and implement a year-long curriculum which emphasizes problem solving, decision making, responsible social interaction, and the relationship of people to the environment. Students are asked to confront and solve increasingly complex but always real-life problems. For example, first they individually map the main components of their community. Later they are asked to draw or photograph the "good" and "bad" aspects of their environments and justify their choices. Students then proceed to transform their classrooms by redesigning the space to meet their individual and class needs. The curriculum includes other topics such as the perception and retention of shapes, the individual and his/her relationship to objects, organizations, community, and the larger environment.

In Saugus, California, a combined fifth and sixth-grade class was involved in the City Building Program. The fifty-six students and two teachers—Ruth Hiebert and Joe Pelletier— were in a double classroom similar externally to the traditional appearance of this

suburban school. But once inside, a visitor quickly sensed that the students were having a different type of educational experience from students in the other classes. Students and teachers were involved in individual and small group activities. Some were working in reading and math textbooks; others were writing stories; several boys and girls were working on an 8- by-12-foot model of their ideal environment; and another group was discussing various building committee decisions.

Three guides, Angie, Missy, and Mark, led a visitor on a tour of the "History Wall," which chronicles the class experiences to date. The guides had obviously performed this service for other visitors; they were articulate, self-confident and well versed in the program's terminology and concepts. When their rhetoric was questioned and their ideas probed, they answered with words and thoughts that were consistent with their previous statements, indicating that they had indeed internalized the concepts of the program. They said they were trying to learn about themselves and understand their relationships to other persons and to the world. They had written about their feelings and experienced how space and the form and size of objects influenced how they acted in a certain environment, and they had become aware of people's need to work together. As one student had written in her class diary, "I feel that the most important thing is the peer to peer relationship between not only the teacher and the student but between students. The student gets a chance to see that he could really be helped by others or he could give help to others."

The History Wall began with what had transpired in September of that school year. Angie described their classroom then—rows of tables and chairs, two teachers making all the decisions, and a lot of children just sitting and waiting to be told what to do. Gradually, things began to change. When Ms. Hiebert and Mr. Pelletier told the students that they needed to take more responsibility for the classroom's physical and organizational structure, the room environment became quite chaotic at first. But the students began to realize that they had to do some planning in order to diminish the chaos. First, two-dimensional drawings of the classroom were made and then a three-dimensional scale model was constructed allowing them to better visualize spatial dimensions and to try out different furniture arrangements. They had to think about creating an environment that would meet everyone's needs.

Further down the wall from the three-dimensional scale model of the classroom were some examples of transformation and scale change activities. Students had changed the function and appear-

ance of film cans so that one was a working clock, another a scale, and another a planter. Replicas of common objects such as milk containers and cameras had been made in progressively larger sizes. The children said these activities had helped them to understand that it was possible to alter the looks and functions of things that were made for another purpose. Also they were able to see how the size of objects influenced people's reactions to them. Examples of students' stories and poems were interspersed among these and other projects such as scale maps of the community and results of a student designed and conducted community survey about environmental issues.

Finally, at one end of the room was an 8- by-12-foot three-dimensional styrofoam model representing a local geographical site. Each student had been given a parcel of land on the model and was supposed to plan for the use of the land by considering all the needs of the area. Children were formed into various regulatory committees, such as transportation, planning, and building, to establish and enforce environmental standards for development of the model site. Several students were building structures, painting parts of the site, planting trees and planning for future construction. Their awareness of the issues to be considered when designing an environment was astounding. They were considering aesthetic, psychological, and social needs of people. At the end of the day, the "mayor" called all the students together for a brief meeting to discuss whether or not they needed to establish a money system for their society.

A long-term goal of the program is to add consultants from other areas besides architecture and to expand the program to include all elementary levels. Each level of schooling would concentrate on a different discipline as the integrating vehicle for other subjects. Consultants from the disciplines would work with teachers and students. If the focus were science, music could be explored as a study of acoustics and the physics of sound, history could focus on the development of science, and reading could concentrate on scientific subjects.

A third grade unit at Wheelock Elementary School in Keene, New Hampshire, is another example of a program integrating the arts into the general curriculum. "Using Photography as a Thematic Medium in which Other Areas of Study Are Integrated" is a long title that means exactly what it says. Students made their own cameras, developed and printed their own film, and in the process learned to use liquid measurements, to estimate distances, to observe chemical reactions, to use the metric system, to explore "points of view" through the camera, to compare the camera eye

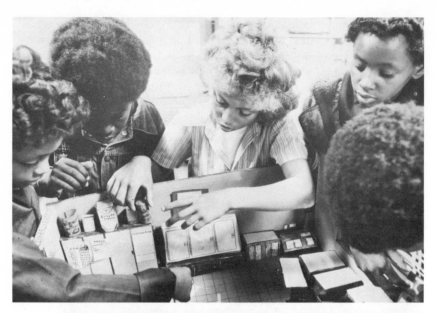

with the human eye, and to write captions, stories, and poems about their photographs.

In still another characteristic approach, the arts are used as a central motivation to stimulate academic achievement and the acquisition of particular cognitive skills. A focus on the visual arts,

Activities in various classrooms participating in the City Building Educational Program. *(Courtesy of The Center for City Building Educational Programs)*

for example, might place specific emphasis on the development of reading or other language arts skills. More attention has been given to these approaches on the elementary level (where basic skill development must provide children with fundamental learning tools) than it has in secondary schools, but instances of the trend can be

found at this level as well. For example, the Institute of American Indian Arts, a secondary school in Santa Fe run by the Bureau of Indian Affairs, has for some years operated on the premise that "young Indian people would gain a stronger and quicker sense of self-realization if they were given opportunities to develop within their own cultural framework."[8] The entire Institute program is centered on the arts; after being exposed to the whole range of art-forms which make up the cultural heritage of native Americans, the Indian student is guided toward work in a specific art form, one in which he can expect to achieve a high degree of success. In this sense, the Institute views the arts both as an end in themselves and as vehicles for creating conditions conducive to learning in other fields. This focus on ethnic identity in the Institute's accredited high school program has produced positive academic achievement and fostered desirable social behavior, in addition to nurturing the artistic capabilities of its students.

A project called *Cablecom* has been instituted in the Memphis, Tennessee, schools which has as one of its major goals the raising of achievement levels in the language arts. A cable TV studio located in the system's Technical High School is connected to seventeen city schools embracing the entire K–12 spectrum. Music, art, and dance augment studies in speech, drama, and journalism, and high school students and faculty incorporate elements of all these disciplines in Cable TV programs that are used as teaching tools in language and social studies classes. While the arts are used purposely here as instruments to help teach other aspects of the curriculum, it is also expected that students will acquire a better appreciation for the arts as well as some of the skills involved in specific arts disciplines. In another project of the Memphis schools, Title I funds are supporting a "Reading through Drama" program in the junior high schools which uses dialogue and other creative dramatics activities to motivate youngsters to read more extensively and effectively.

All the advantages discussed above and others claimed by advocates add up to making integration in the non-art curriculum an important option among the modes of arts programming. A few additional disadvantages or dangers should be mentioned, however. The most important is that when any subject is studied only as opportunities arise from the study of other things, its own internal structure cannot be the guide to scope and sequence of learning episodes. This almost ensures a dilution of impact. Further, it makes the statement that the subject in question is not important enough to warrant its own attention. Make no mistake; children, teachers, and parents get that message loud and clear when a sub-

ject is given no program time of its own. To get somewhere with art—to make progress in all the behaviors discussed in the previous section—requires time, persistence, and curriculum integrity. And, we would argue, it also requires specialist teachers.

Elementary classroom teachers and secondary teachers of other subjects can add an important dimension to arts study, in openness, freshness of view and approach, even in depth of insight. It would be helpful to tap that resource but it is unreasonable to expect it to fill all the needs of aesthetic education. And, loath as we might feel to say it, we must mention the very real potential for abusing, misrepresenting, and deadening the arts by forcing them to serve as handmaidens to the study of everything other than art. The need for careful balancing is nowhere more apparent than here.

STAFFING PATTERNS

The need for schools to take advantage of the major modes of arts programming (single art study, interdisciplinary arts study, arts study within the general curriculum) while keeping them in mutually supportive balance suggests that staffing in the arts should be diverse. Each programming mode requires people with specific training and experience to assume particular teaching roles in the classroom and in production activities. The resulting mix of people serving a single school or set of schools can provide a rich environment for the nourishment of the arts in education.

TEACHING THE ARTS AS SINGLE SUBJECTS

Single art programming requires teachers in each art who have had specialist training in that art. Deep understanding of the problems and joys that students experience while engaging in production activities is far more likely if one's own involvement in similar activities has been deep. The frustrations of learning how to control the application of paint to canvas while trying to capture visually a mental image or feeling are readily understood by the teacher who has painted and who can offer guidance to students to help them in their struggle. Furthermore, the teacher who is actively involved in an art can better serve as a source of inspiration for students.

For example, Lynda McIntyre, head of the previously mentioned program at Wheelock School, is a professional artist (a painter and graphics designer) who holds a doctorate in aesthetic education. She comments, "I have my own studio here in town. I try to work at my own painting during part of every day, if I possibly can. The kids have found out where my studio is and they drop in and watch me

work. They don't interfere, either. We talk about what I'm doing, but they know about artists by now and they respect my need to work at my own craft."[9]

In the Chatham County High Schools of North Carolina, teachers with experience in professional dance and theater are employed to conduct a process-oriented program focused on creative dramatics and creative dance. These art forms were chosen because the county's music and visual arts programs were already well developed, but steps have been taken to have all four arts areas work in close cooperation. The program conducted at Northwood High School the first year (1975–76) was so successful that it was subsequently expanded to the other two county high schools in this rural community.

In addition to its other benefits, an art background enables a teacher to plan classroom activities effectively. The knowledge gained from personal involvement in an art provides insight into selection, sequencing, and pacing of activities, selection of curriculum materials, and effective use of equipment. The trained dancer is more likely to know which exercises students must master before they can accomplish more difficult movements. The potter will more likely know which clays are suitable for hand building and which for throwing on the wheel. And the experienced photographer will know how to set up a darkroom most efficiently.

Similarly, involvement in an art leads teachers to an increased awareness of what contemporary and past artists have accomplished and of the basic issues in the field. Such knowledge can aid them in planning general study activities which try to help students understand the place of the arts across time and within different societies.

But training and experience in an art are not enough, by themselves, to ensure successful teaching of that art to others. An accomplished painter, musician, or actor is not necessarily an effective arts teacher, since to produce or perform one does not need to explain the process to others. The arts teacher must be able to communicate the intricacies of arts processes to students so that they can gain the insights and skills they need in order to participate in the arts. The teacher-specialist in an art must receive pedagogical training in addition to arts training.[10] Knowledge of teaching techniques, grouping procedures, classroom management skills, evaluation methods, and child development are important in any subject area. To think that artists can be effective arts teachers without being skilled in these and related areas is to misunderstand the complexity of arts education.

Once in the classroom the person trained in an art and in educa-

tion should exhibit behaviors of both the artist and the teacher. Contemporary thought views the arts teacher as a resource person responding to students' needs and providing alternatives from which students can choose.[11] Much of the knowledge about alternatives comes from the teacher's background in an art while the ability to judge how much opportunity for choice students can handle results from training in education. For example, students who want to draw people realistically would be presented with a number of ways of looking at and depicting the human body, appropriate for their skill level and decision-making abilities. The arts teacher could also expand the students' understanding of why and how an individual's personality influences his or her appearance. Reference to artists such as Rembrandt, Matisse, or Bosch could illustrate the importance of capturing the inner as well as outer appearances of people. While meeting the students' needs by increasing their drawing skills the teacher will also be improving their artistic decision-making and problem-solving skills, familiarizing them with other artists' works, and helping them to understand the expressive power of the arts.

TEACHING THE ARTS IN AN INTERDISCIPLINARY PROGRAM

Interdisciplinary arts programming requires that arts teachers be equipped to teach multi-art classes by themselves or in cooperation with other teachers. Combining two or more arts for instruction is a difficult task; it tends to be done superficially if a person is not deeply involved in one of the arts and also reasonably familiar with each of the other arts under consideration. There are people who have such backgrounds, and as the interest in interdisciplinary arts education increases the number of trained people will also increase.

Another alternative is to have a group of teachers, each trained in one art yet conversant with several, work together. For example, the Jefferson County School District in Colorado has a team of interdisciplinary arts specialists who identify and develop arts resource materials, offer workshops for classroom teachers and administrators, coordinate the use of community arts resources, and assist teachers in the development of self-initiated projects.

At the Touchstone Center in New York City, teams of teacher-artists representing the various arts work with teachers in the classroom. Richard Lewis, Director of the program, described its operation:

Six teacher artists were hired under my direction to work two full days a week at a school. We agreed to be present three

days total during each school week. The six members of the project were divided up into two teams of three apiece. Each member of the team had a particular group of personal artistic and expressive interests ranging from painting, movement, dance, theater, story-telling, writing and music. The purpose in bringing together a variety of individual interests into a team situation was to minimize the importance of any art form over another. In short, this minimizing emphasized the way in which expressive modes and forms could be integrated as well as leaving open the possibility for all members of the team to represent any and all expressive directions.[12]

Often a group of arts educators or artist-teachers will team up to design and teach a course (or courses) incorporating a related arts approach. The South Carolina Arts Commission has, since the early 1970s, administered a comprehensive school–community arts program called *TAP* (for Total Arts Program) in three relatively rural South Carolina counties. Specialists in the literary, visual, and performing arts serve as teaching artists-in-residence in the participating schools and communities and provide students of all ages a broad exposure to the arts. TAP's School Program offers hands-on arts activities that are individualized for grades K–12 and are augmented by a series of in-school concerts in the performing arts. A related project of the Arts Commission involves two mobile vans— an Arts Truck and a Crafts Truck—which travel statewide to communities requesting them as visual arts teaching centers. Each carries a team of two teaching artists or craftspersons who take up two-week residencies in rural areas and open the mobile studios for classes and workshops. Community members of all ages are welcome but the Commission points out that, generally, youngsters of junior and senior high school age, together with their teachers, take more advantage of these opportunities than younger children or adults.

Familiarity with more than one art form enables the teacher to understand legitimate similarities and differences between the arts. For example, rhythm is an element of the visual arts, music, dance, poetry, and film, but it is defined and interpreted differently by artists in each discipline. The person with multi-arts experience is likely to know this and will not mistakenly represent all the arts as exhibiting rhythm in the same manner. Additionally, works produced in the same historical period but in different art forms are likely to exhibit some similar characteristics as well as possess many differences. Historical, cultural, and social events do influence artists but the unique character and evolution of each art form

affect them as well. Teachers deeply trained in one art and broadly acquainted with others are most likely to present such matters authentically.

The interdisciplinary arts teacher should also possess the type of art and education training that was described previously for the single art specialist. It is a formidable task indeed but one that can present the flexible and adventuresome teacher with an exciting challenge.

TEACHING THE ARTS WITHIN THE GENERAL CURRICULUM

The previous discussion of integrating the arts in the overall curriculum pointed out some values of doing so and also some inherent weaknesses and even dangers. To capitalize on the values, while avoiding the perils, non-art teachers are needed who are sensitive to opportunities to integrate aesthetic learnings into other fields in valid ways and who understand the need to call upon the help of arts specialists to follow up such opportunities. Teachers with little or no artistic training cannot go as far with aesthetic opportunities as students deserve to be taken. Yet the teacher whose attitude is positive can be a strong ally for the aesthetic as a natural component of many learning experiences.

For example, the John Adams High School in Portland, Oregon— which opened in 1969 with the expressed intent of experimenting with an interdisciplinary curriculum—designed and implemented *Project IMAGE* to connect arts experiences with the General Education Program and to develop interdisciplinary arts courses as electives. The high school's General Education curriculum came into being as a result of splitting up the traditional academic departments and asking all faculty members to accept assignment on a series of cross-disciplinary teams. Under Project IMAGE, the general education teams sought ways in which the arts could be used to amplify and strengthen their curriculum by restructuring their room environments and utilizing improvisational drama, craft and visual arts workshops, and other arts resources. Visits by professional performing groups—a mime troupe, chamber music and rock groups, theater and dance companies—were also incorporated into the program.[13] Although John Adams High was restructured into a School-Within-A-School arrangement in 1975 and the General Education approach was thereupon phased out, the major concept of this arts education program has been continued in one of the minischools serving some 150 students. Here a group of nine teachers has designed and implemented a team-taught humanities curricu-

lum that stresses experiential teaching strategies and process learning that embraces all of the arts.

In University City, Missouri, another notable endeavor has been under way since the late 1960s to make the arts integral to the total education experience of students throughout the system. Interdisciplinary arts teams have worked with students and with classroom and subject-matter teachers to develop broadly based units of study. For example, in a unit designed for secondary students called "Themes and Moods which Emanate from Spanish Art," issues such as war, religion, and bullfighting serve as generalized topics about Spain for students to explore in depth through various art forms. Another unit, called "Editing: A Way of Life," utilizes diverse media (visual, aural and filmic) in developing a series of studies which, together, form a senior-year communications course. Students are faced with making specific editing decisions based on aesthetic as well as cognitive criteria.[14]

In two elementary schools in the Webster Central District, Webster, New York, teams of five teachers per building have formed to carry out an ongoing commitment to integrating the arts. While beginning on a small scale, the enthusiasm of those involved is great. Many planned opportunities, as well as informal contacts and communications, have been made available to include other staff members. The Integrated Arts program encourages teachers to use movement, drama, poetry, sound, and visual arts to enhance and extend concepts within the established curriculum. Students are encouraged to expand traditional cognitive learning by exploring ideas through several senses. The emphasis is on training general classroom teachers in the arts and in implementation strategies. While teachers are not coerced to participate if they are not interested, it is hoped that the activities of participating teachers will interest others in becoming involved.

When a school has an active, exciting arts program with many opportunities for single art and interdisciplinary study, teachers of other subjects can be encouraged to contribute without the fear that they are being expected to offer an arts program themselves. In such an atmosphere arts specialists could set aside some time to serve as "roving ambassadors," their appearance and involvement outside their accustomed settings adding a healthy spirit of cooperation to the school atmosphere. And in the opposite direction, at appropriate times a non-art class could adjourn to an arts setting to follow up an interesting lead; the teacher and the arts specialist working together to probe the idea, exemplify in their own attitudes the spirit of inquiry their students are being urged to adopt.

When such freewheeling interactions are balanced by recognition of the uniqueness of each art and the special nature of the aesthetic, none need fear that authenticity of art study or non-art study is being diluted. Instead, natural overlappings are being recognized and good advantage taken of them. The benefits to students, teachers, the arts, and other subjects can be significant.

THE ROLE OF INNOVATION

For most schools in the United States implementation of any program in the arts beyond single art study could well be regarded as innovative, given Webster's definition of innovation as the "act of introducing something new or novel. . . ." But as the word is often used in education circles, it would take more than planned movement toward the kind of balanced program this chapter advocates to earn the appellation "innovative." We tend to think of a program as "truly" innovative when something is purposefully overbalanced or overemphasized or when something so novel is introduced that few have ever thought of it before. Improvement, no matter how solid, is usually not equated with innovation.

In that sense, what the field of aesthetic education needs most of all is not "innovation" but full-scale implementation of program elements that are fairly well accepted as proven; elements such as those discussed in this chapter and others in this book. There is a good deal of agreement on basic objectives, on modes of programming, on how to use staff more effectively, on ways to promote cooperative efforts, on how to loosen up schedules. Present know-how needs to be spread; our schools need to be infused with the richness of experience in arts education already gained.

A major teacher education project in the Cleveland area, "Education for Aesthetic Awareness," is launching an ambitious plan to apply many of the principles discussed in this chapter through a carefully developed strategy for change. The project, funded for a three-year period (1977–80) by the National Endowment for the Humanities, the Alliance for Arts Education, and several local foundations, is planning for the long haul by having the course of study installed at Cleveland State University so that it can continue indefinitely. The teacher education aspect of the project immerses arts specialists, classroom teachers, and non-art teachers in a full year of study (fall, winter, spring, summer quarters). Successive years are devoted to elementary teachers, then middle school and junior high teachers, and then high school teachers, all from the same school systems, so that by the end of a three-year period a

cadre of arts-trained faculty covering the first through the twelfth grade exists in each system participating. Within each system a team of teachers from a single building must participate, the team being the crucial factor for arts advocacy and program development within its building, for spreading its influence to other buildings in the system, and for integrating the program with the other two levels of schooling.

Supporting the teams is an elaborate system of building principal involvements, central office commitments in the form of a liaison team of Assistant Superintendents or Arts Supervisors, and a variety of action programs to involve parent organizations, school boards, and community arts groups. The entire project is coordinated by the Cleveland Area Arts Council, the full-time director, Linda Robiner, working from a Council base.

The training is given by a faculty of arts-in-education specialists representing visual arts , music, dance, theater, literature, architecture/environment, and film, supported by specialist instruction in philosophy of aesthetic education, curriculum development, and change strategies. A team of faculty members from local colleges and universities attends to all aspects of program evaluation. The thrust of the teacher training is toward development of model comprehensive arts programs in each building, including single art teaching, interdisciplinary arts teaching as a program unifier, and correlation of arts teaching with other subjects but with great care to protect the integrity of both the arts and the non-art subjects. While the course develops a concept of an ideal program, each team is trained to adapt its planning to the realities and potentials of its own building, so that its innovations can build upon existing programs in ways acceptable to and supported by the school as a social organism.[15]

Arts educators must be wary of touting "innovation" for its own sake. While some school systems want to be regarded as being in the avant-garde of education, most do not. Most are content to incorporate programs when their solidity has been demonstrated or at least when their practicability is reasonably evident. They do not want a sudden, major change that revolutionizes the curriculum, and to ignore that reality in favor of the glamour of "innovation" is to be self-serving rather than education-serving. Such a tendency is often found in newly emerging fields and in the arts this tendency must be guarded against with special care. Of course the excitement of art itself must touch all we do. Of course movement toward helpful new education patterns should be hailed and celebrated whenever it occurs. Of course people need the feeling that "new times are

a 'comin." But underneath must be a foundation of solid, accumulated experience, of steady growth occurring in all the myriad ways which add up to substantial change in the infinitely complex American education system. Constant call for "innovation" may well impede such growth.

Yet at the same time we also need experimentation, to expand our frontiers, to test ourselves against, to keep us humble. Some people in aesthetic education are by nature experimenters; they are among our most precious resources. Some school systems are natural settings for experimentation, by confluence of special people and special community circumstances; we cannot do without them. Innovation in the stricter sense is an essential ingredient in aesthetic education, along with slower but steady growth. In this matter, as in all others, the key to success will prove to be the striking of an effective balance.

What is being suggested here is that persons involved with designing arts programs acquaint themselves with the pertinent issues in arts education, assess their own situations with reference to the issues, and then respond with appropriate action. This chapter has attempted to set forth relevant issues, including the role of objectives in arts curricula, the implications of aesthetic behaviors for program development, and alternatives for programming arts instruction. However, it must be recognized that the school does not exist in a vacuum and is not the only artistic influence or provider of the arts for young people. The contributions of the community and other arts groups will be considered in the next chapter.

NOTES

1. An example is found in Bennett Reimer, *A Philosophy of Music Education*, Prentice-Hall, Inc., Englewood Cliffs, N. J., 1970. For a more detailed discussion of the use of objectives in arts education, see Ronald Silverman, *A Syllabus for Art Education*, California State University, Los Angeles, 1972.

2. For a more detailed discussion of these behaviors as guides to program development, see Bennett Reimer, "Aesthetic Behaviors in Music," in B. Reimer (ed.), *Toward an Aesthetic Education*, Music Educators National Conference, Washington, D.C., 1971.

3. Gene C. Wenner, "The Arts Program in the High School," position paper prepared for the Study of Schooling. (See Appendix B)

4. A useful description of some 175 secondary school humanities programs is found in Sister Grace Ann Geibel, "The Indexing and Dissemination

of Curriculum Guides for the Arts and Humanities," USOE Final Report, (Project No. 9-B-108), carried out at the Eastman School of Music, Rochester, N.Y., 1971.

5. Materials helpful for producing effective multimedia events are beginning to appear, for example, in *Silver Burdett MUSIC* (1974, 1978).

6. Charles B. Fowler, "The Arts Process in Basic Education," Pennsylvania Department of Education, 2nd ed., 1977, pp. 19–20.

7. A recent issues of *Art Education,* the journal of the National Art Education Association, is devoted entirely to environmental design education. The several articles in the issue attest to the growing awareness and commitment of art educators, among others, to environmental interests. Ronald Nepirud, in his article, "The What and Why of Environmental Design Education," argues that "we have in environmental design an integrating focus—the creation of form, which enhances human existence." He discusses how environmental design is concerned with ideas that are fundamental to the visual arts, such as the creation of form and design, and to areas in the behavioral and social sciences which attempt to understand human needs and aspirations. While recognizing the dangers and difficulties in talking about, let alone designing and implementing interdisciplinary learning, Nepirud presents an interesting rationale for the development of this field.

8. Lloyd H. New, "The Role of Art in the Education of the American Indian," *Arts in Society,* vol. 9, 3, F-W, 1972.

9. Quoted in Junius Eddy, unpublished paper prepared for Try a New Face, in connection with "The Arts and HEW Project," Government Printing Office, Washington, D.C., in press. (Mimeo)

10. Martin Engel, "The Continuing Education of Teachers of the Arts," *Art Education,* vol. 29, pp. 4–9, September 1976.

11. Silverman, op. cit., p. 7.

12. Richard Lewis, "Statement for the Study of the Arts in Pre-Collegiate Education," position paper prepared for the Study of Schooling. (See Appendix B)

13. Wenner, op. cit.

14. Stanley S. Madeja, "The Arts: A K–12 Program," position paper prepared for the Study of Schooling. (See Appendix B)

15. A more detailed description of this project is given in Bennett Reimer, "Education for Aesthetic Awareness," *Music Educators Journal,* vol. 64, no. 6, February 1978.

BEYOND "ENRICHMENT": DEVELOPING A COMPREHENSIVE COMMUNITY–SCHOOL ARTS PROGRAM

JUNIUS EDDY

The intent of the present chapter is to focus on those teaching and learning experiences in the arts which occur either as a consequence of moving children out of school buildings into the real world of the community, or by bringing resource people, materials, and ideas from the community into the formal classroom.

Clearly, both kinds of student and teacher involvement with the world beyond the classroom door are occurring, perhaps somewhat sporadically but with increasing frequency and effectiveness. The intent here is to examine such practices more closely, to identify those which appear to offer young people the most useful and satisfying learning experiences, and to draw on them for insights which may help us make imaginative projections for developing more effective arts education programs for the future.

SCHOOLS AND THEIR COMMUNITIES

It may be instructive, at the outset, to place these practices within the larger context of the history of American education as a whole. The notion that the education of the young might well take place in settings other than formal classrooms—and that persons other than professional educators could contribute effectively to that education—is receiving such enormous currency among leading educational strategists today that we are apt to regard it as a relatively recent invention. At best, we tend to fix its origin somewhere in the late 1950s or early 1960s when schooling was firmly in the hands of an entrenched educational establishment and many school systems were beginning to reel under the impact of their own complexity and the tensions of mass education.

Over the previous hundred years or more, the American school had gradually come to be an institution largely isolated from its environment, having little if any direct involvement with the community around it or with the citizen/public which was taxed to support it. It is clear, however, that American schools were not always this way, and that schooling itself began somewhat differently.

Arthur W. Foshay points out that "before we had the long years of compulsory schooling, children learned through participation in the real world fully as much as they learned in school, and both kinds of learning were equally honored." He continues:

> It is easy to look back nostalgically to a time a hundred years or more ago (for example, during John Dewey's childhood) when schooling was a more or less incidental part of growing up. In an essentially agrarian society, the community was the educator. The excessive formalism of the schools in those days

could be tolerated in a society that did not depend on the school to do what people assume it should do now.[1]

In Colonial America, where the fundamental purpose for educating the young was religious (or at least moral) in nature, the community essentially assumed responsibility for such learning as was deemed necessary. Learning to read was primarily a matter of training young people to read the Bible, and this basic instruction was largely carried on by parents in the home. Skill-oriented learning—the vocational education of today—was supported under a system of apprenticeships. This was first written into law in the Massachusetts Bay Colony in 1642 when these early colonists passed a law requiring apprenticeships for all children not otherwise occupied in learning or in labor "profitable to the Commonwealth."[2] John Dewey, clearly, did not invent the concept of "learning by doing."

These pragmatic and community-oriented grounds upon which the education of America's young people was initially established began, gradually, to assume a more formal character following the American Revolution. The religious base of education, adopted by the colonists, gave way to national concerns espoused in the Declaration of Independence. Soon, individual states began to establish laws providing for free public schools and, while they were seldom enforced, they did provide a modest financial backing for education. By the mid-nineteenth century, with the advent of child labor laws and compulsory education, the institution of the school as the primary—if not the sole—locus of learning came into its own; and the Common School, open to all and serving a wide range of ages, had become the prototype of the American schoolhouse we know today.[3]

As it grew and expanded, this prototype not only changed physically, but more and more it assumed educational functions which had been shared with the community in earlier days. In the process, it was almost inevitable that this now-burgeoning educational enterprise would draw further and further into itself and that the gap between it and the other institutions of society would grow wider and wider.

This may be a greatly oversimplified picture of what the school/community configuration had become by the middle of the twentieth century. But if it is even partially accurate, it is not difficult to move from this view of the schools—as a kind of unassailable bastion where the young of the community go each day for something called "education"—to the assumption that the responsibility, if not the right, for educating the young should be almost exclusively the province of the education professional. To be sure, citizens at the

community level were generally welcomed at school board meetings; they were urged to support their schools when bond issues and tax levies were on the ballot and to participate actively in their local PTA. Nonetheless, as nonprofessionals, most citizens felt largely unqualified to contribute much of substance to the educational diet or to make sound judgments about how or how well it was being purveyed.

The citizen movements of the 1950s and 1960s, organized initially to work with the schools in providing more adequate information about them to parents and taxpayers generally, were the first signs that some members of the community, at least, now wanted more serious and substantial involvement. Citizen dissatisfaction with the way schools were being run began to be expressed more and more frequently at school board elections, and bond issues and tax levies began to be defeated both in suburbia and in some big-city school districts. Organized groups of citizens, highly critical of the education their children seemed to be receiving, voiced their concerns more and more loudly in more and more school board meetings and called upon their elected representatives to do something about it. Clearly, by the mid-sixties, the public mood regarding the public schools had changed—and the educators, just as clearly, could no longer afford to ignore these new demands.

Some leading educators had seen the writing on the wall for a long time—long before, indeed, much of that writing was gut-level graffiti directed specifically at the schools by alienated youngsters. At a mid-sixties national conference of citizens concerned with promoting "better public schools," Francis Keppel, paraphrasing the old saying about politics and politicians, cautioned the group that "education is much too important to be left to the educators." The speaker was, of course, then the U.S. Commissioner of Education, and he was not, it seems clear, engaging in a put-down of the professional educator nor calling for widespread citizen revolt against the schools. The Commissioner was, however, making a point about new educational partnerships few citizens or educators could miss. And, moreover, he was at that moment playing a leading role in the design of a specific legislative instrument that would motivate many traditional educators to engage in more cooperative undertakings. Shortly, the Elementary and Secondary Education Act—and Title III of that Act in particular—would encourage them to seek new and productive alliances with the institutions and citizens of their communities, and it would enable citizens throughout the country to participate more effectively in designing aspects of their youngsters' education.

Title III of ESEA mandated that professional educators must, in the planning and development of innovative proposals for federal funding, ensure the "participation of persons broadly representative of the cultural and educational resources of the area to be served." Thus, for the first time in the history of American education, the contributions of nonprofessionals to the development of certain kinds of educational programs in the schools were officially recognized and written into law. Citizens at the community level were not simply "welcomed," "urged," or "invited" to help; their involvement was an essential precondition for approval of any grant application under ESEA's Title III. And the concept of Title III's "supplementary educational centers and services," which placed vital elements of teaching and learning in a variety of new settings beyond the classroom door, took on added strength as a result of this partnership between educators and citizens.

To be sure, ESEA's Title III has not become the strategic instrument for reforming the schools which many in the mid-sixties thought it might. Neither has it resulted in a decisive decline in the role of the professionally trained educator in the schooling of the young; nor, even more extreme, has it brought about a wholesale shift of educational responsibility from these trained professionals to a host of well-meaning but inexperienced "citizen/teachers" in agencies outside the formal enterprise of schooling.

This, it seems obvious, is not what Commissioner Keppel had in mind, either in his statement or in the Education Act whose passage was the central legacy of his tenure at the Office of Education. ESEA's Title III was, nonetheless, a significant milestone on the road toward a new kind of educational partnership between school and community which many now believe offers significant hope for education in the future. For, in fact, this modestly funded title of ESEA made us realize anew—at a time when "schools without walls" and other kinds of educational alternatives were hardly on anybody's drawing board—that education is, indeed, everybody's business; that schools are only one of the settings in which learning can take place; that the community itself is a potentially valuable environment for learning; and that many persons in the community, other than professional educators, can and should be enlisted as "teachers" for certain kinds of learning experiences.

Although these concepts may seem to be the common assumptions of a considerable body of educational thought today, their application as an accepted fundamental of educational practice has, so far, been limited to a relatively modest number of school systems throughout the country. But the ideas are being tested and more

productive partnerships are being forged, because both partners now seem to sense that the times—and young people themselves—demand it. If the humane values we now espouse for the young as they grow and learn are to be given more than lip service, clearly the established institutions of schooling must begin to adapt to the new environment. Foshay puts it this way:

> The time is almost at an end when we can treat the schools as a special institution, with its special little world that students enter each day and leave in mid-afternoon. For a school to be humane, all that it means to be human must be a part of the school, and that means that the reality of the world must be a part of the reality of the school. . . .[4]

COMMUNITY CONTRIBUTIONS TO THE SCHOOL ARTS PROGRAM

In all of this interpenetration of the community and the school that has begun to take place over the last decade, the arts have often served as the spearhead (or at least the advance guard) of this new movement. It would seem, at first glance, that the domain of the arts—as an area of study or as a body of experiences that could contribute to other aspects of the curriculum—would be the *last* to receive attention in any movement aimed at opening up the schools.

After all, the arts have traditionally been undervalued by the larger society, and their relegation to positions of low priority as nonutilitarian pursuits has largely been mirrored in the value system of the schools. The problems and demands of contemporary life, furthermore, would seem to require other more "practical" and "realistic" community involvements on the part of young people than those offered by arts institutions and professionals in the arts world. Certainly, this has been the assumption on which a good many schools have based their initial attempts to take education out beyond the walls of the formal classroom.

On closer scrutiny, however, we do indeed often find the arts leading the way, and perhaps it is not all that surprising. For it appears quite likely that the very absence of—or the low priority assigned to—good arts programs in conventional schooling may actually be the underlying motivation. When you give lip service to something but don't have a fundamental commitment to it, and therefore can't justify the people or the facilities and equipment to engage in it adequately, you compromise by trying to find other ways you hope will substitute in some measure for the real thing. You take young-

sters on occasional "field trips," for example, and you call it "cultural enrichment." (It is not always clear whether, by adding the word "cultural," our contemporary culture in general in all of its variety is intended, or simply Culture with a capital C, as in *The World of the Arts and Culture.*)

The field trip, of course, has been a venerable educational instrument for generations. It survived, and even flourished, all through the period when the schools were becoming increasingly remote from their communities in many other ways. At the elementary level in particular, imaginative teachers have managed for years to augment the textbooks and discussions of classroom learning by taking children to visit police stations, firehouses, dairy farms, and historical sites. At the secondary level, the scope expanded to include attendance at city council meetings and visits to government agencies, as well as to such commercial establishments as newspaper publishing firms, manufacturing plants, steel mills, and oil refineries.

For the most part, field trips along these lines were and are perceived as supplements to the regular educational program rather than fundamental approaches to learning. Students have often tended to take them in a holiday spirit, their euphoria dampened only by the papers and themes that were usually assigned as follow-ups. In the arts, however, the field trip was often more crucial. It simply took the place, in many schools, of aspects of learning that were hardly in the curriculum at all. Therefore, these occasional visits to art or historical museums, to libraries and cultural centers, and to children's concerts and other performing arts events were, until recently, the major instrumentalities through which many schools provided youngsters with any kind of learning experiences at all in the arts—passive though such experiences often were. Most community arts organizations had developed "educational programs" for school children and made it possible, often at their expense, for students and faculty members to participate in these programs during school hours. Kathryn Bloom points out that:

> . . .since educational programs traditionally were considered part of the services offered their communities, financial support for them was also viewed traditionally as part of the total budget of the arts organization. School systems might underwrite transportation costs to the concert or exhibition, but just as frequently these costs were provided to the schools. Almost without exception, arts organizations supplied financing for the time of their own staff members and the facilities that were needed to offer services for the schools and the community

audiences. Since a few patrons underwrote the total operating budgets of museums and orchestras, financial support for educational activities was not difficult to secure.[5]

Just as the field trip has been a standard device from the past for bridging the gap between school and community, so has the occasional appearance in the schoolhouse of people and ideas from outside it been a solid staple of most schooling for generations. Big-city school systems, of course, have had obvious difficulties with this process because of the sheer numbers of students they must deal with. But in the best of them, and in many smaller nonurban schools, responsible teachers have long made it a practice to invite parents and other representatives from the world of work and the professions into their classrooms to talk about their jobs and discuss ideas related to aspects of the academic curriculum.

Until recently, however—with the advent of the Artists-in-Schools Program developed in the early 1970s by the National Endowment for the Arts and the U.S. Office of Education—this has seldom included professionals from the world of the arts. When artists entered the schools at all, it was to give occasional in-school performances as part of a series of "cultural" assembly programs. Only infrequently did the actors, dancers, or musicians involved find their way into classrooms for more personal involvement with smaller groups of children. And literary and visual artists—poets, painters, sculptors, and graphic artists—were virtual strangers to the average classroom fifteen years ago, except for an occasional lecture-demonstration.

Much of this picture changed radically, of course, with the passage of the Elementary and Secondary Education Act of 1965. Over and above the unprecedented federal funds involved, the two major titles of this act, Title I and Title III, contained built-in incentives that fitted neatly with these traditional but unexploited teaching methods; they extended and enhanced the effectiveness of these practices considerably and, in the process, served to bring out into the open the larger potential of "the community as educator." These two titles were particularly advantageous for the experimental development of new approaches to arts education: they provided funds to supplement the operating budgets for both the schools, whose arts programs were undeveloped or languishing, and for those arts organizations in the community which had been offering traditional educational services but were beginning to suffer increasingly severe budgetary crises. In Kathryn Bloom's words, "a new patron had been discovered" in ESEA for arts organizations wishing to augment their services to the schools.

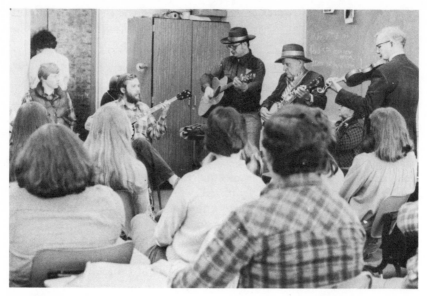

Rabun County High School, Foxfire Program. *(Courtesy of Eliot Wigginton)*

Under other federal programs such as Head Start, the Teacher Corps, the Education Professions Development Act, and certainly the National Endowment for the Arts and the Humanities, the roads leading from the schools out into the community increasingly became two-way streets. The classrooms of American schools began to be augmented and enriched by parents and others from the community serving as resource persons, teacher aides, and paraprofessionals. Among them, one could discover increasingly the enlivening and creative presence of professional artists and dedicated younger professionals who were learning to be artists and who also cared about children.

The fact that, in retrospect, only a few of the arts education programs developed under ESEA's Title I or Title III* have become models for the nation does not diminish the new sense of legitimacy and the ensuing visibility which this historic act gave to the arts in education movement at that time. Neither does it obscure the fact that many projects spawned under these Titles took place outside

*Since 1975 ESEA's "innovative programs," formerly supported under Title III have been added to that Act's new Title IV-c. As of November 1978, USOE sources indicated that this Title was supporting some 165 arts or art-related projects nationally, at a cost of about $4.7 million.

the schools and utilized a wide range of people and resources that had never been so fully employed in the service of education.

SCHOOLS WITHOUT WALLS AND OTHER ALTERNATIVES

By the beginning of the present decade, the forces which had emerged in the sixties to counter existing educational practice in the institutions of formal learning became even more sharply delineated. The effort to place students in a wide variety of learning situations outside the school became increasingly identified as a major educational goal of a large segment of the new school reform movement. At the high school level especially, the search for alternatives has led a large number of urban school systems—and indeed some smaller systems as well—to initiate experiments that have come to be characterized as "schools without walls."

"The temptation over the past decade," the *Carnegie Quarterly* noted in 1974, "has been to give up on the idea of directly changing the existing schools. . . ."

> Instead, many administrators, teachers, and parents have hoped that by starting from scratch on a small scale, they could design "alternative" or "experimental" schools to emphasize individualized methods of learning, responsive relationships between teachers and learners, and community participation in the schooling of its youngsters. The result—motivated and enthusiastic students and hence better learning—as the reasoning goes, would pressure the traditional public schools to change by the force of such accomplishments.[6]

One of the early prototypes, developed in the late sixties, was the Parkway School in Philadelphia where the phrase "school without walls" first gained currency. At the Parkway School, "there is literally no school building, the students carrying on almost all of their educational activities in the existing community institutions, public and private."[7] Moreover, many of the community institutions in which these high school students received part of their education were the cultural agencies and institutions of Philadelphia—the museums and libraries, the studios and galleries used by professional artists, the professional theaters, dance companies and music organizations, the craft and metalworking shops, and segments of the communications industries of film, radio, and television.

Another example is Chicago's Metropolitan High School, a public alternative school headquartered in an office building leased and

remodeled by the school system and located not far from the city's busy downtown area. As described in a 1974 report, "Metro allows its students, who are chosen by lottery from a host of eager applications from [high schools] all over the city, great individual choice and encourages other-than-classroom learning by initiating courses at everything from art museums to businesses."[8]

These schools-without-walls alternatives suggest the possibility that a growing segment of public education might one day be conducted in arts-related settings. Furthermore, as these community-based experiments are refined and pass out of the experimental stage—and in a number of urban school systems many of them already have—they offer the additional possibility that programs in arts education, in partnership with artists and arts organizations in the community, will become a fundamental part of the new curriculum.

Already, there are signs that a number of metropolitan school systems are moving toward a fuller utilization of the resources of the city as an educative instrumentality. Minneapolis, Oklahoma City, St. Louis, New York City, Pontiac, Hartford, and New Haven, in addition to Philadelphia and Chicago, are among those cities in which school systems have begun to explore such alternatives. They are doing it on a scale, and with a commitment to curricular planning, that goes considerably beyond either the traditional field trip or the occasional exposure of youngsters to events and institutions in the adult world. And in Boston a plan has been in the works since 1973–74 that envisions an arrangement under which nearly a quarter of the system's school-age children would attend classes in places other than school buildings.

Boston's "The City as Educator" plan is viewed by its advocates as a means of providing youngsters from kindergarten through high school with relevant, firsthand learning experiences in a variety of community agencies and institutions including art museums, performing arts institutions, neighborhood agencies devoted to ethnic and minority arts, college and university arts departments, architectural centers, and media-related agencies. Government, business, and commercial establishments of the Boston area would, of course, be equally involved. In addition, the plan envisions the establishment of "new resource centers" throughout the city, in facilities to be leased and remodeled within existing institutions or next door to them. According to the Boston Commission on Secondary Education, "The City as Educator programs will cost no more than the present school system. . . . No additional teachers will be needed since the centers will be staffed by regular teachers re-

assigned from their home-base schools, and by personnel from the partner institutions."[9]

The plan was originally targeted for full implementation in 1976–77, but obviously such a sweeping reorganization of educational practice in a large metropolitan setting can't become fully operational overnight. Though temporarily sidetracked by the integration controversies which have wracked the city during the mid-seventies, at last reports the planning was still going on.

Meanwhile, Boston's Metropolitan Cultural Alliance (established in the early seventies as a coordinating agency for the city's cultural institutions) has been pursuing independently many of the original goals of the City as Educator Plan through its Education Project. Partly as a means of contributing to Boston's desegregation efforts, the Project—recently established as an independent agency and redesignated as the Cultural Education Collaborative—has planned and implemented programs aimed at helping Boston area schools and cultural institutions develop in-depth, multisession courses which involve students from area schools in integrated cultural experiences. A major grant from the National Endowment for the Humanities was awarded to the Collaborative in 1977 to carry its work forward, with particular reference to teacher training aspects.

Such developments as these, it should be noted, are taking place within the context of existing public school systems. There have been others which have sought alternatives outside the system where groups of parents and teachers have tried to set up their own alternative schools on a private basis. Without demeaning the motives that have led people to these private alternatives, it seems clear that their staying power is tenuous at best and that it is not on financial grounds alone that many fail to survive; they have generally been unable to create and maintain enduring networks of adults who are both willing and able to commit themselves fully to educating the young under such circumstances. One is compelled to conclude, with Joseph Featherstone, that "the pursuit of 'alternatives' and 'options' must center on public education, because that is where the students and the money to educate them are."[10] He continues:

> It is one thing to argue for "alternatives" or "learning networks" if they have something like a public . . . schools' budget, professionalism and long-term political backing. Then we are talking about an institution that will last over time, that can hire professionals to guide students, help them plan work-

study and apprentice arrangements, connect them to adults offering educational experiences, supervise them and their adult mentors in placement sites, and think about such mundane matters as transportation. It is quite another, infinitely less convincing thing to speak of alternatives lacking these commitments.[11]

The Parkway School, Metro High School, and other schools-without-walls experiments within the system have brought to maturity in differing ways the concept of the "supplementary center" initially given legitimacy under ESEA's Title III. Metro, certainly, as well as the new learning and resource centers envisioned in Boston's City as Educator Plan, are essentially their systems' versions of the supplementary center. As enabling structures for coordinating aspects of a school system's outreach program, their counterparts are now visible in a growing number of localities throughout the country.

Some of these agencies serve differing kinds of functions for a single large district; others meet a similar range of needs on a regional basis, serving clusters of smaller districts which cannot afford to provide such a variety of services by themselves. New York State's regionally located BOCES districts—Boards of Cooperative Educational Services—are versions of the latter concept. Some BOCES headquarters, such as that in Nassau County, also operate their own Cultural Arts Centers where a wide variety of classes in the fine and performing arts are conducted for a group of school systems in a given county. Another version is Chicago's Urban Gateways, an agency that began as a modest cultural enrichment program for poor black children in 1958 and has grown into a multifaceted community resource, coordinating a wide range of cultural services that reach some 250,000 school children (as well as teachers and parents) throughout the Chicago area.

In point of fact, one of the most familiar forms for arts-related projects under Title III was the *cultural resources center,* known variously as a *regional cultural center,* a *cultural arts center,* or a *learning resources center.* By whatever name (depending on their size, location, and purpose) such centers were generally devoted to centralizing a great variety of educational functions and services of an arts-related nature. They functioned, in a sense, as educational brokers in establishing a whole new set of relationships between consortia of schools and performing or fine arts groups, whether they already existed in the area or were brought in under touring programs.

Actually, there is a kind of "educational halfway house" context

in which one can view all of these differing developments taking place within the public education system. Their mission, in a very real sense, is to provide the schools with a differently organized extension of itself. It is an extension which, through new kinds of community based structures that bring a larger dimension to learning, helps young people make the transition to the world outside the formal classroom in such a way that the whole experience becomes a part of the learning process.

With respect to the development of more imaginative arts programs, these new "halfway houses" seem to offer the possibility that learning in other-than-classroom settings might, at long last, be merged with regular classroom learning in the arts so as to bring an entirely new kind of arts curriculum into being. Such a curriculum would integrate the two kinds—or styles—of learning in ways that would enhance and benefit both, rather than using other-than-classroom learning as a kind of enrichment supplement to conventional schooling (which still seems the dominant rationale behind most such practices today). The need to "enrich" the regular curriculum in conventional ways would then be largely eliminated because the entire curriculum would represent—in a variety of alternatives open to every student—precisely the richness, the flexibility, and the diversity it now denies to all but a few.

PLANNING A NEW ARTS CURRICULUM

To talk in these visionary terms about an entirely new curriculum in the arts (or in the aesthetic domain generally), made possible by a greater interaction between the community and the school, is to move immediately onto somewhat shaky and oversimplified ground. Such a discussion cannot deal realistically with the imponderables that will doubtless rise up to plague these practices at every step of their developmental journey. So perhaps it is best not to continue too far into this unknown terrain. It may help, however, before touching briefly on some contemporary models that may point in promising directions, to list a few of the assumptions and conditions upon which a new curriculum of this kind would depend.

- First, it would need to be concerned with a more equitable balance between the varieties of arts experiences involved in community-based learning and the content and activities suggested by the authors of other chapters in this volume for imaginative in-school arts programs.

- Curriculum development would, accordingly, no longer be conducted by the in-school staff in relative isolation from its community counterparts, as is so often the case today. At each educational level decisions about instructional goals in the arts, the content of the new curriculum, and the planning of learning activities which embody them would become increasingly the joint responsibility of both sets of partners. They should reflect, moreover, the most appropriate settings and teaching styles through which these instructional goals could best be accomplished, whether in the school or outside it.

- For that matter, it would become less productive for broad educational planning to be conducted unilaterally by the school-based staff for any specific discipline or area of study. As the arts elements of the curriculum move from their present peripheral position to more equal status with other areas of study, broad interrelated planning will be essential to integrate all aspects of learning regardless of the setting in which it may take place.

- Because, for the arts at least, community-based learning would no longer be a matter of filling in the gaps, enrichment-style, these new working relationships with educational partners in the community will involve much more than merely contracting for services. It will be a matter of cooperative planning and development among all the relevant segments of the school-community teaching teams, and arranging for services would be factored into the planning process at earlier stages than is now the case.

- The vital element of providing more sequence and continuity to arts programs would need, from the beginning, to take account of the ways in which community-based learning could be phased into the total program most effectively. The one-shot exposure to arts events would no longer be tolerated. Curricular decisions involving the most appropriate sequence for differing kinds of learning opportunities in, or provided by, community arts resources would need to take the child's readiness for certain experiences into consideration at every educational level. Attention would have to be given, at each step, to what had gone before and what would follow.

- Decisions would have to be made about all the other requisite factors of schooling—space and equipment requirements, transportation needs, the kinds of credit to be granted for outside learning experiences, grading and evaluation practices, and even such matters as the selection of textbooks and the development of reading lists. Although final authority on all these matters would

inevitably have to remain with the schools, agreement on them would need to be worked out cooperatively with the community-based teaching staff.

- Credentialing criteria would need to be developed for the part- or full-time "teachers" based in community settings—other than those in educational halfway houses (supplementary resource centers) officially operated by the schools and staffed primarily by professional educators.

- Advisory boards of top-notch professionals from the arts field having broad educational experience and commitment would probably need to be appointed to assist the schools in identifying the best arts organizations and people for conducting other-than-classroom learning. Some screening and selectivity would have to be done to prevent—as far as possible—commercial entrepreneurs, artistic charlatans, irresponsible artist/teachers, and artistic groups of less than proven quality from intruding into and damaging the entire educational process. This would not avoid the possibility that poor and/or irresponsible teaching will take place—the schools themselves have their share of this now—but such a screening and supervisory mechanism would help to keep such practices to a minimum and under control.

- This point, moreover, suggests that some better methods of interpersonal orientation will have to be developed between the in-school teaching staffs and the new breed of artist/teachers such an open curriculum will demand. Obviously, neither all professional artists nor all arts organizations in the community will want to become involved in educational matters, and those that do will not necessarily be the best, or even good, teachers. By the same token, professionals in the teaching profession, including those with training in the arts, may not welcome their community counterparts into the teaching fold with open arms. The fact is, neither professional teachers nor professtional artists have an absolute monopoly on the best ways to reach, motivate, and teach the young. Teaching strategies that embody the best of what *both* professions have to offer children will need to be exchanged in more productive ways than has often characterized present attempts to forge this new alliance.

- And certainly, the more such alliances are explored, the more necessary it will become to alter the processes by which teachers are prepared or retrained. The training of arts specialists will need to be broadened, and much greater emphasis placed on interpersonal relationships, on more imaginative uses of com-

munity arts resources, and on the role of the arts educator as a catalyst in building the new school/community curriculum. Conventional training for classroom teachers, with its dependence on traditional "methods courses" in art, music, and physical education (read: "movement" or "dance"), will no longer be sufficient—if it ever was. Aspects of pre-service teacher education will take increasing advantage of community-based arts resources for broadening teachers' arts-awareness through practicums or internships. This, to be sure, is already beginning to happen in some localities, as more and more colleges and universities are looking beyond their own classroom setting and making alliances with such resources in the community as well as with neighboring school systems where good arts programs are evolving. Certainly, too, the retraining process on an in-service basis will need to involve teachers at all levels more fully in workshops, seminars, and institutes conducted by practicing artists (who care about children and learning) either in the schools themselves or in community-based settings. Movements in these directions are also increasingly evident around the country.

These are only some of the more obvious considerations that will need to be faced by school systems which take seriously the commitment to open up the educational process by bringing new partners from the community into it on a more organized and systematic basis.

The most difficult problem of all, however, is the problem of numbers. Is it possible—or even advisable—for a school-community teaching partnership to make a new integrated curriculum of this kind available to *all* the children in a given system? The roadblocks in the way of institutionalizing such practices for every child are seemingly almost insurmountable, even granting that it may be desirable. Financially, most schools at present could not even begin to cope with the probable costs. Even if Boston's plan does become a reality for "one-quarter of that system's children," and it turns out to be no more costly than the present method of schooling, the remaining three-quarters of the children would still be excluded.

Logistically, of course, total school-system involvement in such a partnership approach would be a nightmare for large metropolitan systems—although busing for purposes of racial integration, already a costly and logistically complicated process, might achieve both kinds of purposes without adding greatly to the cost. Indeed, this is one of the major factors which led Cleveland's then-Superintendent, Paul Briggs, to develop in 1966 the prototype Supplemen-

tary Education Center referred to earlier. Busing racially different elementary school youngsters daily to an educational "halfway house" for integrated but more informal learning experiences turned out to be less upsetting to Cleveland parents of both races than busing students to different schoolhouses for regular classroom learning. Other urban systems seem recently to have been proceeding in similar ways toward solutions to their integration problems.

It is on other grounds, however, that more conscientious school-community learning partnerships may find themselves, in the end, unable to extend such experiences to include every child in the system. These grounds simply have to do with the lack of sufficient materials, equipment, or facilities within the community—in the arts or any other subject area—to handle the large numbers of children involved. Certainly this is true of arts resources even before one begins to make qualitative judgments about which resources, among all those available, might be best qualified to offer the kind of educational services this new, open curriculum envisions.

Smaller systems in rural communities and in many suburban communities seldom have such resources available at all. In these circumstances, they must rely on a BOCES-type center or some other kind of supplementary educational halfway house to provide them, through touring arrangements, with occasional booking of performing groups from nearby urban areas, or by transporting youngsters to performances and museums where these opportunities do exist. And so begins the inevitable compromise that results in the traditional "enrichment" approach: either an occasional arts experience for all the children or a more systematic, long-term, and integrated arts curriculum that reaches only a few children—often the very youngsters who show promise in the arts or are already motivated to explore what the arts have to offer.

In the larger metropolitan school systems, where a wide range of arts resources may indeed be available, the sheer numbers of youngsters which must be accommodated almost precludes the possibility that every child in the system can be involved systematically in both learning environments. The adult populations of the cities are already crowding their major cultural institutions—museums in particular—during the daytime hours. Cost considerations, shortages of teaching personnel, plus limited availability of exhibition or performance facilites that could be used simultaneously for learning environments automatically place restrictions on the number of children that could be accommodated. So the same outcome obtains: fragmented "exposures" for the many or deeper long-term involvement for a few.

Serious attempt are being made, of course, to use the latter approach as a kind of opening wedge for broader, system-wide involvement. One of the more conscientious developments along these lines is the Opening Doors Program in Oklahoma City where fifth-grade children from every elementary school in the system were the initial "few" toward whom the program was targeted. The educational staffs of virtually every relevant arts or cultural institution in the city have planned jointly with school faculty and consultants "to develop programs that are based on classroom curriculum and teaching objectives"[12] and which may, in time, be expanded beyond the fifth-grade level if the initial effort develops satisfactorily for all concerned. In Louisville, a similar but far more modest effort, involving fourth-grade youngsters from a few schools, is currently being piloted through a citywide alliance called PARTNERS. And in University City, Missouri, during 1977–78, all fifth-grade youngsters and their teachers were involved in a pilot project, The Arts and The Basic Curriculum, which utilized the full resources of the St. Louis Art Museum.

These models suggest that school-community programs based on the best theories of child growth and development might ultimately emerge which would reach all the children in a given system in a way that would involve them differently at several of the most appropriate stages in their social and educational development. Fully integrated outreach programs might, if explored in these terms by large urban districts, take place systematically for all or most children at, say, the second, fifth, eighth, and eleventh-grade levels in a school system, with particular attention to the kinds of learning experiences that would be most appropriate for each developmental level. In this way, trying to relate large numbers of youngsters to a limited group of outside resources at any one time might be managed more effectively.

ETHNIC AND NEIGHBORHOOD ARTS CENTERS— AN EMERGING OPTION

It may, nonetheless, be in the major cities that arts programs involving other-than-classroom learning have a good chance of reaching large numbers of children. Within the last fifteen years a whole new set of centers, agencies, and institutions has begun to emerge in most cities, places that give long-denied expression to the artistic and cultural experiences of minority-group Americans: the blacks, the Puerto Ricans, the Mexican-Americans, and, to a lesser extent, Asians and native Americans. I have commented elsewhere that, as these groups:

...began to seek out the roots of an ethnic or racial heritage which the dominant culture had systemically ignored or denigrated, the nature of the community-based arts movement began to change. The arts became an obvious and powerful vehicle in this cultural renaissance, a vehicle through which minority group artist-leaders could begin to voice the social and economic concerns of their communities, to assert a new-found historical identity, and to reflect the new sense of racial pride and awareness they believe is essential to their survival in white America.[13]

These groups frequently grew out of arts programs for young people which, for years, had been conducted in neighborhood centers, settlement houses, community action agencies, recreation centers, museums, churches, and a variety of other community settings. As the sixties advanced, many of these groups moved out from under the authority of such sponsoring institutions—mainly as a result of the civil rights and protest movements of that period—and established their own kinds of community arts centers under indigenous leadership, but with all the attendant financial difficulties affecting long-term survival.

A number have survived, however, under new funding arrangements, both public and private. Many of those which have endured, or developed independently, such as Arthur Mitchell's Dance Theatre of Harlem, maintain both a professional performing company (in dance, theater, or music) and their own schools or training programs. Some also conduct a variety of workshops and classes for neighborhood children and youth. Others (like the Performing Arts Society of Los Angeles (PASLA), Cleveland's Karamu House, the Henry Street Settlement in New York, and the sixty-odd affiliates of the National Guild of Community Schools of the Arts) function largely as community arts centers where rigorous traing in the visual and graphic arts, and even in film and television, is often as much a part of the program as the performing arts. Virturally all of these groups, schools, or centers are overwhelmingly youth-oriented because the arts activities that go on in and around them have met the social, educational and artistic needs of low-income youngsters in ways that most inner-city school programs seldom have. Don Bushnell has noted that:

> ...the arts center (provided) an alternative or subschool for many minority students who were seeking relief from compulsory public education. Like apprenticeships, the Job Corps, and the armed forces, the performing arts centers became "a way out" for restless youth—competing with the non-institutional

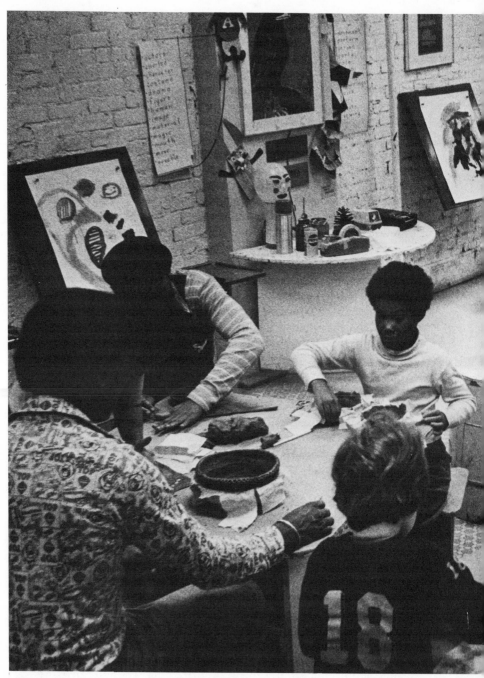

The Children's Art Carnival, open workshop, New York City. *(Photograph by Bill Anderson. Courtesy of Betty B. Taylor)*

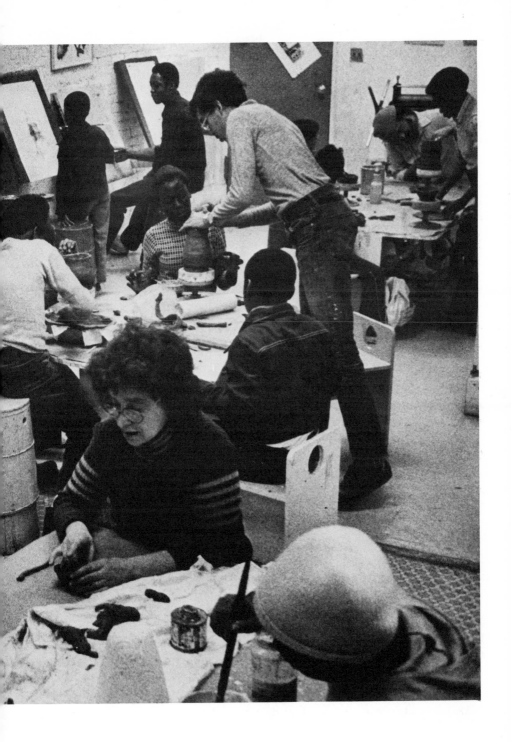

alternatives of dropping out, delinquency or drugs The arts support the life style of minority youth and open up a visual, aural, and kinetic means of expression that is frequently lacking in the educational experience that urban schools purvey.[14]

As the 1968 report of a U.S. Office of Education conference on the arts and the disadvantaged learner pointed out:

> . . .at a time when educators in schools serving the urban and rural poor are desperately searching for new ways to reach the minds and spirits of these disadvantaged children, a whole range of potent teaching strategies *based in the arts* that might be marshalled to assist them is apparently being overlooked or ignored.[15]

To a large extent, they are still being overlooked or ignored by urban school systems generally, but it may be that the climate is more conducive today than in the recent past for an educationally productive mix to take place between the new breed of community arts organizations and the public schools. Certainly the very existence of such centers in urban settings vastly expands the number and kinds of community arts resources that might be explored as the schools seek new settings for other-than-classroom learning. Furthermore, because the artistic work going on in them expresses the richness of cultural tradition in ethnic and racial subcultures of American society, they offer far more appropriate experiences for the growing concentrations of nonwhite young people in our cities than other more established cultural institutions are apt to offer. Certainly, the latter should not be the only places considered by the schools in their search for out-of-school settings.

A growing number of these neighborhood centers and programs are already serving students in their communities in precisely these ways. Some, such as the New Place in a low-income, predominantly black-Hispanic neighborhood in Tampa, Florida, are serving as teacher training sites as well. Richard Loveless, an artist/teacher at the University of South Florida, worked informally for several years with arts education students at the University and with neighborhood young people to develop the approaches embodied in the New Place, which he refers to as "an urban media exploration and communications center where youth can give substance to their unique ideas through the creation of art forms."

By 1974, the New Place had become—for the South, at least—a rather unique multiracial neighborhood arts center, with a staff of

seventeen artists-in-residence (seven of whom were full-time), which served as "a second home" for hundreds of children and adults from many different sections of the Tampa community. Oriented heavily toward the communications technologies of film and television, but embracing activities in virtually all the other art forms, the New Place has never quite institutionalized itself as an alternative school site within the public education system; its present informal relationship—as an out-of-school learning environment for young people after school, at night, on weekends, and throughout the summer—appears to work more productively and comfortably, as Loveless views it now.

The center, with its communications arts projects which reach out across the entire Tampa community, has in recent years offered a wide-open opportunity for university students preparing for teaching careers to immerse themselves deeply in youth-oriented arts projects as part of a graduate workshop called the Urban Arts Environment. Through these projects, largely of their own devising, both prospective and experienced teachers have added rich, new arts dimensions to their own education as teachers.[16]

OTHER COMMUNITY INVOLVEMENT OPTIONS

Up to this point, references have been made to a number of places and programs which have the potential for developing a balanced school-community curriculum in the arts. There are, however, some localities in which specific practices on the part of both school systems and community-based arts resources are occurring that may be worth describing briefly for additional insights into particular elements of the equation.

It should be mentioned here, moreover, that a considerable influence on this entire development has been exerted by one small national foundation—the JDR 3rd Fund—which has, for over a decade now, supported crucial developmental projects in selected school systems around the country to demonstrate the value of the arts in the general education of all children. These projects have emphasized processes designed to integrate the arts with the regular school curriculum, but they have also stressed the critical importance of supplementing this work by drawing more systematically and effectively on the contributions of community-based arts resources, both people and organizations.

This, in fact, has emerged as one of the fundamental tenets of the Fund's arts-in-education philosophy, permeating its work not only in its early school-based projects but, more recently, in develop-

ments seeking to establish comprehensive arts programs within the structures of big-city school systems and a number of state education agencies. The fund has helped support the activities of two "networking" operations to carry these efforts forward in recent years. One brings together representatives of six big-city school systems— New York, Hartford, Minneapolis, Seattle, Little Rock, and Winston-Salem—in a League of Cities for the Arts in Education; the other, called the Ad Hoc Coalition of States for the Arts in Education, joins nine state education agencies together for similar purposes.

Whatever the origin of the practices mentioned in this narrative, however, one hesitates to call them "models" because of their particularity to the specific set of circumstances in which they have emerged. Nonetheless, they do provide further clues for school systems and their arts-program partners in the community that wish to move in these directions.

Before describing further instances of the genre, it is important to underline the fact that programs of this kind are in constant flux. The examples described below (and others mentioned earlier as well) are, in effect, "portraits in motion." Their pictures have been snapped at specific points in their existence, and by the time this volume appears their outlines may well be altered, substantially or slightly, for better or worse.

The nature of schooling in this fast-moving era is such that systemic changes may, in fact, have overtaken many of these somewhat fragile, developmental efforts, as the effect of budget cuts, teacher and administrative turnover, new educational or community priorities (and, to some extent, the back-to-basics movement) begin to impact in varying ways on each locality. Some projects and programs may have experienced productive growth and moved to new levels of development, while others may have been altered drastically, curtailed, or eliminated entirely.

It is, however, the processes, approaches, and ideas embodied in them—not whether they have survived the developmental storms— which make them worth examining. The "models," if that indeed is what they are, remain.

PERFORMING ARTS ORGANIZATIONS

The recent history of attempts by most performing arts organizations to serve the schools has, as noted earlier, been focused largely on exposing school-age youngsters to high-quality performance experiences. These activities were often very costly indeed, and, because they lacked the important elements of sequence and conti-

nuity or failed to concentrate as much on working with teachers as they did with students, the new alliances which generated them have seldom achieved long-term stability or impact on the educational system. Few school systems have therefore been affected in ways which could influence the learning process for future generations of students, and, without relying on outside funding sources, very few performing arts organizations have found it financially possible to sustain their performance-oriented services as an enduring educational resource to the schools.

What some performing arts groups have begun to develop as an alternative to this approach is the creation of special-purpose performing units, on a much smaller scale, for school or community work. A few resident theater companies, for example, have built their educational programs around a carefully trained group of young performers who seldom take part in the company's major productions but whose work is devoted exclusively to creating special-purpose theater experiences for children and youth. These are generally modest, informal productions designed for touring engagements in area schools, although frequently these groups will conduct classes and workshops for students (and sometimes for teachers) at their own performing home as well, bringing student audiences in for performances there. Frequently, too, these school-touring companies augment their in-school performances by preparing special curriculum materials for teachers to use and by moving into regular classrooms for lecture-demonstrations, storytelling, theater games, and improvisational work.

Companies that have engaged in these activities, in differing ways over the last decade, include Atlanta's Academy Theatre, the Improvisational Theatre Program of the Mark Taper Forum in Los Angeles, Baltimore's Center Stage Theatre, the Performing Arts Foundation's (PAF) Arts-in-Education Center on Long Island, the Dallas Theater Center, and the Living Stage Program of Washington's Arena Stage. Other smaller theater companies—such as Boston's Proposition Workshop and the Florida Studio Theatre in Sarasota—and some professional dance companies around the country seem to be doing much the same thing.

Unlike most performing groups which have sought to extend their service activities into community and educational channels, the Academy Theatre in Atlanta began in the early 1970s to make this concern to its functioning as an artistic enterprise and not merely an adjunct to its production and training program.

The approach the company took was to develop a creative setting—a laboratory, if you will—in which both the artistic skills of

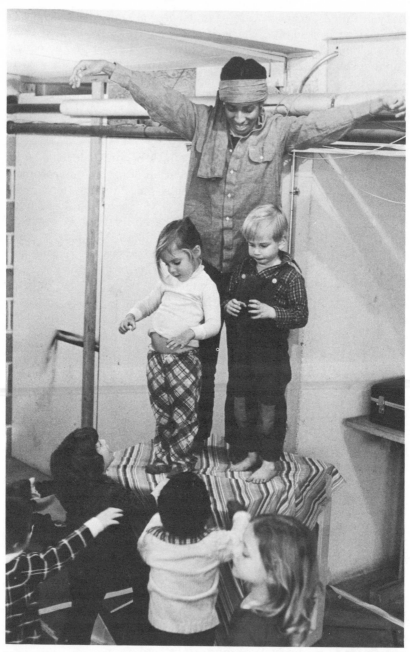

Living Stage, Washington, D.C. Instructor, Rebecca Rice. *(Photograph by Tess Steinkolk)*

the people involved and the services these people can offer the educational community could be simultaneously nourished and refined. By the mid-seventies, the Academy Theatre staff, under the leadership of its founder and artistic director, Frank Wittow, and its administrative director, Nancy Hager, had implemented this approach experimentally in a variety of ways: by augmenting and refining its touring program of relevant, original performances in Atlanta's high schools; by encouraging members of its acting company to work with teachers and students in "learning centers" or in elementary classrooms; by placing these actor-teachers in specific schools where they are responsible for creative drama, improvisation, or movement classes; by conducting workshops for teachers and students; by creating and producing new plays for very young children at the theater; and by teaching courses in the related arts for prospective teachers in the teacher education programs of local colleges and universities.

Early in its existence—in line with its original intention to concentrate on performing original scripts for its adult audiences—the Academy Theatre began to explore new methods of creating its own plays and, thus, developed new works which grew out of the creative improvisational explorations of the entire company. Playmaking of this kind was undertaken initially for presentation to students in Atlanta high schools. Later on, however, it generated a crucial redefinition of the company's role as a performing arts institution in the Atlanta community generally. The central thesis was that the future of the company was inextricably bound up with a commitment to fundamental involvement in educational work of all kinds in the community. It nurtured a small group of unusually gifted artist/teachers who were as committed to their work in educational situations with teachers, students, and administrators as they were to their performance tasks. Thus, company members began to learn how to function effectively and creatively in both areas and to have a deep respect for the training process which has nourished this combined approach.

Clearly, this way of working may not be appropriate or desirable for performing companies geared to a major production schedule of varied theater fare each season. In such situations, the acting company neither has the time nor the inclination to move from main-stage productions to educationally oriented work and back again. And, indeed, the Academy Theatre itself has more recently felt severe economic pressure to pull back somewhat from this approach, following its move to a more formal and larger theater "home"

where "selling" the mainstage productions receives greater emphasis than in the past.

Nonetheless, the Academy continues to explore the thesis that a company can be built around professionals who do not fit traditional role definitions but can, in an organic way, simultaneously be actors, educators, students, and program developers. Its strong artists-in-schools ensemble continues to create original plays with themes and characters emerging from ongoing relationships with rural and urban audiences throughout its home state. It continues to explore imaginative workshop approaches in its residency programs in Georgia schools and accompanying its main-stage tours of the Southeast. The years of artist/teacher training for its senior company members has paid off as they provide a rigorous theater training program for aspiring young professionals. Today it draws most of its new company members from its own school—a group of actors oriented to the artist/teacher model of their resident company.

The Academy Theatre's pioneering exploration and development of the original model has been extremely valuable, and the model itself remains. For the smaller, less conventional company, the Academy Theatre has pointed the way toward a more flexible kind of community/school involvement. Whatever variations in program evolve in the future, its fundamental commitment to educational involvement seems likely to continue.

SPECIALIZED ARTS HIGH SCHOOLS

Broadly speaking, across the country, the talented student of high school age who seeks systematic training in the creative and performing arts is hard put to obtain it within the public school system. Nonetheless, the schools in New York City, St. Paul and Minneapolis, Cincinnati, Washington, Seattle, New Orleans, Dallas, and Houston, among others, and one or two other smaller systems, such as University City, Missouri, have indeed begun to recognize the necessity for establishing a specific high school for students with demonstrated abilities, aptitudes, or interests in the arts.

These institutions range from what might be termed mini-schools within a regular high school to those created specifically as preprofessional schools. The latter are frequently referred to as "high schools of the arts" and "arts magnet high schools." New York's long-established High School of the Performing Arts and its High School of Music and Art, where full-time students majoring in the arts can graduate with a special degree, are early pioneers of the specialized, preprofessional model. In almost every instance, these

schools have been designed to appeal to the student with a special interest or ability in the arts, and students are selected for participation on that basis, often through some type of audition.

Among the intriguing new arrivals on the "arts magnet school" scene is the Arts Magnet High School in Dallas, a city which has been experimenting for some years now with the magnet school concept as a means of providing specific educational alternatives for high school students. Established in 1976, the Arts Magnet High School is under the general supervision of Paul Baker, a pioneer in the nation's educational and resident professional theatre movement. Baker, who founded and still directs the Dallas Theatre Center and has for years headed the theater department at Trinity University in San Antonio, has developed a unique educational approach to the theater arts that is based on what he refers to as "the integration of abilities." He has applied it over the years to his work with college undergraduate and graduate students and now has an opportunity to make it the core philosophy of this new Dallas high school.

In some respects, Baker's approach encourages aspects of artistic development which Wolf and Gardner see as most appropriate for the adolescent years. A blending of the playfulness of early childhood with the concern for craft of the preadolescent, it is a mixture of flexibility with discipline, of subjective reflection with meaningful communication—tempered and refined by practice into a new realization of one's artistic abilities. And it sharpens for the student in a quite personal manner those basic components of artistic work which Wolf and Gardner identify as "communicative skills, symbol use, sensitivity to media, craftsmanship, and critical faculties."

Faculty positions at the new Arts Magnet High School were opened to all Dallas high school teachers both in the regular academic fields and in the arts fields. Most of those who were ultimately selected as faculty for the academic program were chosen because of their strong *avocational* interest in the arts—community theater work, home-based arts activities, or their enjoyment of the arts as consumers or audience-members. Some had secondary credentials in arts education as well. Greater integration of the academic program staff with the arts program staff seems to be one of the outcomes of this staffing principle, and there is evidence of continuing efforts to relate the various arts elements to studies in history, literature, mathematics, and the sciences. A number of professional artists also serve as part-time or adjunct faculty, among them members of the artistic staff from Baker's Dallas Theatre Center.

The Dallas Arts Magnet School serves about 450 students, some

of whom are enrolled full-time. Others enroll only in the arts classes and take their academic work back at their home high schools. Baker's "integration of abilities" philosophy pervades the entire program and, although it is based in the theater arts, its principles are being applied directly to the development of student abilities in the other art forms—and other learning fields—as well.

An interesting variation of the "arts magnet" concept is taking place in three separate communities in Connecticut. All three aim at providing special opportunities in the arts for a relatively small number of exceptionally gifted secondary school students, but in each instance they are sponsored by and serve a consortium of school systems in their regions.

The Educational Center for the Arts (ECA) in New Haven is a program of the Area Cooperative Educational Services; it has a staff of fifteen artists teaching the performing and visual arts to 110 talented students from thirteen local high schools in the New Haven area. Tuition is paid by the local school for each qualified student and two-thirds of the cost is reimbursed by the Connecticut State Department of Education. The ECA administers several other programs as well, such as a project in Applied Creative Thinking for teachers, board members, and school administrators in the area, and an Emergency School Aid Act project which has served over 600 seventh-and eighth-grade students from New Haven middle schools who have attended weekly arts programs at the Center.

The Creative Arts Community (CAC) is a regional program of the Capitol Region Education Council in the Hartford area. The CAC is one component of the Council's Educational Arts Collaborative which was set up to help some thirty-nine separate boards of education enhance the number and quality of educational arts programs in the Greater Hartford region. The Creative Arts Community serves approximately 100 artistically talented students (grades seven through twelve) from four of these cities or towns; its curriculum ranges across all of the arts (including, incidentally, the literary arts: poetry, prose, and drama).

INTERARTS, the third of these consortial enterprises, is a program for exceptionally talented high school students from the entire Greater Bridgeport Region. Some sixty students, from several cities and towns, take classes in drama, music, dance, art, and writing in classrooms used by INTERARTS on the University of Bridgeport campus.

A major problem with the arts magnet school concept is, of course, the probability that students interested in the arts will be lured away from other schools in the system and, consequently, priorities

for arts programs will be lowered in schools serving the rest of the students. In making school systems more flexible and more responsive to the specialized needs of one group of students—by providing a series of alternative schools each of which emphasizes one broad aspect of learning—the system runs the risk that this aspect will become less of a priority for all students.

This tendency poses more of a threat with respect to arts education than it does for other specialized learning fields—communications, the sciences, or industrial arts, for example—because virtually every alternative high school must also provide at least a core academic program in those subjects required for graduation. So some attention, at least, is given to programmatic breadth in all specialized magnet schools including those for the arts. But the arts themselves are seldom incorporated as part of the broad academic program in any of the other magnet schools, and—where arts magnet schools exist—learning in the arts is likely to receive reduced attention in the general high schools as well.

For those educators and parents, then, who believe that the arts are (or should be) a fundamental element in the education of every student and ultimately should receive parity with the rest of the curriculum offerings, there are genuine reasons for uneasiness and misgiving about the magnet school concept. At the same time, the appearance of these "high schools of the arts" on the educational scene, clearly a growing trend in recent years, must be recognized as a major expression of concern by educators for serving at long last that relatively small group of students in any school system whose special artistic gifts and talents need to be nurtured.

Thus, again, we come to the crux of the dilemma facing those who care deeply today about the place of the arts in America's schools: can we at one and the same time serve "the many" and "the few"? Can we begin to build into the system greater opportunities for all students to learn in, about, and through the arts, as a regular part of the educational diet, and at the same time provide deeper and broader opportunities for the unusually gifted few who may wish ultimately to pursue careers in the arts? Both the *audience* for the arts among the many and the *talents* of the few who are (or can be) gifted artists must, someday, be acknowledged and nurtured by our educational systems.

OUT-OF-SCHOOL CLASSES FOR THE TALENTED

Most of the instances mentioned above represent what are essentially *in*-school attempts to meet the needs of the arts-interested or talented student; for the most part, they have been established on

public school turf and generally the artistic community enters that turf when it endeavors to contribute to the education of such youngsters. There are, however, equally interesting attempts to do so in out-of-school settings; in a growing number of large cities especially, professional artists, museums, performing companies, and community-based arts groups have been responding on their turf to the needs of students who desire and deserve more concentrated training in the arts as a career development option.

Essentially these organizations offer a series of courses, plus apprenticeship experiences in the visual or performing arts, which the highly talented or motivated student can acquire during part of the school day. The public schools in these localities are, in turn, going more than halfway to make it possible for students to take advantage of these opportunities. Not only are they working out fairly complicated arrangements of split-day learning activities, but they are sharing some of the costs, recognizing the arts staffs of these community-based institutions as part-time or adjunct faculty members, and giving academic credit to participating students.

Two examples of this concept represent some of the differing ways it is being carried out: Workshops for Careers in the Arts, an organization of professional artists and arts teachers serving the predominantly black school population of the Washington, D.C., schools, and the Urban Arts Program developed by the Minneapolis schools.

Workshops for Careers in the Arts (WCA) was established in 1968 by Peggy Cooper, a graduate of the George Washington University Law School, as a summer arts program for the District's high school students. For some years, WCA was officially sponsored by the university, which—until 1974—served as its administrative home. The program filled such an obvious need, attracted such profound interest, and was conducted so effectively that, by 1970, it had developed into a year-round operation supported in part by a $50,000 line item in the District of Columbia school system budget.

WCA's faculty was composed largely of part-time artist/teachers who offered a range of courses in each of four areas: visual and graphic arts, theater arts, dance, and filmmaking. The courses were sequenced to provide a four-year program on three levels: beginning, intermediate, and advanced. The curriculum in each area was designed to acquaint students with all aspects of that field before they settled on a particular discipline. The courses offered by WCA were accepted by the schools for academic credit and recorded on the student's official transcript. Students were released from their respective high schools at noon each day, enabling WCA to conduct

classes for them in its own leased facilities three afternoons a week and to place students in professional apprenticeship positions the other two afternoons. These apprenticeships were either with individual artists in studio settings, or with museums and galleries, professional performing arts organizations, or film and television studios. WCA also sponsored its own dance company and worked cooperatively with the D.C. Black Repertory Company, both of which provided advanced students with some training and performance opportunities.

Most graduating students who participated in the Workshops alternative have gone on to postsecondary study in the arts or have been accepted in training programs of professional companies. For the several thousand young people (most of whom are black) who have participated in the program since it began, WCA has provided the opportunity for a kind of growth and achievement—arts-related or otherwise—that has been unavailable in most urban high schools until quite recently.

Finally, in the fall of 1974, the District of Columbia school system arranged to convert one of its high schools in Georgetown into a "school of the arts," named it after Duke Ellington, and installed the staff of Workshops for Careers in the Arts as a major segment of the initial teaching faculty.

The Urban Arts Program in Minneapolis was developed in 1970 to serve principally as the coordinating agency for out-of-school arts experiences for students in the Minneapolis high schools. In the mid-1970s, while retaining its managerial autonomy, Urban Arts became part of the system's Department of English and Humanities. According to Seymour Yesner, that Department's full-time coordinator at the time, an effort was made "to use Urban Arts to coordinate all arts programs emanating from some association with outside artists or arts organization, whether the programs occur in the schools or outside them."[17]

The Urban Arts Program emerged from a series of early attempts by the schools to utilize more effectively the arts resources available to them in the Minneapolis community. Yesner comments:

> Out of all these activities grew a community of artists and arts administrators identified to some extent with the schools and their problems. The reverse was also true: school people grew to know and respect the arts and the artists ... as a result, the Minnesota State Arts Council, the Minneapolis Fine Arts Society with its Children's Theatre and its Institute of Art, The Walker Art Center, the Minneapolis Orchestra, some business firms, and the University of Minnesota, all

found themselves cooperating with the schools in arts programs of enormous variety and scope. In addition, in-service courses for teachers taught by artists, often under the auspices of the arts organizations, were offered by the schools.[18]

Perhaps the most extensive involvement of Urban Arts students has been with the Theatre School of the Minneapolis Children's Theatre, which has enrolled nearly one hundred young people each year. Interested students audition and, if accepted, are released for half their school day (usually in the afternoons) to attend classes at the Theatre. Classes are offered in all aspects of theater and drama: body movement (including dance, mime, and fencing), music and voice, dramaturgy, acting (largely through improvisation), and—depending on time and interest—some work in such technical aspects of theater as make-up, sets, lighting, and costuming. Many of the advanced students have assisted and acted in the company's major productions, generally original works with music. A student receives full school credit, usually in English but often in Physical Education, Music, or Art, and sometimes in Social Studies. The home school assumes responsibility for rescheduling each student's classes so as not to neglect courses required for graduation. According to Yesner:

> The concept is simple, but the process in actuality, is quite complex when you add to the Children's Theatre similar (yet quite different) programs with three or four dance companies, two or three orchestral or musical ensembles, poets in classrooms and elsewhere, programs at various centers like the Free School and the Afro-American Center, other theatre programs, and work with individual artists (painters, composers, filmmakers, photographers, and others).[19]

Another aspect of the Urban Arts Program is the involvement of teachers in the system. Based on earlier experiments in which a few art and theater teachers served for some months in apprenticeship capacities with the Walker Art Center and the Guthrie Theater, the Urban Arts staff began exploring the possibility of releasing a larger number of teachers each year from their classroom duties to serve periodically "on site" with arts institutions. Beyond using the opportunity to foster their growth, teachers would work with students in these out-of-classroom arts settings, develop ways of involving other teachers and students, and produce curriculum ideas and materials for regular classroom use.

INVOLVING ARTISTS IN SCHOOL SETTINGS

Although there has been a growing involvement of professional artists in schools and classrooms in recent years—spurred, in large measure, by the Artists-in-Schools (AIS) Program of the National Endowment for the Arts—until quite recently the work of these artists focused largely on students and frequently bypassed the classroom teacher. With some notable exceptions, especially in the fields of dance and filmmaking, the original AIS approach tended to assign artists to selected schools for varying periods of "residency" or intermittent visits; they "enriched" the curriculum briefly, often for limited numbers of students, and when they left the general educational program remained substantially unaltered.

This has not been a blanket AIS practice, to be sure, and in some states and localities there have been notable variations on that approach which have grown out of the imaginative work of state and regional AIS coordinators and their in-school faculty partners. NEA Guidelines for the Artists-in-Schools Program are, in fact, currently being reviewed and, it appears, will be revised with an eye toward developing more productive artist/teacher partnerships.

But whether under the AIS aegis or through the independent efforts of concerned artists, teachers, and administrators, it is clear that a far richer and more effective involvement of professional artists in the world of schooling has been underway during the latter part of the 1970s. It appears likely, moreover, that this effort—particularly as it moves toward greater artist/teacher collaboration—will become more and more of a priority in the years immediately ahead.

One approach is to make a more concerted effort to identify those individual artists or performing ensembles that have an interest in working with teachers as well as with children in classrooms. Another is to begin to develop teams of artists who can be helped, through workshops and other means, to understand better what teaching is all about and how they can assist teachers to deal with the arts. A few examples of these and other such practices may serve to underline the point.

The Alvarado School Art Workshop, located in San Francisco, California, began in 1968 as a project concerned with instruction in one arts area—the visual arts—at one elementary school. Its goal was to assist classroom teachers in "providing worthwhile and lasting visual arts experiences for children." Parent volunteers discovered an abundance of artistic talent within their own community. They worked to coordinate the services of the community artists

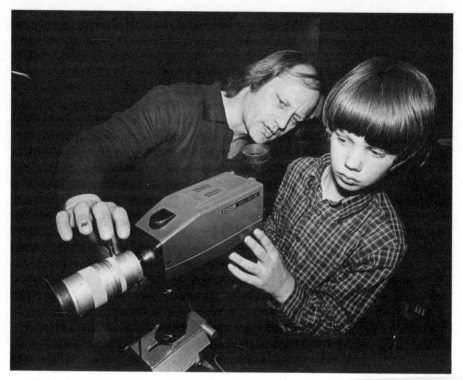

Michael Goodell, visiting artist, MacDonald Elementary School, Seattle, Washington. *(Photograph by Steve Meltzer. Courtesy of Ann Reich)*

with the needs and interests of staff and students at the school. Mosiac wall murals, stained glass windows, mobiles, planter boxes and other student-made art works soon appeared and began to transform the physical environment of the school.

Now, ten years later, professional artists, parent volunteers, and a staff coordinator work with the staff and students of over fifteen elementary schools within the San Francisco Unified School District. While the visual arts were the first focus of the program, music, drama, and the literary arts are now included. Interior and exterior murals, sculptures, textiles, planters and plants, graphics, calendars, poetry, stained glass windows, paintings, puppets, and numerous other types of works have been created by students under the guidance of teams of professional artists and classroom teachers. The program aims at involving students in intensive experiences with creating substantial art forms in order, among other things, to teach skills and offer vocational and career education through the involvement of professional artists.

The De Young Memorial Museum Art School in San Francisco, California, conducts a program of visits to schools by artist/teachers. After a teacher requests visits, members of the art school staff interview the teacher and observe the class in order to plan appropriate activities. Usually three or four visits are made to an individual class. A total of twelve artist/teachers work in pairs to provide arts experiences; usually one is skilled in the visual arts and another in music, dance, or drama. They use two rainbow-painted "Trip-Out-Trucks" to transport needed materials and trunks which contain mini-exhibits of common artifacts, folk art, photographs, and descriptive materials. Some exhibits deal with the process of creating art and others emphasize the objects themselves as works of art. All are designed as teaching tools to be used in conjunction with the art activities planned for the students. To date, there are exhibits on weaving, ceramics, printmaking, basketry, masks, and puppetry.

The Performing Tree, a nonprofit arts education organization, functions in the Los Angeles schools as an independent contractor. One of its major programs involves arranging for artist-specialists to conduct student workshops, classroom demonstrations, and teacher workshops in individual schools. A variety of arts areas encompassing the visual arts, dance, drama, puppetry, and filmmaking are the focus of the activities, depending upon the expertise of the specialists. Information sheets describing the workshop and stating the specialists' philosophy, professional background, and experience are distributed to schools. Interested schools then contact the Performing Tree and arrange for visits. Orientation sheets are sent to teachers before scheduled workshops, and follow-up activities are left with teachers after the workshops are completed.

In Keene, New Hampshire, the Wheelock Elementary School (which serves as a laboratory school for the teacher education program at Keene State College) recently completed a three-year federally funded project called AFCAT—Aesthetics for Children and Teachers. During this period, an extraordinary cross-section of craftspeople and visual and performing artists from all over New England came to Keene for AFCAT workshops and residencies lasting anywhere from two or three days to several weeks.

There have been week-long residencies involving three potters, an oil painter, a sculptor, and a glass-blower; two-week residencies for a weaver, a woodcarver, a kinetic sculptor, a chamber music group, a folk musician and guitar-maker; and a variety of other in-school visits involving a jazz quintet, a percussion group, jewelers, poets, dance companies and theater groups, and a filmmaker. The New Hampshire Ballet (a company of twenty dancers) has given

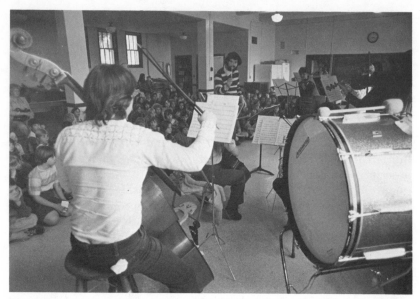

The Northwest Chamber Orchestra, Seattle Public Schools. *(Photograph by Jeffrey Myers. Courtesy of Ann Reich)*

lecture-demonstrations and performances for the entire student body as well as evening community performances.

These AFCAT-sponsored artists didn't merely come into the schools, "do their thing," and leave, on a random basis. Their visits were part of an overall plan, with sequence and continuity carefully worked out at the beginning of each year by the Wheelock teachers with the AFCAT project director. In addition to performances and demonstrations, the artists and craftspeople held separate studio sessions with small groups of children, gearing their work to varied grades and age-levels; they moved into classrooms for extended workshops, worked closely with individual teachers, and in almost every instance conducted in-service workshops in their particular art form with Wheelock teachers and other area educators.[20]

The Young Audiences organization, which has recently expanded its activities to include other art forms in addition to music, has been working experimentally in some localities with both students and teachers for the past several years. This effort has been stimulated largely by the experimental "Intensity Program" developed by YA's National Program Research and Development Laboratory established in 1971 at the organization's headquarters in New York City.

At Arlington High School in Indianapolis a project called "Per-

forming Arts for Curricular Use" utilizes artist-interns, an electronic composer-in-residence, and the local chapter of Young Audiences as resources for augmenting the dance, art, music, poetry and film curriculum. The artist-interns are part of an attempt to relate professional community arts groups (the Indianapolis Symphony and the Indianapolis Ballet Theatre) to curricular objectives in the school. The Young Audiences component is developing new presentational formats initiated by the YA Intensity Program in New York, which tie in directly to the school's curriculum goals; meanwhile, the demonstration site at Arlington (one of four in the state) emphasizes in-service retraining for teachers.

In Seattle, the school system has made a major effort to involve—on a regular basis—virtually all of the city's cultural and artistic resources as the centerpiece of an "Arts for Learning Project" which completed its three-year development period at the close of the 1977–78 school year. Individual artists and performing groups of all kinds, from the Seattle Opera and Symphony to less well-established organizations like Whistlestop (an improvisational dance company), have been made available during this period to six widely scattered "demonstration" elementary schools. Considerable stress was also placed on the art forms and performing styles indigenous to specific ethnic groups and cultures: Asian Arts, African Arts, Hispanic Arts, Appalachian and Native American Arts foremost among them.

Following on the heels of this comprehensive three-year experience, the school system, as part of a citywide desegregation plan, has designated a number of Magnet Schools at all educational levels, each of which has elected to emphasize specific aspects of a general educational program. Eighteen schools below the senior high level chose to place their emphasis on the arts, and the district's Arts Office has formed these multi-arts Magnet Schools into a network to participate in a "Community/School Arts Partnership" program, stressing greater use of community arts resources. The arts programs are directed toward students with special interests and aptitude or talent in any one of the arts. The development of student self-expression, skill in the arts, and general appreciation of the arts are major goals which program leaders expect will be achieved through student involvement in such an intensive multi-arts environment. And a central concern throughout has been to build, through in-service training, a new sense of the importance of the arts among the faculties of these schools.

Other instances of this widely scattered but impressive development could easily be cited, particularly when one realizes that the

National Endowment for the Arts alone is now supporting the involvement of several thousand professional artists each year under its Artists-in-Schools Program. Schools in all fifty states and five special jurisdictions are presently being served by this program. Other programs and projects, including some of those just discussed, are partially supported by HEW funds, either administered through state education agencies or by the Alliance for Arts Education (the joint program of the U.S. Office of Education and the Kennedy Center).

However, two programs in particular should be mentioned in concluding this section. The Touchstone Center, established in 1969 under the leadership of Richard Lewis in New York City, embodies much of the careful development, the commitment, the human relations skills, and the artistic considerations that are needed if such interventions are to be truly productive. Though modestly funded over the years, it has ploughed important new educational ground.

In recent years Lewis has drawn to the Center a number of young professional artists representing almost all the arts disciplines for a series of workshop-seminars devoted to an exploration of the teaming process for artists who want to work with teachers as well as with children. And, since 1974, teams of artists from the Center have been working intensively along these lines in a Manhattan elementary school of some 700 youngsters from varied racial and economic backgrounds. These teams have begun to develop a new understanding of the skills necessary to work creatively with both children and adults. More importantly, perhaps, they have demonstrated to teachers, administrators, and parents how it is possible over a period of time to begin to integrate the artistic and imaginative experience into the regular curriculum of the school. As such, the Touchstone Center and its small cadre of artist/ teachers are in the vanguard of a movement which, on a more direct and personal level than can be achieved by most performance-oriented groups, is working in another way to move substantially beyond the traditional "enrichment syndrome."

The second program, also in New York City, is one of a number of arts-centered approaches that have been established recently in Community School District #4, the so-called Spanish Harlem area on Manhattan's upper east side. Developed under the guidance of Terry Baker, director of the district's arts programs, these approaches have begun to alter the educational character of District #4 by making the arts a major element in bilingual education, in career education, in aspects of communications and health, in programs for the gifted and talented, in Teacher Corps activities, and in the District's seven alternative junior high schools generally.

At the early elementary level, moreover, Baker directs a program called "The Open City Program" which is aimed at "opening the city up" to those black and Hispanic youngsters who have only fragmentary knowledge of the nation's largest city because they have never ventured beyond the limits of their own neighborhood. Open City is essentially aimed at improving language arts skills in youngsters at six District #4 elementary schools. It accomplishes this by taking the children out of "El Barrio" for a variety of encounters with the social and cultural world of the larger city. And it has followed each field trip up by bringing into the classrooms a wide range of professional artists who highlight and reemphasize the experience in direct curricular ways using writing, drawing, reading, sculpture, puppetry, and social interaction. In schools which formerly held out little hope to their students, new visions of what they might become (and a new sense of the skills required to do so) are beginning to emerge in the classroom.

CHANGING APPROACHES TO MUSEUM EDUCATION

As a massive study project of the Council of Museums and Education in the Visual Arts has recently revealed, a wide range of arts education activities—not limited to the visual arts—are now beginning to take place in museums throughout the country.[21] They represent a wider set of options and suggest some new and imaginative ways for out-of-classroom learning to take place in conjunction with school arts programs. There is room here to mention only two such instances as indicators of what can be done when the schools and museums work together in creative ways.

The Urban Outreach Department of the Philadelphia Museum of Art, among other intriguing practices, recently engaged six students from the Parkway School to design and develop:

> . . . a Micro-Museum for youngsters from Kindergarten through fourth grade where the watchword is 'Please Touch!' A series of provocative activities, designed with simple materials, endeavor to teach the basic concepts of size, shape, color, texture and movement . . . in an environment which balances learning and play.[22]

The exhibit was build to travel to art and community centers throughout the Philadelphia metropolitan area following its initial installation at the Fleisher Art Memorial.

Other museums have mounted such "hands-on" aesthetic-learning exhibits for children in recent years—Boston's Children's Museum, Atlanta's High Museum, the Anacostia Neighborhood

Museum, and the San Francisco Exploratorium among them—but the Micro-Museum project in Philadelphia is perhaps unique in the full-scale involvement of high school students in the exhibit's creation and design.

The Walker Art Center, a major participant in the Minneapolis schools' Urban Arts Program, has been making it possible for both students and teachers to serve as docents or guides for special exhibits or events. (The Exploration does this, too, calling its high school guides "explainers.") The students and teachers are trained in advance by museum staff members and then "serve, in some cases all day, for the length of the exhibit—six weeks or more—receiving appropriate credit."[23]

The practice began in conjunction with an exhibit of American Indian Art at the Walker, in which Indian youngsters were involved in docent capacities, and was expanded during a subsequent Walker exhibit on "New Learning Spaces and Places," when several teachers were released to coordinate the activities of more than sixty students who were involved in helping to plan and develop that exhibit.

THE FOXFIRE LEARNING CONCEPT
Finally, mention should be made of an out-of-school learning concept that has proved effective in providing community-based learning for high school students in culturally different localities and especially those in rural or more sparsely settled regions of the country. It is a concept which was developed initially by Eliot Wigginton, a young high school teacher of English and Journalism at the Rabun Gap-Nacoochie schools in Rabun Gap, Georgia. His approach centered around the publication of a folklore quarterly which Wigginton proposed as a way of involving his students actively in learning about their own mountain culture. Here, the whole community and even the region becomes the educator in ways "the city" seldom does for urban schools.

Beginning in 1967, students in Rabun Gap journalism classes set out with cameras, sketch pads, and tape recorders to document the lives, the vanishing skills, and the rich folk-wisdom of older people in the region. Acquiring a wide range of editing, production, and distribution skills—many of them linked to perceptual and expressive skills in the aesthetic domain—these students have since published nearly fifty issues of the magazine they named *Foxfire*. Four bestselling anthologies—the *Foxfire* books—have drawn on materials in the magazine. More significantly, the learning concepts embodied in Wigginton's approach to experiential education have spread to involve high school students in nearly 150 other culturally

different localities and communities throughout the United States and abroad, including Duke Ellington High School, where *Cityscape: A Journal of Urban Life* has been published since the mid-1970s. These young people are now searching out and documenting their distinctive cultures and publishing the outcomes in their own versions of *Foxfire*. And some state education agencies have been exploring the applicability of the process to curriculum development in humanities education.

Rather than separating students from their cultures and communities, *Foxfire's* "cultural journalism" approach depends heavily on both for its source material and its inspiration. In its "field" component, it offers an opportunity for young people to understand their own cultural heritage, to find a new relevance in the past, to develop a sense of pride about an older generation they had often ignored, and in the process to come to better terms with their own individuality. In a more formal educational sense, the approach can be linked directly to curriculum elements in other disciplines beyond the English/Journalism classrooms from which it springs. It not only touches on and integrates learnings in the arts and social studies but connects to the sciences and mathematics and nurtures within the broad field of the humanities the seeds of a genuine interdisciplinary learning experience.

It is not surprising, therefore, that in the rural school where the project began, from which few students went on to college before the advent of *Foxfire,* graduating seniors have been admitted to college in ever-increasing numbers, with by far the largest number drawn from those who have worked on the magazine sometime during their high school careers. More recently, the ten-member Foxfire staff has begun working in similar projects at the Rabun County High School and is moving toward even greater involvement with local communities in that region of Appalachia.

Largely using royalties from sales of the *Foxfire* books, the project recently acquired a mountainside tract of land in Rabun County which now serves as its headquarters. With local student and contractor help, the staff moved over twenty original log buildings from various sites around the county and rebuilt them on this site. Here, they are used as offices for the magazine, residences, and dormitory space as well as studios and workshops for new student-involvement programs: video and recording projects, environmental studies, archival and museum facilities, and furniture making.

The staff teaches special courses in all these subjects daily at the Rabun County High School. Its emphasis on the involvement of community adults as "adjunct teachers" was celebrated in the

Stanley Hicks shows two Foxfire students how he makes a banjo out of walnut using groundhog hide for the head. *(Photograph by Dot Jackson. Courtesy of Eliot Wigginton)*

spring of 1979 during a week-long "community teach-in" at the school, where community people with particular expertise worked with students in virtually every course offered at the secondary level, from art to athletics and from biology to industrial arts. In the offing, too, is development of a smaller section of land the project has acquired down the main valley highway . Here Foxfire plans to erect a main office and display building, a furniture-making factory and print shop, a small television studio, and a greenhouse—all to be fitted with various solar energy demonstrations and used for experimental education purposes by students and, by providing jobs for local people, as an economic development project for the area.

The scores of cultural and literary offshoots around the country inspired by Foxfire's relatively uncomplicated notion for making education relevant to young people's lives and interests is impressive testimony to the value of the basic idea; and it suggests, as well, that a good educational idea *can* be replicated if one knows how to go about the process and the original idea itself is sound.[24]

CONCLUSION

The ideas and examples described in this chapter are only a few of the hundreds which might be cited, but they do suggest the breadth and diversity of the explorations going on today in the attempt to find new and better ways of relating learning to life. This diversity in itself is encouraging because it puts more options before students and their adult mentors (in the schools and outside them), and it adds richness and variety to the available alternatives.

Even if we find it impossible to achieve, in some future time, an arts curriculum or a total curriculum that is fully balanced between formal and informal learning situations for all students, it is clear that the schools can no longer remain isolated from the communities in which they exist. It is equally clear that many would-be artist/teachers, including those who represent their community's arts resources, have as much to learn about the schools, about teaching the young, and about education generally as those within the formal educational enterprise have to learn about these resources and the ways in which they can be more fully utilized for educational purposes.

But a growing number of artists and community-based arts administrators are obviously ready and increasingly able to contribute a great deal to the education of the young. If both partners to the process come to realize that planning and development efforts must be jointly shared and cooperatively implemented, we may indeed be on the way toward a more integrated and rewarding kind of arts curriculum.

NOTES

1. Arthur W. Foshay, *Curriculum for the 70's: An Agenda for Invention*, National Education Association, Washington, D.C., 1970, p. 45.

2. Judith Hoos, "A Brief History of Learning in America," in "New Learning Spaces and Places, DQ 90/91," a special issue of *Design Quarterly*, Walker Art Center, Minneapolis, 1974, p.75.

3. Ibid. p. 76.

4. Foshay, op. cit., pp. 45–46.

5. Kathryn Bloom, "Arts Organizations and their Services to Schools: Patrons or Partners?," unpublished paper from a manuscript in preparation, The JDR 3rd Fund, 1974, p. 2.

6. Barbara Radloff, "Creating 'New' Schools: How Knowledge Plus Pressure Equals Change," *Carnegie Quarterly,* Winter 1974, p. 10.

7. Foshay, op. cit., p. 46.

8. Radloff, op. cit., p. 10

9. The Boston Commission on Secondary Education, "The City as Educator: A Proposal for the Boston Public Schools," in "New Learning Spaces and Places, DQ 90/ 91," op. cit., p. 79.

10. Joseph Featherstone, "Youth Deferred - II," *The New Republic,* vol. 171, no. 9, issue 3112, August 31, 1974, p. 25.

11. Ibid, p. 24.

12. *Opening Doors: A Handbook for Volunteers,* Arts Council of Oklahoma City, Oklahoma City , 1973, p. 4.

13. Junius Eddy, "Government, the Arts and Ghetto Youth," *Public Administration Review,* vol. XXX, no. 4, July/August 1970, p. 403.

14. Don D. Bushnell, "The Arts, Education, and the Urban Sub-Culture," report of the National Survey of Performing Arts for Disadvantaged Youth, submitted to HEW, Washington, D.C., September 1969, p. xiii.

15. Ronald Gross and Judith Murphy, *The Arts and the Poor: New Challenge for Educators,* HEW, Washington, D.C., 1968, p.iii.

16. Richard L. Loveless, "The Arts Outside of School," position paper prepared for the Study of Schooling.

17. Seymour Yesner, "The Arts Program at the High School Level," position paper prepared for the Study of Schooling.

18. Ibid.

19. Ibid.

20. Drawn from material the author contributed to *Try a New Face,* in connection with "The Arts and HEW Project," Government Printing Office, Washington, D.C., in press.

21. Barbara Y. Newsom and Adele Z. Silver (eds.), *The Art Museum as Educator,* University of California Press, Berkeley, Ca., 1978.

22. Material drawn from unpublished brochure of the Philadelphia Museum of Art, Department of Urban Outreach, 1973.

23. Yesner, op. cit.

24. Material drawn from 1974 internal paper by Junius Eddy, for the Board of Trustees of The Rockefeller Foundation during consideration of Eliot Wigginton as a candidate for the JDR 3rd Youth Award for 1973. Wigginton received the award in December 1974.

BEYOND THE RHETORIC OF PROMISE

JOHN I. GOODLAD

University of California, Los Angeles, and
/I/D/E/A/

This concluding chapter makes two assumptions. The first is that there is now broad agreement among specialists regarding the desirability of comprehensive arts education programs. The second is that there is a growing and useful body of insight regarding educational change and improvement to be used in creating the needed programs. These agreements and insights lead to some steps and strategies for meeting the challenges of making the arts a vital part of educational programs and of students' lives.

Since moving toward solutions requires knowledge of the problems to be solved, this chapter begins with an analysis of the gap between the rhetoric of promise in this field and the realities of lesser accomplishments, especially in schools. This analysis suggests at least the major elements to be orchestrated in seeking to narrow the gap.

The specialist in any of the subfields addressed in this volume is likely to know far more about that subject than is presented here. However, higher levels of development in arts education will not be achieved solely by specialists clarifying issues that concern them, important though this is. The collaboration of many different kinds of specialists, including some outside the arts, is required. Consequently, it is our hope that this chapter will, for example, stiffen the spine of the school superintendent who believes in an expanded arts education program but who is nervous about advocates of back-to-basics. Simultaneously, we hope what follows will emphasize to the arts specialist that more is required than teachers with preparation in the arts, necessary as they are. This chapter will have failed in its purpose unless it clearly conveys the message that any significant, early progress in establishing comprehensive arts programs for all children and youth requires collaboration of a kind and to a degree rarely envisioned let alone achieved. Most of us, armed with very good intentions, tend to limit our effectiveness because of parochialism in outlook and overconfidence in piecemeal solutions.

THE ANATOMY OF A PROBLEM

From one perspective, it is surprising that we have a problem in arts education and that this problem is so severe. As stated in Chapter 1, most state and local school districts have committed themselves to the arts in their goals for schooling since the 1950s. Beginning soon after the publication of Dewey's pivotal *Democracy and Education* (1916), every major national commission on goals for American education has included reference to individual prerogatives, even though specific reference to the arts appeared infrequently, if at all, until the 1930s.

Recently (1977), the Panel on the Arts, Education and Americans released a major report on the arts for American education.[1] In it, as in previous chapters of this volume, there are encouraging accounts of exemplary school programs and of support for the arts at local, state, and national levels. The concluding list of recommendations is exhaustively comprehensive, ranging from the provision of arts experiences for all students to teacher education and the use of artists and, finally, to matters of government policy, funding, and research.

Although the Panel's report may be one of the most ambitious and far-reaching of its kind, it certainly is not the first. The rationale for the arts put forward by the now-defunct Educational Policies Commission comes to mind.[2] Or, at the state level, there is the Report of the New York State Commission on Cultural Resources which " . . . is dedicated to citizen influence on the local educational system in the hope that the concerned citizen will recognize the promise which the development of the arts in the school holds for the total health of our society and the promise of life for the individual."[3] And there are available excellent reports on school and community efforts to translate commitments into programs.[4]

We seem to know what to do and how to do it. But the doing occurs so rarely that it provides frequently cited exemplars rather than the norm. There is a paucity of well-conceived programs translated into reality.

Why? The thesis on which rest both the diagnosis and the remedy put forward in this chapter has to do with lack of focus for integrating and maximizing the effects of a considerable but piecemeal effort: the recommendations of national commissions, directed to almost everyone, require action by undifferentiated groups whose conscience and energies are rarely reached; state goal commitments seldom are accompanied by resources and plans for action; persons with extensive preparation in the arts teach in schools with no special interest in arts education; teachers do not know how to make good use of artists made available to them through grants; and so on. The commitments and recommendations, like virtue, are commendable but insufficient in themselves. We need literally thousands of grass-roots efforts, such as those attempted in recent years in University City, Memphis, Minneapolis, and other cities cited in earlier chapters, in which local dedication and various combinations of local and outside fundings have played important roles.

At the moment we even begin to think about education, we frequently are off in the wrong direction. The first mistake is to equate education and schooling, but I shall pass over this one since the purpose here is to focus on schools anyway. The second mistake is to

focus on almost everything but schools: teachers, reading, counseling, principals, busing. These are the pieces but they are not the whole; nor do they necessarily add up to the whole even when all are dealt with individually. Many persons who develop educational policies and procedures fail to link their work conceptually or in practice with real schools and the students who attend them.

The strategic place for effecting improvement in school arts programs, then, is the individual school. Unless the commitment is schoolwide, the arts are likely to receive only sporadic attention and are not likely to enter the lives of all students. Needless to say, what goes on in classrooms is what counts, but few classrooms will provide education in the arts unless time and resources are made available as matters of school policy. A strong commitment at the local school level depends heavily, in turn, on goals endorsed by the state and district and the provision of personnel and materials for their implementation. The final test of rhetorical endorsement and even of the visible allocation of resources is whether comprehensive arts programs are available to and enjoyed by all students in each school. If the educational system is deficient in the arts, that deficiency shows up in the thousands of schools young people attend.

Data on whether the arts are taught in elementary and secondary schools, what arts are taught, how they are taught, and who participates would reveal much more about the condition of arts education in this country than do statistics on money spent or supervisors employed for arts instruction in schools. A Study of Schooling in the United States (see Foreword) was designed to provide the needed techniques for such inquiry and will offer some useful insights.[5] However, an even more massive undertaking would be required to answer two other significant questions: (1) What part of the effort for the arts mounted outside of schools but within the system never reaches and improves school programs? and (2) Why?

It is reasonable to assume that the slippage from good intentions to real programs in the arts in real schools is substantial, given our rhetoric of intentions. It also is reasonable to assume that the rhetoric in itself has some beneficial effects that are not easily traced. But the ultimate criteria of effect must be identifiable programs and participants in them. Many of my colleagues in the education profession will be less than happy with some of the examples selected below as having explanatory power in regard to this slippage. Although part of the explanation lies with inadequate public commitment and funding at all levels of education, beating our breasts over such problems is not productive. A more productive agenda awaits our attention.

One set of problems is endemic in the organization and funding

processes of federal and state governments. At the federal level, where categorical aid is the guiding principle, the mechanisms for improvement are focused almost exclusively on the pieces, not whole school programs. The National Endowment for the Humanities, the National Science Foundation, and the National Endowment for the Arts compete for part of the same pot of money and for part of the hypothetical curricula of imagined schools. All share, by admission of some of their own staff members, inadequate knowledge of what is taught and of how the teaching is conducted in the subjects they represent, let alone in the total program which all fields share. The National Science Foundation has been timid in regard to finding out how the millions of dollars spent on curriculum reform during the sixties affected mathematics and science curricula and scarcely at all interested in the impact on the school curriculum as a whole. These three rather large federal agencies together employ only a handful of people who have studied or worked in precollegiate education.

Where there are not such agencies, Congress responds with special legislation—for vocational education, health education, career education, special education, or whatever—and the net effect is more segmentation. It is not the effort to attend to special interests that is being challenged here but the failure, so far as I am able to determine, to have some conception of the setting where all this federal effort and expenditure must come home to roost—the finite dimensions of a school. There are only so many hours per day and so many days per year (a total of about 1,000 hours each year) within which provision for about a dozen sociopolitical goals for schooling must be accommodated.

The fragmentation at the federal level is repeated and compounded at the state level, where legislatures pass innumerable bills addressed to endless specifics of instruction. Today, the structure of state departments of education largely reflects the categories of federal funding. Divisions of elementary and secondary education are staffed almost exclusively by specialists in literally dozens of subdivisions which supposedly reflect reality in schools somewhere. Again, it is not the concern for specialities that troubles me unduly but rather the lack of concern for the whole. I startled the curriculum division of a state department of education by asking if the various specialists (about two dozen subfields were represented in the audience) had ever come together to construct a real school program out of their pooled recommendations. Of course, more than eighteen hours of each day would have been used up before half of their ideas were enumerated.

It would seem reasonable (although it must be egregiously unreasonable!) to expect federal agencies and state departments of education to maintain, for presentation and examination, models of desired elementary and secondary school programs and data-based assessments of discrepancies between these models and extant conditions in a representative sample of schools. The first task, a conceptually difficult one, would require constructing a set of models for school programs designed to implement alternative sociopolitical goals. To argue that such conceptualizations would become prescriptive and unduly interfere with local prerogatives is a weak excuse. What now goes on at state and federal levels is intended to affect local practice, or the activities there would stop. The problem is that these remote, piecemeal efforts encourage similar segmentation at the local level. And, of course, federal agencies always protect themselves by conducting the necessary work through universities and research agencies. The development of often rigid guidelines for providing funds assures that certain kinds of things and not others will be done.

The segmentation of school programs and the competition among subfields at federal and state levels are carried over to schools, particularly junior and senior high schools. Persons interested in developing school arts programs whose vision reaches only to the arts are frequently myopic and naive. They must come to realize that a school is a culture where certain priorities already have been established. Only in rare instances do the arts rank high among these priorities. Proposals calling for more time and resources devoted to arts education put in motion certain powerful defensive reactions by people representing well-entrenched departments. Efforts to bring about change inevitably encounter the realities of school culture, and to be at all successful somehow must deal with that culture.[6] I shall return to this point in the concluding section of the chapter.

From the late 1950s through most of the '60s, the dominant view was that school improvement efforts would be generated largely outside of schools and then injected into them. Accompanying language was derived from the military: products (like missiles) are delivered to targets. Later in that reform era, the language softened: need was to be perceived through expert research (R), products were to be developed through field trials (D), and then disseminated or diffused (D).[7] This was the RD and D model of change largely employed in curriculum projects supported by the National Science Foundation, in a variety of reforms encouraged by the United States Office of Education, and in the provision of scholars to interested schools by the National Humanities Faculty (at that time, sup-

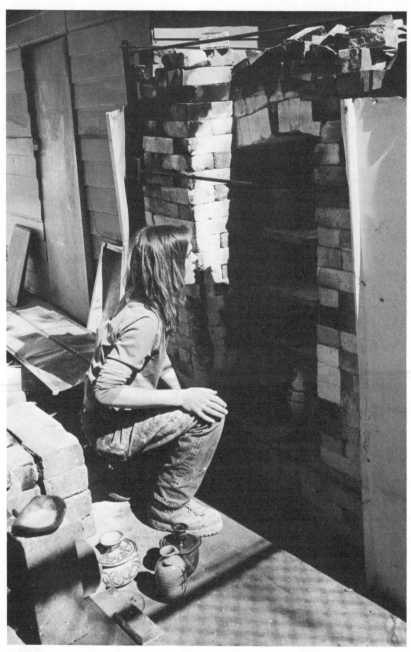

Jefferson County Schools, Colorado. *(Courtesy of Larry T. Schultz)*

ported almost entirely by the National Endowment for the Humanities).

The shift in the seventies was toward some greater involvement and identification of need at the local level, by school district or individual school. Announcements of funds available by major federal agencies frequently were accompanied by the requirement that some kind of local "needs assessment" be conducted. While this was a commendable move, the idea of someone outside of schools (and not necessarily intimately acquainted with them) knowing what is best for them was still very evident in guidelines accompanying requests for proposals.

Of greater import, there was lack of awareness at both state and local levels regarding the ability of school faculties or segments of faculties to engage in useful, valid self-appraisal or assessment of parental and community expectations. "The state of the art" is, of course, primitive. Few useful instruments for data gathering are available; most so-called needs assessments are simply collections of individual preferences and wants. If the pecking order of the arts among the subjects in a given secondary school is low or if there are no advocates of the arts in the elementary school, arts education is unlikely to show up as a high priority need. Since these "ifs" are more fact than supposition, it is not surprising that the arts play a small part in the culture of most schools.

A number of factors at the local level conspire to retard progress in the arts. School board members tend to be oriented toward politics and business. The general neglect of the arts in their own schooling usually has not aroused a keen desire to correct this deficiency in contemporary education. They usually know little about the inadequacies of norm-based achievement tests but are very much attuned to lowered scores. They have thought only a little about the broad goals for schools and, usually, even less about arguments for the arts such as those put forward in this volume. They have virtually no information about how time is spent in schools of the district or how teaching is conducted. The knowledge base for decision making by local school boards is at least as limited as that available to decision makers at federal and state levels.*

Part of the problem lies with the professional leadership of the

*In creating the United States Office of Education, Congress called for periodic reports on the quality of education conducted in schools. Well over a hundred years later, this mandate goes unfulfilled. The only methods so far available are measures of program effects and not of program characteristics.

district. When school boards have no carefully developed goals or no educational goals at all, do superintendents demand such guidelines for their work?[8] And, when goals are stated and include the arts, do superintendents request the resources to mount the needed programs? When school board members demand that more time be devoted to reading, writing, and mathematics in the primary grades, do superintendents provide data showing how time presently is spent? When superintendents of schools develop no-frills, no-nonsense programs in the three R's, is this because they have thought seriously about the alternatives or because it is the course which appears to be most defensible politically?

For the most part, schools are ill organized for change. Substantial changes in the secondary curriculum are not likely to be effected by key policy groups made up of department chairpersons, which is the way most high schools conduct their business. Their preservice training prepared them primarily to be specialists, not educators in the broad sense, and their present jobs reinforce that orientation.

Elementary schools are staffed with little or no thought to a balanced curriculum reflected in the balanced interests and competencies of the faculty. When a vacancy occurs, the usual staffing procedure is for the personnel office to send a new teacher, without thought given to the make-up of the staff as a whole. A school with two persons having strong backgrounds in music may receive a third; a school with no such person receives a person whose background is in the social studies. Almost without exception, school district personnel policies use employment criteria other than the composition of the staff which the replacement teacher is to join.

In seeking to give some attention to the arts, many school districts have opted for specially trained supervisors working out of the district office. Sometimes, such persons teach the only arts offered in elementary schools. Teachers in otherwise self-contained classrooms have welcomed the relief provided by itinerant supervisor-specialists. Often, the classroom teacher's decision to take the afternoon off has been a relief to both parties. The net effect often has been to relegate the arts to a special and somewhat peripheral status. Classroom teachers who do not work side-by-side with specialists, learning with and from them, do not often build a commitment to the arts. An arts program that is not integrated into the school day and its ongoing activities builds no solid constituency. When budget cuts come and the special supervisors go, there rarely is an outcry from teachers as a whole—merely an expression of regret over the loss of previously available free time. We can and do decry the lack of adequate support for arts education in the larger society

but often fail to recognize the fragile nature of support from within the education profession itself.

The foregoing has described only part of the anatomy of the problem underlying the discrepancy between the rhetoric of promise and the reality of performance in arts education. This discrepancy is not unique to the arts. The analysis would apply equally to an emerging field such as global education where commitment to goals is ambiguous and development of programs fraught with value conflicts. At least intentions in arts education enjoy considerable public support; and while programs may be regarded as peripheral in many quarters, they are controversial in few.

What rarely is recognized by well-intentioned persons, even many arts specialists and others who serve for months on commissions for arts in schools, is that there is not a large and sympathetic army of educators ready and willing to march for the arts. "Army" is in many ways the relevant word because the culture of the school, especially at the secondary level, is marked by competing factions for whom a subject specialty is a banner and time for that specialty is what the fighting is all about. And the arts in schools, for all their friends in the Arts Councils and Junior Leagues, have very few troops and fewer captains.

At the core of the problem is the fact that we—and by *we* I mean lay citizens, legislators, members of Congress, heads of government agencies, school board members, administrators, teachers, art specialists, teacher educators—do not yet think regularly and consistently in comprehensive, holistic terms when we involve ourselves in schooling or education. We do not use the development of the total human being as the goal and criterion for judging success.

It is not just the arts that have not yet broken out of the confines of limited vision and puny performance. It is education itself that lies mired in trivia, prejudice, chronic measurement diseases, and all the rest, waiting for leadership which is so busy with management that education is largely forgotten. Perhaps this is why success in school seems not to predict stellar performance in all those goals of citizenship, work, and self-realization to which the educational system is committed.

The arts will prosper in schools and other places only to the degree that education of the self is valued in these settings. The fate of the arts in education is inextricably interwoven with the future of general education. But general education is still too narrowly restrained by traditional expectations to prepare only for work and survival. The challenging purpose to which the arts have so much to contribute lies waiting in the wings:

Surely, the educational system has no higher function than to help people to have creative engagements with the world of the free self. For if the world of the free self is appropriately cultivated, its felicitous admixture of playfulness, concentration and socializing can affect, infect, and help to liberate the world of work and coping. The free self then becomes not a mere segment of existence but a quality of existence.[9]

PROGRAM REQUISITES

This chapter is focused primarily on factors inherent in the context and conduct of the public educational enterprise that seem to impede progress in developing arts education programs, and on strategies for dealing constructively with these factors. Earlier chapters describe and illustrate the elements of what is required. Despite the programmatic examples provided in these preceding chapters and the emphasis on change and improvement in this one, it seemed desirable to briefly remind readers of the kinds of programs that would take us significantly beyond the rhetoric of promise.

Specialists in arts education, like specialists in other fields, maintain a lively debate over the uses and misuses of behavioral objectives, the virtue of integrated over discrete subjects in the curriculum, issues of scope and sequence, alternative approaches to evaluation, and so on. Despite the importance of these issues, their resolution lies beyond the scope of this chapter and the expertise of its author. At a slightly more general level, however, there is a set of agreements behind which all the resources and forces for arts education can be mobilized. They include the following:

1. Arts programs must be made available to all students as part of their general education. Access to the arts only to enrich the curriculum or when other school work is completed is not adequate. Schools falling short of this minimum fail in their responsibility to individuals and society. Many of the programs described by Reimer and Eddy are designed to provide arts experiences for all students, notably programs at Evanston Township High School and University City, Missouri, and Project SEARCH in New York State, discussed in Chapter 5.

2. In developing educational programs for children and youth, the full resources of the community must be made available. In this and the preceding statement, then, the concept of schooling is extended well beyond the confines of a school building and a 9

A.M. to 3 P.M. school day. In effect, school and community become an ecological unit seeking to provide for the full range of academic, vocational, social, and personal goals to which our educational system is committed. The discussion in Chapter 6 offers many excellent examples.

3. Opportunities to go beyond arts in general education must be available to those students who seek, because of special interest and talent, to refine and deepen their capabilities in some art form. Such opportunities need not be provided in regular school buildings or by regular school personnel but must be regarded as part of a legitimate school curriculum at no additional cost to the parents. Eddy describes several programs designed to develop the abilities of talented students, such as the Educational Center for the Arts, the Creative Arts Community, INTERARTS in Connecticut, and Workshop for Careers in the Arts in Washington, D.C. It is recognized, of course, that such extended opportunities must be kept in balance with parallel opportunities for students whose talents lie in other directions. The concept of developing special talents in each successive phase of schooling was discussed in Chapter 1.

4. Retarded or handicapped students have an equal right to share in arts education programs. Indeed, for many the opportunity is especially important to their maximum development as human beings.

The arguments for this minimal set of agreements rise directly out of the nature of human beings and the arts and the needs of our society, as presented in Chapter 1 and developed in the rest of this volume. The supporting rationale has been eloquently and succinctly put forward by Bloom and Remer and is abbreviated below to provide a kind of summing up of the role of the arts in education. Readers are urged to turn to their original statement of this rationale as well as to other articles in the issue of *The National Elementary Principal* where it appeared.[10]

■ The arts provide a medium for personal expression, a deep need experienced by children and adults alike.

■ The arts focus attention and energy on personal observation and self-awareness.

■ The arts are a universal human phenomenon and means of communication.

■ The arts involve the elements of sound, movement, color,

P.S. 9, New York City. *(Photograph by Helen Buttfield. Courtesy of The Touchstone Center)*

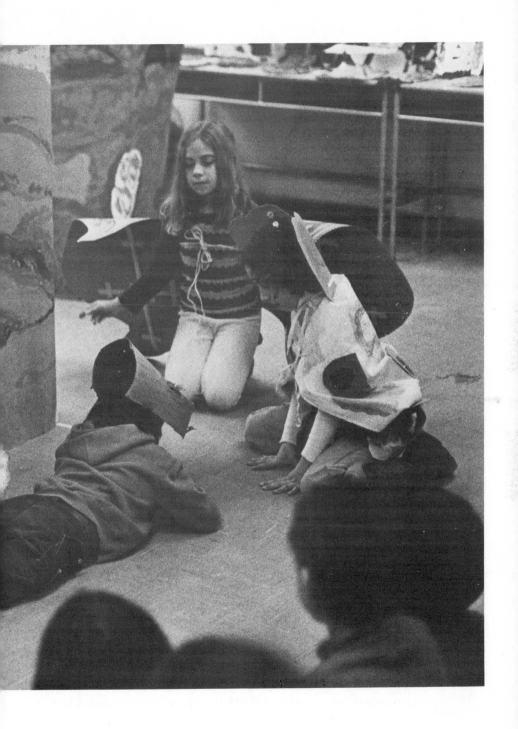

energy, space, line, shape, and language. These elements, singly or in combination, are common to the concepts underlying many subjects in the curriculum.

- The arts embody and chronicle the cultural, aesthetic, and social development of man.

- The arts are a tangible expression of human creativity, and as such reflect humanity's perceptions of the world.

- The various fields of the arts offer a wide range of career choices to young people. Arts-in-education programs provide opportunities for a student to explore the possibility of becoming a professional actor, dancer, musician, painter, photographer, architect, or teacher.

- The arts can contribute substantially to special education.

- As a means of personal and creative involvement by children and teachers, the arts are a source of pleasure and mental stimulation.

- The arts are useful tools for everyday living. An understanding of the arts provides people with an expanded range of choices about the environment in which they live, the life-style they develop, and the way they spend their leisure time.

EFFECTING IMPROVEMENT

Just as we now know a good deal about what constitutes an effective, comprehensive program in arts education, we also have useful knowledge about the complexity of the educational enterprise and some insights into what is required to bring about constructive change. These insights reveal that complex problems rarely are solved with simple solutions. Unfortunately, this revelation seems to encourage as much as discourage the advocacy of panaceas and useful but limited proposals: better materials, improved teacher education, artists-in-residence, specialists in elementary schools, and so on.

Also, persons unaware of this complexity are turned off by the seeming indifference of school personnel to their offers of assistance. It is not always easy to incorporate into crowded school days the expertise of a volunteer who never has dealt with twenty-eight twelve-year-olds at once and who believes the world is ready and waiting for what she or he has to offer. One of the difficulties with good schoolkeeping or teaching is that the elements of pedagogic artistry are not easily observed or acquired.

We have seen that the arts are not well established in schools, in spite of the rhetoric of support and the goal commitment. Indeed, their position is tenuous. What we are talking about, then, in proposing programs to reflect the rationale summarized on previous pages, is rather fundamentally changing an institution. The arts are not simply to be added; they are to be incorporated into a system of finite time and resources. While proponents, wary of stirring up the system's defense mechanisms, will argue that nothing is to be "basically changed" or taken away, their soft talk must be consumed with a large grain of salt. There simply is no way of implementing what is required in arts education without affecting and infecting the entire social system of the school.

One must be acutely conscious of this fact throughout any process of attempted improvement, but there is no need to be blatant about it. In my judgment, success requires attention to a set of propositions which are accepted as working guidelines or principles. Several of these already have been implied or made explicit. First, there must be a climate of support going well beyond philosophy and well-turned phrases. Second, those who will be most responsible for and affected by processes of change must be actively involved from the beginning. Third, the focal point is the individual school with its principal, teachers, students and parents. Fourth, there must be a larger collegial involvement than that provided in a single school. Fifth, there must be some reasonably permanent, nonpunitive source of ideas, help, and encouragement—preferably not part of the larger school district to which schools belong. Sixth, there must be a mechanism to provide new knowledge and skills as the need for these becomes apparent. Seventh, there must be a supportive infrastructure, all parts of which share a common goal and focus. Each of these assumptions is treated briefly below.

A CLIMATE OF SUPPORT

Two major elements make up the necessary climate of support. The first is the highly visible kind provided by voluntary groups (such as the Junior League)—some of which are made up of both professionals and lay citizens (such as Community Arts Councils)—and various national and state commissions or task forces. Although professionals are a little weary of still another eloquent appeal for the arts in education, they must recognize the importance of distinguished persons putting their names and accompanying prestige behind an area of great but unmet need. Their reports undoubtedly influence policy makers at all levels and increase the flow of resources. Almost always, the work of such bodies precedes the inclusion of new

emphases in educational programs and stimulates the more sustained efforts of local support groups.

The second element usually depends for much of its strength on the first. This is the sociopolitical commitment to arts education which is legitimized in statements of goals and made meaningful by the allocation of resources. Although this commitment is by definition a public one, professionals play a very large part in determining its ultimate impact. Special interest groups for the arts frequently go away encouraged from meetings with the chief state school officer and then wait in vain for something to happen. Officials often become exceedingly skilled in giving lip-service to easily articulated ideas and equally skilled in nullifying them with faint praise at the budget table. States (such as Pennsylvania)[11] that have carried through goal commitment to significant follow-up action are considerably outnumbered by those that have not. The difference is professional leadership.

This is a strategic time for pushing art education out of the side-eddies, where it has been circling, into the mainstream. It is gratifying that the work of the Panel on Arts, Education and Americans referred to earlier did not end when its report was issued. Thanks to the support of several philanthropic foundations, dialogue stimulated by the report is being carried to major regions of the country. In many of those places where leadership is making a difference, one frequently sees the strategic effect of moral support and small grants by foundations such as Rockefeller and the JDR 3rd Fund. It is no accident that moral support and additional resources tend to find their way to where leadership exists.

CHANGE IS A PROCESS OF CHANGING PEOPLE

Although behavior directed toward educational improvement often ignores the knowledge gained during and following the sixties, we now know that missionary-type projects conceived and developed remote from their intended sites fall far short of their goals. Slippage from conception to implementation is monumental. Schools are "people places." Those who run them must change if things that happen in schools are to change. Providing people with new tools is no assurance that they will use them or that their use will be directed to new ends. The social systems almost always act to reinforce what is done now and block or deflect anything calling for change. Schools are extraordinarily capable of appearing to absorb everything without actually changing anything. Telling schools to return to the basics is telling many of them to keep on doing what they already do.

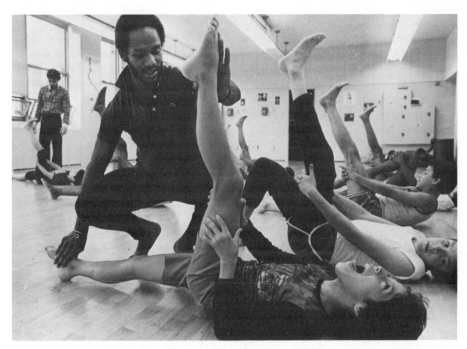

Reggie Smith teaching at the Jackie Robinson Junior High School Dance Company, East Harlem, New York. *(Photograph by Maria Bastone)*

The trouble with most innovators is their dislike of the slow, laborious process through which people gain new insights and attitudes and, in exploratory fashion, begin to do new things or employ new ways. Innovators often want relatively instant, immaculate change and soon become bored when it fails to materialize. But any reform or innovation of significance changes the entire system or institution and requires for its attainment several years of hard work on the part of all those involved. Anything short of this effort probably will turn up a kind of fool's gold, not worth the effort of even scraping the surface. The exciting results of these efforts, such as the program in the Webster Central District mentioned by Reimer and the Foxfire Program—essentially the work of one teacher—described by Eddy, make all the hard work worthwhile.

If the arts are to be established in and integrated into school life, the faculty of the school must do it. Nobody else can do it for them. This principle seems so simple, commonplace, and unspectacular that it is ignored far more often than it is observed. Consequently, the changes in the culture of the school required to accommodate the arts frequently are much-discussed nonevents.

THE SCHOOL AS THE ORGANIC UNIT

It is in schools that the arts must find time and space—time and space usually occupied by other curricular areas. Change from a relatively weak to a relatively strong position requires a political process of bargaining and compromising, a process not likely to benefit the arts unless leadership and external support are strong.

A catalyst for initiating this process could be a rather different approach to accountability than has prevailed in recent years—a requirement that schools be responsible for developing comprehensive general education programs, serving in a balanced way the full range of goals referred to earlier. This would contrast markedly with the requirement that teachers and students achieve progress on basic skills as measured by standardized achievement or competency tests. Such an approach would require faculty involvement in a process of schoolwide self-evaluation of a kind desired but seldom conducted for accreditation purposes. Steps to correct programmatic deficiencies would then be taken.

The processes of decision making involved are not well developed in schools; the institutional level appears to be the weakest of three levels of decision making—societal, institutional, and instructional—through which school policy and practice are determined.[12] The reasons for this lie partly in the sheer complexity of the substantive issues school staffs encounter and the unique demands of democratic, participatory processes.[13] But they lie also in the culture of schools.

Elementary school teachers see themselves as responsible almost exclusively for covering their perception of a year's work with a class of approximately thirty pupils. Their teacher education programs tend to reinforce such a view. Faculty meetings, if held at all, emphasize things more peripheral than the total program of the school. Few principals are prepared or expected to give leadership to a continuing process of refining ends and means. Attention to the school as a whole, as a functioning social system, is even less prevalent at the secondary level where the largest decision-making unit usually is the department. While the malfunctioning culture of schools begs attention, that same culture rarely encourages and supports what is required to change it.

Needed, then, is cultivation of a social system in which group decision making on school-wide matters is expected, supported, and rewarded. In working with eighteen elementary schools over a period of six years, my colleagues and I discovered that social systems of this kind could be productively cultivated.[14] Teachers and principals frequently are frustrated by their inability to change con-

ditions that seem to have become chronic and intractable. With a little help, they usually grasp the nature of the problem and are willing, sometimes eager, to work on it.

In our collaborative project with the eighteen schools (the League of Cooperating Schools), two sets of processes were encouraged simultaneously. First, the principals met monthly to share their experiences and, as they became more comfortable, their difficulties with participatory decision making. Later, they turned their attention to identifying and improving the necessary personal skills. Second, the staffs of the several schools engaged seriously, with varying levels of success and satisfaction, in school improvement processes requiring group dialogue (D), decisions (D), actions (A), and subsequent evaluation (E).[15]

In a very real sense, this process of DDAE became the vehicle for introducing into the schools those curricular and organizational changes that transcend the scope and power of teachers working alone. High-level performance on the criteria which principals and teachers defined for DDAE appeared, from our accompanying research, to be associated with a high sense of potency or worth, professionalism, and good morale. Barry found DDAE to be related positively to what she called a school's propensity for renewal and change.[16]

The usual approaches to improving arts teaching, emphasizing refinement of teachers' insights and skills and provision of more resources, no doubt affect the quality of ongoing programs. But a more substantial infusion of the arts into a school, especially into general education, affects the culture and various subcultures of that school. Such infusion requires supportive attitudes from and various actions by this culture and its subcultures. Unless the significance of a school's social system is recognized and a substantial portion of its culture is involved in seeking to translate sociopolitical commitment into functioning reality, the present paucity of and deficiency in school arts programs will continue.

NETWORKING

Resilient though a school may be in preserving its characteristic ways, it is relatively vulnerable when it seeks to break with tradition. Consequently, processes of significant change in schools are aided when there is a relatively powerful peer reference group from which to draw support and legitimation. This can be provided through membership in a consortium of schools commited to similar kinds of programmatic improvements. Participation helps overcome the feelings of isolation or ostracism which tend to accompany

change and innovation. Also, an extraordinary amount of practical help can be derived from sister schools when communication and sharing are cultivated. A well-established network of schools can be the margin of difference in effecting a change seen as going against established practice.

There is now a rather substantial body of experience with and some research on networking, most of it in fields other than education.[17] The use of networking by individuals is familiar. In various parts of the country, superintendents of several neighboring school districts exchange information and come together regularly for dialogue. Scholars with common research interests keep in close touch with one another, sometimes using computers for cumulative conferences extending over long periods of time. Professional associations provide a kind of loosely knit network of persons with interests in common. In many ways, existing networks of individuals reinforce the divisiveness of the existing educational system and perpetuate segmentation.

But experience to date with networks of institutions, including schools, is limited. The League of Cooperating Schools, referred to earlier, and its accompanying research (the Study of Educational Change and School Improvement) provided a useful body of information. There is no doubt that the League, rather carefully cultivated as a new social system, stiffened the spines of school principals, fostered decision-making skills, and supported a host of improvements in school life which would not have occurred without it. In effect, the social system of the League became sufficiently salient for those affiliated with it to sustain their efforts over a relatively long period of time and sufficiently credible to support changes sometimes running counter to practices endorsed by the school district. Indeed, we have evidence to show that changes taking place in League schools affected district-wide policy in neighboring districts as well as in the eighteen districts to which League schools belonged.

Current examples of large-scale institutional networking include over 1,500 schools clustered in collaborating groups as part of the Individually Guided Education network supported by the Kettering Foundation, the Community School network created by the Mott Foundation, and the League of Cities for the Arts in Education coordinated by the JDR 3rd Fund. The latter is of particular interest here because of its focus on the arts and on institution-wide efforts in the clusters of schools participating in each city. The key strategies employed are very similar to those found effective in our experience with the League of Cooperating Schools. Remer has this to say about their impact:

We are . . . discovering that the collaborative process, by its very nature, stimulates an ever growing spirit of cooperation among a diverse and normally disparate group of educators, artists, and members of the lay community. The arts appear to be an organizing and frequently a neutralizing force that permits large groups of people to overcome seemingly insurmountable obstacles to cooperation. An important outcome of this process is the understanding and support it can generate from a broad segment of the community for the program, the school, and the arts.[18]

The usefulness of networks is in establishing and legitimizing in the culture of several schools simultaneously something that was not there before. For example, the creation of networks of schools for the arts in education in several sections of the country would be an exceedingly productive way to implement the recommendations of the Panel on the Arts, Education and Americans. Those recommendations calling for collaboration—and there are several strategic ones in the report—probably will soon be forgotten unless strategies of this kind are employed. Individuals, panels, and commissions are excellent for the creation of new ideas; networks have a significant role to play in establishing these ideas in practice.

The creation of institutional networks should not be entered into lightly. In contrast to networks of individuals, which usually yield most of their returns from simple mechanisms such as letters, telephone calls, and small meetings, networks of whole schools are maintained only through the expenditure of considerable energy.[19] Unlike the former, which wax and wane over long periods of time and are easily resuscitated when they languish, networks of schools serve little purpose unless they are massaged vigorously. Without a good deal of tender loving care, they simply collapse, sometimes leaving behind a legacy of disappointment and frustration.

THE HUB

How long a productive network of schools in the arts or anything else survives and remains vigorous depends in large measure on what we came to call "the hub." Ideally, the hub is an autonomous or semiautonomous entity which maintains a rather delicate inside-outside relationship to the rest of the network. It is a source of ideas, support, certain kinds of help and, above all, the kind of open encouragement that can come only from an agency with no punitive power or authority. There is little evidence to date about the most effective kinds of hubs but one of the least useful probably would be an arm of the district's central office, unless it had a greater degree of autonomy than usually is the case. In the League of Cooperating

Schools, the Research Division of the Institute for Development of Educational Activities, Inc. (/I/D/E/A/) served rather satisfactorily in the hub role.

The major danger with networks, other than the most informal ones, is that they tend to ossify and linger long after they have served their usefulness. Networks of individuals often evolve into a kind of "buddy system" or "old boys club," which is pleasant enough but more effective for reinforcing well-established ideas than nourishing new ones. At their worst, such networks repress creativity and ostracize what industrial workers refer to as the "ratebuster," the person who sets a faster pace for himself than has prevailed before. Rather than stimulating and fostering new knowledge and methods, networks (including some professional associations) sometimes do precisely the opposite.

It is to assure continuing renewal that an independent, noncaptive, cosmopolitan hub is required. It is imperative that this hub be plugged into information systems, knowledge production activities, and the like, extending well beyond the operating domain of the network it serves and of which it is a part. One of my major conclusions, in reflecting later on the League of Cooperating Schools,[20] is that the hub should either maintain or assure an ongoing research process of a kind designed to provide data-based feedback to all participants. Otherwise, there is a great danger that a reasonable but untested belief will become orthodoxy and beyond question. When this occurs, decay lies not far behind.

The fact that institutional networks often are relatively short-lived does not detract from their potential usefulness. Indeed, if a cluster of schools has been successful in changing or in installing needed reforms in their cultures, disbanding the formal character of the network before the onslaught of orthodoxy could be advantageous. Those staffing the hub at the outset of creating a high-energy network are necessarily creative, imaginative people with a talent for working with others. Their interests usually change, and they move on. Frequently, those who replace them are somewhat more pedestrian in their personal characteristics and the spirit of continuing renewal ebbs a bit. It probably is better to plan the deliberate demise of the hub than to assure for it a long and mediocre life. In so doing, one probably assumes almost simultaneous demise of the network.

However, one needs only a little imagination to see how the hub for a league of schools for the arts in education might be staffed with a minimum of full-time people and many short-term and part-time artists, arts educators, generalists, researchers, and the like. Finan-

cial support could be derived from local, state, federal, and foundation resources. Descriptions of what some hubs might look like are found in Chapters 5 and 6: for example, the Jefferson County School District and the South Carolina Arts Commission discussed by Reimer and the Nassau County BOCES and the Southwest Iowa Learning Resources Center mentioned by Eddy.

PEDAGOGICAL SERVICE STATIONS

Earlier, the point was made that viewing the process of educational improvement as persons outside schools bringing enlightenment to those on the inside is not very productive. The rationale proposed here is that, since change in education is a "people problem," those in schools must become involved in the necessary processes of self-renewal and reconstruction. In doing so, they become resources for each other and, ultimately, a tremendous pool of talent becomes available, far surpassing what is available on the outside.

Making arrangements for persons seeking help to meet persons able to provide it is a productive, low-energy activity for the hub. As the social system of a network becomes increasingly effective, these persons find each other with relatively little assistance from the hub. We found that a League newsletter aided the process, with a kind of classified ad section announcing the availability of and the desire to help.

We discovered, also, that the demand for developing certain leadership or teaching skills often came in waves and required sustained attention. This can be taken care of by temporary "pedagogical service stations" through which teachers teach teachers for as long as the need exists. Sometimes, it is desirable for the hub to recruit some specialized "outside" assistance or to set up extension types of seminars and workshops under the auspices of universities. In a dynamic network, however, the system seems to generate much of the needed expertise from within. Many teachers' centers operate on this principle of mutual assistance. However, it can be carried to extremes, again leading to orthodoxies and inadequate questioning of prevailing practices. A steady infusion from the outside retards the process of aging.

THE INFRASTRUCTURE

A strategy for change bringing together the several elements described on preceding pages can be highly productive for arts in education programs, which require much more than mere improvement on what already exists. In fact, inadequate progress can be explained in part by the piecemeal nature of most approaches

attempted to date, particularly rather myopic preoccupation with pre- and in-service teacher education focused on individuals. A well-conceived and operated league of schools for the arts in education can survive and make a difference even when the larger milieu is indifferent and, at times, hostile.

But the possibilities for exponential progress are substantial when such strategies enjoy a fully supportive infrastructure. I have described the elements elsewhere.[21] They include a superintendent who views the district as a collection of individual schools, who genuinely delegates considerable authority to each principal, and who assures a large measure of autonomy to each school. The latter means that school personnel, in collaboration with community representatives, are free to select priorities and recommend a budget for their site to reflect these priorities.[22] Such decentralization is proclaimed much more than practiced.

Central office personnel in a truly decentralized district should direct their energies to each school and generate district-wide enterprises only when a relatively common need is identified. They work on-site, with each school's policy-making body and working groups, in seeking a well-balanced program for all children enrolled. Too often, central office personnel work virtually in competition with one another in promoting the interests of their particular specialties and not the interests of each unique school.

The supportive infrastructure recognizes the importance of school-based in-service education, assists in finding time for it (in part by being careful about imposing other time-consuming demands), and rewards it in any merit aspects of salary schedules. By contrast, in many school districts today, teachers who work together in seeking to improve their school settings usually are simply adding self-imposed activities to those required by the district. The view of the school as the organic unit for educational improvement simply is not generally accepted within the existing system.

A different role from that of simply turning out new teachers is required of colleges and universities. Beginning teachers acquire most of their teaching habits from experienced classroom teachers. Their professional preparation rarely includes involvement with the staff of a school in a process of redesigning the setting. They too often equate what is with what should be. Consequently, departments and schools of education and the arts should participate in a league of schools made up of those in which their student teachers are placed. These students become junior members of the staffs of these schools; university professors join the pool of available resources and become active partners in an ongoing process of school

improvement. Pre- and in-service teacher education overlap and become better as the schools become more dynamic, satisfying places to work and learn. The "Education for Aesthetic Awareness" teacher education project described by Reimer and the New Place discussed by Eddy are exciting examples.

The elements of everything described on preceding pages now exist; the "Education for Aesthetic Awareness" program in Cleveland incorporates most of them. The costs of redirecting and rearranging energies and resources as proposed are no greater than prevailing costs of operating the present system. But the elements and costs involved are focused on a clearly definable entity—the individual school where students enjoy or are cheated out of the balanced general education they should have. With the school in the spotlight, the state of the arts becomes conspicuous.

ASSESSING THE CONDITION OF THE ARTS IN EDUCATION

Efforts to improve education and schooling in any field almost invariably begin with a relatively quick assessment (or none) of a shortcoming or deficiency to be remedied and relatively elaborate articulation of what should be. Discussion and disagreement more frequently take place around the proposed treatment than the accuracy or adequacy of the diagnosis. Sweeping charges of triviality in the curriculum or of soft pedagogy periodically have fueled reform movements in the United States, especially when made by highly visible persons and given broad coverage in the press. Accusations of watered-down programs and the like seem to have become more widespread with increased school attention to our long-standing promise of educational opportunity for all.

Diagnoses of what ails the schools usually have focused on student achievement in a few subjects as measured by standardized tests. Much less often has the diagnosis included reference to the near absence of other areas of rhetorical commitment not usually or easily tested, such as the arts. So-called qualitative measures of what goes on in schools have attracted little attention from policy makers and researchers. The task of gaining valid and reliable insights into different kinds of schools is difficult and complex.

Over the past two decades or so, a handful of studies[23] have provided some leads worth following up in more detail and with more comprehensive measures. These suggest at least four interesting hypotheses regarding elementary education which may explain the status of the arts in school programs. First, classroom emphases are

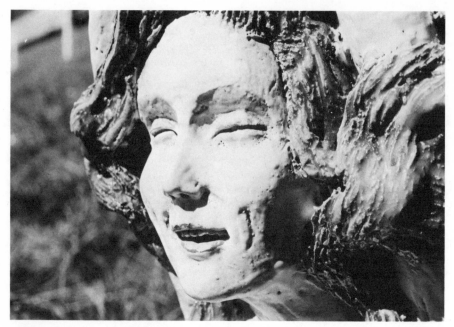

Student sculpture. Jefferson County High School, Colorado. *(Courtesy of Larry T. Schultz)*

predominantly directed toward relatively low-level cognitive behaviors—mostly the possession of information. Second, oral and written language is used almost exclusively as the vehicle for developing these behaviors. Third, mathematics and language arts (the social studies and science are predominantly taught as exercises in the language arts) account for most of the time spent each day on instructional tasks. Fourth, an inordinate amount of time (the figures range from about 30 percent to 70 percent) is taken up with classroom routines and controls appearing to have little or no educational value. Some researchers estimate that actual learning time ranges from as low as 12 percent to only as much as 30 percent of the school day.

These hypotheses lead to two rather tantalizing speculations. First, it appears that the arts have little standing in elementary schools either in their own right or as an aid to other learnings. Second, the problem is not space or time for arts experiences in the curriculum. Plenty of time appears to be available, without intruding at all on time spent on other fields. Speculative diagnoses such as these are at least as valid as (and probably more valid than) those curricular and pedagogical diagnoses setting off various back-to-basics movements.

It becomes increasingly clear from suggestive studies such as these that we seriously lack and badly need hard data on what is taught in schools, how it is taught, what teachers perceive school goals to be, how students react to current school fare, and so on. From these studies, conducted periodically in a reasonably representative national sample of schools and regularly in local schools, useful diagnoses regarding the curriculum and teaching can be made.

The arts in education stand to gain immensely from such inquiry. As stated earlier, my colleagues and I are endeavoring to lay the groundwork for conducting such studies as a matter of course through A Study of Schooling. A significant substudy seeks to document the condition of arts education in our sample of schools, including their use of community resources. My present guess is that the data will provide supporters of the arts in schools with stronger arguments than they have had heretofore regarding the need for programs in the arts. To put the matter more forcefully, I expect our findings to reveal a shocking gap between the rhetoric and the reality of our commitment.

To return almost to where I began, however, the most productive agenda for improvement in school arts programs will be built at the local level. These, too, must begin with hard data regarding existing curricula, what the students actually are studying, how daily time in classes is spent, and so on. In most instances, the findings will be sobering. They will not, in themselves, provide a new sense of direction. But it is difficult to believe that teachers, students, and parents will respond to what they find by seeking still narrower, more rigid programs of instruction. And it is difficult to believe that they will fail to find ways and time for including more attention to the arts and other areas of neglect that are identified.

During the 1960s, we probably expected too much of our schools. Vice President Humphrey, addressing the 1965 White House Conference on Education, said that we would go down in history as the nation that employed its educational system to clear up slums, eliminate poverty and unemployment, and assure world peace. Teachers were asked by creators of innovative programs to transcend the realities of crowded classroom boxes and use pedagogical methods designed to employ all of a child's senses in processes of learning. Only a few school districts provided the in-service education and support systems required for teachers to succeed. Only a few school districts were able to mount arts education programs to match even some of the rhetoric.

Such gains as were made proved to be very fragile when disillusionment regarding the schools not surprisingly set in early in the

1970s. It soon became clear that the full importance of the arts had not been adequately internalized even in school districts that had become virtual lighthouses for the field. The superintendent who had articulated the goals moved away; the director of arts education was not replaced; the back-to-basics proponents (usually supported by the local press) prevailed. It became clear that the arts were not yet established beside mathematics and the language arts as essential components of the curriculum. Students in school after school in our sample (for the Study of Schooling) placed the arts high in personal liking and preference but low in importance in the pecking order of school subjects.

The back-to-basics movement slowed visibly late in the seventies. States seeking to define basic education almost invariably came up with broad definitions that included the arts. The voices of humanism in its many forms—for alternative modes of expression, for developing the processes of both left and right hemispheres of the brain, for the creative and aesthetic—made themselves heard more loudly and clearly once again.

The shifts from the "soft and tender" toward the "hard and tough" and back again in education occur in cycles of ten to twelve years. If this pattern prevails, the soft and tender with all of its concern for total development of the individual will find a place on the educational stage once again during the 1980s. Let us hope that it does not push aside its "tougher" counterpart so completely that, once more, a cycle of debilitating reform is triggered. What we need now are balanced programs in each and every school reflecting the four broad goal commitments elaborated in Chapter 1. These programs, in turn, must provide every student with the varied array of experiences in the arts described throughout this volume. The arts are not an educational option; they are basic.

NOTES

1. The Arts, Education and Americans Panel (David Rockefeller, Jr., Chairman), *Coming to our Senses,* McGraw-Hill, New York, 1977.

2. Educational Policies Commission, *The Role of the Fine Arts in Education,* National Education Association, Washington, D.C., 1968.

3. Commission on Cultural Resources, *Arts and the Schools: Patterns for Better Education,* New York State Commission on Cultural Resources, New York, 1972, p. v.

4. See, for example, Stanley S. Madeja, *All the Arts for Every Child,* The JDR 3rd Fund, New York, 1973.

5. John I. Goodlad, "What Goes on in Our Schools?" *Educational Researcher,* vol. 6, no. 3, March 1977, pp. 3–6.

6. Seymour B. Sarason, *The Culture of the School and the Problem of Change,* Allyn and Bacon, Boston, 1971.

7. For description and analysis, see Ernest R. House, *The Politics of Educational Innovation,* McCutchan, Berkeley, Ca., 1974.

8. Elizabeth C. Wilson provides an interesting account of the needed goals being generated by the professional staff and officially sanctioned by the board. See her chapter in John I. Goodlad and Associates, *Curriculum Inquiry—The Study of Curriculum Practice,* McGraw-Hill, New York, 1979.

9. Stephen K. Bailey, *The Purposes of Education,* Phi Delta Kappa, Bloomington, Ind., 1976.

10. Kathryn Bloom and Jane Remer, "A Rationale for the Arts in Education," *National Elementary Principal,* vol. 55, no. 3, January/February 1976, p. 45.

11. See, for example, *The Arts in Basic Education (A Message to Curriculum Developers)* and *The Arts Process in Basic Education,* Pennsylvania Department of Education, Harrisburg, Pa., 1973.

12. Gary A. Griffin, "Levels of Curricular Decision Making," in Goodlad and Associates, op. cit.

13. Robert M. McClure, "Institutional Decisions in Curriculum," in Goodlad and Associates, op. cit.

14. Ann Lieberman and David A. Shiman, "The Stages of Change in Elementary School Settings," in Carmen M. Culver and Gary J. Hoban, (eds.), *The Power to Change,* McGraw-Hill, New York, 1973.

15. For description and clarification, see Mary M. Bentzen and Associates, *Changing Schools: The Magic Feather Principle,* McGraw-Hill, New York, 1974.

16. Elizabeth F. Barry, "The Relationship Between Propensity Toward Self-Directed Change in School Faculties and Selected Factors in the School's Subculture," unpublished doctoral dissertation, University of California, Los Angeles, 1974.

17. The School Capacity for Problem Solving Group in the National Institute of Education has been endeavoring to pull together this useful knowledge. The volume of papers commissioned by this group was not available for documentation at the time this manuscript went to press.

18. Jane Remer, "Networks, the Arts, and School Change," *National Elementary Principal,* vol. 55, no. 3, January/February 1976, p. 44.

19. For some useful distinctions between low-energy and high-energy networks, I am indebted to Matthew Miles and Dale C. Lake, "Communications Networks in the Designing and Starting of New Schools," paper presented at American Educational Research Association Annual Meeting, 1975.

20. John I. Goodlad, "Networking and Educational Improvement: Reflections on a Strategy," paper commissioned by the School Capacity for

Problem Solving Group in the National Institute of Education. (Mimeographed.)

21. John I. Goodlad, *The Dynamics of Educational Change,* McGraw-Hill, New York, 1975.

22. Alex Sergienko, "Building the Budget from the Bottom Up," memorandum to principals, Tacoma Public Schools, June 10, 1974. (Mimeographed.)

23. For a summary of several such studies, see John I. Goodlad, "Intervening in Learning Environments," in Kenneth H. Hansen (ed.), *Learning: An Overview and Update,* U.S. Office of Education, Washington, D.C., 1976, pp. 43–58.

APPENDIXES

APPENDIX A
EXCERPTS FROM
POSITION PAPERS

One of the early actions of the Advisory Panel for this volume was to invite a series of position papers commenting on arts programs. Authors of some of these papers are on the faculties of colleges and universities or on the staffs of arts or research institutions where they study the role of the arts, plan and design arts programs, and train teachers to carry them out. Others are curriculum specialists or arts supervisors who work with a group of schools or coordinate a system-wide program. Still others are teachers who actually put arts programs into operation with students. We asked them to discuss the elements they thought would continue to ideal arts programs and to describe the actual workings of the programs in which they were involved. In many cases, these papers formed the basis for the chapters making up this book.

However, many of these papers have important and interesting things to say in their own right. Therefore, we dicided to select and compile excerpts for the enjoyment and information of the reader. Some excerpts are simply random thoughts that impressed the editor as being interesting, enlightening, or provacative. Others are more fully developed arguments for specific positions. Still others are detailed descriptions of programs discussed in the preceding text.

No paper has been included in its entirety. Rather, excerpts have been taken from each and the selections grouped according to subject. Thus, comments by a single author may be found either in one place or scattered throughout the Appendix. Authors are identified at the end of each selection.

Selections are arranged under six major headings: The Role of the Arts, the Arts and Education, Programming the Arts, the Role of the Museum, Individual Arts, and Programs.

Some of the position papers were prepared as long as five years ago. The programs they discuss may have changed greatly or may no longer exist. We include these excerpts because they have value in revealing what could be, has been, or might be again in the uncertain and exciting story of arts and the schools.

THE ROLE OF THE ARTS

THE ARTS PROVIDE ALTERNATIVE VIEWS OF SOCIETY

It has always been difficult for man to interpret his own society. The only vision that is "clear and sure" is hindsight. Since the artist frequently has a view of the world which is unencumbered by parochial and received prejudice, he can often envision liberating options. The tendency for some artists to ignore traditional views is not rebellion in the usual sense, it is rather a natural type of conformity to self. Since the artist tends to place high value on individualism, he is less concerned with tradition, and he has a greater orientation to innovation.

THE ARTS TEND TO IDENTIFY EMERGING VALUES

The role of censorship continues to be a dominant social problem. The art of cinema provides an interesting example. It is true that we are faced with a torrid spate of brutality, pornography, and sensuous stimulation which are presented as surrogates for mediated experience. Should we protect the public, or should we protect the artist? We should remember that in certain nations the arts are frequently evaluated in terms of their social usefulness, and that this criterion often severely limits the quality of artistic creation.

It may be difficult to distinguish between films as works of art and films as mere time-filling entertainment. But, what segment of society with what special credentials will decide for the rest of us? In view of the fact that what was considered heresy yesterday is considered ordinary today, and in view of the significant social and political problems which confront us, it no longer possible to let "others" decide. Individuals should have the opportunity to study the arts systematically in order to develop sufficient insight to exercise their own independent critical judgment.

THE ARTS PROVIDE UNIQUE INSIGHTS INTO THE NATURE OF MEANING

Is the nature of musical meaning dependent upon a story, a theme, or the composer's life-space? Is the composer's sociopolitical view important to know as one tries to interpret the music? Can a monkey and a man create the same meaning on a canvas? Can a documentary film be a complete statement of objective fact? Operationally, truth for each person is dependent upon a singular perception of reality. Since we are uniquely individual, from a psychobiological orientation, our perceptions of reality are also individual. Hence, if truth is dependent upon a reality which is personal to each of us, what is or is not true as a statement of fact may be open to question. An investigation of the arts in terms of their epistemology, syntax, and aesthetic meaning adds a rich dimension for the synthesis of experience.

THE ARTS EMPHASIZE THE CULTURAL PLURALISM OF CONTEMPORARY SOCIETY

In education, the most frequent criticism of pluralism is either that it leads to poor standards or that there are no standards. Such fears are unfounded since art without standards ceases to be art. There are always some basic criteria that transcend a wide variety of styles, for example: (1) degree of originality; (2) technical excellence; and (3) expressive content.

It is important to remember that a pluralistic society will produce a wide variety of styles; this condition may be described as aesthetic pluralism. Hence, it is not unusual to have to draw distinctions among professional arts, poor art, and non-art. What separates the professional from the amateur is quality.

THE ARTS PROVIDE MULTIPLE REALITIES

Aesthetic reality is suprareal, for it is an event, a condition or an experience in which greater sensitivity and insight for the human condition is developed. In the theater, for example, personal dilemmas, intricate human relationships, and social and political vectors are examined so that the imagination is engaged. Membership in an audience provides a unique form of aesthetic participation in which insights are stimulated, values are examined, while emotions are being orchestrated. Where daily living can be commonplace, often revealing little in the way of penetrating insights, aesthetic realities can be deepening and broadening. This reconstruction of experience is at the core of aesthetic reality, for it holds significant meaning for those who seek a more profound understanding of both self and society. Without aesthetic reality, only a partial view of the universe is possible.

THE ARTS PROVIDE OPPORTUNITIES FOR SELF-ACTUALIZATION

Three types of activities are dominant in the arts: (1) creating, (2) performing, and (3) appreciating. Since each of these functions involve perception, cognition, affection, and developmental synthesis, they are all self-actualizing to some degree. When man creates, he projects his very essence through a particular medium (sound, oil and canvas, etc.) in such a way so as to share his experience with society. Participation in the arts is both highly personal and uniquely social. To develop our own expressive potential, and to appreciate the originality of others, is to encourage the development of the most fundamental human quality: creative behavior.

THE ARTS ENCOURAGE THE DEVELOPMENT OF INTUITION

Creative behavior always begins in response to an unease, a hunch, an itch, or a suspicion. In traditional education, however, we tend to

emphasize the scientific method, hard evidence, and observable behavior. Among the lessons to be learned from men like Freud, Einstein, and Fuller is that they did not overlook the unconscious synthesis that provides direct access to available truth, managed perception, or prepared cognition. Since many of the arts exist in a non-verbal context, the cultivation of this type of knowing stimulates qualities of perception and cognition that hold great potential for transfer. Intuitive behavior is a crucial component of the creative process and requires the same type of disciplined knowledge of syntax, technique for execution purposes, and freedom to make the quantum leap.

GERARD L. KNIETER[1]

1. Art is a dialogue between all people, not a select few human beings, verifying through logic and imagination the significance of life processes.

2. Discursive as well as nondiscursive forms are equally legitimate tools for the expression of man's unique ideas, feelings, and attitudes about life.

3. While art experience, particularly in the visual arts, has been thought of as an individual process, the new technology tends to open the potential for collaborative techniques by groups and individuals.

4. The new technology cannot be ignored as a potentially significant force in transporting the nature of man's ideas, be they aesthetic or whatever, to new publics.

5. The economically advantaged maintain control over traditional arts institutions in the country, fashioning them after their European ancestors, rather than developing unique American forms.

6. The decentralization of arts institutions to include the other 98 per cent of the public should not be construed as a threat, but a challenge to the self-actualizing process of contemporary humans in a democratic society.

RICHARD L. LOVELESS

The arts can provide an avenue into understanding lives and cultures of people. The visual arts, music, and dance can be universal languages. They offer the possibility of access to the life-style,

[1]From *Music Education for Tomorrow's Society*, Arthur Motycka (ed.), GAMT Music Press, 1976. Reprinted by permission.

values, and world-outlook of people who may be distant in time or space. Learning about the traditional art forms of people who may be our neighbors helps us better understand their beliefs and way of life. Through the arts, students can become aware of the concerns that unite mankind and the varied ways in which these concerns are met and find artistic expression. The variety of cultures manifested in the arts heightens consciousness of one's own way of life. By learning how beliefs are encoded in the arts, students come to recognize that verbal language is but one way of realizing and communicating ideas and feelings. They learn that there are ways of expressing meanings that are shared by a culture and artistic expressions that are unique to an individual. They see that although individuals and cultures may devise art forms that are distinctive, there is a universal preoccupation with the great mysteries of life—that the enigma of human existence in the world is posed in myriad ways in the arts of all peoples.

HILDA P. LEWIS

THE ARTS AND EDUCATION

Every child deserves the chance to discover and fulfill his potential. Each one has the capacity to do and become many things. Human potential is multifaceted. The conditions of life hone some talents; others, finding no sustenance, die away. The loss to the person and to the society of capacities that have withered early for lack of encouragement and opportunity can never be assessed.

Traditionally the central concern of schools has been with survival skills—the basic competencies needed in society. Now we are becoming aware that making a living is not enough; life itself must be made worthwhile. Over the ages, the arts have helped people to transcend the limits of their daily existence. The joys of life are expressed in the arts and it is in the arts that people seek solace. A life without art is barren, indeed.

HILDA P. LEWIS

All across the country adolescents are dying at their desks, dying spiritually, mentally, emotionally, because academic learning has been cut off from its roots in art, and the arts have been made peripheral instead of central to their education. We are the victims of a long and erroneous tradition which takes pride in man's rational nature; we should be proud—or at least grateful—that man can become conscious. Consciousness consists in continually scanning inner and outer reality in order to integrate them into new wholes. To create such wholes takes all human powers, not only intellection

but feeling, valuing, intuition, imagination, physical awareness, and spiritual insight. An education centered on the arts would evoke all these powers. It would also lead naturally to the widest possible scope of study—the sciences, human behavior and culture, alternative language system such as words and numbers. Most art teachers would welcome such interconnectedness; many urge it on their "academic" colleagues and are rebuffed. Unfortunately, most academic teachers do not understand that their teaching should evoke all the human powers and that their subject matter is incomplete if it never fans out into poetry, music, movement, and the other arts. So the division gets deeper and the death rate rises.

The conscious search for consciousness begins in early and middle adolescence. This is what Erikson describes as search for identity. The young at this age cry out to understand human behavior, for now that the clear rules of our society have faded and the rule-giving institutions are passing into decay, they are at the mercy of impulse or of the short-term conventions of their peers. They ask to study human feelings, the future, power in society, growing up, identity itself, not just in rap sessions but in depth. This is a major change of emphasis; younger children take the human world largely for granted and concentrate their exploratory drive on the wonderful world of things, asking, "How do they work? What are they really like? How will they respond if I do this or this?" In adolescence the search moves inward to self and therefore outward to other who may help to explain self. Not all the relations to the human world are positive. Younger adolescents are much possessed by death and violence; conscious sexuality rockets them out of a life that can have seemed quite manageable only a year or so earlier. Becoming aware of personal isolation, of their own inevitable end in death, of the crazy ineptitude of adults in a world capable of genocide, young people cling to one another, have in-jokes (many of them "dirty" for the same reasons that people living under dictatorships make political jokes), try out minor and major delinquencies, play hard-to-get with adults, fool around, and are bored, bored, bored— all reactions typical of those who flinch from a painful reality. Almost all go through some period of high fever or dulled perceptions, not because adolescence is necessarily fevered or deadening but because they have built up no immunity against the personal and social disorder they meet when they look around them. A year or two later, with luck and good management, some will move on to the greater stability and scope of the later teens quite comfortably, even if school is not all that it ought to be. But too many get stuck, opt out, refuse the pain and risk of growth into identity, and cease once and for all to search for consciousness. Yet the crying need of our age, our requirement for survival and spiritual evolution, is for more of as to become more deeply conscious, more connected with the cosmos, more comprehending of others, more aware of ourselves.

In the context of a search for consciousness, younger and middle adolescents need the arts desperately, and they need them at three different levels. First and most simply the arts are a useful escape, an engaging activity in which they can lose themselves. Most art in most schools provides some escape, and art periods are therefore the best part of the school day for many youngsters, even when the quality of experience offered in studio or shop is relatively trivial. At a more serious level, young people's sense of themselves is strengthened if they can make something that is all their own, something that they can see or hear or experience; it helps to give a sense of personal shape, of being someone who chooses this form which is manifestly different from other choices made by other people. This externalizing happens not infrequently in school, though too often the schedule is rigid or the youngsters are locked in an assembly line of "skills training," as opposed to acquiring skill through the pursuit of their own creative style. A special value of identification through work in the arts is that the form is ambiguous; a piece of work is recognizably one's own, not another's, but its significance is not certain. So an artist's identity is revealed and yet hidden, a useful protection for an age-group that is much governed by shame. So far so good, in some schools. There is some enjoyment, some individualizing, some mastery. But the arts rarely play the more profound part which they might, for young people rarely have the chance to create meaning in what many suspect to be a meaningless universe because the circumstances of their learning do not allow them to go sufficiently deeply into their material or into themselves or to integrate them into wholes that match the scale of their anxieties or of their hopes.

The function of the arts is the elucidation of consciousness, but they are essential also for the notation and elucidation of ideas. In the adolescent phase of transition from purely concrete to concrete and formal operations (in Piaget's terminology), visualization and concretization of ideas are just as important as they are in childhood. Yet in schools, most formulation is in words, which have the great disadvantage of being serial rather than synchronistic. Throughout all the curriculum the use of graphics should be encouraged, as well as the creation of three-dimensional models, which can be fiddled with until they represent an idea precisely and can be altered as ideas develop.

CHARITY JAMES

No one can claim to teach imagination. Rather our job is to rediscover and relocate the imaginative capabilities people were born with. And by imagination we mean the whole problem-solving apparatus we can bring to bear, not simply the part concerned with the aesthetic arrangement of materials and ideas. Too often arts programs are dismissed with a wave of the same hand that kissed off

"progressive education" as having nothing to do with day-to-day living. Notwithstanding the ridiculousness of that objection, arts training can really serve kids who, unhappily, will neither create nor enjoy works of art. The flexibility, risk-taking, originality, and fluency basic to problem-solving are there for all students no matter what their orientation.

VICTOR B. MILLER

Education in the arts is characterized by opposing loyalties, unresolved issues, and a general absence of adequate conceptual development. There is also a lack of widespread realistic assessment of the complexities involved in developing arts education alternatives which can achieve a degree of continuity over time. . . .

Artistic creation has been a characteristic of human beings since the earliest days of existence; even in trying and primitive circumstances, such as in bomb-devastated cities or in concentration camps, human beings manifest strong desires to create artistically and to experience aesthetic pleasure through the arts.

There are other bases for including the arts and for developing aesthetic sensibilities through the school curriculum. Although technology is essential in today's civilization, it is also evident that technology has been used, at times, for inhumane and destructive purposes. There is, furthermore, substantial evidence from studies of the alienation of middle-class American youth that accumulation of material goods does not necessarily lead to a satisfying and productive life. The arts and humanities add other needed dimensions to the experiences of people and give directions for the use of technology in the service of society.

There is another fundamental reason for the development of artistic experiences and aesthetic sensibilities through the school curriculum: the arts provide a deterrent to totalitarian rule. It is not accidental that all of the arts are limited and censored in unfree societies. In such societies, the restrictions placed upon poets, musicians, dancers, filmmakers, and other artists are imposed logically to contain and to eliminate, if possible, alternatives which are contradictory to "the system." Paradoxically, the idiosyncratic nature of the arts and the lack of agreement within the arts, often cited as an area of weakness, is one of the major justifications for inclusion of the arts in the curriculum. . . . The arts are essential in the development of sensitive, humane, creative individuals capable of achieving the fullest of possibilities in a free society.

CARL J. DOLCE

We must not overlook one of the most important aspects of human development—the affective aspect, including one's feelings and one's emotions—and the role of these in learning. All experience

occurs in a feeling climate, with an emotional tone, in an affective state. Experience does not occur independent of feeling—nor does one's learning. At the same time, feeling and emotion do not exist apart from experience. Emotion and experience are coextensive; one is always deeply embedded in the other. Feeling and emotion provide vividness in human experience and human learning.

<div style="text-align: right">GEORGE KYME</div>

The justification for a more dynamic role for arts education is in no way to be construed as a device to diminish the importance or the relevance of the other curricular areas. Quite the contrary is intended. What prevents arts education from reaching its full potential also hinders the development of the other areas in reaching their full capabilities to contribute to the total educational process. It is not essential that a disproportionate amount of the total school resources be allocated to the arts, but that we re-order our priorities so that the immense contribution that the arts can make to every aspect of the curriculum be utilized to its fullest.

<div style="text-align: right">MONROE EIDLEN</div>

We look forward to the implementation of programs in which: the arts become central to the instructional program; the arts infuse every area of the curriculum; all the arts are offered to all students; flexible and varied staffing patterns are developed in order to provide the best possible arts instruction; space is designed to accommodate the special needs of arts programs; training is provided at the pre-service and in-service levels in preparation for new teaching roles in arts education; schools, museums, and community arts agencies enter into participation in arts programming for children and young people; teachers, artists, parents, and members of the community at large work together in planning and developing curricula, instructional materials, and teaching resources; alternatives in staffing, scheduling, housing, grouping, and administration facilitate programming that is attuned to the individual needs of learners and makes optimal use of human and material resources. Through these measures we can maximize learning in schools that are joyous, person-centered, and humane.

<div style="text-align: right">HILDA P. LEWIS</div>

PROGRAMMING THE ARTS

GOALS AND OBJECTIVES

Even the delineation of the objectives for the arts in education is subject to disagreements and disputes. Some view the arts as

<div style="text-align: right">247</div>

instruments to achieve other ends. Among those who view arts experience as a means of attaining other objectives are the proponents of using the arts to facilitate the teaching of reading, composition, and computational skills. Others emphasize the use of the arts as a means of understanding history, others focus on the arts as a therapeutic agent in drug therapy or in mental health. Still others advocate the arts as a means of self-concept development or as a mechanism to foster ethnic identity or as an effective means for enhancing psychomotor development. Many visual artists justify the visual arts as facilitating visual discrimination, i.e., learning "to see." Some music educators view music as a means of stimulating auditory discrimination, i.e., learning "to hear."

In contrast to those who view the arts as a means of achieving other and "greater" ends are those who assert that since aesthetic experiences require no further justification, arts experience in themselves are the prime consideration. . . .

The concept of universality of arts education can perhaps be clarified by contrasting this concept with that'of particularity. While universality is inclusive as to students and objectives, particularity is limited as to students and/or objectives. Vocational or preprofessional education in the arts, an example of particularity, is aimed at a limited group of students with specific objectives for skill development for those students; the use of the arts in drug therapy is similarly aimed at achieving a particular set of objectives for a particular audience.

Universality of arts education as basic education denies the traditional monocultural and monoethnic emphasis which permeates current arts education programs. If basic education is viewed as generative in nature opening a wide set of alternatives to students, failure to include experiences in arts produced by other cultures and minority groups limits the generative aspects of the curriculum. Humanity transcends a particular culture, a particular nation, a particular race or class. The arts provide differing sensitivities and perspectives derived from differing experiences and heritage. Multiculturalism in arts education is an essential aspect of basic education. From a universalistic vantage point, all students should have multicultural arts education experiences. Such a universalistic concept transcends but does not preclude particularistic applications. For example, the arts can be used legitimately in the development of ethnic identity and pride for some, a particularistic function.

CARL J. DOLCE

The goals for aesthetic education as an area of study include:

1. To demonstrate to students that all phenomena in our environment have aesthetic qualities and to heighten their capacity for recognizing, analyzing, and experiencing these qualities.

2. To demonstrate to students how the arts contribute to the aesthetic condition of our environment.

3. To assist students in discovering similarities and differences among the arts and by these means to enhance responses to aesthetic qualities in each of the arts and demonstrate that all the arts are potential sources of aesthetic experience.

4. To involve students in various models of behavior which are aesthetic in nature, such as the creative or critical processes.

5. To introduce students to a wide range of views about aesthetic qualities so that they develop their own criteria and ability for making aesthetic judgments.

6. To demonstrate the importance of aesthetic values to the individual and society, and

7. To make aesthetic values relevant to the student's own life style.

Another set of goals should be developed providing for aesthetic content within non-arts disciplines, such as the aesthetic outcome for mathematics or science or social studies or language arts or literature. These would define the outcomes for content in disciplines outside the aesthetic area of study and would be based on the relationship of the arts to the non-arts disciplines. An example of possible aesthetic goals for non-arts disciplines are these suggested for Social Studies:

1. To make the student a critical analyst of the aesthetic condition of our environment.

2. To gain knowledge about the social significance of the arts in a variety of cultural and political context.

3. To make informed aesthetic judgments about problems which affect the general human condition when viewed from a social, political, humanistic, or economic perspective.

STANLEY S. MADEJA

The following series of guidelines are projected as program objectives for more specialized courses in the arts. They might be achieved, for example, through interdisciplinary art and humanities courses in combination with courses in photography, film, dance, and architecture.

 1. To develop taste and discrimination in making independent aesthetic judgments.

 2. To develop flexibility and originality in creating, performing, and appreciating to the arts.

3. To develop an awareness of the arts in social and symbolic contexts.

4. To become acquainted with other cultures through the arts.

5. To become acquainted with several systems of aesthetic values.

6. To recognize the uniqueness of each art and the similarities among the arts.

7. To learn to identify the effective use of the arts in propaganda, advertising, and commercial entertainment.

8. To develop the use of the arts for leisure time.

9. To acquire nonverbal means for learning and self-expression through the arts.

10. To understand the role of the arts as a vehicle for the transmission of the cultural heritage.

<div align="right">GERARD L. KNIETER</div>

Three processes are fundamental to the curriculum: Inquiry (exploration, experiment, and the search for explanation), Making (of ideas or objects or sounds, as opposed to merely doing an allotted task, which I called Doing), and Dialogue (awareness of the natural and the man-made world, of other people, and of inner self). Dialogue with the outer world is at risk during adolescence, as young people learn to think more of what things are worth and how to use them than of what they are in their own right. The arts will not be fully nourishing to the young unless they have a contemplative aspect. It is necessary to insist on opportunities for Dialogue because so much in the culture deadens the sense of wonder. When there is a glut of material goods and obsolescence is economically favored, it is hard to see anything as precious even if one is personally poor or deprived.

<div align="right">CHARITY JAMES</div>

One way of expanding the arts program without extending the school day, increasing the number of teachers and spending large sums for facilities and equipment is by integrating offerings and resources in a comprehensive arts program keyed to the total curriculum and utilizing existing materials, space, and talents in the schools and in the community.

Integration is a time-honored solution to an expanding curriculum. The social sciences, for example, have been unified for instruction in the elementary school for many years. Similarly, the recognition of the interrelatedness of reading, speaking, writing, and

listening and their dependence on vocabulary, grammar usage, spelling, and punctuation gave rise to programs in the language arts. Clearly, the time has come for those who teach the arts to acknowledge that integration can facilitate richer, more varied programs, permit more effective use of instructional time, and eliminate wasteful competition over access to resources.

An integrated arts program emphasizes what is fundamental to all the arts. All of the arts involve forms that are aesthetic, creative, and expressive. They all bring into existence something that was not there before. They embody and communicate human aspiration and feeling. The arts are rooted in ritual and symbolism. They all require a body of skills that are developed through practice.

There are many strands common to all the arts that might be used to tie them together for instruction. The arts can be related by a shared expression of an emotion, by a common theme, by analogies of form, by a common origin in a particular culture. It is not difficult, for example, to find works of art, music, and poetry and stories, ballet scenes, folk dances, and rituals whose theme is valor, bravery, or heroism. The love of mother and child finds frequent expression in the arts. Learning experiences might also be built around the similarities and differences in formal elements such as line, rhythm, color, space, or pattern as they apply in various art forms. Or the arts of a culture could be considered along with its history, geography, and anthropology.

HILDA P. LEWIS

The distinction between art education and aesthetic education is significant. Art education has, in reality, focused on teaching art *to* children with the artist being the primary model in curriculum building. An emulation of the artist is at the heart of traditional approaches. Aesthetic education methodology places an emphasis on teaching the child *through* arts experiences. It strives to maintain a balance between cognitive and affective learning. This approach translates the artist's modes of activity into a structure for learning sometimes called the arts process. The components of this process—perceiving, responding, understanding, creating, evaluating, and skill development—are compatible with and conducive to learning in all subject-matter areas. Further, the artist is only one of many models in an aesthetic education curriculum—historians, critics, consumers, philosophers, sociologists, and others are equally considered. Though these distinctions are grossly simplified, they do suggest an exciting alternative for methodological emphasis. It appears to me that joining interdisciplinary programming and aesthetic education is exemplary matchmaking.

DAVID W. BAKER

CRITERIA FOR GOOD ARTS PROGRAMS

1. There must be a concise and clear statement of the program, its goals and objectives, and how they relate not only to the arts but to the general education of the students.

2. The applicability of the goals of the arts program to the general instructional program of the school system must be articulated. This implies that an understanding of the arts program goals be shared by the school board, the superintendent, and the teaching staff. It also implies these goals have a relevance to the students of a given school system.

3. The implementation of the program must draw upon a well-defined curriculum structure and a staffing pattern with a wide range of resources.

4. There must exist a well-trained staff having a variety of skills and a substantive background in the arts, and the non-arts specialists on the staff must be receptive to the inclusion of aesthetic content in their subject areas.

5. These must be activities for students which are well grounded in the arts.

It might be said that these criteria apply to any good educational program. I would agree. The arts are no different from any subject area in terms of what constitutes good educational programs. The same considerations should apply.

<div align="right">STANLEY S. MADEJA</div>

The overriding principle for the selection of content for the entire school program is that it will involve: (1) all of the arts; (2) the arts of all cultures and all periods; and (3) the best art available.

<div align="right">GERARD L. KNIETER</div>

The key word in looking for a school with a good arts program is *balance*. In order for there to be a balance, *both* sides of the scale must have weight rather than "either this or that." A balance of performance/studio activities and those which are open to all students; a balance between the study and performance of traditional art forms and those in the contemporary or popular idiom and from non-Western sources; a balance between the interdisciplinary involvement of the arts and the arts for their own sake; a balance between the arts specialists as the source of the program and the use of other subject-area teachers and community resources; and a

balance between special schools in the arts and the regular school arts program.

GENE C. WENNER

TEACHERS AND TEACHING

Without question, the art teacher must be an artist-teacher, an artist with studio skills and an indepth knowledge of what he is teaching. Art teachers are often trained with a minimum of hours in studio classes, sometimes without any exposure to the areas of printmaking, photography, pottery, and crafts. Method classes in art education are general with little indepth concentration.

A well-qualified art teacher has the following qualities:

1. Wants to work with young people.

2. Is a producing artist.

3. Is skilled in the areas to be taught.

4. Is a program builder and innovator.

5. Is sensitive to all the arts and their role in society and human culture.

6. Is a member of the local art museum or art center.

7. Is knowledgeable in art history and architecture.

8. Is aware of current books, galleries, artists (national and local), films, and slide resources.

9. Knows how to transfer knowledge to students and obtain creative quality work from them.

10. Has a home or apartment that is filled with art, making a visitor aware that art is a vital part of the resident's life.

LARRY SCHULTZ

I believe once the artist/teacher understands the aims and objectives of his or her work and the conditions under which it is to be accomplished, the artist should be allowed complete freedom as to how to go about it. Needless to say, the success of such a program depends upon the selection of the right professional artist. At least as important as the kind of work offered is the way in which it is presented. The dedication, knowledge of the art form, and easy confidence which an artist/teacher brings to the classroom will most often elicit a response by the students to the artist as a *person*, which gives a richness to the experience for all concerned.

What I do know and care about and want to emphasize is the

chance for kids to come together with the artists in a one-to-one situation for as many days in a row as possible. Artists use their feelings—their guts—as part of their craft, and it is wonderful to watch them bring out hidden qualities in young people who doubt that anything they might make or do or say has value to an adult. This feedback process makes an enriching experience for the artist, too. As a means for strengthening perception and creativity, it's great!

<div style="text-align: right;">ERIN MARTIN</div>

A few words in support of the team approach are in order. It appears quite clear to me that the most exciting learning that is going on in schools is the result of joint planning that results in interdisciplinary approaches to learning. The strength of these programs lies in the fact that they are a result of a number of teachers contributing their best thinking to a common learning goal or concept, the result of which is learning packages that transcend any of the disciplines represented by the individual teacher. The product that comes about as a result of their combined efforts is equal to more that a sum of its parts.

In order for a team to be successful it must have the confidence of its leadership and its membership. It must be able to make decisions, and it must have the total well-being of the child as its central theme and concern. If individual team members concern themselves more with problems than they do with solutions, the team will never get off the ground. From the start there must be a strong commitment to the potential of a team approach to the arts by all team members or the project should not be undertaken.

<div style="text-align: right;">DAVID B. MARSH</div>

There are many ways in which the problems and possibilities of the arts and the imaginative process can be introduced into the training of teachers. One year's experience in this area has shown us that while teacher-training institutions are becoming increasingly concerned with a skill-oriented curriculum, we have seen the deep importance of bringing to the attention of all teachers the role that the imaginative life must play in the development of children. Unfortunately, there are few institutions that are willing to spend the time needed to encourage individual teachers within the teacher-training process to find those links to their own imagination that can effectively become the imaginative link to the children they are teaching.

It has been our observation that most students being prepared for teaching are anxious to involve themselves in a program that enables them to learn more about the use of the arts as an element of

the imaginative process and the arts as they are practiced and realized by children. It is our conclusive feeling that many more professional artists/teachers must be brought into the teacher-training situation, and that students in training colleges should be given a wider spectrum of choice as to how they utilize their own means of self-expression. Too often we have heard teachers say during the year that they do not have any imagination. It is our belief that the only remedy to this statement is workshops and classes that enable teachers to view themselves not so much as teachers but as learners who, through the very process of learning, are in fact using their imagination.

It is also our belief that a greater use of team-teaching within the arts must be used both with children and with adults, so that the artificial separation of various forms of expression are eliminated and a greater use of the arts as an integrative force is made possible.

Finally, it is also our feeling that resource arts centers should be established in which persons interested in the imaginative and artistic process can come together not only to discuss their mutual endeavors in their particular disciplines, but to form a cooperative relationship to teacher-training institutions and to schools throughout a given community.

<div align="right">RICHARD LEWIS</div>

EVALUATION

Evaluation is essential to all educational programs. Teachers need feedback on the effectiveness of new teaching procedures. Taxpayers, boards of education, and funding agencies want evidence that funds are being well spent. Students and their parents are interested in growth attributable to participation in the program. Curriculum developers, including teachers, need information that permits assessment and diagnosis concerning the goals of the program, appropriateness of content, effectiveness of teaching procedures, usefulness of instructional resources, and student outcomes. An array of questions must be posed to meet the needs of all concerned; procedures must be established to provide necessary information.

Evaluation should be comprehensive in that it deals with all aspects of the program and taps all relevant data sources. Classroom observation; interviews with teachers, administrators, students, and parents; anecdotal records, logs, and diaries; comparison of work samples taken early and late in the program; and taped lessons or performances can all be used in describing the processes and achievements of the program.

Enlisting the aid of non-school personnel in the evaluative process is useful in gaining fresh perspective. Outside evaluators are able to focus on the evaluation process but are not expected to help keep the

program going at the same time. They are free to move about and talk to people. As a "disinterested party," their perceptions are likely to be more readily accepted than the reports of those with a vested interest in the outcome.

The teacher, however, is the key to program evaluation. It is the teacher's responsibility to keep a continuing record of progress and problems and supportive data in the form of work samples, photographs, slides, films, tapes, video-tapes, and the like. Questions such as the following can remind the teacher of things to look for and record:

- What evidence indicates that the program has promoted growth in the basic processes—perceiving, responding, understanding, creating, evaluating, and developing skills?
- What evidence indicates that students have become more aware of the quality of life as it is reflected in the physical environment and in the emotional climate?
- What evidence indicates that students have become sensitive to a spectrum of emotions and can see how feelings are expressed in artistic form?
- What evidence indicates that students have developed the skill and sense of self to express and communicate their feelings through the arts?
- What evidence indicates that students have become more sensitive to the significance and sensory qualities of experience?
- What evidence indicates that students are developing discipline and dedication to the arts and the habits of concentration and industry that are needed for accomplishment in all areas?
- What evidence indicates that students are able to engage in artistic inquiry and discovery?
- What evidence indicates that imagination has been activated?
- What evidence indicates that students are becoming better able to judge their own work?

HILDA P. LEWIS

FACILITIES

A gym is a gym is a gym ... but it is not a *special* place. Into it come thirty recalcitrant young bodies unwilling to take off their socks. (I think fourteen-year-old boys regard their feet as sex organs.) A "Special Place" can be almost any place a kid is not used to going to for a class. A theater is great, but so many times I have found my classes there pre-empted by an orchestra rehearsal or a janitor who will not make the space available or ... or. ... It is bad

news to hold a dance session in a room where all the seats are pushed aside just asking for reluctant students to flop in, and it is well-nigh impossible to conduct a class at one end of the gymnasium while a basketball game is going on at the other. Concrete floors or wood floors laid directly on concrete pose a severe accident hazard. Of course, all these problems can be overcome. I have had successful classes in all of the above situations and more, but my point is *why* do we always wind up with *less* when with some understanding and concern and cooperation, the situation could be better for the work involved. Once again, I believe it is a question of priorities.

<div align="right">ERIN MARTIN</div>

Space is a factor which often challenges the imagination; no sinks, storage room, tables. Far too often an art teacher will be hired to teach art in regular classrooms or with a traveling cart. This is not the case with physical education. They get a gym with equipment and baskets at each end. But that's the way they play the game.

Art takes space, storage, shelves, equipment, furniture. This fact must be communicated to administrators when new buildings are to be constructed. In old spaces and buildings imagination will identify space available to use, enlarge, or convert.

Happily, art teachers are now more demanding. They have been in lots of situations and have seen how others are organizing space and curriculum. They outline their needs, present plans, drawings, and alternatives. We are all impressed with a resourceful person; it's hard to say no to someone who knows what he needs and will deliver a good program to students in exchange. The art teacher must know the school's curriculum and budget and the time and space demands for the art program. Present these well to administrators remembering that in most cases they are not experts in art. Once they understand your needs, in most cases, they will do all within their power to help you.

<div align="right">LARRY SCHULTZ</div>

SCHEDULING

The time factor for instruction in the arts translates as scheduling. Scheduling practices are perhaps the one single factor which diminishes, if not eliminates, the possibility of carrying out many worthwhile curriculum practices. It seems that the standard alibi for not doing something is "bad" schedules. The scheduling of arts specialists is generally determined by contractual stipulations providing release time for classroom teachers. The arts specialists have traditionally provided an expedient solution for staff coverage

<div align="right">257</div>

of students during classroom teacher absence. Consequently, student and program needs in the arts all too often have been of secondary importance. Further, arts classes are usually scheduled after the important "adademic" subjects are accommodated—the arts get the leavings. I feel there is a desperate need to establish a rationale for scheduling which can be proposed, argued, and employed based upon legitimate arts program needs.

DAVID W. BAKER

The usual high school period runs 55 minutes; with time for dressing, this leaves about 45 minutes for a dance class. This is too short and a distinct disadvantage to developing a quality program.

SHIRLEY R. RIRIE

Class periods are usually subject to a 40-minute or at best a 60-minute time limit which makes it impossible to move into creative work in any depth and difficult to acquire simple competence. Thus, all too often, teaching is reduced to a half-hearted introduction to a skill. By falling victim to the American passion for identifying and teaching so-called skills, many teachers kill two birds with one stone: the trained falcon, the artistic discipline which is ordered and intentional, and the dove, or maybe the stormy petrel, of personal meaning and commitment. It is painful to see how easily the creative forces of human beings are confined simply by having schedules which make it impossible to linger, to become immersed, to go off in a corner and brood, to break through a psychological block.

CHARITY JAMES

PROBLEMS

There is a need for curriculum planning and design applicable to the public schools in each of the art areas. Curriculum designs and instructional material available for any of the arts, be it visual art, music, dance, theatre, or film, is infinitesimal compared to other subject matter. The music teacher may be in the best position to teach music as he or she can lay claim to the most resources among the arts but compared to the reading teacher this resource list is very small. If a school were asked to implement a dance program, there are very few if any resources, such as instructional textbooks, guides, films, or other media, available. The situation is especially critical at the elementary level. . . .

The arts have consistently lacked generalizability to other areas of the school curriculum. Most arts educators will say that there are

many connectors or links to social studies, mathematics, science, or physical education that can be designed and applied to the arts. However, most arts programs, when looked at closely, are very insular and self-protecting. They tend to be "apart" from the general education program. In most cases there is no effort to relate the arts among themselves as disciplines let alone relate them to other disciplines such as history, mathematics, or science. The narrowness of the content of most arts courses can be attributed to the teachers of the arts and the way in which they were prepared. Their narrow view of the subject matter definitely stems from the organization of our teacher training programs where the emphasis is on just one or two areas within an arts discipline and almost no attention is given to relating one art form to another or the arts to other areas of study. A possible exception may be training programs in theatre arts, as the nature of the subject matter seems to be able to build bridges to other disciplines.

The goals for most art programs are related to outcomes that apply to the training of the professional artist, not the student who is trying to obtain a general education in the arts. As we all know, the two are very different. Nevertheless goals which are more applicable to professional schools of music, art, or theatre continue to be applied to arts programs at the high school and elementary level. There is no doubt that there are and should be some overlapping or common goals, but it is a matter of emphasis and applicability. The need here is to define outcomes applicable to all students at every level of instruction in the pre-college program. This has not been done with any consistency in the arts.

STANLEY S. MADEJA

Problems include: the boundary maintenance activities of exponents of the various art forms who insist upon the centrality in the curriculum of one particular art form over another, ideological matters concerning the nature and functions of the arts, and rivalries between practicing artists and arts educators.

CARL J. DOLCE

The pressing need to provide better programs for the teaching of reading and mathematics seeks solution in more special reading and mathematics programs usually funded through ESEA or state-supported programs for the educationally disadvantaged. The Federal guidelines which make it difficult for school boards to sponsor funded programs in the arts also create an atmosphere among the public (as well as among some of the professionals in education) that precludes arts education from receiving its fair share of resources. In some instances, programs in the arts have been removed to create

room for more remedial services. Our lack of significant progress in overcoming basic skills deficiencies does not dissuade us from mounting still more programs of the same ilk. Perhaps we are merely dealing with the symptoms of the distress but not with the total educational product which may be the real cause of the problem.

MONROE EIDLEN

CHANGE STRATEGIES

The two new superintendents and myself found ourselves in agreement about the necessity of lifting the Minneapolis school system (a perfectly good school system, mind you, as school systems go) out of its doldrums, out of its attitude of self-satisfaction, of its business-as-usual instincts, and we saw the arts as one of the ways of doing so. Because the arts depend on inventiveness and original- ity, I saw them, especially when joined with artists, as ways of open- ing up minds and of making those minds receptive to new ideas, new ways of thinking and doing things, and, as a result, enlivening the experiences of kids in the schools. . . .

We were searching and fumbling around a great deal, and to a large extent we still are, which ironically may be the strength of the program. Precisely because it is imprecise, erratic, unprogrammed, often poorly planned, it is open to ideas, to change, to restructuring and redesign. We are more committed to the doing of things than to the forms and formulae for getting them done. Too often in educa- tional circles the contrary is true; the organization—the structure— becomes of overriding importance, assuming that with organization learning activities will naturally take place. So school systems spend hours contriving changes that usually amount to nothing but superficial alterations or procedures and lines of command. After the changes are done, the same courses with the same content are still being taught in the same way.

Our organization was so loose, so chaotic, so laissez-faire that no one was troubled much by altercations, by programmatic shifts, by totally unexpected behavior or results.

Out of all these activities, successes and failures, grew a commu- nity of artists and arts administrators identified to some extent with the schools and their problems. The reverse was also true: school people grew to know and to enjoy the arts and the artists. In a sense, a kind of trust developed, a delicate, easily damaged trust.

SEYMOUR YESNER

The most effective way of instituting any change in attitude about the arts is through the teacher. Any attempt to circumvent or become independent of the teacher only widens the gap between the child's expressiveness and the concerns of the classroom.

RICHARD LEWIS

Our first efforts were directed at teachers because we felt that the school environment, its offerings, its ambience, could only be changed if teachers wanted it changed. We also felt that in many respects teachers in classrooms were isolated from each other, from association with community resources like artists, and from ideas; that in fact teachers were parochial in their outlooks and were kept that way almost by design.

SEYMOUR YESNER

In order to move from a program in which the arts are ornamental to one that sees the arts as essential, school and district personnel must regard the change as both possible and desirable. The attitude of people affected by change is a critical factor. Change is not likely to succeed if it arouses apprehension—if people feel inadequate to the new demands and fear failure, loss of respect, and loss of status. Properly conceived, change will be regarded as an opportunity to grow in a desired direction, to be more effective, and to find greater personal satisfaction.

HILDA P. LEWIS

In order to create a schooling situation in which there would be an optimum use of the innate expressive capacities of children, all facets of learning, as well as any knowledge both implied or as consciously taught, would be scrutinized by all members of the society of a school, which should include parents, administrators, children, and all other personnel connected with the school. There must be agreement within the society of a school as to the demonstrable need for the use of the expressive and imaginative realm of human thought within every component of what we term a "curriculum."

It has been our observation that the reason the arts take a peripheral role within schools at present is the lack of understanding between the variety of people who make up the social institution of schooling. Often the school succumbs to pressures from parents to teach those aspects of social mobility that our society deems necessary for success. Often school administrators are more concerned

with results than with individual growth. Often teachers are not aware of the nature of childhood and the way in which the expressive and imaginative concerns of childhood are an integral part of a child's development.

With so many variables at work in terms of the expectations of a school, it seems that schools must be established that take a leading position for the rights of the child to maintain his or her own capacities of human expressiveness. Such a school would have to alter much of the present thinking about human cognition and would eventually have to be a force in changing what we have come to expect of the "educative process."

Within such a school there would be set up a room in which such a scrutiny of learning and knowledge could be demonstrated to the adults working within the society of that school. The room itself would be an ongoing example of the ways in which those responsible for the learning of children could confront all aspects of learning within themselves. Coexistent with this confrontation would be in-depth explorations of subject matter and ideas so as to make apparent the experience of any in-depth study in naturally using all varieties of expressive media as part of the exploratory process.

The staff of this room would be resource personnel representing a wide spectrum of human knowledge who would work consistently with all the members of the society of the school to achieve a more integrated use of human knowledge and learning as well as being available to all classrooms and individuals in those rooms to help explore individual areas of human learning. Such a resource staff would make no differentiation between the sciences and the arts except in attempting to bring a greater fusion in the ways in which the human mind asks questions of itself and the world around it.

Art as an ongoing human activity within the school would become the responsibility of all persons involved within the school so that the making of the school's very environment would in fact be one of the major learning experiences of the school. A great deal of emphasis would have to be placed on the evolution of the need to make art a function of the society of the school. In short, the school would come to the art process as a way of making the school function effectively.

<div align="right">RICHARD LEWIS</div>

THE ROLE OF THE MUSEUM

Education departments are the fastest growing areas within American museums today. Not only are there increasingly more and more educators and larger education departments, but those

departments have achieved greater status and influence than ever before. They are charged with directing the total educational thrust of one of the nation's greatest resources, the museums of the visual arts. In many communities, they are the only voice for the visual arts.

Today's museum educator is a far cry from the appointments secretary who sat in a basement room arranging school tours and who, twenty years ago, was the education department of many museums. Today, he or she is usually the most visible member of the museum staff. Nevertheless, the museum educator's work, concerns, and problems are seldom known or understood, particularly by other educators. . . .

The museum educator spends a great deal of time training and supervising the 40 volunteer docents who tour every sixth grade class in the city during their first—and probably last—class visit to the museum. This touring of children, though well organized and efficiently executed, seems to the the fulcrum of the museum educator's job, as well as of his dissatisfaction. On the one hand, the year-long training of the docents, and the ongoing program of in-service training, is a model laboratory for the teaching of art to adult non-art majors, and at its best far outshines any other teaching being done in this area by the colleges or universities. Yet the teaching of the sixth graders in the galleries often represents the worst education happening in America today.

The docent/teacher is an amateur and inexperienced in teaching, save for the accumulation of museum volunteer experiences. In most cases she does not know the class she is teaching. There frequently is no class preparation before the museum tour, so she has never seen the children before; there is almost never follow-up or evaluation, so she never sees the class again. When either preparation or follow-up does exist, it is by slides with a teacher's manual and then a teacher questionnaire, so she would have no opportunity in any case to see the children except during their sixty-minute stay in her care. She meets these children in a strange place they have never seen before, and she must keep them moving during the entire lesson. Not knowing the names of the children and very little about what happens in their school classroom or in their homes, she is to lead them into one of the high experiences of human existence—communication with art. . . .

The bane of museum education is isolation and the absence of continuity. Each museum educator rehashes what the last educator rehashed. Within the profession, there are no writers, no theorists, no savants. (The latter, of course, become museum directors.) In the colleges there are no courses or even individual lectures in museum education, even where museology programs exist. There is no literature, no journal, and only four or five respectable articles on the

subject. The museum conventions sometimes present helpful twenty-minute sessions, which are never published. . . .

The museum educator is burdened and sometimes blinded by his assignment. It is a most unrealistic assignment, and one which no one but he is charged with. The assignment is unique in America and has been made, emphatically since the beginning of museums on this continent. A 1906 publication sums it up nicely, "EDUCATE THE CITY," Enlightenment of the masses is persistently declared to be the first and main task of the present day museum. In a recent museum education survey, the vast majority recognized the education of the general public to be their responsibility.

There is an awakening to the possibilities of television and film in fulfilling this utopian task, but there is little expertise within the profession. The printed word has been the most satisfying means to reach the masses, but publication is a major educational effort in only a handful of museums. At any rate, the museum educator makes do with an operating budget of only about $10,000 a year, and not many museums put more than 13 per cent of their total budget into education. No museum spends more than a quarter of its budget on education. When one considers that thousands of cities across the country put over $500 a year into each school child's education, exclusive of teachers' salaries, what museum education is presently doing is a miracle, and what it is expected to do is just so much whistling in the dark. . . .

The presence of a large studio program for children, amateur adults, and occasionally for the training of professional artists, confuses the aims and philosophy of the museum educator. A statement made at the Cleveland Conference on Education in the Art Museum in November 1971, sets forth the purpose of the education department of "any" art museum in these words: "To promote the direct access of its community to art objects in such a way as to encourage the enjoyment and understanding of these objects and thereby the *development of the individual's own creativity.*"

There is a very long history to this attitude which absolutely splits the museum education profession philosophically. The attitude that the museum should affect creativity in the community has its roots in the early 20th century expectation that the presence of a museum would improve taste and have direct bearing on local design and manufacture. Yet if The Detroit Institute of Arts closed shop tomorrow, automobiles would still look the way they do today. Roy Strong, the brilliant director of the Victoria and Albert Museum in London, recognizes that "museums and galleries have lamentably failed to make themselves loved and essential parts of everyone's life."

A growing and vocal majority of museum educators recognize that the dual stance of American museums as art centers *and* art galleries has led to a plethora of peripheral cultural pastimes that distract

from central and professional concerns. On the whole, they would rather concentrate on that unique attribute of an art museum, namely, the collections. The art of the museum attracted our educator to this profession in the first place, and the art of the museum is central and elemental to everything he does. He is not primarily interested in the literature of art history, or in art history itself, except inasmuch as they are tools towards understanding the art on his own museum walls. In Worcester, Massachusetts, the Renaissance revolves around Piero di Cosimo, and in Detroit, Michigan, Sasetta is a central Renaissance painter, "Sure I like Monet, but we don't have one," is a typical museum educator statement.

This concentration on the collections of his own institution becomes "Interpreting the collections to the public," or "Bringing the public into conversation or dialogue with the art," or "Encouraging and aiding people to make first-hand and intimate acquaintance with the works of art," or "Helping people to learn to see with their own eyes," or "Drawing man into communication with works of art." Each educator says it in his own way, and it happens on a multitude of levels and through a variety of approaches.

In practice, museum education methodology is always a gallery experience. It is always a visual experience. It may resemble a well-written, typical art history exam: "Describe, compare, contrast," but the presence of the original and unique object, the work of art, lifts it from an exercise of memorization and recall to one that is personal, spontaneous, and experiential. It is also an experience of imagination. Imagination is the museum educator's answer to creativity.

The practice of museum education has become the laboratory that is missing at the university and often rejected by the university art historian. And for this reason the general public, the public schools, and more and more, the publisher and the television producer, turn to the museum—not to the university—for learning and communicating about art. In terms of personnel, background and depth of learning, and professional practice, the university is better equipped to handle this job—but for the absence of the object, it is not.

The museum educator is also audience centered. He feels, in fact, that he is the only one on the museum staff who truly understands the public. If any good has come out of the directive to educate the city, it is that the museum educator has learned the city. He identifies his audience for every project, every event, every exhibition, and every lesson. What happens to them and what they experience becomes more important to him than anything he does.

The museum educator is the ultimate popularizer. He speaks on this subject by quoting Alexandre Dumas. Dumas spoke of Lamartine and Hugo; our educator speaks of the curator and the professor. "The one," he says, "is a dreamer; the other is a thinker. As for

myself, I am a popularizer. I take possession of both. I give substance to the dream of one, I throw light upon the thought of the other, and I serve up to the public this excellent dish, which, from the hand of the first would have lacked nourishment, being too light, and from the second, would have caused indigestion, being too heavy, but which when seasoned and introduced by me, will agree with almost any stomach, the weakest as well as the strongest.". . .

Art is an integral part of our culture. We don't want it regarded as a separate entity housed in a place that provides a pleasant field trip once a year. Students must see art in their own environment and grow comfortable with art as an expression in visible terms of all aspects of man's interests, joys, hopes, needs. Then they will be able to enjoy and understand the standard of excellence met by museum pieces. What it boils down to is turning teachers on to art, and showing them how to use art and the museum in their teaching.

We could do this through personalized teacher contact and development. The museum would go into the schools and meet the teachers on their own ground in a series of short seminars. Carefully worked out teaching aids and other materials to demonstrate learning possibilities at the museum would be presented. We would eventually like to develop both textbooks for the Detroit public schools on the art of our museum and general texts for others. But to begin with, we want to offer the teachers creative approaches to art that tie into the present public school curriculum. For example, the perspective in early Renaissance paintings, the flora and fauna of tapestries and paintings, the equilibrium of sculpture could provide exciting study for science classes. The contrast of moods in two different paintings or the similarities between works of totally different periods could be an exercise in learning to read letters and words by learning to "read" colors and shapes. History and literature teachers could use a wealth of subjects to complement their particular disciplines. . .

The specialness of contact with original works of art in a child's development can't be stressed enough. He knows reproductions too well already. Everything he sees in his society is a one-of-a-million kind of thing. But *this* painting, *this* sculpture in this museum was made once and can never be made again. It is enriching to communicate with an original work of art, and that idea is at the center of this teacher development plan. But education about the art object must begin with the teacher. It must happen in the classroom before it happens in the gallery. We hope we can develop materials that deal with universal concepts, applicable to any art. . . .

We are developing curriculum-related resource materials about the visual arts for the use of the self-contained classroom teacher. We can't do everything at once. We have begun with American art and architecture to supplement American history, which seems to be taught in every school system in the country at the fourth, fifth,

and/or sixth grade level. Junior high school and high school units will be our next task. World history and then African studies are reserved for future topics.

We are developing *resource* materials. The word *resource* came under discussion. What is an example of an excellent resource? We all decided that a dictionary is the best we could think of. Our materials will be dictionary-like. That is, they will not be set lessons or projects but multi-level resources from which a teacher can draw year after year without exhausting them. For example, if George Washington is the subject, illustrated discussions in a resource manual would cover some of the American portraits of Washington, seeing him as *Pater Patriae,* military leader, statesman, Virginia gentleman, family man, etc. The artists' lives and training and their relationship to Washington would be discussed, as well as the social role of the artist. Some of the paintings have unique histories. One by Gilbert Stuart, for instance, became the model for the dollar bill portrait. Another found its way into the design of a 20th century postage stamp. These lead to discussions and illustrations on engraving, lithography, counterfeit versus original, the artist as copyist, contests for stamp and coin designs, and artists and designers today. Then there are portraits of Washington by foreigners, as well as sculptured portraits and equestrian portraits. Each subject leads to a multitude of other subjects: from bronze casting to hockey-hero trading cards. Finally, artists, techniques, concepts, attitudes, social and historical contexts, and modern day parallels are all discussed.

Our materials are organized in units that relate to the usual chronological organization of American history texts. "A Portrait of Early America" centers on the Revolutionary period and the first years of the new Republic. It includes sub-units titled: "A Portrait of Posterity," which will include portraits of leading statesmen, preachers, merchants, craftsmen, and self-portraits of artists; "The Group Portrait" will portray the family, the patriotic group, and the team; "Portraits of George Washington" is discussed above; "Portrait of the Native American" will present early paintings, drawings, or engravings of American Indians in their environment and in daily activities; "The Intimate Portrait" centers on miniature paintings as a characteristic of the period; "Portrait of a City" deals with the village green, the country square, the formal garden, the plantation, and the estate; "Portrait of the Natural and the Homespun" will cover the records of naturalists and explorers and American *trompe l'oeil* painting; and "Portrait of the American Ship" will present the variety of ships, schooners, and frigates of the day.

In a typical sub-unit, there is a discussion of each work of art in an "Art Appreciation Subject Matter" section covering historic references and aesthetic analysis. A "Cultural Background" section contains research pertaining to ideas related to the broad cultural

context from which the selected works of art come and biographic notes on artists and craftsmen. "Teacher Aids" suggest visual, auditory, and other aids, and often include pronunciation guides, technical information, and instructions for making classroom aids to assist in the development of the lesson. "Interdisciplinary Integration" and "Creative Activities" are two further components of each sub-unit. They give lesson planning ideas and attempt to be conceptual in approach. A final section, "Psychological Growth and Development," discusses the child and his receptiveness to the art resource materials. In a sub-unit on the Colonial Craftsman, which centers on Paul Revere, this section discusses hero worship and the gang-age child, respect for labor and the crafts, and the appropriateness of working with craft materials for this age group.

A cross-reference index is essential. The teacher may want visual arts material on Mount Vernon; he will find Mount Vernon is mentioned in discussions of Versailles, Houdon, George Washington, furniture, and gardens, as well as having its own listing.

Right now all the visuals are either slides or mounted illustrations. The resource manual pages themselves are not yet illustrated. A technical problem is to supply enough illustrative material in the resource manual to gain the teacher's interest and to find ways to make that illustrative material available in the classroom. A slide duplicating each illustration in the manual presents cost problems, and we'd rather find a way for the illustrations to actually be exhibited in the classroom, not merely turned-on for occasional use. Inexpensive posters with many illustrations on a given topic, such as portraits and postage stamps, have been suggested. The addition of an art-educator/illustrator to the project staff will allow experimentation and testing of various formats.

From the point of view of an art museum, the situation in the schools today, in regard to the visual arts, is appalling. One textbook on world history, used in all the high schools in our city, is profusely illustrated with the best art and architecture that exists. Not a single illustration is identified, however, much less discussed. The art is used to reinforce the social studies content of the book, but the sad thing is that most of the teachers using the book don't know what the illustrations are. In seminars during the past year with all of the city's high school history teachers, we were able to point out numerous parallel examples of the textbook art illustrations in our own museum collections. It was an eye-opener for the teachers.

A second example demonstrates an even sadder state of the present situation. We were curious about mounted, full color portraits of the American presidents that we saw in a sixth grade classroom we were visiting. They looked vaguely familiar, yet there was something extremely odd about them. What was odd, we soon learned, was that all of them, Washington through Lyndon Johnson, were by

the same artist. The approach was the same for each president—a kind of trading card hero worship, modified, but not quite enough, by the honesty of the contemporary portraits that served as the models. Some publisher had actually commissioned a contemporary hack to paint this series, when far more interesting portraits, for which the presidents themselves sat, are available at infinitely less cost. The teacher, whose class we were visiting, was leading a discussion about Gilbert Stuart's interpretation of George Washington. She had issued dollar bills to each member of the class, and they were comparing the engraved image to the original which they had seen projected from a color transparency. "I never use the president portraits," she said. "They are just there. The District bought them for all the classrooms. I wish I had a mounted reproduction of the Stuart." How very close the schools are to incorporating the historic visual arts into their approaches to social studies and history! But the right materials do not exist for classroom use.

The hot summer when Thomas Jefferson was penning the Declaration of Independence and Betsy Ross was stitching up red, white, and blue cotton, John Singleton Copley was limning images of the Colonial leaders. The work of all three played a role in stimulating the patriotism that led to the forming of a new nation and should still play a role in recreating that era for students today. But Copley is left out. We do not ask for art history to be taught as a separate subject in the schools. We ask for it to be considered in its historic and conceptual context. Our materials are a start. . . .

As materials are developed, they go through a number of classroom tests. Our writer herself tries out the materials. She also trains a small group of teachers to use them. A corps of para-professionals, trained by the writer, test them in schools not previously contacted and oriented by the museum staff. A fourth set is used by teachers who have been oriented to the goals of the program but who are not instructed in the use of the materials; they receive them in the mail and work out their own use from the materials themselves. All evaluation is through staff auditing of classrooms using the materials and personal discussions with the teachers involved with the testing process. . . .

Important criteria in reviewing the materials have been teacher usability and student interest and comprehension. We ask, "Do teachers find the materials relevant to their on-going lessons? Do they strengthen the lessons? Are they easy to incorporate into the lesson plans? Are all of the teachers' questions about each art topic answered? Do the materials lead to new ideas and new lessons? Do the children find the materials interesting and important? Do the art ideas presented confuse or enrich the study of American history?

We look to a day when all classroom teachers will be literate about the history and appreciation of the visual arts. We want this learning about the arts to be specific and object-oriented, because

we think that is the most exciting way to approach the arts. We want the arts to be presented as examples of man at his best.

RICHARD C. MÜHLBERGER

INDIVIDUAL ARTS

DANCE

As a dancer and choreographer, I am frequently challenged to give reasons for going into the profession. I can easily answer that I am able to express myself in dance, just as others are able to sing, paint, sculpt, or write poetry. But what if one doesn't choose to make dance a life's work? Is there then any reason for attempting to experience or master a form that demands total involvement of the human body?

Dance is not elitist; it is a language universally understood. We danced before we had poetry or music; we dance (unconscious of the fact) every day of our lives. In most other cultures, dance has been a part of ritual and religion and is considered a legitimate way to explore and increase physical power. In America, it has been burdened with a great many of our society's sexual taboos; though we enjoy thinking of ourselves as being comparatively uninhibited people, survivals of the stern Puritan morality continue to confuse. If we are to dispel some of the unconscious fear of and resistance to the art form, we must begin to awaken people to the joy of the human body in motion, the power of the unconscious rhythms reflecting passions, fears, and fantasies, as well as emphasize the unique effort and discipline that are required by our most structured dance techniques.

I believe that the first requirement for a dance program in the schools is that it be an exchange, a shared experience between students and artist/teacher. Students learn best by doing, and what we call "aesthetic perception" or "art appreciation" will best be acquired by participating in a project that will involve them—in varying degrees—as artists themselves. Properly presented, dance makes demands upon the body that even the most hardened athlete can understand and respect. The rigorous mental, emotional, and physical discipline, exemplified in the professional dancer, demands respect from anyone who comes to understand it. And a performing artist/teacher can easily dispel the notion that dance is effete, unrelated to the rest of life, or all glamour and no work. Educators, in my experience, seem to find it strange that students get a clear idea of the need for discipline (an unpopular word in its most common usage) both in private and public life from such artists, when some of the students find it difficult to learn discipline at home or in the schools. Artists do not find this strange at all, for they are all too

270

aware of the sacrifices and choices that they have made in their own lives.

<div align="right">ERIN MARTIN</div>

A good dance program should include technique, improvisation, composition or choreography, and some exposure to history, theory, and contemporary trends. The bulk of the time should be in the doing. In the most successful programs, there is a strong emphasis on student choreography. Through creative work there are many skills and understandings to be developed which will carry through a lifetime. Personal growth is greatly enhanced because in dance there is great emphasis on group work. Students lead, follow, and interact; they discover how to communicate, both verbally and non-verbally. They learn to pool resources and come up with maximum quality rather than a mediocre product. In improvisation for dance there is much self-discovery. Awareness, sensitivity, spontaneity, and resourcefulness are improved. All of this happens with a good teacher; none of it happens with a poor teacher. As a student works with dance technique, his physical body improves. In swimming, gymnastics, and dance the body gets the most complete exercise and training. A dancer is lithe, flexible, strong, has endurance, and looks good. No one could deny the value of the physical training. In dance the instrument is the body, the mind, the emotions, and the spirit; a dancer must integrate all these parts of himself. It is no wonder that once this kind of involvement is discovered, a dancer becomes dedicated to the art. Dance becomes so necessary because it makes one feel so complete. It is true that on the high school level we are not looking for this kind of dedication, but it happens. With most students the love of dance stays, even though they go on to other things, and this kind of involvement, even briefly, must be good. I am speaking now of those students who become the "dance club" members, who rehearse many hours to put on a performance. I truly think they get a taste of what it might be like to be an artist; they begin to understand.

<div align="right">SHIRLEY R. RIRIE</div>

The most seriously undervalued art form in American schools is movement (with improvisational drama a fairly close second). Movement is the most direct expression of inner reality, the simplest way of becoming aware of, or simply working through, the most deeply felt thoughts. It provides mastery of the body much needed during adolescence, and when worked into a presentation, simple or elaborate, it can draw on wide resources of music, myth, decor, and costuming. It should be seen as an essential aspect of

education in childhood and adolescence, yet it is available to few girls and practically no boys.

<div align="right">CHARITY JAMES</div>

MUSIC

Music is an expressive medium. Through a distinctly unique and forceful language of sound, it conveys ideas and feelings. It is a way of knowing and experiencing, but it is also a method of communicating, of addressing the spirit of man. Music expresses values, and as one learns to associate his musical experiences with those aspects of his life which he values most highly, he finds in music a source of beneficence in his life. Because music has the power to affect man's mind and emotions with a unique intensity and breadth, the expressive content of music cannot be translated into verbal terms. As Mendelssohn has said, "the thoughts which are expressed to me by music . . . are not too indefinite to put into words but, on the contrary, too definite."

<div align="right">GEORGE KYME</div>

THEATRE

Theatre, as a communal art form, lends itself quickly to school as a model for interaction and work. In a metaphorical sense, the teacher becomes the director (in an enlightened manner) and the students become the ensemble company. Here the metaphor stops because it is not our desire to train children to act, but to give them the basic skills of exploration and interaction one would expect of a trained artist. The process for achieving the goals involves training teachers in theatre games and improvisations as well as activities drawn from many other art forms. The teachers internalize the work at various levels and replicate the process, using the same tools with their students.

<div align="right">VICTOR B. MILLER</div>

PROGRAMS

THE CITY BUILDING EDUCATIONAL PROGRAM, LOS ANGELES, CALIFORNIA

The sequence of activities which make up the City Building Educational Program is designed to guide the student's development in important basic skills and skills that they need to become successful citizens and people—planning, evaluation, and visual, spatial, and

inventive thought and conceptualization. As the program proceeds, the problems become increasingly complex, requiring the use of skills mastered in previous activities. Students learn to work together in progressively larger and more developed social groups. As the students develop their organizational skills, they are given greater responsibility for the program and more resources to work with.

The activities of the program are divided into four slightly overlapping phases or topic areas, each dealing with a different area of development. During Phase I the students explore their own capabilities and become aware of how they interact with others.

PHASE I: PRELIMINARY EXPERIENCES AND INTRODUCTORY ACTIVITIES

TOPIC:	ACTIVITY:
Child's self-awareness	Preliminary experience: "Who am I?" (1 hour)
The perception and retention of shapes	Preliminary experience: Shape recognition (1 hour)
Child's self-perception and retention of the immediate environment	Preliminary experience: Community mapping (3 hours)
Individual investigations of "good" and "bad" environments	Preliminary experience: Environmental evaluation (2 weekends)
The use of the matrix as an evaluative and decision-making tool for making choices	Introductory activity: Classifying objects (2 hours)
The individual's relationship to time, the future, and urban processes	Introductory activity: City building simulation (12 to 15 hours for site building, research and planning, 2½ hours for playing and evaluation)
The individual's relationship to structure and transformation	Introductory activity: Classroom transformation (6 hours)
The individual's relationship to objects in space	Introductory activity: Imagination games (1 hour)

Objects are studied in Phase II, with the introduction of concepts like structure, function, scale, craftsmanship, and the relationship between objects.

PHASE II: THE INDIVIDUAL'S RELATIONSHIP TO AN OBJECT

TOPIC:	ACTIVITY:
The object as a structure	Salt and flour structures (4 to 10 hours)
The object as a structure transformed by a change of scale	Object transformation (25 to 45 hours)
The object transformed by a change of identity	"I am an object" (1 hour)
The individual as an object and its relationship to other objects	Relativity games (3 hours)

Students begin developing organizational, decision-making, and group problem-solving capabilities while doing Phase III activities.

PHASE III: THE INDIVIDUAL'S RELATIONSHIP TO AN ORGANIZATION

TOPIC:	ACTIVITY:
The classroom as an organization	Re-organizing the classroom (15 to 30 hours)
The classroom and participants as an organization	Decision-making games: Gonotube or Ruler game (½ hour)
The classroom and participants as an organization	Decision-making games: Time game (½ to 2 hours)
The classroom and participants as an organization	Decision-making games: Energy game (2 to 6 hours)
The classroom and participants as an organization transformed over time	Planning classroom activities with a flow chart (15 to 30 hours)
Natural environment as an organization	Survival simulation sequence: Site model design (5 to 15 hours)
Natural environment as an organization transforming in response to natural forces	Survival simulation sequence: Selection of natural objects (1 to 6 hours)
People as an organization transforming in response to natural and social forces	Survival simulation sequence: Natural structures building simulation (5 to 15 hours)

The interaction between the individual, social organization, and the environment is explored during Phase IV.

PHASE IV: THE RELATIONSHIP BETWEEN THE INDIVIDUAL, THE COMMUNITY, AND THE ENVIRONMENT

TOPIC:	ACTIVITY: (Varies, depending upon resources, student interest, and teacher prerogatives)
The community as an environment	Site selection simulation and preparation of site model (varies)
The relationship of private property to the community	Land parcel development and distribution simulation (varies)
The relationship of change to the community	Goals for the city, a survey of the city (varies)
The relationship of government to the community	Government simulation (varies)
The relationship of the individual to the community	Individual design process (varies)
The individual and the environment	The final city, discussion and evaluation (varies)

Perhaps the best way to explain this approach is through a detailed discussion of one particular phase. Phase II, the study of the individual's relationship to an object, teaches students that one way to change things is by altering their size and scale. Students in a classroom deal with their own individuality by each selecting an object, analyzing it for its content and usefulness to society, constructing models of it at various scales, and increasing its size to cover their bodies as a costume. This activity allows them to express and act upon their preferences for shape, color, use, and connotation, and it forces them to create a new shell for themselves. As students transform themselves into objects, a new set of perceptions are taken on and students see themselves and others in a new context much as an actor creating a new role.

The examination of self occurs with the task of measuring one's body and the proportions needed to expand a simple object (a crayon or a can of house paint) into a sturdy structure. The architect/planner/designer helps the students with the mathematic process of ratio and assists them in creating the appropriate skeleton on which to build a structure. The teachers guide students through the research and visual examination of the details of the object, teach-

ing the use of measurement tools and developing the motor skills necessary for increasing or decreasing letters and shapes.

The involvement of self and object is extended when the object becomes lifesize. The mere scale of the thirty to one hundred object-creations made by students is awesome and has tremendous impact on them. What originally appeared to be an individual exercise clearly becomes a shared experience as students see common shapes, colors, and structures. The crayon and the paint can have a relationship based on their cylindrical skeleton, but differences exist in their function and size. A crayon looking at a can of house paint sees things differently than child A looking at child B, and the dialogue between the two objects offers a possible system for creating new classroom social structures. In addition, unlike many school experiences that can easily be put aside, the immense scale of the projects make them a constant reminder of object transformation.

DOREEN NELSON

SENIOR HIGH ART PROGRAM, NEWTON, MASSACHUSETTS

"20th CENTURY ART" is an attempt to take one of the popular basic studio courses and bring it closer to what is happening in our "Forms of Art" and "Art History" courses. We have found that too often studio-oriented students are not eager to study *about* art, while on the other hand, academically disposed students who opt for art history are fearful of extending themselves into the murkier waters of studio or object-making areas. "20th CENTURY ART" is a studio-based program which uses art history as its context. It assumes that the study of art works and movements is more palatable if wedded to creative activity. It is open to anyone and has no prerequisites. It is planned in the summer by those staff members who have elected to teach it. The course grows out of a series of units all of which contain the same components: a brief review of the history and character of an art movement, suggested studio activities which are derived from the concerns of the movement, a set of slides, books, and reproductions of art works to be used as a basis for discussion, as motivation, and as historic analogies to the students' projects.

We have prepared units on Cubism, Expressionism, op Art, Pop Art, the Bauhaus, and others. This is, frankly, a "package" approach to art in that it supplies the teacher with support materials designed to accomplish a particular task. The units have not been selected, nor necessarily taught, on a chronological basis. We have instead worked from an affective level and selected those areas of study which excite the teacher. This gives us some assurance the material will, in fact, be used. We have found it works to the extent that a student may be curious as to how Shmidt-Rotluff handles a woodcut

after trying to deal with the problem himself. A kind of affinity is set into motion between student and history, which is what we were after in the first place. The funding includes two weeks work for two teachers in the summer plus expenses for slides, reproductions, and books.

AL HURWITZ

THE NEW PLACE, TAMPA, FLORIDA

R oving puppet theaters who perform in neighborhoods are not particularly unique, but the variation of this idea we developed I think is. Knowing the fascination of puppets for all ages, and always searching for ways to develop a tension between traditional and new technologies, we combined the media of the puppet and the super-eight camera. A mobile theater was created, not exclusively for performance but to engage people in creating participatory experiences. A volunteer carpenter on the center staff built a portable theater which included a rear-view screen of frosted plexiglas. The theater folded and was easily stored in a van which also held a projection and sound system to be plugged into any willing 110-volt outlet. The mobile theater traveled to housing projects, neighborhood service-centers, and recreation centers where workshops in puppetry and filmmaking were conducted by our staff to anyone who came along. The mobile theater returned to each neighborhood regularly to allow participants to view their films and to interact with them through the puppets they had created. You have to imagine puppets in front of a rear-view screen, with children vicariously talking to their neighborhood peers about their own film now appearing behind them. Everyone likes to make puppets and to express through inanimate forms their deep feelings, be they expressions of humor, fear, anger, or frustration. The film added another dimension in supporting their creations with dynamic images reflecting that sense of community where each lives out his life.

An outgrowth of this program was the hiring of one of the student-volunteers by the County Recreation department to develop puppetry workshops for its recreation staff. That evolved into a mobile workshop which not only engages youth in programs but has been very successful with retired drop-in centers. . . .

Video can be used to capture unique cultural events in the community, but the experience can be extended to new levels of awareness with a little imagination and effort. An example of such an effort is reflected in one of our experiments. One New Year's Eve, some neighborhood kids and I went to the Lilly-White Gospel Tabernacle, a black church, where an all-night gospel-singing celebration was going on. We video-taped, filmed, and sound-recorded some seven hours of musical performance. The simple curiosity of famil-

iar kids controlling the technology was enough to attract many of the participants to The New Place the following week to see themselves. The next Tuesday, over 100 community residents were in the center seeing themselves for the first time on the tube. One of the singing groups was represented by four generations of a family; so you could observe a four-year-old alongside of a 17-year-old brother, a 28-year-old uncle, a 45-year-old father and a 64-year-old grandaddy, experiencing each other singing on the video screen. This experience led to the various groups coming to rehearse at the center and the establishment of gospel singing marathons which are now held there quarterly. Neighborhood kids involved in still photography created publicity photos for some of the groups. . . .

We are just beginning to experiment with the Xerox telecopier system as a means of transporting graphic images to new and varied publics. For those who are not familiar with it, the telecopier is a unique invention which allows one to send black and white images from one copy machine to another over the telephone. Telecopiers exist in all sorts of businesses, such as doctors' offices, law firms, stock markets, and police stations. It's as simple as plunking a drawing in a machine and making a phone call. Since they are limited to 8½ × 11 sheets, it gets especially exciting to make large wall murals in modules, sending a few each day, so that recipients can attach them to a wall and see the work progress gradually through to completion. Since all copiers both send and receive, the recipient can if he chooses modify the image and send it back to the sender—or perchance create his own. If you really get into the machine with tape-recorded sounds and other acoustical ways of teasing its highly sensitive recording systems, you can generate some highly imaginative images. Not only can these systems be used for transporting aesthetic objects, but they could be used imaginatively by arts institutions for advertising and promoting events, etc.

RICHARD L. LOVELESS

URBAN ARTS, MINNEAPOLIS, MINNESOTA

Let me use as a model the Children's Theater School which has the most elaborate program and expectations and the longest hours, offering courses in twelve different aspects of theater. The Children's Theater became involved with the Minneapolis schools via English and Humanities in about 1967 when certain students, some with the Theater Company, others not, were having trouble with school authority and school regimen. By making special provision for out-of-school attendance and credit, we opened the first cracks in the prevailing structure. This association began around a common concern for reaching some students (possibly with dramatic talent) who could not manage the school restraints.

Students for the Children's Theater are recruited by a number of

methods. Students are asked to apply and once having done so are given an audition date. They are auditioned and, if accepted, the school and the parents are informed.

As a result of this acceptance, a student is released every day for one half of his school time, preferably in the afternoon, to attend the Children's Theater school on site at the theater. (With other companies the students may be released in the mornings or even for a mid-day block of time. Whatever is convenient and suits the rehearsal and professional needs of these companies is arranged through Urban Arts which uses its liaison teachers, who are on part-time assignments, to contact students, parents, the schools, and cooperating arts organizations.) There the students take "classes" in body movement—including dance, mime, fencing, etc.—music and voice, acting (largely through improvisations), and, if time and interest permit, some work in the technical aspects of theater: make up, costumes, sets, lighting. Many of the students assist and act in actual performances.

For this participation, a student receives school credit, usually in English but often in Physical Education, Music, Art, or sometimes Social Studies. Some students, for example, have received all their English credits through Urban Arts. The credit is bestowed by the school upon proper acknowledgement from Urban Arts that the student has performed satisfactorily and attended regularly. The home school takes responsibility for rescheduling the student's classes so that courses required for graduation will not be neglected.

SEYMOUR YESNER

TEACHER TRAINING PROJECT, TOUCHSTONE CENTER FOR CHILDREN, NEW YORK CITY

The following is a short categorization of the different methods that were used by the staff of the Touchstone Center during the academic year 1972–73 in association with the Bank Street School and the Manhattan Country School in order to initiate the training of teachers in the imaginative life of children and their subsequent expressiveness through the arts.

Our evaluation of these different methods was based in part on the degree to which the students who were being trained responded to children and to themselves differently than when they first started working with us. We believe that no one way of working with students is in any way definitive—each method and relationship established has come out of a variety of needs on the students' part. Ideally, there should be a fluidity of approach that enables those training teachers to be as flexible as possible in the type of methodology used in opening up a student's consciousness concerning the imaginative life. The following is a list of the major methods used during the year.

A. *The Imagination of Childhood: A fifteen-week seminar.* Although the fifteen-week seminar is perhaps the most traditional of the various methods used within a graduate teacher-training program, I have tried to make the seminar a challenge to the student to approach the imaginative experience as a real and valid part of human activity and growth. Both the spring and fall sessions of this seminar—meeting once a week for two hours at the Bank Street School—were aimed at establishing a dialogue about the very process of creation itself.

In the fall seminar, students were asked as their major project to make something. They had the choice of using any type of materials and subject matter and creating something that was of importance to them. Interestingly enough, in a class of twenty-five students, no two students chose to make the same thing. After presenting his creation to the class, each student was asked to examine the imaginative experience that went into the making of that thing. In the second semester, with fifteen students, the emphasis was placed on students individually creating "a delicate thing" and then later in the semester participating in a large group effort to make something. Again the emphasis was on the problems of creation and how the child confronting his own need to create begins to find various means of symbolic language through gesture, movement, drawing, drama, words, music, and play in order to express what is of importance to him.

B. *Intensive weekly seminar.* In an attempt to work directly with individual students on the imaginative process, a four-hour weekly seminar was begun during the fall semester made up of three students, each assigned to a different school in the city. The seminar focused on individual imaginative projects created by the students themselves in schools in which they were doing their student teaching.

Each of these special projects was discussed at length at each seminar, and each student was challenged to find some practical solutions to work out the expressive problems they had posed to the various children they were working with in the classroom. Because of the small size of the group, it was possible to elucidate many of the very subtle and complicated ideas involved in bringing children and teachers into a compatible creative relationship.

C. *Apprenticeship program.* During the fall and spring semester, different students at the Bank Street School were assigned as apprentices to work with me with children at the Manhattan Country School. These students, who numbered no more than three at any one time, worked basically within a particular classroom as assistant teachers and, because of their work with me, they were allowed to find ways of working with children in the arts as part of the total classroom curriculum. Meetings were held with each of these students every week, sometimes in a group and sometimes

individually, to discuss their progress in exploring some of the expressive potential of the curriculum. The following are some of the projects carried out.

1. One student who was assigned to a class of eight- and nine-year-olds was interested in the degree to which stories could be told to children in order to bring from them their own personal stories. She brought small groups of ten children from her class to the resource center, where two members of the Touchstone Center staff (a storyteller and a dancer), working along with the student teacher and myself, told the children a group of Eskimo stories which were subsequently re-interpreted through the children's own expression in dance, movement, drama, and art. At the end of each week, each child was given a folder with the story that was told that week and was encouraged to take the story home. In between visits to the Center, the student teacher worked with the children to elicit their own stories.

2. One student who was assigned to a group of five- and six-year-olds worked with me toward establishing a "magic corner" in the room so that the children could feel the validity and reality of their own sense of magic. Because of the success of this particular magic corner (with its own magic box of magic people and animals), the same concept was applied to two other classrooms of children of approximately the same age. As a culmination of this interest in magic, student teachers in all three classrooms participated in a "Magic Day" in the spring.

3. Two students who were particularly interested in teaching the arts within the curriculum were assigned to me in the latter part of the spring. One of the students, whose interest was in clay, worked initially in a classroom that was studying Eskimo culture, and she developed a drama with the children using masks and the children's own ideas of the origin of each mask. Subsequently, she established a workshop for children at P.S. 3 and a series of workshops for children at the Manhattan Country School connected to the development of a "Jungle Day" for older children in the school.

The second student, whose interest was in toy making, also worked with different groups of children in making artifacts and toys for "Jungle Day." By and large, both students were working at all times with other resource persons interested in other forms of expression, such as drama, writing, and art. This teach-teaching relationship enabled each of the students to sense the degree to which specialists could work together as well as reinforce each other.

4. One student who was assigned to a particular group of nine- and ten-year-old children worked with me in extending a study of

Lapp culture so that what initially was a social studies unit turned into a highly expressive activity for the children.

The whole class at one point came to the Center to listen to a storyteller tell Lapp legends and myths, and from this experience the children became interested in one of the stories in which stones played a prevalent part. In the succeeding weeks, the same children became involved in studying not only stones but seashells, and this study evolved into a larger unit on whales and whaling. In subsequent visits to the Center, the children were encouraged to draw a large mural of all that they imagined existed at the bottom of the sea.

D. *Workshops.* As part of the work that was being done in the two fifteen-week seminars at the Bank Street School, a series of three full-day workshops was created for fifteen students who wished to participate on their own time on three separate Saturdays. The purpose of these workshops was to work through a particular aspect of the imaginative experience so that the students would have a greater understanding of the means by which the imagination works on all levels.

It was decided the workshops would concentrate on the imaginative process of "transformation." Each of the workshops was set up in the following way: three members of the Touchstone Center staff (myself, a dancer, and a storyteller/actress) were present throughout the three sessions. In the morning of each session experiential work was the main activity, while the afternoon was devoted to discussion as well as a performance by invited resource persons. Essentially, these workshops became for most of the students involved an extensive working out of their own imaginative experience and an articulation of that experience.

E. *Advisory to students.* Throughout the year, announcements were made to all students who participated in the seminars that the Center staff would be available on an advisory basis for any problems they were having in regard to initiating imaginative work in the different schools throughout the city to which they had been assigned.

An example of this type of advising was a weekly meeting between myself and four students who were attempting to create an afternoon program for a large group of eight- and nine-year-olds in a public school. Our main point of discussion within these advisory meetings was how to take the children's own interest in "monsters" and turn it into a viable and expressive art form for the children. These advisory meetings were always of an informal nature, taking place only when the students felt a need for them; and the importance of the meetings was the degree to which they were supportive of the students as they began to experiment with ways of opening up the imaginative process in children.

RICHARD LEWIS

APPENDIX B
CONTRIBUTORS OF
POSITION PAPERS

David W. Baker	*Title*
Director of Related Arts	The Arts in the Middle School
Brookline Public Schools	
Brookline, Massachusetts	
Carl Dolce	
Dean	The Arts in the High School
School of Education	
North Carolina State	
University	
Raleigh, North Carolina	
Monroe Eidlen, Principal	
Henry Hudson Junior High	Art Education in the Middle
School	Schools
Bronx, New York	
Al Hurwitz	
Division of Program	State of Idea on Senior High
The Newton Public Schools	School Art Programs of Newton
Newtonville, Massachusetts	Public Schools
Charity James	Art and Consciousness
Gerard L. Knieter	
Dean and Professor of Music	Guidelines for Education in the
College of Fine and Applied	Arts
Arts	
The University of Akron	
Akron, Ohio	
George Kyme	
School of Education	Music in General Education at
University of California	the Elementary School Level
Berkeley, California (retired)	
Hilda P. Lewis	
School of Education	The Arts in the Elementary
San Francisco State University	School
Richard Lewis	
Touchstone Center for Children	Statement for the Study of the
141 East 88th Street	Arts in Pre-Collegiate
New York, New York	Education

	Title
Richard L. Loveless Department of Art Education College of Education University of South Florida Tampa, Florida	The Arts Outside of School
Stanley S. Madeja, Director Aesthetic Education Program Central Midwestern Regional Educational Laboratory, Inc. St. Louis, Missouri	The Arts: A K–12 Program
David B. Marsh, Director Health and Physical Education Ridgewood Public Schools Education Center Ridgewood, New Jersey	The Development of a Meaningful Arts Program in the Middle School
Erin Martin Dancer, Choreographer and Teacher of Dance	Report on Dance Programming in Pre-Collegiate Education
Victor B. Miller Workshop Coordinator Center for Theatre Techniques in Education American Shakespeare Theatre Stratford, Connecticut	Arts Program
Richard C. Mühlberger Springfield Museum of Fine Arts Springfield, Massachusetts (formerly Chairman of Education, The Detroit Institute of Arts)	A Report of Museum Education and an Arts Program for Classroom Teachers
Doreen Nelson, Director City Building Educational Program 235 South Westgate Los Angeles, California	The City Building Educational Program: A Design for Elementary Education
Shirley R. Ririe Department of Modern Dance The University of Utah Salt Lake City, Utah	A Quality Program in Dance on the High School Level

Larry Schultz Art Coordinator Jefferson County Public Schools 809 Quail Street Lakewood, Colorado	The Visual Arts
Gene C. Wenner President American Music Conference Wilmette, Illinois	The Arts Program in the High School
Seymour Yesner Consultant in English and Humanities Minneapolis Public Schools Minneapolis, Minnesota	The Arts Program in the High School Level

THE ARTS AND SCHOOLING: ANNOTATED BIBLIOGRAPHY

Selected and Compiled
by
LILLIAN K. DRAG

Part I: *Theory and Themes*
Part II: *Programs and Projects*
Part III: *People and Process*
Part IV: *Periodicals*

This selection of readings relates closely to the themes developed in the body of the text although most of the references cited in chapter notes are not listed. Additional sources have been selected and annotated to complement and enrich the ideas presented.

The bibliography is arranged in four parts. Part I presents theoretical ideas about the contribution of the arts to full development of human potential. It deals with philosophical, psychological, and social issues along with dominant themes in the history and development of art education in America. Part II reviews concepts and practices in curriculum development for art and aesthetic education. Intended for the curriculum builder or the enterprising administrator, it describes programs with potential for enhancing instruction, research studies with implications for teaching and learning, and projects which further progress toward the goals of art education. Part III considers teacher-student relationships in teaching the arts both in the schools and outside. In discussing the background teachers need to carry on more effective instruction, it stresses that "the essence of art lies in the experience of art." Approaches range from emphasis on ideas to concern with arts media and processes, but the selection is merely representative. Many significant references might easily have been added to these selected works which serve only as samples or as stimulants to thought and action. Part IV offers a list of periodicals with prices and addresses indicated for the convenience of the reader who plans to pursue a specific interest on a continuing basis.

PART I. THEORY AND THEMES

Arnheim, Rudolf: *Art and Visual Perception: A Psychology of the Creative Eye,* new version, University of California Press, Berkeley, Ca., 1974. (First published, 1954.)

Cites experiments, develops principles, and discusses "some of the virtues of vision" in trying to apply approaches and findings of psychology to the study of art.

————: *Visual Thinking,* University of California Press, Berkeley, Ca., 1969.

Emphasizing the creative aspects of the mind, the author uses the experimental and theoretical bases developed in gestalt psychology to show that visual perception is a cognitive activity. Uses many references and illustrations to demonstrate the way the arts contribute to the development of a reasoning and imaginative human being.

Arts, Education and Americans Panel, American Council for the Arts in Education: *Coming to Our Senses: The Significance of the Arts for American Education,* McGraw-Hill, New York, 1977.

A report by a distinguished twenty-five member panel, chaired by David Rockefeller, Jr., concerned with the urgency of arts education and its potency for improving the quality of life. Arts education is seen as learning in *the arts, about the arts, and* through *the arts and as an essential part of "basic education" since the arts are basic to individual development. Discusses the role of federal legislation and provides statistical information concerning the status of aesthetic instruction. Proposes fifteen recommendations for change stressing the integration of the arts with other studies. Appendix includes research information listing exemplary programs, research reports and resource persons, and a selected bibliography. See also the Council's* We Speak for the Arts *reporting the project, "Art's Worth," which uses extensive quotes from great people to embellish the argument for more and better arts programs in education.*

Arts in Society, vol. 11, no. 2, 1975, "The Arts in Education"; vol. 12, no. 2, 1975, "Our Changing Outlook on Culture"; and vol. 12, no. 3, 1975, "Arts in Higher Education."

The arts are examined from a scholarly and sociological standpoint in this now defunct periodical.

Bassett, Richard (ed.): *The Open Eye in Learning: The Role of Arts in General Education,* The MIT Press, Cambridge, Mass. 1969.

Examines the value of arts education to an individual and to the community, and attempts "to study its logical place in the school system." Considers "Art and the Educated Citizen," "Art and the Human Equipment," "The Educational Scheme," "The Art Course in Practice: Elementary Art," "The Deliberate Approach: Secondary School Art," "Curricular Planning," "The Whole Man and the Citizen," "Teaching Supplement," and "The Training of Teachers."

Batchelor, Ronald, and Vincent P. Franklin: "Freedom Schooling: A New Approach to Federal-Local Cooperation in Public Education," *Teachers College Record*, vol. 80, no. 2, December 1978, pp. 225–248.

A section of this article, "Freedom Schooling and Arts Education," used to illustrate the alternative type of schooling the authors are suggesting, serves as a current statement strongly supporting improved arts education in the public schools.

Battcock, Gregory (ed.): *New Ideas in Art Education: A Critical Anthology,* E. P. Dutton, New York, 1973.

Generally negative essays about usual practice and goals of art education, deploring emphasis on technological aspects. Some feel art education shouldn't be left to teachers (artists are better). Most view art as inseparable from social, urban, and global conditions since it is a broad, communicative system. Little on specific techniques or recommended curricula—Sanders and Leepa are exceptions.

Broudy, Harry S.: "The Structure of Knowledge in the Arts," in Stanley Elam (ed.), *Education and the Structure of Knowledge,* Rand McNally, Chicago, 1964, pp. 75–106.

Discusses aesthetic meaning and development of aesthetic perception.

————: "Arts Education: Necessary or Just Nice?" *Phi Delta Kappan,* vol. 60, no. 5, January 1979, pp. 247–250.

Proposes that "the aesthetic mode of experience" is necessary, that schools must provide it for the entire school population, and that formal instruction in this field is possible. Relates arts education to the development of language, thought, and feeling by enriching the store of images that make comprehension of concepts possible.

————: *The Whys and Hows of Aesthetic Education,* CEMREL, St. Louis, Mo., 1978.

Presents a rationale for the inclusion of aesthetic education in the

public schools. This paper may profitably be used as an introduction to aesthetic education for teachers, administrators, parents, and others. See also Broudy and Edward Mikel, A Survey of the Aesthetic Attitudes of Key School Personnel, *CEMREL, 1978.*

Coming to Our Senses: The Significance of the Arts for American Education. See entry under Arts, Education and Americans Panel.

Dewey, John: *Art as Experience,* Capricorn Books, New York, 1958. (First published in 1934.)

Based on a series of lectures at Harvard University on the philosophy of art. Explores the ways in which works of art enlarge human experience and help to deepen meanings through imagination. Indicates how the creative process of art makes connection with experience to intensify, clarify, and ⬥ırich living. Dewey relates the practical and the fine arts and shows the aesthetic role that art can play in the formation of cultural attitudes.

Eddy, Junius: "Bridging the Gap Between the Arts and Education," in Elliot W. Eisner (ed.), *The Arts, Human Development and Education,* McCutchan, Berkeley, Ca., 1976, pp. 185–97.

Provides an overview of governmental and private support for the arts in general education since 1965, deploring the lack of cooperative effort and mutual understanding between the world of education and the world of arts in American schools. Cites a few current efforts to overcome this dichotomy in order to foster development in the arts as a basic element in education.

————: "Why Are the Arts So Undervalued in American Schools?," *RF Illustrated,* March 1974.

A summary of a report to the Rockefeller Foundation titled "Perspectives on the Arts and General Education."

Educational Policies Commission: *The Role of the Fine Arts in Education,* EPC, Washington, D.C., 1968.

Briefly presents main arguments to justify education in the arts: historical, art for art's sake, therapy, creativity, acceptance-of-subjectivity, and end-of-work (leisure) rationales. The Commission accepts the last three areas as justification for supporting education in the arts and makes specific recommendations to promote it. Concludes: "The greatest benefit for people in the future might be to develop now their capacity for self-expression through education in the fine arts."

Eisner, Elliot W. (ed.): *The Arts, Human Development, and Education*, McCutchan, Berkeley, Ca., 1976.

In discussing the social and individual aspects of artistic development, Lanier, Broudy, Feldman, and Hurwitz attack the problem of "popular" versus serious art. Eisner, Efland, Ecker, and Gardner describe theoretical views of children's artistic development. Silverman, Lewis, and Hausman discuss practical aspects of teacher education, development of school programs, and community problems. Eddy, Nash, and Eisner identify professional, political, and social realities needing attention.

Erikson, Erik H.: *Childhood and Society*, Norton, New York, 1963.

"A psychoanalytic view of development stressing the affective domain." One of the two major views of development discussed in Chapter 3 by Wolf and Gardner.

Field, Dick, and John Newick (eds.): *The Study of Education and Art*, Routledge and Kegan Paul, Boston, 1973.

Leading British authorities discuss education and art from cultural, philosophical, and psychological points of view. Most of them imply the assumption that the essence lies in the experience of art. Concludes with a symposium report, "Is It Necessary to Make Art in Order to Teach Art?"

Gardner, Howard: *The Arts and Human Development*, Wiley, New York, 1973.

Presents an integration of developmental theory and the artistic process. Uses Erikson's psychoanalytic view of development and Piaget's cognitive view to construct a schema for studying artistic development in children.

————, Ellen Winner, and Mary Kircher: "Children's Conceptions of the Arts," *Journal of Aesthetic Education*, vol. 9, no. 3, July 1975, pp. 60–77.

Interviewed 121 children (4–11 years old) from different backgrounds, asking responses to a series of aesthetic topics and media.

Getzels, Jacob W., and Mihaly Csikszentmikhalyi: *The Creative Vision: A Longitudinal Study of Problem Finding in Art*, Wiley, New York, 1976.

Research involving aspiring young artists indicated that they painted in order to get a better understanding of reality. Those who sought ways to express unformulated problems of life were rated higher. Showed that for the young artist art is a cognitive process, though clearly different from a rational one.

Golumb, C.: *Young Children's Sculpture and Drawing,* Harvard University Press, Cambridge, Mass., 1974.

"A comparison of the early stages of artistry in two media." Supplements the ideas expressed in Chapter 3 by Wolf and Gardner.

Goodlad, John I.: "From Rhetoric to Reality in Aesthetic Education," in Robert L. Leight (ed.), *Philosophers Speak of Aesthetic Experience in Education,* The Interstate Printers and Publishers, Danville, Ill., 1975.

Points out that the omission of aesthetic goals from national statements of school goals need not deter any school from developing arts programs since schools are not goal oriented—they are experience oriented. Addresses the problem of how to "get the substance and processes [of aesthetic education] through the classroom door."

Goodnow, Jacqueline: *Children's Drawing,* Harvard University Press, Cambridge, Mass., 1977.

One of a series on "The Developing Child" examines in detail through children's graphic works the growth of a child's thought processes and his approach to problem solving. Points out that communication takes place visually as well as verbally, which may provide a means for finding a relationship between drawing and behavior in general.

Greene, Maxine: "Artistic-Aesthetic Considerations," in *Landscapes of Learning,* Teachers College Press, New York, 1978, pp. 161–210.

This teacher of teachers makes a case for teachers to become more sensitive to the qualities of things, to know personally what it means to be receptive to the arts, and to be informed enough to articulate how the arts expand human possibilities. Chapter 11, "Towards Wide-Awakeness: An Argument for the Arts and Humanities in Education"; Chapter 12, "Artistic-Aesthetic and Curriculum," (also available in Curriculum Theory, *vol. 6, no. 4, 1977); Chapter 13, "Imagination and Aesthetic Literacy"; Chapter 14, "Significant Landscapes: An Approach to the Arts in Interrelationship."*

Harvard Project Zero: Basic Abilities Required for Understanding and Creation in the Arts, Nelson Goodman, David Perkins, Howard Gardner, Harvard University, Graduate School of Education, Cambridge, Mass., 1974.

Final report for U.S. Office of Education, Project No. 9–0283. A long-range basic research program to study the varieties and inter-

action of human abilities, the nature of the tasks involved in the several arts, and ways to develop those abilities. Used psychological experimentation and clinical study of the brain as well as field work in schools to research the problems involved.

Hausman, Jerome, J.: "Elitism in the Arts, and Egalitarianism in the Community—What's an Art Educator to Do?," in Elliot W. Eisner (ed.), *The Arts, Human Development and Education,* McCutchan, Berkeley, Ca., 1976.

Traces the movement from formalist orientations to such forms as environments, happenings, and pop art—evidence of artistic activity as an integral part of creative community experience. Sees artists' roles as more involved in community, needing to develop more cooperative and supportive relationships.

The Journal of Aesthetic Education, University of Illinois Press, Urbana, Ill., vol. 11, no. 2, April 1977, Special Issue: "Research and Development in Aesthetic Education"; vol. 12, no. 1, January 1978, Special Issue: "Policy and Aesthetic Education."

The first of these issues presents some illustrative research topics which provide a context for doing policy research. The second issue addresses policy making in the arts.

Jung, Carl G. (ed.): *Man and His Symbols,* Doubleday, New York, 1964.

Develops an aesthetic theory yielding insight into the nature of literature, poetry, and the visual arts.

Kaufman, Irving: *Art and Education in Contemporary Culture,* Macmillan, New York, 1966.

Deals with major philosophical concepts: sensitivity and awareness are basic to making, appreciating, or teaching art (more important than skills and techniques of art education); aesthetics of art education are to be stressed over description of appearances and procedures; the individual and subjective nature of understanding; the triviality of aesthetic concerns in a technological society. Points up relationships, describes various approaches, acts as gadfly for "individual reader to seek his own answers." Out of print. May be available in libraries.

Kreitler, Hans, and Shulamith Kreitler: *Psychology of the Arts,* Duke University Press, Durham, N.C., 1972.

An attempt to unify the psychological theories of different art forms into one encompassing theory, general enough to account for painting, sculpture, music, literature, dance, etc. Part I discusses the

elements of art forms. Part II deals with processes basic for all kinds of art experiences whose functions are analyzed and illustrated by presenting side-by-side examples of all the major arts. Concentrates on the spectator of the arts rather than the creator.

Langer, Susanne K.: *Feeling and Form: A Theory of Art,* Charles Scribner's, New York, 1953.

Contains detailed explanations of each major form of art. Presents a philosophy revealing art as a form of symbolization which can communicate aspects of human experience that might otherwise remain unexpressed. "Art is the education of feeling, and a society that neglects it gives itself up to formless emotion." Out of print. May be available in libraries. See also the author's Philosophy in a New Key, Harvard University Press, 1957, in which she refers to symbol making as a fundamental process of mind that goes on all the time and makes clear the incapacity of language to conceptualize all that humans can know.

————: *Mind: An Essay on Human Feeling,* Johns Hopkins Press, Baltimore, Md., 1967.

Shows the relationship between art and life. Expresses the belief that there is a biological or "natural" basis for aesthetic experience, that art is a basic means for making contact with life.

————: *Problems of Art,* Charles Scribner's, New York, 1957.

Develops the idea of art as expressiveness; gives views on human feeling, aesthetic means, and sensory illusion; and shows how the various arts are and are not related. The author's treatment of poetic creation embraces creation in all the arts. "All art is the creation of perceptible forms expressive of human feeling." Out of print. May be available in libraries.

Lanier, Vincent: "Assessing the 'S' in Arts Education," *The Journal of Aesthetic Education,* vol. 12, no. 1, January 1978, pp. 71–80.

Asserts that the idea of art as communication similar to verbal language needs more careful examination. Indicates that clearly identified distinctions among the arts must be made in attempting a combined arts education.

Leight, Robert L. (ed.): *Philosophers Speak of Aesthetic Experience in Education,* The Interstate Printers, Danville, Ill., 1975.

Reports a conference dealing with conceptual aspects, curriculum implications, and applications of aesthetic education. Relates aesthetic experience to education in the arts. Includes papers by Harry S. Broudy, John I. Goodlad, Arthur W. Foshay, and others of note.

Madeja, Stanley, S. (ed.): *Art and Aesthetics: An Agenda for the Future,* First Yearbook on Research in Arts and Aesthetic Education, CEMREL, St. Louis, Mo., 1977.

Proceedings of a conference sponsored jointly by CEMREL and the Education Program of the Aspen Institute for Humanistic Studies, supported by the National Institute of Education. Part I, "Speeches from the General Sessions," include those by Francis Keppel, Harold Hodgkinson, David Rockefeller, Jr., and Margaret Bush Wilson; Part II, "Surveys and History of Research in the Arts and Aesthetics"; Part III, "Methodological Issues"; and Part IV, "Researchable Problems." Includes chapters by Elliot Eisner, Howard Gardner, Harry Broudy, Arthur Foshay, Martin Engel, and other eminent contributors. D. Jack Davis provides a chapter, "Research Trends in Art and Art Education: 1883–1972," which includes an extensive bibliography.

————: *The Arts, Cognition, and Basic Skills,* Second Yearbook on Research in Arts and Aesthetic Education, CEMREL, St. Louis, Mo., 1978.

Focuses on cognitive and noncognitive approaches to the arts, developmental theory and the arts, perception in cognition and the arts, and the role of transfer of knowledge in the arts. Papers on "The Arts as Basic Skills," "Recycling Symbols," "Intuitive and Formal Musical Knowledge," and "Identification and Different Arts Media" are especially pertinent to education.

Maslow, Abraham: *Toward a Psychology of Being,* 2d. ed., Van Nostrand, Reinhold, Princeton, N.J., 1968.

Sees "learning one's identity" as an essential part of education, and the arts, therefore, as closer to the core of education than are other subjects. Chapter 10 differentiates between creativity associated with great tangible achievements and the potential for creativity and self-actualization in everyone.

Meyer, Leonard B.: *Music, The Arts and Ideas: Patterns and Predictions in Twentieth Century Culture,* University of Chicago Press, Chicago, 1967.

Latter part of book presents a discussion of contemporary artistic trends. Cautions against attempting to coordinate style periods among the several arts or to relate style periods to political or social history.

Morrison, Jack: "'Vulgarizing' the Arts: New Commitments for Education," *Arts in Society,* vol. 12, no. 2, Summer/Fall 1975, pp. 195–201.

Defines "vulgarizing" as making plain, clear, useful, and available to all people. Describes efforts of the Arts in Education Program of the JDR 3rd Fund to find ways of relating all the arts to all children at all levels.

The National Elementary Principal, vol. 55, no. 3, January/February 1976, National Association of Elementary School Principals, Washington, D.C., 1976.

This issue is entitled "The Ecology of Education: The Arts," one of a series intended to point up a new relationship between the school and society. Practicing artists and educators discuss the value of arts in education. Brief reports of ongoing programs are included, national as well as local efforts. Offers a readable and concise presentation of the state of the field.

The National Humanities Faculty Why Series, Chandler and Sharp, San Francisco, 1973–1975.

Each title in this pamphlet series presents a transcribed conversation between two people—one an authority in a particular branch of the humanities, the other an experienced educator. Dialogues reveal fundamental questions and some equally thoughtful answers. Titles include: "Why Pretend?," "Why Draw?," "Why Move?," "Why Sing?," "Why Pop?".

National Research Center of the Arts, Inc.: *Americans and the Arts: A Survey of Public Opinion,* Associated Councils of the Arts, New York, 1975.

The second nationwide public survey on attitudes toward and participation in the arts, including support. Section on children and the arts indicates wide support for teaching the arts in public schools as part of the core curriculum and for opportunities for children to go to arts events and performances. Highlights and summary of findings is available from ACA Publications, 570 Seventh Avenue, New York, N.Y. 10018.

———: *Californians and the Arts: A Survey of Public Attitudes Toward and Participation in the Arts and Culture in the State of California,* National Research Center of the Arts, 1974.

A 24-page summary of highlights is available from the California Arts Commission, 808 O Street, Sacramento, Ca. 95814. Similar surveys have been made in New York State; Anchorage, Alaska; Ontario, Canada; Washington State.

National School Boards Association: *The Arts in Education: Research Report 1978–2,* NSBA, Washington, D.C., 1978.

Mainly consists of a digest of Coming to Our Senses, Arts, Edu-
*cation and Americans Panel of the American Council for the Arts
in Education. See entry under Arts, Education and Americans
Panel for annotation.*

National Society for the Study of Education: *Media and Symbols:
The Forms of Expression, Communication, and Education,* Sev-
enty-third Yearbook, Part I, David R. Olson (ed.), University of
Chicago Press, 1974.

*Scholars explore the view of man as an image-making, symbol-
using creature. Gardner et al. of Harvard Project Zero specify a
scheme to analyze all symbol systems. Larry Gross questions use
of educational TV as a shortcut to learning, expressing doubt that
it can replace the child's basic experiences of learning through
active performances, especially in the arts. Harley Parker similarly
argues for a more general education in the arts to balance the
senses now dominated by reliance on print. I. A. Richards empha-
sizes the important role of acquisition and use of meanings by chil-
dren, stressing need for developing techniques (visual depiction,
etc.) to enhance these functions. Arnheim suggests how images
may be made more instructive and more interesting. Gombrich
says that what a picture means to the viewer is strongly dependent
on his past experience and knowledge and therefore the visual
image is not a representation of reality but a symbolic system.*

Pappas, George (ed.): *Concepts in Art and Education: An Anthology
of Current Issues,* Macmillan, New York, 1970.

*Presents concepts, methods, and theories based on the interrelated
areas of the visual arts, aesthetics, psychology, sociology, and
anthropology. Contributors range from John Dewey, Susanne
Langer, and Viktor Lowenfeld to Eisner, Hausman, Ralph Smith,
Broudy, and Goodlad.*

Piaget, Jean: *Play, Dreams, and Imitation in Childhood,* Norton,
New York, 1962.

*A cognitive view of development focused on early forms of symbol-
ization. One of the two major views of development discussed in
Chapter 3 by Wolf and Gardner.*

Read, Herbert: *Education Through Art,* 3d. rev. ed., Pantheon
Books, New York, 1956.

*A classic work which promotes the conception of everyone as an
artist in his own craft (doing something well). Argues for creative,
aesthetic expression as the basis of education. Analyzes artistic
activity in children using their own drawings as illustration. Sees*

teachers as sensitive, patient mediators developing "sensibility" and "imagination." See also his Education for Peace, *Charles Scribner's, 1949, in which he describes education by aesthetic discipline. Considers art a general process through which man achieves harmony between his internal world and the society in which he lives. Out of print. May be available in libraries.*

Reid, Louis Arnaud: "Aesthetics and Aesthetic Education," in Dick Field and John Newick (eds.), *The Study of Education and Art,* Routledge, Boston, 1973.

Helpful distinctions are made between: art, the aesthetic, aesthetics, the aesthetic object, criticism, aesthetic education.

Reimer, Bennett: A *Philosophy of Music Education,* Prentice-Hall, Englewood Cliffs, N.J., 1970.

Contains implications for all the arts, not only music. Presents alternative views about art suggesting the aesthetic theory of "Absolute Expressionism" as best suited to teaching the arts today: it promotes the experience of art for the insights it yields into human subjective reality and as a means to self-understanding. Develops a model for generating units of instruction in general aesthetic education.

———— (ed.): *Toward an Aesthetic Education,* Music Educators National Conference and CEMREL, Washington, D.C., 1971.

Conference position papers, presentation papers, and articles focusing on music in aesthetic education.

"The Role of the Fine Arts in Education," *Art Education,* Journal of the National Art Education Association, vol. 21, no. 7, 1968.

The Education Policies Commission of the NEA and AASA established rationales for the importance of the arts in education including the historical, art for art's sake, therapy, creativity, acceptance-of-subjectivity and end-of-work rationales. See also entry under Education Policies Commission.

Rothenberg, Albert, and Carl R. Hausman (eds.): *The Creativity Question,* Duke University Press, Durham, N.C., 1976.

The two editors, a psychiatrist and a philosopher, collected readings focusing on the combination of novelty and control (or order) and made choices also based on their disciplinary perspectives. Selections fall into three categories—descriptive, explanation, and alternative approaches to creativity—in order to illustrate the major issues involved. Those that fall under explanations are

attempts to determine the conditions responsible for creative activity and to predict its outcome.

Seattle Public Schools: *The Arts in Education: Seattle Reflections,* Seattle Public Schools, Seattle, Wa., 1976.

A statement of beliefs indicating that the arts are important not only in their own right, but as motivation and tools for learning in all areas of the curriculum to improve the quality of education. Outlines the Seattle Arts in Education Program.

Smith, Nancy R.: "Developmental Origins of Graphic Symbolization in the Paintings of Children Three to Five," Ph.D. thesis, Harvard University, Boston, 1972.

Presents a rationale, based on the importance of symbolization in human experience, for the inclusion of painting in education as a cognitive as well as an affective and aesthetic aspect of knowledge. Suggests some practical means of implementing the cognitive aspect of painting in early childhood education.

Smith, Ralph A. (ed.): *Aesthetic Concepts and Education,* University of Illinois Press, Urbana, Ill. 1970.

Eminent philosophers and educators provide essays on the key concepts in aesthetics as a field of study and their relevance to aesthetic education. Essays include Monroe Beardsley, "Aesthetic Theory and Educational Theory"; Donald Arnstine, "Aesthetic Qualities in Experience and Learning"; Harry S. Broudy "Feeling and Understanding"; Maxine Greene, "Imagination"; Barbara Leondar, "Metaphor in the Classroom."

————: *Aesthetics and Problems of Education,* University of Illinois Press, Urbana, Ill. 1971.

Brings together significant materials under the headings: "Historic Ideas of Aesthetic Education," "The Aims of Aesthetic Education," "Curriculum Design and Validation," and "Teaching-Learning in Aesthetic Education." Selections from Herbert Read, John Dewey, Susanne Langer, Rudolf Arnheim, Harry Broudy, Ralph Smith, Maxine Greene, Philip Phenix, Bennett Reimer, and Elliot Eisner, among other notables, are presented here.

Taylor, Harold (ed.): *The Humanities in the Schools: A Contemporary Symposium,* Citation Press, New York, 1968.

A stimulating presentation led off by Taylor, "The Arts and the Humanities"; followed by Harold Rosenberg, "Where to Begin"; Stephen Spender, "Language as Communication"; Stanley Kauffman, "Films and the Future"; Robert Shaw, "The Conservative

Arts"; Edgar Friedenberg, "A Teaching Credential for Philoc-
tates?"; and Taylor on ideas for action. *Proposes that humanities
are best approached by participation in one or more of the creative
arts.*

Williams, Roger M.: "Why Children Should Draw: The Surprising
Link Between Art and Learning," *Saturday Review,* September
3, 1977, pp. 10–16.

*Cites specific cases that indicate study in the arts enhances the
capacity of the brain.*

PART II. PROGRAMS AND PROJECTS

Arts in Education Symposium, Oklahoma City, 1976: *Arts in Edu-
cation Partners: Schools and Their Communities,* Nancy Shuker
(ed.). Jointly sponsored by the Junior League of Oklahoma City,
The Arts Council of Oklahoma City, Oklahoma City Schools, The
Association of Junior Leagues, The JDR 3rd Fund. Available
from Associated Council of the Arts Publications, New York,
1977.

*An illustrated handbook developed from the substance and conclu-
sions of the symposium initiated to address the question: How can
a community and its school district cooperate to initiate, develop,
and maintain an arts in general education program? Stimulated
by the Oklahoma City Public Schools arts program, "Opening
Doors," which uses community cultural agencies as educational
resources. Offers guidelines for working together in problem areas
and for setting priorities; brings perspective to goals of arts in
education; cites case studies; presents a rationale and a
bibliography.*

Association of Art Museum Directors: *Education in the Art
Museum: Proceedings of a Conference of Art Museum Educators,*
held in Cleveland, Ohio, November 4–5, 1971, New York, 1972.

*Presents varied opinions and miscellaneous statistics to help build
understandings, synthesize divergent concepts, and increase
growth in art museum education in U.S.*

Barkan, Manuel, Laura Chapman, and Evan Kern: *Guidelines:
Curriculum Development for Aesthetic Education,* CEMREL, St.
Louis, Mo., 1970.

*Presents a concept of aesthetic experience for curriculum develop-
ment: "whether it be listening, looking, performing or producing,
involvement in an aesthetic experience carries the desire to sustain
and feel the full impact of the moment for its own sake." The goal*

for aesthetic education—to increase the student's capacities to experience aesthetic qualities—is used as the basis for identifying units of instruction and demonstrating how to design and use them in courses and programs. Out of print. May be available in libraries.

Brittain, W. Lambert: *Creativity, Art, and the Young Child,* Macmillan, New York, 1979.

Offers a nontechnical synthesis of pertinent research findings on the art of young children in order to form a base for better understanding of creativity and children's development. Directed toward the teacher of young children emphasizing the importance of creative rather than structured activities for developing cognitive competence. Gives some suggestions for practice.

California State Department of Education: *Art Education Framework,* Sacramento, 1971; *Drama/Theatre Framework for California Public Schools,* 1974; *Music Framework for California Public Schools,* 1971.

Curriculum frameworks developed by statewide committees available to all California public schools.

————: *Promising Programs in Arts Education,* Sacramento, 1976.

The California Alliance for Arts Education Committee identified twenty-three exemplary programs grouped here into three categories: comprehensive programs providing multi-arts experiences or interdisciplinary activities; in-school programs unique to one arts discipline or a particular school's program; school/community programs. Brief descriptions give focus, outline, objectives, grade level, content, and resource material.

Central Midwestern Regional Educational Laboratory (CEMREL): *The Aesthetic Education Program: A Report on the Accomplishments, 1969–1975,* CEMREL, St. Louis, Mo., 1977, 2 vols.

Describes in detail the work of the Aesthetic Education Program. Vol. I deals with the devlopment of curriculum materials. Vol. II describes the evaluation of the materials and their implementation and includes bibliography. See also entries under Madeja, Stanley.

————: *Five Sense Store: Aesthetic Education Program Instructional Materials,* Comenius, Inc., Weston, Colo., 1973.

Multimedia for kindergarten through grade 7. Each package contains ten hours of instruction in: "Aesthetics and the Elements"; "Aesthetics and the Creative Process"; "Aesthetics in the Physical

World." See also CEMREL's Handbook for "The Five Sense Store Exhibit: An Aesthetic Design for Education" *by Susan Ingham, CEMREL, St. Louis, Mo., 1973.*

————: *Tests in the Arts,* CEMREL, St. Louis, Mo., 1970.

Consists of an index and set of abstracts of measurement instruments and tests applicable to the arts. Provides an overview of the various psychometric methodologies used in the development of tests in art, dance, literature, music, and creativity.

Churchill, Angiola R.: *Art for Preadolescents,* McGraw-Hill, New York, 1971.

Develops art curriculum for grades 5, 6, and 7 designed to promote "aesthetic activities that channel preadolescents' energies and talents so that they may find art a meaningful resource for the rest of their lives." Teaching methods and strategies are related to the psychological traits of preadolescents and their interests, giving emphasis to the contemporary art scene and a variety of media.

Curriculum Theory Network, vol. 4, nos. 2–3, 1974.

Presents current ideas from prominent scholars including Elliot Eisner, "The Mythology of Art Education"; Charity James, "Art, Prophecy and Education"; Irving Kaufman, "Art Cannot Be Reduced to Ideas"; Stanley Madeja, "Aesthetic Education, Some Strategies for Intervention"; Ralph Smith, "The New Policy-Making Complex in Aesthetic Education"; Jerome Hausman, "Mapping as an Approach to Curriculum Planning"; and others.

Eddy, Junius: *Arts Education 1977—In Prose and Print,* HEW, Washington, D.C., 1977.

A "report on reports" in arts education prepared for the Sub-Committee on Education in the Arts and Humanities of the Intraagency Committee on Education, HEW. See also his "The Upsidedown Curriculum," Cultural Affairs, Summer 1970, issued as a 1970 Ford Foundation Reprint.

————: "Arts Education: The Basics and Beyond," *Art Education,* vol. 30, no. 7, November 1977, pp. 6–12.

Asks "what's essential to the education of human beings beyond the basics?" Proposes that the arts enhance basic skills and, indeed, are among the needed basic skills for full development of the person.

————: "A Review of Federal Programs Supporting the Arts in Education" and "A Review of Projects in the Arts Supported by

ESEA's Title III," both issued as Reports to The Ford Foundation, 1970.

Eisner, Elliot W.: *Educating Artistic Vision,* Macmillan, New York, 1972.

Examines the background and dominant themes in the development of art education in America; discusses theoretical ideas about student's development in art; reviews concepts and practices in curriculum development using Stanford Kettering Project as one example; considers teacher-student relationships in teaching art in the school; and concludes with a statement of the contribution of art education to society through schooling. See also his Teaching Art to the Young: A Curriculum Development Project in Art Education, *Stanford University, Stanford, Ca, 1969.*

Gaitskell, Charles D., and Al Hurwitz: *Children and Their Art: Methods for the Elementary School,* 3rd ed., Harcourt, New York, 1975.

"Deals with the theoretical basis of art education as well as the practical methods for teaching art. A broad creative program is presented as a logical extension of art, its history in the schools, and its unique function in the lives of children." (Preface.) Updated materials can be found in chapters titled: "Relating Art to the General Curriculum," "Appraising Children's Progress," "Special Education: Art Activities for Slow Learners," and "Developing a Program of Studies in Art." Includes examples of children's art from many countries. A rich source.

Gary, Charles L., and Beth Landis: "Music Education," in William J. Ellena (ed.), *Curriculum Handbook for School Executives,* American Association of School Administrators, Arlington, Va, 1973, Chapter 12.

Proposes a program that is "challenging to all students," recognizes "a diversity of musical behaviors," and involves "music of all periods, styles, forms, and cultures."

Goodlad, John I.: "A Strategy for Improving School Arts Programs," *Journal of Aesthetic Education,* vol. 10, July–October 1976, pp. 151–63.

Strategy includes taking into account the school as a social system, the teacher as an active participant in the development of improved programs, and the significance of "the individual school with its pupils, teachers, principal and ties to home."

Hurwitz, Al (ed.): *Programs of Promise: Art in the Schools,* Harcourt, New York, 1972.

Presents a wide variety of approaches with a wide variety of goals. Art processes, such as perception, organization, and structure, are used for their potential in general learning, while other directions for teaching are self-awareness for the student or art for social planning. The writers are teachers—"The free-wheelers and the mystics are here along with the logicians."

The Institute for the Study of Art in Education: *Museum-Art Education Seminars.* The Institute/City College, New York, 1972.

Seminars set up to explore the expanded educational role of museums especially in relationship to art education programs in schools. Irving Kaufman's initial paper serves as a target for response papers from Elliot Eisner, David Hupert, Robert Reals, and others. Summary statement is made by Jerome Hausman with suggestions for improving shared efforts.

Lewis, Hilda P.: *Art Education in the Elementary School,* National Education Association, Washington, D.C., 1972.

One of "What Research Says to the Teacher" series. Draws from research information which relates to classroom teaching. Discusses briefly how young children draw and how representation develops, the role of the teacher, evaluating progress, etc.

———: "Crystal Gazing, Forecasting, and Wishful Thinking: The Future of Arts in Public Education," in Elliot W. Eisner (ed.), *The Arts, Human Development and Education,* McCutchan, Berkeley, Ca., 1976, pp. 159–73.

Describes arts education as the author would like it to be: offers all the arts to all the children; places the arts at the center of the curriculum; is individualized and varied; is flexibly staffed; involves school and community. Identifies favorable trends and suggests ways to promote movement toward these goals.

Logan, Frederick M.: "UpDate '75, Growth in American Art Education," *Studies in Art Education,* vol. 17, no. 1, 1975, pp. 7–16.

A concise overview of growth in the field during the past twenty years. Cites the development of associations of art teachers, significant texts in art education, the publications of professional associations, the effects of governmental and private agencies, and research activities which have changed the teaching of art to children.

Lowenfeld, Viktor, and W. Lambert Brittain: *Creative and Mental Growth,* 6th ed., Macmillan, New York, 1975.

A classic in the field of art education stresses concern for the creative development of the child. Shows the contribution that art

education makes at the various stages of the child's growth to a fuller development both creatively and mentally. Outlines a "natural" pattern of development in art, from scribbling to "schematic" stages to stages of "realism," which must be understood and respected.

McFee, June K.: *Preparation for Art,* Wadsworth, Belmont, Ca., 1970.

Presents an anthropologically oriented program of art in the schools. See following entry for updated and expanded version of this popular text.

―――― and Rogena M. Degge: *Art, Culture, and Environment: A Catalyst for Teaching,* Wadsworth, Belmont, Ca., 1977.

Offers more than a handbook for art teachers in that it stresses individual, psychological, and cultural aspects of growth in art. Attempts to help students learn to "relate the qualitative aspects of art to solving environmental problems as well as to cultural understanding and appreciation." Emphasizes the elementary years but also includes material for junior and senior high school students.

Madeja, Stanley S.: *All the Arts for Every Child: Final Report on the Arts in General Education Project in the School District of University City, Mo.,* The JDR 3rd Fund, Inc., New York, 1973.

An account of the Project's development over a three-year period: conceptual approaches, establishing goals, staffing, organization and practices for teaching art through the integration of subject areas, creating complementary resources, using the arts in the community, evaluation techniques.

―――― et al.: *Final Report on the Institute in Aesthetic Education for Administrators,* CEMREL, St. Louis, Mo., 1974, 2 vols.

Vol. I, An 8 Day Week, reports the content and process of the Institute which was designed to expose administrators to the conceptual bases of aesthetic education, make them aware of resources available for implementing a program, and help them plan for such a program. Vol. II, Working Papers contains: John Goodlad, "Strategies of Educational Change"; Charles Dorn, "Aspen Institute Evaluation"; and Louis M. Smith, "Images and Reactions."

―――― and Sheila Onuska: *Through the Arts to the Aesthetic: The CEMREL Aesthetic Education Curriculum,* CEMREL, St. Louis, Mo., 1977.

Describes forty-four supplementary instructional units in the elementary curriculum developed over an eight-year period, divided

into six areas: "Aesthetics in the Physical World," "Aesthetics and Arts Elements," "Aesthetics and the Creative Process," "Aesthetics and the Artist," "Aesthetics and the Culture," and "Aesthetics and the Environment."

Morrison, Jack: *The Rise of the Arts on the American Campus,* McGraw-Hill, New York, 1973.

Chapter 5 offers recommendations concerning teacher training in the arts.

Murphy, Judith, and Lonna Jones: *Research in Arts Education: A Federal Chapter,* U.S. Office of Education, Washington, D.C., 1978.

An analysis and summary of research in the arts in education undertaken in the Arts and Humanities Program (AHP) of the U.S. Office of Education funded between 1965 and 1970. Offers many lessons to be learned from the fruits of that program for further research and development in arts education.

National Art Education Association: *Art Education: Elementary,* NAEA, Reston, Va., 1973.

Written by a Task Force of specialists in elementary art education, chaired by Pearl Greenberg. Chapter 2, "Innovation or Renovation? An Historical Inquiry," offers seven approaches to art education and a selected bibliography followed by further discussion of specific current teaching approaches as described by participating professionals. Chapter 3 deals with personnel, programs, learning experiences, financing, and facilities for developing art in elementary schools and their communities.

————: *Art Education: Middle/Junior High School,* NAEA, Reston, Va., 1973.

Written by a task force of art educators, chaired by Walter Hathaway. Some strategies for the teaching of art: student-centered, art approached experientially, perception centered, artist as model, art as a discipline, interdisciplinary programs and behavioral objectives. Describes a quality art program. Chapter III, Art in the School and the Community, offers specifics for initiating and developing programs at this level, suggests resources outside the school, alternative teaching arrangements, and careers in art.

————: *The Essentials of a Quality School Art Program: A Position Statement by the National Art Education Association,* NAEA, Reston, Va., 1978.

A brief, useful pamphlet presenting a definition of objectives and

guidelines on facilities, teaching load, scheduling, materials, and staff qualifications.

————: *Report of the NAEA Commission on Art Education,* Charles M. Dorn, Commission chairman, NAEA, Reston, Va., 1977.

Section I summarizes conclusions and recommendations. Section II presents current and historical data and philosophical arguments, including criteria for practice and an agenda for change. Section III, Appendix, "Selected Models for Practice Developed for Sixth Grade," gives illustrations of the various philosophical positions presented. The Commission supports an eclectic model for art teaching in public schools.

————: *Research Monographs,* NAEA, Reston, Va., 5 vols:
No. 1—*Creativity and the Prepared Mind,* by Ray Hyman.
No. 2—*Viktor Lowenfeld: His Impact on Art Education,* by Manuel Barkan.
No. 3—*An Eye More Fantastical,* by Frank Barron.
No. 4—*Teaching and Learning in the Arts,* by Henry D. Aiken.
No. 5—*Self in Art Education,* by Edward L. Mattil.

National Assessment of Educational Progress: *Knowledge About Art: Selected Results from the First National Assessment of Art,* NAEP, Denver, Colo., 1978.

Report of educational attainments in art of 9-year-olds, 17-year-olds, and adults (ages 26–35). Emphasis is on Western art history and conventions. Results show that students do not have an extensive knowledge of art. Also available from NAEP: Music Objectives; The First National Assessment of Musical Performance, An Overview; Music Technical Report, Summary Volume; Art Objectives; Design and Drawing Skills; Art Technical Report: Exercise Volume; Art Technical Report: Summary Volume; and Attitudes Toward Art.

NASSP Bulletin, vol. 59, October 1975.

Presents a symposium, "Music Education: Its Place in Secondary Schools," which includes descriptions of successful music programs. Stresses the need to offer enrichment to as many as possible rather than prepare the senior class for a musical program at graduation.

National Endowment for the Arts: *Federal Funds and Services for the Arts,* U.S. Office of Education, Washington, D.C., 1967.

Lists and describes 90 federal programs providing funds and services for artists and arts programming since the inception of the National Foundation on the Arts and the Humanities created by Congress in 1965.

National Society for the Study of Education: *Art Education,* The Sixty-fourth Yearbook, Part II, W. Reid Hastie (ed.), University of Chicago Press, Chicago, 1965.

Discusses teaching and learning at each educational level, the process for improvement of instruction in art, and the preparation of teachers. Identifies guidelines for future development in the light of the historical and present status of art education in America.

Nelson, Doreen G.: *Manual for the City Building Educational Program: Architectural Consultant Edition,* Frederick A. Usher and Jeff Bernstein (eds.), The Center for City Building Educational Programs, Los Angeles, 1975.

Demonstrates potential for linking current environmental concern with education by innovative alternative teaching strategies, using architect/planners as consultants. Stresses activities which help elementary school children learn how to learn, solve problems, make decisions, and work with others, at the same time attending to required state curricula. A curriculum guide to stimulate creativity, to encourage "future thinking" and to develop sensory awareness.

New York State Commission on Cultural Resources: *Arts and the Schools: Patterns for Better Education,* Albany, N.Y., 1972.

A guide designed for the public, cultural organizations, and the professional educator to encourage fuller aesthetic experiences in the schools. Narrates the successes and failures of the State's educational system in this area, cites general trends and specific problems, and reports findings and recommendations.

Newsom, Barbara Y., and Adele Z. Silver (eds.): *The Art Museum as Educator: A Collection of Studies as Guides to Practice and Policy,* University of California Press, Berkeley, Ca., 1977.

The Council on Museums and Education in the Visual Arts reports the results of an eighteen-month study into visual arts education programs in schools, museums, universities, and community centers. Part II develops comprehensive lists of programs for school children in museums and other sites; visual arts programs for high school students; and teacher training programs and classroom materials available.

Pennsylvania Department of Education: *The Arts Process in Basic Education,* Harrisburg, Pa., 1974.

Promotes the infusion of the arts into the total curriculum, with responsibility for arts education shared by all teachers in order to expand the base for learning experiences for all students.

Pittsburgh, Pennsylvania, Board of Public Education: *Visual Arts in the Primary Grades,* Pittsburgh, Pa., 1975.

A teachers' guide to an art program which is concept-oriented rather than product-oriented. Aimed at developing an awareness of visual and tactile qualities, learning to make qualitative judgments, and understanding and appreciating the art of the present and past. Other guides are available from grade 1 through senior high school. Stresses education of individual sensibilities.

Project ABC (Art Based Curriculum) Learning Package, Russell Siracuse, Director, Bureau of Education, Department of Mental Health, 44 Holland Avenue, Albany, N.Y. 12229.

A multisensory approach to the education of handicapped children through the arts. Contains filmstrip/cassette, a videotape demonstration, and an activities card file.

Project IMPACT (Interdisciplinary Model Program in the Arts for Children and Teachers), U.S. Office of Education, Arts and Humanities Program, Washington, D.C.

Began in 1970 at five schools, survived for a few years. In Eugene, Oregon, the project grew into an "alternative" Magnet Arts School (K–6) where the arts "are used as a discipline in themselves but mostly as a vehicle to teach other disciplines."

Project SEARCH (Search for Education through the Arts, Related Content and the Humanities), Utica City School District, New York.

One of six New York State sites chosen to implement an ESEA Title IV-C program designed to humanize education through development of innovative models in the curriculum focusing on an integration of the arts and humanities. Presents strategies for integrating the skills in the arts with the skills in cognitive areas through a series of workshops using visual artists, actors, filmmakers, musicians from the community and its schools. Developed accompanying materials.

Project Zero, Harvard Graduate School of Education. See *Harvard Project Zero* in Part I.

Pterodactyls and Old Lace: Museums in Education, Schools Council, published by Evans/Methuen, distributed by Citation Press, New York, 1972.

Considers ways in which museum services could be used more effectively by teachers based on a clear statement of philosophy of the educational use of museums. Replete with examples of current practice and possibilities for the future.

312

Ross, Malcolm: *Arts and the Adolescent: A Curriculum Study* from the Schools Council's "Arts and the Adolescent Project" based at the University of Exeter Institute of Education (1968–72), Schools Council Working Paper 54, Evans/Methuen Educational, London, 1975.

Studies arts teaching in order to develop an instrument which enables arts teachers to control arts education. Basic conceptual framework constructed to permit analysis and assessment of current practice in six rather varied types of schools. Problems: role of arts in society and in education is well down on list of priorities; the feeling that arts teachers are "different"; cross-purposes of the arts curriculum today—lack of consensus. Chapter III, "The Arts Curriculum and the Intelligence of Feeling," looks at the characteristic features of each of the arts subjects highlighting the major conflicts which divide arts teachers and which keep them in unproductive isolation.

Silverman, Ronald H.: *A Syllabus for Art Education,* California State University, Los Angeles, 1972.

A collection of ideas and approaches for teaching the visual arts in a sequential and cumulative way. Outlines an introduction to the theory and practice of art education, offering examples and readings to supplement the text.

Stake, Robert (ed.): *Evaluating the Arts in Education: A Responsive Approach,* Charles E. Merrill, Columbus, Ohio, 1975.

Proposes an alternative to "preordinated" evaluation: using program activities, portrayals (case studies), testimony, and audience comprehension. Natural rather than formal communication methods are used, such as classroom observation and documentation of issues. Suggestions are made to improve reliability of observation and opinion-gathering and a 12-point scheme is offered for responsive evaluation. Other chapters deal with accountability, judging school as a place conducive to art, the consumer's viewpoint, and an extensive annotated bibliography.

Thomas, Ronald: *MMCP Synthesis,* Media Materials, Inc., P.O. Box 533, Bardonia, N.Y.

Presents the rational of the Manhattanville Music Curriculum along with examples of suitable strategies for use with students from grade 3 through high school.

Urban Education Studies, 1977–78 Report, sponsored by the Council of the Great City Schools in Collaboration with the University Council for Educational Administration, Francis S. Chase, Director, Urban Education Studies, Dallas, Tex., 1978.

Data on 599 programs in thirty large city school districts indicate success in four areas, two of which pertain to the arts in education: action-learning and community interaction. Describes programs in the Arts and Humanities Center located in the Atlanta Memorial Center; the creative arts school for the gifted and talented in Milwaukee; the Dallas Arts Magnet High School which offers creative experiences in expressive and performing arts; the Oakland community resource sites including the California Museum and others.

Walker, Decker, F.: "Curriculum Development in an Art Project," in W. A. Reid and D. F. Walker (eds.), *Case Studies in Curriculum Change,* Routledge and Kegan Paul, Boston, 1975, pp. 91–135.

An observational study of the Kettering Project directed by Elliot Eisner designed to develop a curriculum in the visual arts for elementary school children. Although this chapter emphasizes the processes of planning and the development of material, the substance of art in the curriculum is clearly identified. Defines three domains of learning in art: the critical (judgment), the productive, and the historical.

Wenner, Gene C.: *Dance in the Schools: A New Movement in Education,* The City Center of Music and Drama, The National Endowment for the Arts, the JDR 3rd Fund, 1974.

Describes the Artists-In-Schools Dance Program with suggested strategies, roles, and functions for participants.

Western States Arts Foundation: *Artists, Poets, Schools: A Study of the Poetry and Visual Arts Components of the Artists-In-Schools Program, Technical Report,* Western States Arts Foundation, Denver, Colo., 1976.

Wildemuth, Barbara M. (comp.): *Program Evaluation in the Arts,* ERIC/TM, Educational Testing Service, Princeton, N.J., 1977.

Briefly describes all the research programs in the arts in the ERIC library up through August 1977. Evaluations were informal, for the most part, suggesting how teachers and interested parents might pursue similar research projects with a view to maintaining successful programs.

PART III. PEOPLE AND PROCESS

The American Institute of Architects: *Built Environment: A Teacher Introduction to Environmental Education,* AIA, 1975 (distributed by the National Council for the Social Studies).

Emphasizes the spatial and artistic dimensions in the study of the environment. Offers three approaches: discovery, theoretical problem, and the "real world" situation, and provides examples, suggested activities, resources for each.

"Arts in Education," *Christian Science Monitor,* November 8, 1976.

A 12-page pull-out section carries the message for incorporating all the arts in every facet of education: "Art is being, is wholeness." Cites and illustrates ongoing practice.

Association for Childhood Education, International: *Children Are Centers for Understanding Media,* ACEI, Washington, D.C., 1973.

Ideas for involvement of children as photographers, filmmakers, videotapers, etc. With the collaboration of the Center for Understanding Media, articles include Rose Mukerji, "Creating and Becoming"; Susan Rice, "The Children's Film Theatre" and "Some Sound Ideas"; and resources for further study. See also the Association's Play: The Child Strives Toward Self-Realization *and Emily Gillies,* Creative Dramatics for All Children, *1973.*

Bamberger, Jeanne, and Dan Watt: *Making Music Count,* Educational Development Center, Newton, Mass. 1978.

Bamberger of MIT and the Cambridge public schools piloted innovative teaching approaches to find ways to reach adults and children so that making music might become natural for everyone.

Bradley, Ian L.: "Development of Aural and Visual Perception Through Creative Processes," *Journal of Research in Music Education,* vol. 22, Fall 1974, pp. 234–240.

Processes employed allow students to create their own music through improvisation, writing, playing, and listening to their own musical creations.

Castillo, Gloria A.: *Left-handed Teaching: Lessons in Affective Education,* Praeger, New York, 1974.

Personal approach to confluent education includes: awareness of here and now, sensory awareness, imagination, polarities, communication, building trust, aggressive nature, space, art. Many games and activities and an annotated bibliography are included.

Chapman, Laura H.: *Approaches to Art in Education,* Harcourt, New York, 1978.

A profusely illustrated, up-to-date text for classroom teachers which concentrates on what to teach and why rather than how to

teach it. *Basic information on the development of art education, children's artistic development, activities, program planning, and evaluation. Bibliography includes books for students and teachers and lists of sources for other media.*

Dimondstein, Geraldine: *Children Dance in the Classroom,* Macmillan, New York, 1970.

Sees the goal of arts education as that of educating feelings, consisting of experiences that heighten sensitivity to sensory phenomena and increase the power of personal expression. These experiences are drawn from all the arts and involve the social sciences and other curricular areas.

————: *Exploring the Arts with Children,* Macmillan, New York, 1974.

Believes that the arts are a way of knowing and demonstrates a variety of experiences in painting, sculpture, dance, and poetry for teachers to use with children.

Educational Facilities Laboratories, Inc.: *Arts and the Handicapped: An Issue of Access,* EFL and the National Endowment for the Arts, New York, 1975.

Describes the creation of cultural facilities and programs in schools, art institutions, and community centers for the handicapped. Reports the people and places now involved, from tactile museums to halls for performing arts, for all types of handicaps.

————: *Cooperative Use of Resources for the Arts,* EFL, New York, 1978.

Suggests sharing activities and describes groups that have tried them.

————: *Hands-On Museums/Partners in Learning,* EFL, New York, 1975.

Case studies of fourteen museums now providing programs and facilities for young people to become actively involved in learning.

————: *New Places for the Arts, Book Two,* EFL, New York, 1978.

A selection of arts facilities of various sizes in different parts of the country.

————: *The Place of the Arts in New Towns,* EFL, New York, 1973.

Reports the experiences, problems, and aspirations of persons involved in the arts in some new towns. Also relates experiences in

other settings of programs, support, planning, and facilities that could be applicable to new towns.

———: *Technical Assistance for Arts Facilities,* EFL, New York, 1977.

Lists federal, state, and private sources for help in planning arts facilities. See also entry under Schoolhouse.

Elementary Science Study: *The Musical Instrument Recipe Book, Grades 3–8,* Teacher's Resource Book, McGraw-Hill, New York, 1971.

Provides instruction on how to build simple musical instruments from string, wood, nails, bamboo, empty cans, etc. Easy-to-make instruments are also easy for children to use in creating music. Developed at the Education Development Center, Newton, Massachusetts.

Feldman, Edmund: *Becoming Human Through Art: Aesthetic Experience in the School,* Prentice-Hall, Englewood Cliffs, N.J., 1970.

Deals with the nature of art, children's learning and creativity, and art curriculum. Uses photographic reproductions and children's work to promote aesthetic education and insights. Unusual format of a parallel text allows for further comment on issues raised in the main body of the work.

Goldberg, Moses: *Children's Theatre: A Philosophy and a Method,* Prentice-Hall, Englewood Cliffs, N.J., 1974.

Provides a rationale for children's theater, discusses psychology of the child (audience), and kinds of children's theater throughout the world. A detailed set of instructions on formal play production includes directions for playwriting, directing, acting, management, and design. Appendix consists of plays, suggested activities, and sample lesson plan.

Heinig, Ruth, and Lyda Stillwell: *Creative Dramatics for the Classroom Teacher,* Prentice-Hall, Englewood Cliffs, N.J., 1974.

Emphasizes maximum involvement and development of children. Offers detailed examples, ideas, and instructions on informal classroom dramatics for the inexperienced teacher. Begins with simple activities and gets progressively more involved. Includes pantomime, story dramatization, and bibliography of useful stories and poems.

Koch, Kenneth: *Wishes, Lies and Dreams: Teaching Children to Write Poetry,* Random House, New York, 1971.

A poet describes his successful experiences with elementary school children in teaching them to express their own ideas in their own way.

Kramer, Edith: *Art As Therapy with Children,* Schocken Books, New York, 1974.

A resource book for teachers of normal as well as handicapped and disturbed students.

Krantz, Stewart, and Joseph Deley: *The Fourth "R,"* Van Nostrand, Princeton, N.J., 1970.

Presents a convincing argument for the use of art experiences as a way of helping culturally and economically deprived children develop better self-concepts. Shows that successful experiences in art can help children improve in other areas.

Linderman, Earl W., and Donald W. Herberholz: *Developing Artistic and Perceptual Awareness: Art Practice in the Elementary Classroom,* 4th ed., Wm. C. Brown, Dubuque, Iowa, 1979.

A rich source of ideas to help teachers become more open and creative in order to promote children's creative growth in art through their own greater awareness and sensitivity. Offers many suggestions for providing a richer environment and variety of experiences to stimulate the child's participation and exploration in the arts.

McCaslin, Nellie: *Creative Dramatics in the Classroom,* 2d ed., David McKay, New York, 1974.

A guide for the inexperienced classroom teacher in planning simple exercises and in adapting material for use in creative dramatics. Defines creative drama as a play developed by the group, as opposed to one that follows a written script, giving children an opportunity to develop imagination, become independent thinkers, learn cooperation, release emotions, improve speech, etc.

McIntyre, Barbara M.: *Creative Drama in the Elementary School,* Peacock, Itasca, Ill., 1974.

Designed.to help the classroom teacher gain insight into the dramatic process and how it can stimulate children's language learning, increase the child's understanding of himself, and develop his ability to communicate. The dramatic process entails sense of awareness, movement, characterization, improvisation, and dramatization.

Martin, Keith: "The Arts, the Schools, and the Communitywide Resource Center," *Phi Delta Kappan,* vol. 56, January 1975, pp. 334–36.

The Roberson Center for the Arts and Sciences at Binghamton, New York, demonstrates how to move community resources in the arts, history, and science into the schools.

Meske, Eunice B., and Carroll Rinehart (comps.): *Individualzied Instruction in Music,* compiled for the National Commission on Instruction, Music Educators National Conference, Center for Educational Associations, Reston, Va., 1975.

Designed to help teachers develop music programs appropriate for new learning environments (open classrooms). Offers examples of programs, suggestions for implementing changes, sources of materials and potential resources, and innovative approaches such as classroom experiments with electronic music.

The National Arts and the Handicapped Information Service: *Annotated Bibliography (First Draft),* ARTS, Box 2040, Grand Central Station, New York, N.Y. 10017, 1978.

Media and materials listed include books, recordings, films, and materials transcribed in Braille and large print produced since 1970. Because materials on arts and the handicapped are difficult to find, the publisher's address and prices of most of the publications are given.

P. K. Yonge Laboratory: *Aesthetic Awareness: A Means to Improve Self Concept in a Multi-Cultural Environment,* College of Education, University of Florida, Gainesville, Fla., 1973.

A small experimental program, brief in duration, examines a variety of experiences from an aesthetic point of view with emphasis on growth in the affective domain. Findings: shift from ego-centered to other-centered; aesthetic appreciation for the environment was heightened; more socially acceptable ways of expressing feelings and emotions were shown; and concept of self and others was improved.

Richards, Mary Caroline: *Centering: In Pottery, Poetry, and the Person,* Wesleyan University Press, Middletown, Conn., 1964.

Writes poetically of her insights into art and life: "Artistic vision registers and prophesies the expanding consciousness of man . . . Artistic imagination creates what has never before existed. To live artistically is to embody in social forms the unique individual and the intuitions of union. . . . Poetic images create in us capacities for personal reality and for participation." Speaks to the need for interdisciplinary participation.

Rossman, Michael: *Learning Without a Teacher: Music Lessons,* Phi Delta Kappa Educational Foundation, Bloomington, Ind., 1974.

A personal record of a "natural" process of learning in which the learner was free to choose what and how he would learn. Implications for teachers of all subjects at all levels.

Saunders, Robert J.: *Relating Art and Humanities to the Classroom,* Wm. C. Brown, Dubuque, Iowa, 1977.

An idiosyncratic presentation of philosophy, substance, and teaching practices to aid teachers in identifying goals, gaining background information, and relating their art lessons to the total school program. Stresses the approach, rather than the subject matter, based on child growth and development. Emphasizes human values and human needs as explored through the arts and humanities.

Schafer, R. Murray: *Creative Music Education: A Handbook for the Modern Music Teacher,* Schirmer Books, New York, 1976.

Five issues are dealt with: creativity, ear training, the acoustic environment, words and music, and music in relation to the other arts. Touches other subject areas: geography, sociology, communications, public affairs, poetry, etc. Involves students in experimentation, improvisation, and analysis.

Schoolhouse: A Newsletter from Educational Facilities Laboratories, Inc., New York.

September 1975 special issue describes how schools are sharing space with the performing arts community. October 1975 special issue supported by the National Endowment for the Arts describes community use of school facilities in the performing arts. April 1977 special issue is about visual, participatory, and performing arts facilities and programs for handicapped children and their teachers.

Silverman, Ronald: "Goals and Roles in the Art Education of Children," in Elliott Eisner (ed.), *The Arts, Human Development, and Education,* McCutchan, Berkeley, Ca., 1976.

Discusses the influence of the teacher on the quality of art education. Stresses two major variables: clarity with which the teacher understands the goals he formulates and the role he is to perform as a teacher.

Smith, Nancy R., and Lois Lord: *Experience and Painting: Understanding and Supporting the Work of Children Two to Nine,* Bank Street College of Education Follow Through, New York, 1975.

Helps the teacher understand individual differences and development in art, and the use of appropriate classroom techniques for

promoting them. Offers an analysis of psychological characteristics of child growth stages, techniques for initiating children's activities, appropriate teacher responses, and aesthetic characteristics of each stage.

―――, and Margery B. Franklin: *Symbolic Functioning in Childhood*, Erlbaum Associates, Hillsdale, N. J., 1979.

Discusses the influence of different materials, relating their expressive properties to children's experiences.

Spolin, Viola: *Improvisation for the Theatre: A Handbook of Teaching and Directing Techniques*, Northwestern University Press, Evanston, Ill., 1963.

Emphasizes the student's participation in following processes similar to those used by actors concentrating on the process of creating rather than on the result.

―――: *Theater Game File*, CEMREL, St. Louis, Mo., 1976.

Theater games and communications exercises are adapted for use with students from kindergarten through adults. Each of the 200 games is printed on a card and may be used in conjunction with arts education, language arts, social studies, and physical education.

Stewig, John W.: *Spontaneous Drama: A Language Art*, Charles E. Merrill, Columbus, Ohio, 1973.

A book for the classroom teacher on spontaneous dramatics—what it is, how it is done with children, and why it should be done. Concludes with a suggested step-by-step sample sequence. Annotated references list supplementary readings for teachers, children's literature found useful as motivation, records which provide aural stimulation, films about drama, poems, and suggestions for visual motivation.

Townley, Mary R.: *Another Look*, Addison-Wesley, Menlo Park, Ca., 1978.

Emphasizes the importance of observing expressive properties in art to develop children's sensitivity and feelings for art.

Wigginton, Eliot: *Moments: The Foxfire Experience*, Institutional Development and Economic Affairs Service (IDEAS), Washington, D.C., 1975.

Wigginton, teacher at Rabun Gap, Georgia, provides insights into the philosophy, the processes, and the "real, self-perceived learning moments" of the Foxfire program. Emphasis is on creative use of

the talents of high school students by involving them, through conducting extensive interviews with members of the oldest generation, in the documentation of their own cultural heritage. Developed skills in photography, layout, newspaper writing, and other means of communication as well as aesthetics and self-development. See also Wigginton (ed.), The Foxfire Book, Doubleday, 1972.

Witkins, Robert W.: *The Intelligence of Feeling,* Heinemann Educational, London, 1974.

Probes the consciousness of arts teachers in the Schools Council's "Arts and the Adolescent" project about the role of arts in society and education, their feelings about themselves as they and others see them, and the conflict in purposes among art teachers. A conceptual framework is presented which distinguishes between subject and object knowing, expressive and impressive action. Final chapter shows the teacher how to enter the expressive act of the child and assist its development "from within."

PART IV. PERIODICALS

American Journal of Art Therapy: Art in Education, Rehabilitation and Psychotherapy, Elinor Ulman, Ed. and Pub., Box 4918, Washington, D.C. 20008. Quarterly, $10.

Art and Man, Scholastic Magazines, 900 Sylvan Ave., Englewood Cliffs, N.J. 07632. Designed for the student. 6/yr., $5.50.

Art Education, National Art Education Association, 1916 Association Dr., Reston, Va. 22091. 8/yr., $15 for nonmembers.

Art Journal, College Art Association of America, 16 East 52nd St., New York, N.Y. 10005. Quarterly, $8 for nonmembers.

Art Teacher, National Art Education Association, Reston, Va. 22091. 3/yr., $10.

Arts and Activities: Creative Activities for the Classroom, Development Corp., 8150 N. Central Park Ave., Skokie, Ill. 60076. Monthly (Sept.–June), $9.

Audiovisual Instruction, Association for Educational Communications and Technology, 1126 16th St., NW., Washington, D.C. 20036. Monthly (Sept.–June), $18 to nonmembers.

Ceramics Monthly, Professional Publications, Box 12448, 1609 Northwest Blvd., Columbus, Ohio 43214. Monthly, $8.

The Creative Arts, Educational Arts Association, 90 Sherman Street, Cambridge, Mass. 02140. Quarterly, $8 for nonmembers.

Design Quarterly, Walker Art Center, Vineland Place, Minneapolis, Minn. 55403. 4/yr., $5.

Educational Theatre Journal, American Theatre Association, 1317 F St., NW, Washington, D.C. 20004. Quarterly, $15 for nonmembers.

Journal of Aesthetic Education, University of Illinois Press, Urbana, Ill. 61801. Quarterly, $12.50.

Journal of Music Therapy, National Association for Music Therapy, Box 610, Lawrence, Kans. 66044. Quarterly, $7.

Media and Methods: Exploration in Education, North American Pub. Co., 401 N. Broad St., Philadelphia, Pa. 19108. Monthly (Sept.–May), $9.

Music Educators Journal, Music Educators National Conference, Center for Educational Associations, 1902 Association Dr., Reston, Va. 22091. 9/yr., $12.

Music Journal: Educational Music Magazine, Music Journal, Inc., 20 Hampton Rd., Southampton, N.Y. 11968. Monthly (Sept.–June), $11.

New Ways, Educational Arts Association, 90 Sherman Street, Cambridge, Mass. 02140. Bimonthly newsletter, $6 for nonmembers.

School Arts Magazine, The Art Education Magazine for Teachers, 50 Portland St., Worcester, Mass. 01608. 10/yr., $10.

School Musician/Director and Teacher, Anmark Pub., P.O. Box 245, Joliet, Ill. 60431. Monthly (Sept.–June), $7.50.

Schoolhouse, Newsletter from Educational Facilities Laboratories, 850 Third Ave., New York 10022. 4–5/yr., free.

Stone Soup: A Journal of Children's Literature, Stone Soup, Inc., Box 83, Santa Cruz, Ca. 95063. 3/yr, $5. Written and illustrated by children.

Studies in Art Education: A Journal of Issues and Research in Art Education, National Art Education Association, Reston, Va. 22091. 3/yr., $15.

Theatre Crafts, Rodale Press, Emmaus, Pa. 18049. Bimonthly. $8.

INDEX

LIBRARY
ST. LOUIS COMMUNITY COLLEGE
AT FLORISSANT VALLEY